PUNK ROCK: SO WHAT?

It's now over twenty years since punk first pogoed its way into our consciousness. *Punk Rock: So What?* gathers together leading cultural critics to provide a controversial reassessment of punk and its place in the history of popular culture. Combining new research and exclusive interviews, the book brings a fresh perspective to the analysis of this primal generational scream, and kicks over many of the established beliefs about its meaning.

Punk Rock: So What? re-situates punk in its historical context, exploring its possible origins in the American surf-garage scene and London clubs as well as in Malcolm McClaren's brain. Challenging the standard mythology of punk, the contributors question whether it deserves its reputation as an anti-racist, pro-feminist movement, which was confined to the big cities and which, despite the words of the Crass song, was dead by 1979.

The contributors trace punk's legacy in literature, art, comics and cinema as well as in music and fashion – from movies such as *The Great Rock 'n' Roll Swindle*, to the graphics of Jamie Reid; and from novels of Richard Allen to the comix of Savage Pencil. Meditating on the appeal of the Ramones, the Slits, Johnny Rotten, itchy mohair jumpers, and hair dye that ran in the rain, the contributors establish that, if anything, punk was more culturally important than anyone has yet suggested – though perhaps for different reasons.

Contributors: Frank Cartledge, Paul Cobley, Robert Garnett, David Huxley, David Kerekes, Guy Lawley, George McKay, Andy Medhurst, Suzanne Moore, Lucy O'Brien, Bill Osgerby, Miriam Rivett, Roger Sabin, Mark Sinker.

Roger Sabin is a Lecturer in Cultural Studies at Central St Martin's College of Art and Design.

PUNK ROCK: SO WHAT?

the cultural legacy of punk

Edited by Roger Sabin

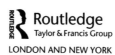 Routledge
Taylor & Francis Group

LONDON AND NEW YORK

First published 1999
by Routledge
2 Park Square, Milton Park, Abingdon, Oxon OX14 4RN

Simultaneously published in the USA and Canada
by Routledge
270 Madison Ave, New York, NY 10016

Transferred to Digital Printing 2003

Routledge is an imprint of the Taylor & Francis Group

Typeset in Perpetua and Steel-String by Keystroke, Jacaranda Lodge, Wolverhampton
Printed and bound in Great Britain by Biddles Ltd, King's Lynn, Norfolk

British Library Cataloguing in Publication Data
A catalogue record for this book is available from the British Library

Library of Congress Cataloging in Publication Data
Punk rock: so what? / [edited by] Roger Sabin.
p. cm.
Includes bibliographical references (p.) and index. (pbk. : alk. paper)
1. Punk rock music–History and criticism. I. Sabin, Roger, 1961– .
ML3534.P89 1999
781.66–dc21 98–37416
CIP

ISBN 0–415–17029–X (hbk)
ISBN 0–415–17030–3 (pbk)

CONTENTS

CONTENTS

FIGURES

FIGURES

CONTRIBUTORS

Robert Garnett is a freelance art critic for, among others, *Art Monthly*, and a Lecturer at the London College of Printing and Distributive Trades. He would like to do to Cultural Studies what the Pistols did to pop, but he can't afford to. He collects avant garde pop records instead.

Miriam Rivett is a Lecturer in Writing and Publishing Studies at Middlesex University. A classic part-time punk, she spent much of the late 1970s searching out Undertones gigs and (as now) worshipping John Peel.

George McKay is a Reader in Contemporary Cultural Studies at the University of Central Lancashire. He was a 16-year-old Glaswegian living in rural Norfolk in 1977, so felt a bit fractured anyway: then punk came along and safety-pinned him together for a while. He's since found himself writing about a cluster of issues around its legacy, and his books include *Senseless Acts of Beauty: Cultures of Resistance Since the Sixties* (London: Verso, 1996) and, as editor, *DiY Culture* (1998).

David Kerekes is the editor/publisher of *Headpress: the Journal of Sex, Religion, Death* and co-author of *Killing for Culture* (Creation, 1994). He was at engineering college in 1977, where he surreptitiously carved into a desk 'Who are the Clash?' in order to infuriate fellow student and six foot punk rocker 'Boomer'.

David Huxley lectures in the Department of the History of Art and Design at Manchester Metropolitan University. He was too old for punk, but too young to die.

Guy Lawley works as a GP and moonlights as a cultural critic. His life was irrevocably changed when he read his first Marvel comic in 1965, but luckily the resultant stunting of his development was ended 11 years later by the arrival of punk. A minor relapse in 1992 led to his founding *Comics Forum* magazine, published by the Comics Creators Guild of the UK.

Mark Sinker is a former editor of *The Wire*, and writes about music and movies, sex and politics. His forthcoming book *The Electric Storm* is a critical history of how technology changed music between 1876 and 1976, or thereabouts.

Frank Cartledge no longer vomits on a voluntary basis to impress girls, but now induces a similar effect on others in the course of his lecturing at various educational institutions.

Bill Osgerby (a.k.a 'Billy Ramone') is a cultural historian and writer. Presently teaching at a range of institutions of higher education, his survey of post-war British youth culture – *Youth in Britain Since 1945* – is shortly to be published by Blackwell. He faces years of therapy after a Dickies gig at which Leonard Graves Phillips – lead singer of the legendary LA punksters – brutally assaulted him with an inflatable, squeaking baseball bat.

Paul Cobley was at secondary school when punk exploded onto the national consciousness. He wanted to go to see The Stranglers in 1977 but his mum and dad wouldn't let him. He is now Senior Lecturer in Communications at London Guildhall University, a fact which offers no succour.

Lucy O'Brien is author of *She Bop (The Definitive History of Women in Rock, Pop and Soul)* (Penguin, 1995), and a regular contributor to various publications including Q magazine, *Sibyl* and the *Independent on Sunday*. She's currently updating *Dusty*, her 1989 biography of Dusty Springfield (due out in 1999). Her abiding memory of punk is a pair of purple boots and hair that stood up of its own accord.

Roger Sabin is a Lecturer in Cultural Studies at Central St Martin's College of Art and Design in London. His latest book is *Comics, Comix and Graphic Novels* (1996), and he writes regularly for a number of publications, including *Speak* magazine in the USA. He has vague memories of playing in a band called 'Pedigree Scum'.

Andy Medhurst teaches Media Studies at the University of Sussex. He is co-editing *Lesbian and Gay Studies: A Critical Introduction* (1997), and has written extensively about music, film and television for publications including *Sight and Sound* and *The Wire*. As his chapter indicates, he has never really recovered from 1977.

Suzanne Moore is a columnist at the *Mail on Sunday*, and her latest book is *Head Over Heels* (1997). She remembers everything. And nothing.

ACKNOWLEDGEMENTS

I would like to thank: at Routledge, Ian Critchley, Chris Cudmore, Steven Jarman and above all commissioning editor Rebecca Barden (secret Goth Queen); at Central St Martin's, Caroline Dakers and library staff; plus the staff of Wandsworth libraries. Also, of course, family and friends.

Pictures are reproduced as historical illustrations to the text, and grateful acknowledgement is made to publishers, illustrators and photographers. Copyright is credited according to original copyright date. Every effort has been made to trace copyright: any omission or incorrect information should be notified to the publisher, who will be pleased to amend any future edition of the book.

INTRODUCTION

Roger Sabin

> There are LOADS of myths about punk, but NONE of them live
> up to what it was/is like.
> > (*Vague* fanzine, number 15, 1984)
>
> Many of the people whose lives were touched by punk talk of
> being in a state of shock ever since.
> > (Historian Jon Savage, speaking at the ICA, London, 1991)

It's over 20 years since the death of Sid Vicious, yet in some ways interest in punk
has never been so intense. It's no longer the subculture of the moment, of course,
but people's fascination with it is evident in other spheres.[1] There's the plethora of
books on the subject, for example, both learned and not so learned (e.g. the
innumerable 'cuttings job' band biographies); the quantity of documentaries on
radio and TV (four major new series on British TV planned for 1999); and the
number of articles in the press (hardly a week goes by, it seems, without some kind
of punk-centred feature in the Sunday supplements). Then there's the fact that
reissue CDs are doing great business (often in boxed-set form), and that ephemera
is being collected at a furious rate by museums (London's Victoria and Albert
Museum finishes cataloguing its new collection of fanzines this year). Even the
auction houses are making a profit: Sid's 'My Way' tuxedo was recently sold by
Sotheby's for £1400 – he must be spinning in his grave.

Part of the reason for this continuing interest is that 'pop culture' has gone
mainstream. It wasn't ever thus, and there was a time, pre-punk, when pop culture
was still considered to be vulgar, 'corrupting', and (in Britain) 'too American'
(prejudices that were a hangover from Victorian notions of high and low culture).
But now pop is much more acceptable, and, for example, in the media, subject
matter previously thought to be the domain of the alternative and music press has
made its way overground (there is now more space in the mainstream for the
coverage of gigs, street fashion, drug culture and so on). Indeed, journalists
themselves have often made the transition without much difficulty: in Britain, it's
become a cliché that writers from the punk era now set the cultural agenda on

'Fleet Street' publications (from the Roxy Club to the Groucho Club, if you like). Even academia has not been immune. The growth of Cultural Studies since the 1970s has meant that it is now possible to study modules on popular culture, indeed on punk itself, in universities and art colleges across Britain and the USA (I can hear Sid spinning again . . .).

But the problem with all this debate around punk is that history is being rewritten. There'd be no need to worry if the discussions were making the correct historical connections; if the parameters of the debate were sound; if, ultimately, the commentators were 'getting it right'. But unfortunately, in general, they haven't been, and some serious errors of emphasis have been made. This is not to say that outstanding analyses do not exist: they do. It is simply that overall the consideration of punk has been hamstrung by two things: the narrowness of the frame of reference (how many more times must we hear the Sex Pistols story?), and the pressures to romanticise (usually equating with seeing punk as a form of nostalgia). The aggregate result of this has been to solidify our notions of what went on during punk into a kind of orthodoxy – i.e., whenever we approach a new piece of writing on the subject, we think we already know what it meant.

The purpose of this book is to explode that orthodoxy and start again: the 'So What?' of the title implies both a challenge and a new way of looking at things. More specifically, the collection of articles presented here provides a diverse range of perspectives with one aim in mind: to start the process of relocating punk in cultural history. This involves not only taking issue with previously published accounts, but also exploring areas which have hitherto been largely ignored. For one of the key underlying assumptions is that punk was not an isolated, bounded phenomenon, but had an extensive impact on a variety of cultural and political fields. In other words, we're going to move away from music a little bit, and explore such disparate areas as film, literature, comics, fashion, and everyday behaviour. Once we adopt this vantage, new – and hopefully exciting – avenues are opened up for exploring punk's complicated relationship with the social differences of class, region, age, gender, sexuality and ethnicity.

First, some background. Since much of the book is about the consequences of punk, it is necessary to begin with some kind of working definition of the term (the grim duty of any writer of introductions). As most readers will be aware, 'punk' is a notoriously amorphous concept. Yet, bearing in mind that words tend to mean 'what they've come to mean', we can work backwards – in a sense – to try to fix certain essentials. Thus, at a very basic level, we can say that punk was/is a subculture best characterised as being part youth rebellion, part artistic statement. It had its high point from 1976 to 1979, and was most visible in Britain and America. It had its primary manifestation in music – and specifically in the disaffected rock and roll of bands like the Sex Pistols and the Clash. Philosophically, it had no 'set agenda' like the hippy movement that preceded it, but nevertheless

stood for identifiable attitudes, among them: an emphasis on negationism (rather than nihilism); a consciousness of class-based politics (with a stress on 'working-class credibility'); and a belief in spontaneity and 'doing it yourself'.

So far, so familiar. As a capsule definition this is fine, and has the advantage of concurring with all the contributions in the book. But, of course, there is much more to say: the problem is agreeing on exactly what. Inevitably, this brings us back to the questions of where to focus and how to avoid romanticising – for part of the orthodoxy that was mentioned earlier is a belief in a whole nest of other ideas about punk which are much more controversial (to put it mildly). This is not the place to go into these in detail (indeed, many of the essays engage with them directly), but it is nevertheless helpful to raise a few basic questions about some core examples.

First of all, there is the issue of where and when, exactly, punk begins and ends. The generally accepted view is that it originated in America, due to the existence there pre-1976 of bands such as Television and the Ramones and antecedents going back to the garage bands of the 1960s. Specifically, the start-point is usually given to be around 1973–74, and the place of origin New York (primarily due to the existence there of the club CBGB's). The look, the music, the *idea*, is then said to have been imported into Britain – with help from Malcolm McLaren. This has been the line taken by a number of high-profile histories (in book and TV form) in recent years.[2]

Yet, if we accept that one of the key defining elements of punk was an emphasis on class politics, then it could only have begun at one time and in one place – Britain in the late 1970s. For example, if we think of punk as an explosion caused by the bringing together of various unstable elements, then the UK's economic recession during this period can be seen as the catalyst. This is not to say that the American bands (or McLaren) did not have an influence – of course they did. Just that the 'quality' of the experience in America was different, and much less politicised. It is self-evident, for example, that the New York bands, in contrast to their British counterparts, generally dealt in outrage for art's sake. (How far recent claims for America-as-starting-point amount to cultural imperialism is at least worth taking seriously.)

There is similar controversy over when punk ended. Most accounts take the termination point to be 1979, mainly because this is seen to be the moment at which it was overtaken by other youth movements (many of which it had helped spawn) – notably in the UK, the Two Tone scene, the mod revival and New Romanticism – and by when, in counterpoint, punk had lost its energy and had been largely co-opted by the mainstream (a process that allegedly began with music and fashion 'going overground' and ended with punks parading themselves as tourist attractions down the King's Road).[3] Sid's death has thus come to be seen as a symbolic full-stop. It's also a convenient date because it saw a new kind of politics

come to power in Britain in the form of the election of Mrs Thatcher's Conservative government, and because, very simply, it caps off the decade.

But if punk stops in 1979, then it can be argued that there is a great deal of the story that is left out. This includes punk offshoots such as Oi!, the controversial but very popular 'street punk' movement of the early 1980s; the neo-fascist punk scene (Skrewdriver *et al*.) which had its peak in the late 1980s; the anarcho-punk movement, with bands like Crass who took the anarchist message seriously and who on occasion inspired actions which were a real challenge to the 'Thatcher–Reagan axis'; and, most importantly in America, Hardcore, a toughened-up, speeded-up variant; which in time begat Grunge (Nirvana *et al*.); which in turn begat Riot Grrrl, a kind of aggressively feminist punk – all critically important musical/cultural developments. According to this argument, there is a part of the punk tradition that was never fully co-opted, which *did* develop an agenda, and which is still thriving today.

Second, there's the connected question of the politics of punk – a huge subject that has generated a corresponding volume of debate. One major strand has centred on (1976–79) punk's supposedly 'left-wing' credentials, and what kind of anarchism it stood for – if any. The conventional view tends to encompass the notions that punk was heavily influenced by Situationism, but at the same time was anti-hippy politics (which were perceived as including a belief in utopian revolution, achieved if possible by pacifist means). Similarly, most accounts assume that punk was 'liberating' politically, and created a space for disenfranchised voices to be heard – notably women, gays and lesbians, and anti-racists (punk's involvement with Rock Against Racism being a key reference-point).

Yet, there is plenty of evidence to counter these claims. For example, that Situationism was only important among a tiny cognoscenti, and never had a deep impact (if that was punk's secret history, John Lydon once quipped, 'then it was so secret that nobody told us' (Pecorelli 1996: 60)). Or that the hippy movement was in fact drawn upon philosophically to quite a significant degree – especially in terms of its tactics for subverting mainstream culture, and its DIY ethic (which raises the question of whether punk was, indeed, the last gasp of the 1960s counterculture). Or that punk, far from being liberatory, could in fact be very reactionary, and was riven through with sexism, homophobia and racism. Perhaps the danger highlighted by this last point is that punk should never be viewed through the 'ideologically sound' prism of the 1980s and 90s, but in the context of its own time.[4]

Third, and finally, there is the problem of what (and what not) to include under the aegis of punk. As has been implied, most histories are content to limit themselves to discussion of what happened within the fields of music and fashion – typically tracing the story in terms of the actions of charismatic individuals (for example, the Pistols for music, and McLaren and Vivienne Westwood for fashion).

These were the aspects of punk that the media focused on at the time, because of their importance in forging a youth identity and their undeniably spectacular natures, and the same has been true of histories ever since. Once again, punk has become contained, dealable-with on a limited level, and thus much more vulnerable to being turned into a subject for nostalgia.

But, there is a strong case for saying that punk was not demarcated in this way, and rather than being about isolated areas, was a cultural and political 'movement' – even representing a basic shift in the zeitgeist. If this was/is true, then there is clearly a long way to go before its contribution to other fields is properly recognised. Culturally, these might include literature, fine art, comics, film, theatre, television, comedy, journalism, body modification, and many more, while politically we can point to its impact on anarchism, green radicalism and neo-fascism, to name a few (indeed, one of the problems with seeing punk in purely cultural terms has been that its political impact has often been conveniently elided). Many of the chapters in this book attempt to cover at least some of these areas: suffice to say that once we adopt this broader perspective, it's hard to imagine a modern Europe and America not transformed by punk.

These are just a few simplified examples of the tortuous historical arguments about definition. They show that until we can decide what punk was, it is impossible to say what its consequences were. But they also indicate that any attempt to define is also part of a process of *construction*: that to map a sub-culture is simultaneously to 'make' it. This becomes an especially difficult task when there are obvious tensions and contradictions (we've already outlined a few but, for example, punk was also 'about' originality and plagiarism; anti-commercialism and commercialism; sophistication and dumbness; humour and seriousness). The problem is emphasised when we consider that subcultures themselves are constantly mutating, and that participants negotiate their own positions within them.

This is an important point because, however punk might be delineated (and with our original schema in mind), there is still a need for interpretative flexibility, and for a recognition that its followers were as much its creators as created by it. Until recently, subcultural theory has not been good at acknowledging this subtlety, and a form of determinism has held sway. Too often, 'big theories' have been relied upon (Marxism, the sociology of deviance, semiotics, etc.), which picture those involved in subcultures as passive pawns of history, their lives shaped by grand narratives beyond their control.[5]

This is not the case in Cultural Studies any more, thankfully. In the 1990s there is a much greater willingness to re-focus towards a more subjective approach. For instance, within any subculture, such factors as a person's class, gender, race, sexuality, geographical location, and age-group are bound to be crucial in determining the way they experience it. The same goes for what they bring to it

in terms of their education and upbringing. In theoretical terms, the social status that is conferred by such experiences has been described as 'cultural capital' (which is to say a store of cultural wealth that has nothing necessarily to do with money).[6]

This also brings us back to that word 'hip', which we might previously have understood instinctively, but which has now been theorised in a much more systematic fashion – in terms of 'subcultural capital'.[7] This refers to the ways in which people acquire a sense of distinction and self-worth within a subculture through such means as insider knowledge and 'good taste'. (Which is not the same as saying that hipness equates with 'resistance' to mainstream culture.) It helps to explain, for example, why wearing straight-leg trousers became such an issue during punk ('like trousers, like brain', as Joe Strummer was wont to say[8]).

It follows from this more individualistic approach that there has to be an acknowledgement that subcultures are not 'fixed', and that a participant's subcultural capital might additionally be affected by this. In other words, people might move in and out of them (a punk one minute, a mod the next), or simultaneously interest themselves in other kinds (the punk who goes to soul clubs). There is also the issue of different levels of engagement, from the hardcore 'activist' for whom the subculture might be a way of life, to somebody who dips in occasionally by buying a record or going to a gig ('part time punks' in the Television Personalities' time-honoured phrase).[9]

Thus, once somebody has made a commitment – on whatever level – to a subculture, then they make their own choices. So, for example, when I think back to my love of the band Wire, I can see in retrospect how this might have been influenced by such subjective factors as the facts that I could play some of their songs on my new guitar ('Lowdown' was basically two notes repeated), that I could use them in my war against my mum and dad ('12XU' as 'I-won't-tidy-my-room' music), and that, being a bit of a weed, I felt relatively safe going to see them because they had a less 'heavy' following than Sham 69 or the Pistols. (This combined with the fact that I was simultaneously a big fan of heavy metal probably meant that my store of subcultural capital was nil.)

By extension, this theoretical perspective implies new possibilities. It raises the question of what an 'authentic' experience of punk might have been (such an important issue, bearing in mind the 'hipper-than-thou' snobbery so often associated with it). Thus, the experiences of a 14-year-old punkette from a small Welsh village can be seen as just as 'valid' as those of John Lydon. Her age, gender and regional location have no bearing on her 'authenticity', which is not an organic concept, but itself constructed. By implication, 'history from below' is as valuable as that 'from above', and perspectives from outside London as useful as those from within (this book happens to include essays about Ipswich, Sheffield, Southampton, Wigan, Manchester and Essex, as well as America). How we date punk is also

important: for if we extend things past 1979, the 'punk club' (of people who were 'there') becomes much less exclusive.

Finally, this approach also raises the possibility of a more focused analysis of actual trends, which eschews generalisations – theoretical or otherwise – in favour of looking at case studies. A peripheral, but not insignificant, example makes the point clear: the quintessentially punk art of gobbing. This is usually – and lazily – explained as a way for an audience to show their appreciation for a band. But what about those bands who were gobbed on because they were genuinely hated (a pretty frequent occurrence)? Or the case of Adam and the Ants, with their fetish gear and 'sex punk' fans, where gobbing took on distinct S & M connotations? Or the Freudian implications of when young male fans would gob on female performers like Gaye Advert and Siouxsie Sioux? Or even of the story in which a rugby club was having a dinner in a room in a pub above a punk gig, and the drunken, besuited diners came downstairs and asked the doorman if it was okay to spit on the band?

But if there are so many interpretative options, and if punk can be seen as an inchoate welter of individual voices and decisions, does this mean that we should jettison our working definition altogether? The answer is: of course not. The 'vast impersonal forces' of history (in T.S. Eliot's words) still have a role to play. It is just that we need to recognise that it is up to the individual to define those forces, appropriate them, and ultimately use them for their own ends – or not, as the case may be. The onus is then on the historian to construct a narrative that is ideally led by empirical research rather than by theory (the latter, of course, being a much cheaper prospect to fund for universities).

The chapters in this book hopefully (re)construct punk in a new and exciting way. They appear grouped into two halves. The first, 'Shock Waves and Ripple Effects', is about looking at the impact of punk on disparate areas of the arts and on behaviour. Robert Garnett kicks off with a meditation on its relationship with the visual, starting with the graphics of Jamie Reid and ending with 1990s 'Brit Art'. Miriam Rivett then looks at punk fiction writing, and rediscovers the remarkable 15-year-old novelist Gideon Sams. The literary connection is extended in George McKay's chapter on cyberpunk, which begins: 'much attention has been paid to the "cyber", but what about the "punk"?' David Kerekes then looks at transgressive film – 'the only true Punk Celluloid' – and interviews director Rick Baylor. David Huxley follows with an analysis of the more mainstream movie *The Great Rock 'n' Roll Swindle* (a film everybody saw, in contrast to the very few who saw the Pistols themselves). Next, Guy Lawley surveys the impact of punk on comics (a medium in their own right, of course), with an emphasis on titles like *Love and Rockets* and *Hate*. Finally, ending Part I, Mark Sinker presents an idiosyncratic take on punk etiquette, which goadingly asks what the consequences would have been if Moses had returned from the mountain not with the Ten Commandments, but with Siouxsie and the Banshees' first album.

Figure 0.1 Adam and the Ants on stage (1977): S & M nasties?
Source: Photograph by Ray Stevenson.

Part II, 'Experience, Memory and Historiography', takes a position that is more critical of established historical accounts (the temptation was to call it 'Well, I don't remember it that way . . . '), and which is typically more personal in tone. It begins with Frank Cartledge on fashion in Sheffield, a chapter which eschews the McLaren/Westwood mythology in favour of exploring what most people actually wore (including Frank's own memories of buying gear via adverts in the

back of music papers). Bill Osgerby then takes issue with accounts of American punk which have downplayed its pop and surf influences (the nearly forgotten Dictators resurface in the process). Paul Cobley follows with a searing attack on histories that are elitist and London-centric, and offers instead a view of events in and around the Wigan Casino. Next, Lucy O'Brien argues for a more balanced view of the role of women in punk, utilising a range of new interviews with key players and memories of her own experiences. Then, there is my own chapter on racism, which posits that, contrary to received wisdom, the politics of UK punk probably owed more to Enoch Powell than to Guy Debord. Penultimately, Andy Medhust offers some autobiographical thoughts on the 'flashbulb' nature of remembering (confessing, along the way, to wearing 'Extra-Large' flares to a Vibrators gig), and explores the dangers of subjecting something so emotive as punk to intellectual analysis. Finally, closing the book, Suzanne Moore, in another reflective piece, asks whether we should keep the punk legacy alive, or simply 'kiss its arse goodbye'.

Of course, there is a great deal that the book could not cover. Sadly, there's very little about Crass or Hardcore; or about fanzines or body modification; or so many other important aspects. Also, it would have been nice to have had more on international perspectives. For example, what about punk in Spain (so fascinating as a moment of release after the fall of Franco)? Eastern Europe (as a signifier of dissent in totalitarian regimes)? Australia (especially the vibrant Melbourne scene – including the young Nick Cave)? South Africa? Japan? (If we accept that punk's ramifications were indeed widespread, then the scope for investigation is almost unlimited.) Yet, as was said at the beginning, the aim of the book is not to be comprehensive but to re-start the process of questioning, and to point up new areas for research.

Finally, a personal word on the contributors. All of them are authorities in their respective fields, and many are internationally known. Yet the reader may still feel disappointed that none of the big names associated with 'punk studies' are included: for example, Jon Savage (*England's Dreaming*), Dave Laing (*One Chord Wonders*), Dick Hebdige (*Subculture; the Meaning of Style*), Simon Frith (*Sound Effects*) and Greil Marcus (*Lipstick Traces*). This is because they were not invited by me to contribute – not that they'd necessarily have been able, or wanted, to in the first place. This was not out of any disrespect for their work: on the contrary, they were responsible for putting serious discussion of punk on the map (and the extent to which they are referred to in the chapters here bears witness to their continuing importance). Rather, my feeling as editor was, very simply, that a new approach to the subject required new voices to be heard.

For some of those voices, the book has proved a cathartic process (even if we didn't necessarily agree with Savage's point about being 'in shock', we still believed that punk had been a profound influence in our lives). Questions of 'authenticity'

Figure 0.2 Does the media reflect subcultures or make them? *Sounds* (1977) has a bash at
defining the 'New Wave' . . . and accidentally includes heavy metal band
Iron Maiden.
Source: *Sounds* 2 April 1977.

Sounds of the New Wave

The bands

ALTERNATIVE T-TV
Mark P and Alex Nobody (late of the world-famous Nobodies,) put the 'band together one month ago, there may be a single out on Step Forward Records in the next couple of months.
"Avant-garde — yeah. Close to Can and reggae type rhythms. But also very fast. We're aiming to go in another direction".
"Fire of London was just history — 1666/Never saw the Blitzkreig — 1941/Men in black berets — 70's reality" ('Never Saw The Blitzkrieg')
Mark and Alex favour dark grey Beatle jackets. Mark says, "There ain't gonna be no articles about us in Sniffin' Glue".

ARTHUR COMICS
Sutton-based quartet whose manifesto and music are said to bear strong resemblances to the MC5. Titles like 'Loot', 'Danger — CIA At Work', 'Media Killer' and 'Whitehall Guillotine' are accompanied by fervent three-chord tricks and 'revolutionary use of tape effects' says their home-made press release. A limited edition privately pressed album 'Peter Nostril' is due in April, at which time the band promise to "obliterate every other group on the scene" Let's just wait and see, shall we?

THE BOYS
The Boys have landed a good gig on the John Cale tour. They've been together for 6 months and have played 12 dates so far.
There are five of them — Matt Dangerfield vocals and lead guitar, John Plain rhythm, Jack Mack drums, Kid Reed vocals and bass and Casino Steel on piano. They play fast.
They have a 45 out on NEMS in the first week of April, 'I Don't Care', with an LP to follow.

BUZZCOCKS
Pete Shelley (lead vocals, broken stairway guitar), Steve Diggle (guitar), Garth

(bass) and John Maher (drums).
Even though they've been around since last June they're still suffering from a gig shortage, which the popularity of their EP — 'Spiral Scratch' — hasn't altered. Their former lead singer Howard Devoto — who was featured on the EP — left suddenly in February.
All they can say about their music is — "It's about mixed up feelings".

CHELSEA
Chelsea were reformed by Gene October after 3 members split to form Generation X last December. The new lineup is: Carey Fortune (drums), Marti Stacey (guitar), Bob Jessie (bass) and Gene October, vocals. Chelsea have signed to Miles Copeland/Mark P's new lable, Step Forward Records. Expect a 45 in around 6 weeks.

THE CLASH
Like The Pistols, The Clash are in grave danger of getting their political attitude and society's idea of what pop groups are about badly tangled.
The continued non-materialisation of a permanent drummer as competent and 'radical' as the departed Terry Chimes is becoming increasingly perplexing. It's a big country, after all . . .
On the plus side, The Clash do have superb material, three excellent front men and a very powerful single going for them. The band's debut album should be out shortly and is reportedly a killer.

CORTINAS
Jeremy Valentine (lead vocals), Mike Fewins (lead guitar), Nick Sheppard (rhythm guitar), Dexter (bass) and Dan Swann (drums).
The Cortinas formed in July '76 as a R&B band. They first played London's Roxy Club last month and received three encores.
Jeremy: "We play what we

about five months.
"What's the point of being political when we can't even vote" (Brian).
Eater's debut single 'Outside View' c/w 'You' has just been released on an independent label called The Label, distributed by Virgn.

GENERATION X
Kings of the second spurt of new wave bands. Song titles are instant punk mottoes: 'Above Love', 'Youth, Youth, Youth', 'Too Personal', 'New Orders', . . . current fave live number is 'Ready, Steady, Go', a wry excursion into anti-nostalgia.
The one they hope'll be their first 45, though, is 'Your Generation': "Might take a bit of violence, but only violence ain't our stance, Might make our friends enemies, but we got to take that chance, Ain't no time for substitutes, ain't no time for idle threats . . ."

IRON MAIDEN
Line-up: Den Ace (vocals), Ron Rebel — (drums), Steve Harris(bass), Bob Tawyer and Dave (lead guitars).
They've been together for two years and describe themselves as 'visual energy rock', 'aggressive', 'bloody

Continues page 26

see, we're trying to produce good rock'n'roll. The songs are about individuals".
They have been signed by Step Forward Records and should have a 45 released in a couple of months.

THE DAMNED
Although some hard-core New Wavers sneer at The Damned for their 'lack of commitment', The Damned are undoubtedly the band who've achieved the most in strict music biz terms—a fine debut album, two excellent singles, TV and — despite all the prejudice against 'punk' bands — extensive bookings across the country. Everyone who's seen them by now must be aware that at heart The Damned are simply a very good rock'n'roll band trading in high-speed, high-energy music, richly visual personalities and very powerful songs.

DRONES
The Drones are all 18/19, come from Manchester, and have been together for two years.
Next week they're going into the studio to cut an EP, which'll be cut in two weeks on their own label. It'll be a private pressing distributed through Virgin.
Their songs include: 'City Drones', 'Kids On The Street', and 'Persecution Complex':
'Paranoia in my head, I just wanna stay in bed, Schizophrenic human race. I . . .'

EATER
Retaining an average age of fifteen Eater are Andy Blade vocals, Brian Chevette guitar, Ian Woodcock bass and Dee Generate drums. The current line-up have been together for

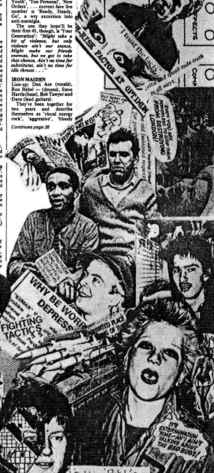

11

aside, it helped, too (for reasons that become clearer in Chapter 13), that most of us tended to be 'of the right age' to have been involved in punk first hand — as musicians, fanzine writers and designers, journalists or simply as fans. This is in contrast to the typical profile of an academic writer as a much older 'outsider', who takes the stance of an anthropologist exploring an exotic terrain.

Whatever the case, all the contributors shared the view that punk was too important to leave to the nostalgists. The past, as the saying goes, is a different country — nice to visit, but you wouldn't want to live there. Instead, this book makes the case for punk as a continuingly important event, the effects of which we are still living through, and for Sid *et al.*'s collective two-fingers to the world as a pivotal moment in cultural history. At a time when every new account of punk styles itself as 'the last word', there has never been more to say.

Notes

1 The debt owed by the 1990s techno/dance scene to punk has been fulsomely acknowledged (see, for example, Reynolds 1998, pp. 48, 83–4, 135). However, the (modern) counter-culture has been more ambivalent, and what is striking about the essays in McKay's study of 1990s radicalism is how infrequently punk is referred to. As the editor notes: 'The danger of focussing on direct action is that it contributes to a culture of immediacy, that what can be overlooked or lost in the excitement of the moment is the past – history . . . ' (1998: 13).

2 These include not only American histories such as Gimarc (1994) and (most aggressively) McNeil (1996), but also pop histories such as Boot and Salewicz (1997) and BBC TV's *Dancing in the Streets* (1996), which collectively feel the need to begin by outlining the history of the New York scene before moving on to the UK (no doubt in part because it makes them easier to sell in the bigger US market). Historically speaking, this approach is doubly questionable because other countries had strong claims to having important pre-punk scenes – notably France, where a Parisian subculture of Lou Reed fans calling themselves 'les punks' had been around since the early 1970s, and where, not coincidentally, the first punk festival was held in August 1976 (at Mont de Marsan). There was also, of course, a vibrant pub rock scene in Britain from the early 1970s, which was a huge influence on punk.

3 The notion of 'co-option' itself, of course, is far from uncontroversial. Recent work on subcultures has pointed to the fact that they are as much 'made' by the parent culture as reflected and exploited by it. (Despite its anti-'sell out' rhetoric, in other words, was punk ever anti-commercial?) The point about the fracturing of punk also requires qualification: arguably this was happening as early as 1977 with the emergence of 'power pop'.

4 For a fascinating discussion of how rock is often at its most powerful when it is at its least politically correct, see Reynolds and Press (1995).

5 For a good introduction to the history of subcultural theory, see Gelder and Thornton (1997).

6 The concept of 'cultural capital' is associated with Pierre Bourdieu (especially 1984).

7 The concept of 'subcultural capital' is associated with Sarah Thornton (especially 1995).
8 Joe Strummer, quoted in *Sniffin' Glue* no. 4, November 1976.
9 Television Personalities 'Part Time Punks', on the 'Where's Bill Grundy Now' EP, Rough Trade, 1978.

Bibliography

Boot, Adrian and Salewicz, Chris (1997) *Punk: The Illustrated History of a Music Revolution*, London, Boxtree.

Bourdieu, Pierre (1984) *Distinction: A Social Critique of the Judgement of Taste*, Cambridge, MA: Harvard University Press.

Dancing in the Streets, BBC TV, 1996.

Frith, Simon (1983) *Sound Effects: Youth, Leisure and the Politics of Rock 'n' Roll*, London: Constable.

Gelder, Ken and Thornton, Sarah (1997) *The Subcultures Reader*, London: Routledge.

Gimarc, George (1994) *Punk Diary 1970–79*, London: Vintage (with CD).

Hebdige, Dick (1979) *Subculture: The Meaning of Style*, London: Methuen.

Laing, David (1985) *One Chord Wonders: Power and Meaning in Punk Rock*, Milton Keynes: Open University Press.

Marcus, Greil (1989) *Lipstick Traces: The Secret History of the Twentieth Century*, Cambridge, MA: Harvard University Press.

McKay, George (ed.) (1998) *DiY Culture*, London: Verso.

McNeil, Legs and McCain, Gillian (1996) *Please Kill Me: The Uncensored Oral History of Punk*, London: Little, Brown & Co.

Pecorelli, John (1996) 'Hide Your Grandmothers: It's the Sex Pistols!', *Alternative Press*.

Reynolds, Simon (1998) *Energy Flash: A Journey Through Rave Music and Dance Culture*, London: Picador.

Reynolds, Simon and Press, Joy (1995) *The Sex Revolts*, London: Serpent's Tail.

Savage, Jon (1991) *England's Dreaming: Sex Pistols and Punk Rock*: London, Faber & Faber.

Thornton, Sarah (1995) *Club Cultures: Music, Media and Subcultural Capital*, Cambridge: Polity.

Part I
SHOCK WAVES AND RIPPLE EFFECTS

existed was closed down, things like 'Anarchy' simply couldn't be made anymore, and nothing like it, nothing with the same gravity, nothing so abject has been made since. Twenty years on, the pop scene is probably more conservative than it has been at any stage in its history; there is little 'serious' debate in the music press now, and the pop culture industry is more totally administered than ever; rigorous debate only seems to take place within the critical arm of the pop business – the Cultural Studies industry. Now, then, seems an apt moment at which to reconsider the relations between art and pop. In order to do this it will be necessary to look at the visual aspects of punk, and it is fortunate that in the work of Jamie Reid an almost perfect visual counterpart to the Pistols' music exists. His work has frequently been exhibited in art gallery contexts but, like the Pistols' music, Reid's work was made in different space, a space apart from the institutionalised spaces of art and graphic design. At the time they were made, if considered as art, they would have looked like hopelessly naive, sub-Dada juvenilia; but, at the same time, he also trashed the professional protocols of graphic design and his work cannot properly be placed in that category either. Like 'Anarchy', they were made somewhere else and gained their gravity due to the ways in which they were connected with, and were informed by, a constellation of ideas, histories and practices, albeit for a brief moment in time. When this space was closed down Reid turned to art; there was nowhere else for him to go if he did not want to become a pop industry professional. What Reid had made for the Pistols could not be made in the same way in art however; art was then, and is now, a distinct, specialised discourse.

Via punk's critique of the pop culture industry, a significant constituency was able to gain some critical purchase upon, not only pop, but also culture more broadly. It would be hard, however, to make similar claims for any current movements within pop culture. The pop culture industry is too circumscribed today to enable any space to be made within it from which a critique of its operations might be mounted. If this critique is seen to be the most important aspect of punk then punk's legacy can only be seen to exist in other areas of culture than in pop itself. One tendency that has recently been compared to punk is what is referred to as the 'new', or 'young British art', that has emerged in London over the past 10 years (see Garnett 1998). Like Punk, the new British art scene can be thought of as a kind of spatial and temporal montage. Another parallel is that a significant amount of it was created on the margins of the mainstream art world; like the best of punk, though, it had no intention of staying there. For this generation of artists punk exists as an inescapable cultural fact, part of what defines the parameters of cultural practice; it is as important as any recent movement in art. Again like punk, much of the work is deliberately low-tech, or is as suspicious of the grandiose claims made for the art of the 80s as punk was contemptuous of the 70s' reverential attitude towards music. But, like the best of punk, this aspect of the new British art amounts to a meta-trash aesthetic, one that is self-consciously

about the low, the base and the profane. More than anything else, it is in the way in which new British art has opened up a space between academic high art and the realm of popular culture that it can be said to form part of the legacy of punk. And, as is the case with punk, its singularity can only be appreciated if it is discussed alongside the categories of high and low.

Art into Pop?

Punk emerged in 1976 and it was approximately coincidental with the rise in currency of the term Postmodernism within intellectual culture. It was around punk that the reconfiguration of the interface between high art and popular music first began to be conducted. The first study to analyse popular culture from the perspective of semiotics was Dick Hebdige's *Subculture: the Meaning of Style*. Hebdige (1979) went beyond a conventional sociological analysis of popular culture and theorised subcultural formations as semiotic counterpractices – practices that actively operated against the grain of hegemonic mainstream culture by appropriating its signs and objects and recoding them, turning them against the system. Hebdige was to withdraw from this position some time later, conceding that it was premised upon an over-investment in the oppositional potential of such strategies that, within the context of the popular culture industry, function as an essential research and development department for the production for profit of new and novel lifestyles (1988: 155–181).

Nevertheless, *Subculture* was groundbreaking and demonstrated the ways in which punk had transformed for good the ways in which popular music was conceived. The conception of pop within Cultural Studies in the 'postmodern' 80s was to be at odds with punk, however. What took hold was not a continuation of punk's negation of pop but an affirmative, populist theorisation of pop itself. Paradigmatic of this approach is Simon Frith and Howard Horne's *Art into Pop* (1987). This study was premised upon a now fully postmodernised, relativist notion of culture as a level field of signifying practices, within which the great divide between high art and low culture – pop music, design, fashion – was now gone for good. Frith and Horne argued that art was now no more than 'a mass-cultural myth, created and sustained by specific state and and mass-cultural forces, specific middle-brow mass-media, museums and exhibitions' (1987: 3). 'The commercialisation of art', they contended, 'meant that art had lost its critical distance', and any attempt at an avant-garde counter-strategy was now 'doomed to failure, because it depends on maintaining that sense of artistic 'difference' that mass-market conditions deny' (ibid.: 110). If art was commerce, they concluded, 'then commerce could be art' (ibid.: 107). Art was dead, they demotically implied – long live rock 'n' roll!

Nevertheless, art had been, and still was, alive enough to form the main axis of the study, around which its central argument was constructed. The basis of this argument was that British pop had gained its vitality due to the 'art school connection' – that the transposition of art ideas into pop, via the art school, had provided British pop with a more acute sense of the meanings and functions of pop style. Within their argument, the idea of an art-informed pop is ostensibly meant to function as a 'deconstruction' or 'sublation' of the distinctions between high art and popular cultural practices. One example given is that of The Who, who on their 1967 album, *The Who Sell Out*, foreground in a self-conscious 'Pop art' style its status as commercial product by intercutting each track with parodies of radio advertising jingles. Pop art, they argued, had by the late 1960s lost its original meaning, had been recuperated and institutionalised as high art; the Who by 'appropriating' Pop art created a 'Pop art pop'. What this latter neologism does, however, is less to dissolve the distinctions between art and pop, than to reproduce the high/low opposition within pop itself.

A further problem with arguments like this is that they are premised upon a very superficial grasp of the complexities of art critical and historical discourse, and the specific dynamics of art history. The terms of art and the terms of popular culture are not as easily interchangeable as this, and the relations between art and popular culture are discontinuous and non-synchronic. Art terms, when transposed into the context of popular culture, are more often than not reduced to metaphors that retain little of their original meaning. *Art into Pop*, like most populist Cultural Studies, attempts to argue away the specificity of art, commits a category error and, therefore, lacks any immanence with regard to its 'critique' of art, and it ends up as little more than a reductive, economistic and sociologistic elision of art's semi-autonomy. This is not entirely surprising, given that its authors are, like most Cultural Studies academics, social scientists.

This lack of immanence is where the arguments of *Art into Pop* fall down, for as Adorno reminds us, 'thought that fails to immerse itself in the phenomena on which it takes its stand, extracts from its objects that which is thought already' (1973: 27). And what Frith and Horne's arguments, along with a good deal of other populist postmodernist accounts of the high/low interface, reproduce is a residual form of rather un-postmodern binary thinking. The agenda of *Art into Pop* is not really to deconstruct the opposition between art and the 'popular', it is to affirm the 'popular' side of the equation, which is, consequently, over-privileged and thus the opposition is reinforced. When reading studies like this, it is not difficult to detect behind the 'postmodernist' façade a misplaced counter-chauvinistic prejudice against the aesthetic, not of the 'New Times' of the 80s, but of the Old Left – only this time, it is not socialist realism that is demanded, but a 'people's art' of pop music and style culture. By the 1980s, fashion was no longer 'tyranny', as Barthes once described it, it was, according to 'go-ahead' academics

such as Elizabeth Wilson, 'performance art'; style magazines, such as *The Face* were no longer just style magazines, they were radical vehicles for transgression through chic.

While such accounts might have seemed plausible in the 'designer decade' of the 80s they certainly don't square with punk. The last thing punk, at its best, was interested in was an 'aesthetics of consumption', and looking back on it from the context of the present, it is surprising to see how Adornoesque it was in its attitude towrds the popular culture industry. Adorno is, of course, the last figure one would expect to see mentioned within the British Cultural Studies debate, and he was ignored – necessarily, as far as populists were concerned – until postmodernist confidence began to wane in the early 90s. One of the very few figures to have made any connection between punk and Adorno is Greil Marcus, who in his flawed classic, *tour de force* study of punk, *Lipstick Traces*, argued, 'that, in a way, punk was most easily recognisable as a new version of the old Frankfurt School critique of mass culture . . . but now the premises of that critique were exploding out of a spot no one in the Frankfurt School, not Adorno, Herbert Marcuse or Walter Benjamin had ever recognised: mass culture's pop-cult heart' (1991: 70).

And, in a way, Marcus is correct because while much has been made of the ways in which punk can be seen as a putting into practice of Situationist theory, Situationism has in recent years all too easily fallen prey to the kinds of post-modernisation described above, within which all cultural practices are reductively homogenised into 'spectacle'. Discussing punk within the context of Adorno's classic analysis of the culture industry, despite its numerous drawbacks, at least allows for punk's negativity to be emphasised, and enables it to be distinguished from the kinds of 'pop Situationisms' that have emerged since punk, within which any element of 'appropriation', 'artistic plagiarism' or 'parody' present in that practice can superficially be read as amounting to a 'detournement' of that practice. However, as Debord (1989: 9) acknowledged, parody and plagiarism are always already elements of any art practice – or at least any substantive work of art made since the advent of the historical avant-garde. 'Detournement' as a concept has, since the late 1970s, been reduced, within the context of pop, to a meaningless cliché, in the same way in which art terms and concepts are rendered otiose when transposed into the context of popular culture. It is a claim of this chapter that the only really effective instance of detournement to have occurred within pop music, the only 'pop detournement' worthy of this epithet, is that of the Pistols' activities up to 1978. It was effective because what the Pistols conducted was a negation of pop undertaken with the realisation that, if such a detournement of a mass form was to be effective, it had in its own turn to be mass and had to generate a mass impact. 'God Save the Queen', released in 1977 to coincide with the Queen's Silver Jubilee, was banned not only from the airwaves and TV, but also from public display. It nevertheless reached Number 1 in the

charts, and for the first time in pop history the top position in the chart was occupied not by the name of the band and the title of the song, but by two thick, blank, black lines.

Another way of describing this detournement would be to describe it as a negation of pop, because what the Pistols – and by the Pistols I mean not just the band or McLaren but the whole contingent who constituted the phenomenon – achieved was what Adorno would have referred to as an immanent and trans-cendental critique of the pop culture industry. Far more than simply exploiting the transgressive potential of pop style, the Pistols went further and exploited the space they occupied to refuse the illusory pleasures and fraudulent myths of the pop culture industry itself. It was the extent of this refusal that made it a detournement of pop. More than a simple inversion of hippie optimism, the Pistols literally trashed the claims of any previous rock radicalisms. Parodies of the pop business, such as Frank Zappa's *We're Only in it for the Money*, and his subsequent would-be detournements of rock were all too easily subsumed by the West Coast culture of experimentalist 'far-outism'. Next to the Pistols, the Velvet Underground sound too self-consciously and self-importantly 'arty' in a way that prefigures the pretentious poeticism of their New York punk progeny, Patti Smith, Television and others; while the Stooges, on the other hand, sound too one-dimensionally trashy. Comparing the Pistols to their peers shows just what a false conflation the punk category actually is; it is a far more inclusive category than any other in the history of pop, containing, as it does, a whole host of mutually exclusive tendencies, styles and attitudes towards style.

What sets the Pistols apart from other punk is their purposeful disinvestment in anything that pop had previously represented. The Pistols' music still can't be made to fit into the category of Classic Rock, unlike other punk bands, such as the Clash for instance, who like other major punk acts, such as the Ramones and the Buzzcocks, 20 years on function as authenticating 'points of origin' for a new generation of guitar-led, 'back to basics' pop nostalgists. The Pistols, as Greil Marcus has argued, 'created a breach in pop culture' (1989: 3) and cannot, therefore, be fitted into some seamless narrative account of 'The Story of Rock 'n' Roll'.

It should be clear by now that when I say 'punk at its best' I am referring to the Pistols. I do not mean to make any qualitative judgement here in terms of the superior musical 'quality' of the Pistols' music; such a judgement would be contradictory anyway, would be at odds with the Pistols' negation of the validity of such criteria. What I do mean to say is that if punk did stand apart from anything else that preceded it in pop then the Pistols stood even further apart. They, in effect, occupied a different territory, lived somewhere else; they had some near neighbours, but few of them came close to crossing their threshold. The Pistols seem most vividly to embody everything that we now associate with punk. What

testifies to this is that whenever the word punk is mentioned, the first band most people would think of would be the Pistols.

Punk and the visual

If the Pistols are the first band that springs to mind at the mention of the word punk, then the first images that would spring to mind would be the visuals created for the Pistols by Jamie Reid. Reid's work is important not just because it amounts to the greatest single contribution to punk's visual identity, but because it also articulated the most vital aspects of the Pistols' critique of pop. It was, therefore, more than just simple publicity material, a collection of posters, record sleeves and flyers. Reid's work became even more than a visual equivalent of the music; his visuals inflected the experience of listening to the music to the extent that they became a part of it. The ways in which the visual and the aural interrelate within pop music is one of its least discussed aspects. The singularity of the phenomenon that was the Pistols, however, cannot adequately be grasped without analysing its synaesthetic elements.

The most direct way in which Reid's visuals relate to the Pistols' music is in terms of their montage form, their decentred pillaging of fragments of pop-cultural detritus. The Pistols pilfered their riffs from a repository of stock rock 'n' roll prototypes and, in doing so, literally trashed them, along with any last vestiges of 'authenticity', 'competence', 'originality', 'meaning', 'artiness' and 'significance'. Reid appropriated his materials from the trash populism of tabloid culture and downmarket advertising, and he added to this a vital element in the form of his appropiation of the language of the 'alternative', or to use a phrase of the time, 'agit-prop' political press. The latter was something that Reid had been directly involved in for some time, having co-founded the Suburban Press in Croydon in 1970. The Suburban Press (SP) remit was micro-political and community based, employing what Reid has described as 'a kind of shit-stirring format, with thorough research into local politics and council corruption, mixed with graphics and some Situationist texts' (quoted in Savage 1987: 35). His background in Situationism lent the SP paper a particular sharpness and reflexivity with regard to its use of the agit-prop form. Like the sloganeering of '68, the six issues of the SP were characterised by a self-conscious use of humour and a Dadaistic sense of the absurd. In common with these precedents, there is a refusal within the SP to play the same game, to speak the same language as conventional political activism. Rather, the language of 'agit-propism' is 'quoted' or sardonically and indirectly articulated, and is thus sent up rather than directly spoken in the first person. For example, in the 'Sticker Campaign' of 1972/3, Reid and the SP designed a series of stickers emblazoned with images and captions or slogans, such

as 'Turn Something on for the Miners' or 'Keep Warm This Winter – Make Trouble', that intervened in the Government of the time's campaign to encourage energy conservation during the oil crisis. Other subtly subversive tactics included anti-London Transport stickers – plausible-looking informational stickers featuring the London Transport logo and typeface that were displayed on tube trains. While this situational strategy of intervening in specific contexts might appear in retrospect to amount to little more than harmless mischief-making, they do evince the fact that Reid had a sophisticated and prescient understanding of the limitations of conventional alternative/radical activism. The SP exploited the 'in-yer-faceness' of agit-prop rhetoric and, at the same time, sent it up; they refused to preach an authoritarian, universalising political message and irreverently eschewed the patronising pose of worthiness that characterised conventional activism. All this prefigured one of the most important aspects of the Pistols: their trashing of the pretensions of engaged 'political' rock, punk or otherwise. Above all, it was Reid's understanding of the form of agit-prop rhetoric, over and above its content, that set him apart from any other radical/political designers or illustrators of the time.

When, in the Autumn of 1976, Reid received the call from Malcolm McLaren to work for the Sex Pistols he seized the opportunity to put the above strategies into practice in the context of pop culture on a much larger scale. This time it was for real, and the explosive collisions within his montages were to have equally real repercussions. By this time, Reid had become 'disillusioned at how jargonistic and non-commital leftwing politics had become' (ibid.: 55). Nevertheless, he was, as he has stated, 'still inflamed with the spirit' that had attracted him to leftist politics in the 60s and 70s, and he saw the Pistols as 'a perfect vehicle to communicate the ideas that had been formulated during that period, and to get them across very directly to people who weren't getting the message out of left-wing politics at the time' (ibid.). As the Pistols phenomenon began to take off Reid realised he was 'playing for very high stakes' (ibid.).

The stakes would have been a lot lower, though, were it not for the fact that the space within which Reid was working was, as his comments imply, one in which the spirit of '68 had not yet entirely dissipated. While it may no longer have been 'realistic' to 'demand the impossible', the memory of having envisaged the impossible remained palpable. It was this that perhaps made the 'politics' of punk possible. Reid has stated that he 'argued with McLaren regarding the "political" aspects of the Pistols' (ibid.), who the latter initially saw as a kind of transmogrified Bay City Rollers boy band that could be exploited in order to promote his shop, Sex. What Reid had in mind, though, was, via his graphics, a transposition of the Pistols' and Glitterbest's attitude into a style – or, rather, a shit-stirring anti-style.

Because of the position Reid had worked out for himself, there is hardly one example of his Pistols work that doesn't work, that isn't rigorously resolved and

pitch-perfect, even though many of them were a result of an ad hoc, extemporised working process. But, if there is one that stands out, it is, for the purposes here, the cover of the 7-inch single, 'Pretty Vacant' (see Figure 1.1), and it stands out because of the ways in which it references almost everything that made Reid and the Pistols' work so potent. The B-side of the single is a cover of the Stooges' 'No Fun' that is reframed and recontextualised so that it finally makes sense. This is augmented by Reid's use of his SP period 'Situationist buses' design for the back cover – a collage of two tourist coaches the desinations of which are 'nowhere' and 'boredom'. The front cover features the shattered glass of a picture frame, beneath which is emblazoned, in ransom note lettering, the name of the band and the song. Nothing, at the time, so vividly articulated what it was like to hear the Pistols shattering the edifice of rock 'n' roll mythology: it was exactly like the sound of breaking glass – and you didn't know where the shards were going to fall.

When they finally began to settle, Reid launched his most direct attacks upon the pop culture industry; reflexivity and irony, though, prevent them from becoming dumb propaganda. The slogans are again 'quoted' rhetorically and lack any pretence of earnestness that distinguishes them from the rhetoric of parallel tendencies like 'Combat Rock' and Rock Against Racism. While Reid might have sympathised with the sentiments behind the latter, he doesn't seem to have invested much in them; he was too sharp to the politics of the rock form, the star system and its attendant power relations and modes of consumption – all of which conventional 'radical' or 'conscience' rock exploited and left flawlessly intact. Reid, like the Pistols, took more risks, and the best of his late work is based upon the problematic use of a symbol that is loaded to say the least: the Swastika. But, Reid pulled it off in a way that most of its less intelligently irresponsible users couldn't. The first ones consisted of collaged guitar-shaped Swastikas used in conjunction with images of soldiers or that *bête noir*, Richard Branson; super-imposed over these were slogans such as 'Join the Rock 'n' Roll Army', or, 'Music Keeps You Under Control'. In the 1979 poster for the Dead Kennedys' 'California Uber Alles', surrounded by a border of cannabis leaf swastikas, is an image of the massed crowds at a Woodstock-style rock festival; over this is the caption, 'Never Trust a Hippie' and the name of the song. In one sense this can clearly be read as an Adornoesque, microcosmic indictment of the totally administered rock culture and its authoritarian power relations, but again the rhetoric of the piece ironises it. But, nevertheless, there are few places within which the contradictions of late-capitalist power relations are more palpably evident than at a rock festival. For there was, and is, a Nuremburg rally-type aspect to such spectacles of massed ranks of fans passively consuming the aura of unattainable demi-God rock stars, preaching a would-be-liberatory hippie mythology, the whole thing policed by almost equally massed ranks of security. At the same time, however, such mass events also offer the experience of communality, a temporary refuge from anomie

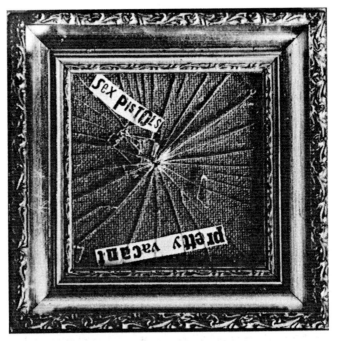

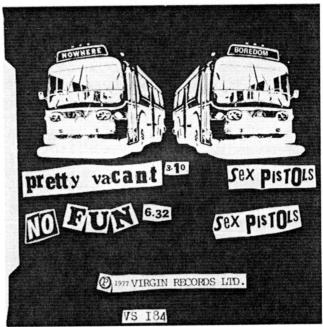

Figure 1.1 Front and reverse of sleeve to Sex Pistols single 'Pretty Vacant' (Virgin, 1977). Graphics by Jamie Reid.

and atomisation that, however illusory, is nevertheless intensely, bodily felt, and, therefore, amounts to momentary glimpse of a utopia. One of the few criticisms one could make of Reid here is that his disillusionment makes him, like Adorno, simply totalise this all away.

However, via this critique Reid and the Pistols were able to realise something that no other punk band could quite do: for a brief moment their assault on rock amounted to a démystification of it. In doing so, they created a 'space between', a 'breach' within which a significant constituency could gain some critical purchase on culture, could thus become empowered. After the myth had been shattered, they were no longer passive consumers, they could 'think for themselves'. This is, I think, the true meaning of the phrase 'Do It Yourself'. After the space within which they operated was closed down, after the conjunction that made its opening possible was forced apart by history, 'Do It Yourself' became just another Thatcherite means of 'getting on your bike' and self-improving your way out of Giro City.

Conclusion: Art into Pop revisited

Since the demise of punk, the neo-punk epithet has been applied to a whole range of phenomena. But, hopefully, this chapter has shown that punk could never be repeated. Its historical space disappeared and some of its best exponents, like Reid, tried in vain to practice elsewhere; others either gave up or sold out and became highly successful pop professionals. Nevertheless, despite the contrary claims of populist postmodernism, it is still possible to create similar spaces, and that is because the 'space between' of the Historical Avant-Garde never quite disappeared. It has certainly undergone manifold transformations, but what Barthes referred to as 'that old thing art' is still very much alive.

It is art, particularly the phenomenon referred to as the 'new British art', that has attracted comparisons with punk. A number of cultural critics have been tempted to argue that the work of such artists as Damien Hirst, Sarah Lucas, the Chapman brothers and many others can 'most easily be seen as a revival of the aesthetics of pop art and the provocational strategies of Situationism relearned through punk' (Wakefield 1985: 10). This, regardless of certain clear parallels between art and punk, is a misplaced comparison however. A work of art that intelligently demonstrates this, while at the same time conveniently addressing all the issues discussed in this chapter so far, is a sculpture entitled 'Pop', made in 1993 by new British artist Gavin Turk (see Figure 1.2). 'Pop' consists of a lifesize realistic fibreglass cast of the artist assuming the identity of Sid Vicious. The figure is based upon the 'My Way' sequence of the *Great Rock 'n' Roll Swindle* film, where Sid's gun-toting pose was based upon that of Elvis' in Warhol's Elvis

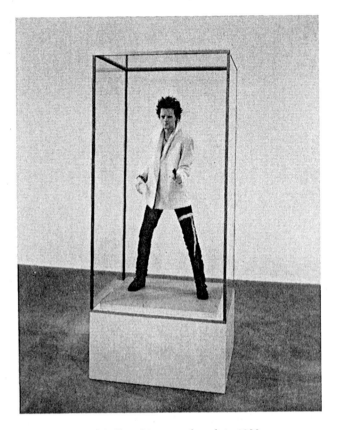

Figure 1.2 Gavin Turk's 'Pop' (fibreglass, mixed media), 1993.
Source: Courtesy of The Saatchi Gallery.

silkscreens of 1963, that were in their turn based upon a still from the Elvis western, *Love Me Tender*. Via this, a neat conjunction of references are made to Pop art, pop culture, identity and the body.

'Pop' is a multi-layered work and, as such, perfectly exemplifies the distinct ontology of art. On one level, the work takes as its 'subject matter' the ways in which it might be received critically. Produced at the cusp of the advent of the 'young British art' phenomenon, it presciently anticipates attempts to see it as a 'revival of the provocational strategies of Situationism relearned through punk'. Such readings are problematised, if not refused, by the fact that the figure brandishes what is clearly a plastic, toy pistol – a 'pop' gun. Any enactments of such a strategy, this clever Duchampian pun implies, would generate little more gravity than the title of the work. So, rather than an instance of neo-Situ shock tactics, this work is 'about' their futility. This is because, as the piece takes pains to demonstrate, it is a work of art, hermetically sealed within an institutional glass case.

We can no longer, however, see art as being detached from the low, the popular, and the everyday; we can no longer subscribe to an Adornian purist view of Modernism. This work, like all the best art in the tradition of the Historical Avant-Garde, opens up a space between Art with a capital 'A', and the realm of 'everyday life'. This space did not disappear in the 60s with the success of Pop art, as Frith and Horne naively suggest, but it doesn't simply exist either: it is a space that has to be made and remade. This is what constitutes the dynamics of art history in the modern (and 'postmodern') period. And this is the space within which Turk's 'Pop' is made, and it is there that we might negotiate the contradictions of investing in and identifying with pleasures and practices of the everyday, while at the same time feeling compelled to criticise them, of enjoying 'low' pleasures while knowing that they can be bad for us.

Within most populist Cultural Studies, this space is simply elided, is post-modernised away, along with all its implicit contradictions. Much vital and productive work has been done within Cultural Studies with regard to the politics of pleasure, but it has been a contention of this chapter that this has all too often been at the expense of neglecting negative experiences of the popular. There has been much talk about style and the body, much less about body fascism and the inverted, reflex exclusivity and elitism of style culture. There has been much media celebration of the status of London as the style capital of the world, the 'coolest city' on the planet, but not since the days of Cultural Studies' emergence as a distinct discipline in the 60s and 70s has there been much discussion of the social and economic conditions that impel generation after generation of the youth of Britain to invent their own, for want of a better, less dated term, 'subcultures'. A small constituency of one generation was wise, however, to what the real cost of admission to the pop palace of fun was. For the first time in pop history they decided it wasn't worth paying. But, rather than be left out in the cold with all the other fetishists of the marginal and the alternative, they stormed their way in and turned the place over. Within days business was back to normal. But had they not done this we might never have got to know what really went on there in the first place.

Bibliography

Adorno, Theodore (1973) *Negative Dialectics*, London: Routledge & Kegan Paul.

Debord, G. (1989) 'Detournement as negation and prelude', in P. Taylor (ed.), *Post-Pop Art*, New York: Flash Art Books.

Frith, S. and Horne, H. (1987) *Art into Pop*, London: Routledge.

Garnett, Robert (1998) 'Britpopism and the populist gesture', in J. Stallabrass, D. McCorquodale and M. Siderfin (eds), *Occupational Hazard: Critical Writings on Recent British Art*, London: Black Dog Press.

2

MISFIT LIT

'Punk writing', and representations of punk through writing and publishing

Miriam Rivett

This chapter deals with a rather selective assemblage of writings which might be termed punk – printed texts which have been chosen because they are texts which, albeit in different ways, are constitutive of punk as much as they were constituted by it. A common element which links these texts is that they have been claimed as punk (rather than assessments of punk) – in some cases by their producers (writers), and in others by their publishers as part of the complex process of commercial/cultural classification that positions these, or indeed any, texts for particular markets and readerships. The linkage of such texts and/or their producers to punk is in itself a part of the broader cultural processes through which punk has been variously defined, redefined and laid claim to. In deference to the possible readership of this chapter (many of whom will have their own concept of what constitutes punk writing to bring to bear on any discussion) it must be stated that the assemblage discussed here is by no means exhaustive: in such a brief space how could it be? It should also be noted that the survey of punk-writings – for want of a better term – in print form contained here does not incorporate a discussion of the zine or zine culture which was crucial to the initial circulation of much of the writing represented here.

In direct contrast to the zine the selection of works presented here are all published in book form. This may seem a rather obvious distinction but it is significant in that books occupy a different symbolic space in contemporary culture – the book as a form is often associated with fixity, permanence and a consequent gravity. Books are, also, subject to a rather different set of conventions from publications such as the zine in terms of their material properties, i.e., their physical form – size, typeface, design, layout and so on. More usually produced subject to a particular set of conventions of editing,[1] these various editorial conventions of book publishing are not simply part of a production process through

which texts pass on their way from the writer to the reader. These conventions impacted and continue to impact on the reception of the texts discussed here in a number of ways: the forms of textual apparatus – blurbs, covers, prefaces, etc. – which are part of the processes and practices through which books are presented set up an interpretative framework which suggests how they should be received; not least as indicators of genre which set up the expectations which will be brought to bear on a text. However, this is not to say that there are not certain similarities or overlaps with the punk zine: many of the writers associated with punk and post-punk originally produced for fanzines; the appearance of their work in book form often signals a shift in their cultural significance, potential readership and so on.[2]

The selection of works under discussion here are all still in publication at the time of writing; in other words this is a snapshot in time rather than a complete historical survey. With the exception of some of the references to Stewart Home's work – for reasons which should become obvious – they are all fiction texts; in other words their status as creative pieces, with all the associations this entails, is foregrounded.[3] There are a number of cataloguing systems (possibly the best known of these is Whittaker's) which classify books available in the UK via a cross-referencing system dictated by publishers. A recent search for titles cross-referenced to punk yielded a range of works in the area of social/cultural analysis, alongside more informal studies of punk rock and punk fashion. However in the category matching punk to fiction, in addition to one-off titles such as *The Punk* – see below – certain publishers and authors appeared time and time again: authors such as Richard Allen, Stewart Home and small presses such as CodeX. Surveys of reviews, publishers' catalogues, and other forms of media brought in writers classified as post-punk such as Martin Millar, Irvine Welsh and Richard Hell. American writers such as Richard Hell, and transatlantic publishers such as Serpent's Tail, in turn form a bridge to a grouping of American writers and texts which have been termed Blank Generation. Although these writers and publishers do not account for the entirety of punk (and post-punk) writing they can be used to demonstrate certain preoccupations, themes and recurring elements which it is useful to consider when examining punk's published expression.

It would be hard to claim that the texts selected here are linked as an easily definable genre; whatever model of genre were to be adopted, overall they do not have shared formal or stylistic conventions beyond the classification of fiction; yet they are a grouping of texts which have certain resemblances. These resemblances, or rather what all of the punk writings included here could be said to share, take the form of certain underlying ways of thinking expressed in an adherence to a particular set of cultural assumptions and frames of reference. Some of which are manifested as much via their reception as in their production or textual forms – perhaps more importantly they are also subject to a form of cultural consensus, in which they are simply *known* as punk and frequently referenced as such in reviews,

songs, interviews, fanzines and so on. These shared characteristics are part of the way in which these forms, their producers, and their targeted readers interact; in part drawing on and promoting – not necessarily explicitly – particular conceptions of identity, as part of a framework in which experience implies authority. These characteristics are not restricted to fictional works/forms; for example they are also discernible in Stewart Home's factual, discursive work.[4] A fundamental element of the set of cultural assumptions referred to is the way in which experience is both conceptualised and foregrounded. This foregrounding is evident not only in texts related to, or designated as, punk, but in the ways in which punk writing and writers are often represented both by artistic mediators – such as publishers and critics – and by their audiences. This concept of experience is one in which punk becomes part of a process through which, by direct participation, identities are formed. Such experiences then become the foundation for authenticating certain texts and writers as punk and others not. Experience then is laid claim to as a way of legitimating certain knowledges and excluding others.[5]

One of the earliest British works represented as and representing punk was the novel entitled *The Punk* by Gideon Sams, first published in 1977 by a small publisher, Polytantric Press; its chairman Jay Landesman was strongly associated with the countercultural scene of the time.[6] *The Punk* (see Figure 2.1) took the form of a limited edition paperback: the original print run was a mere 1,000 copies. The cover carried a carefully constructed image of John Lydon in his Johnny Rotten persona with the addition of an actual safety pin threaded through the book's cover and Rotten's lip. This type of image of punk might seem rather over-exposed now and subsequently has been used as much as a symbol of British heritage or of nostalgia as anything else, but at the time it was still a relatively unfamiliar image capable of generating a number of meanings in which it could be read as both novel and iconoclastic, as could the cover design itself. The same image could also be read in the context of the specific constructions of punk and of Lydon in broad evidence at the time, perhaps exemplified by the extensive and extensively negative mass-media coverage centred on the Sex Pistols after the – now infamous – Bill Grundy television interview with them on the *Today* programme in December of 1976. The use of this particular cover-image might suggest a reading of Sams's book in the context of these dominant representations of punk – as personified by the figure of Rotten – circulating at the time, in which Rotten and punk were represented as undesirable manifestations of social disturbance and subject to high moral censure in the popular press. However the connotations of such an image would have been inflected by its appearance in the context of a Polytantric Press edition, a context in which *The Punk* could be understood as part of, and read in terms of, an ideological movement rather than in terms of the 'moral panic' depicted by the mass media.

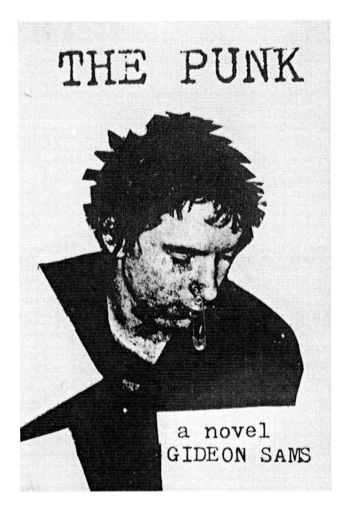

Figure 2.1 Gideon Sams's *The Punk* (1977), 'The First Punk Novel', complete with real safety pin through Rotten's lips.
Source: Courtesy of The Polytantric Press.

Later the same year the novel was republished by Corgi, a mass-market paperback imprint known for having a highly commercially successful fiction list – as a Corgi title the novel ran to over 50,000 copies. The inclusion of this title on such an explicitly commercial list is not only significant in terms of access to wider distribution and greater potential sales, changes in imprint and edition also signify a shift in the way in which a text is to be received. The publication of a book in limited numbers by a small 'underground' press signifies that a title is of value beyond the purely economic, whether that value be understood as ideological, social, aesthetic or of some other kind.[7] The publication of *The Punk* as a Corgi[8]

title signals a potential shift in the public meaning of the novel; foregrounding its economic value and signifying its repositioning in relation to an already identifiable, broad market; a potential readership, for whom the subject-matter of the book *Punk* had already been signalled as of national, social significance. The book then becomes marketable as a means of access to certain knowledges about punk, the identity of the author as a 15-year-old involved in punk culture serving as a form of authentication for the book's contents – Sams himself appeared on television more than once to discuss punk as a phenomenon.

In 1996 the book was republished in yet another British edition, this one bearing the name Tadao Press (an obscure press, *The Punk* appears to be their only available title, and is distributed through a music company Rittor Press Europe). The book carries the coverline 'The first punk novel': the juxtaposition of punk and novel is not an expected one and seems to situate the book not only as a document of punk, but also as a constituent of punk – it's not just a novel about punk it *is* punk. The blurb on the back cover describes the book's context in terms of the author's youth at the time of writing and his early death at the age of 26. This focus appears to foreground a myth of punk in which it is essentially a vehicle of youth identity-formation, a myth of which this book then becomes a representative through its author's own life story. This focus displaces any possible interpretations of punk, in this context, as a specific political or aesthetic movement. The main cover image is that of a figure recognisable as depicting Cupid poised to shoot an arrow – connoting the inevitability and timelessness of love – a slightly ironic Cupid overlaid with a mohican, a bondage-style jacket, and one, unlaced boot; an image which serves to direct a reading of *The Punk* that is simultaneously specific yet timeless, whilst ironic yet romantic.

The 1996 edition is introduced with a foreword by Mike Sarne[9] and is headed by a black and white photograph the focus of which is Gideon Sams, wearing a black jacket adorned with badges, and leaning against a pinball machine (see Figure 2.2). The Foreword takes the form of a personal reminiscence describing Sarne's first meeting with Sams in the late 1970s, a 'thin, shy boy' who wrote *The Punk* as a homework project. Sarne describes how Sams initially discarded the piece (it was rescued by Sams's mother). Sarne's foreword suggests that *The Punk*'s particular history of production can be understood as part of a wider cultural narrative in which 'youth versus age' is a recurring theme (he suggests Pete Townshend of the Who's lack of interest in the novel as a potential musical may have been influenced by the description in the novel of the Who and the Rolling Stones as 'washed-up old hippies') as much as in the context of the 'anyone-can-do-this' ethic on the basis of which many punk bands, labels and fanzines were set up. The Foreword, in its description of Sams as a prodigy, also draws on ideas circulating in the dominant culture in which the desired status of the author in relation to their work is that of the creative and unique producer. All of this, together with the book's jacket,

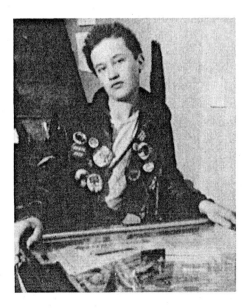

Figure 2.2 Portrait of the writer as a young punk. Gideon Sams in 1977, aged 14, plays some pinball. Photographer unknown.

sets up a particular set of expectations which can be brought to bear on the interpretation of the novel itself. This set of expectations makes the status of the novel as punk secondary to these other considerations.

The novel documents the relationship between the punk, Adolph, and a teddy girl, Thelma, whilst incorporating an ironic commentary on attitudes and behaviours that denote the quintessentially punk – for example why punks have a predilection for odd, and depressing, names such as Johnny Vomit or Vince Violence. The story is set in West London where Adolph lives in a high-rise council flat in Trellick Towers with his parents. The aesthetic distinctions high-lighted in the descriptions of interiors of the various domestic settings in the novel seem almost calculated to convey cultural tensions and divisions between social classes in late 1970s London. For example, the council flat is the most cursorily described of the environments that Adolph moves through, even down to the formica table serving as a marker of the 'misplaced' aspirations of Adolph's parents.[10] Adolph's mother is described by her activities, which are dominated by domestic chores performed in the kitchen, similarly Adolph's father, whose existence is represented in terms of passive consumption; he passes his time reading mass-market papers such as the *News of the World*[11] and watching documentaries on stamp collecting.

Adolph spends his days at the employment exchange and his nights congregating with other punks and going to gigs; later he moves into a 'punk flat' made so by its

interior decor, which features slogan-painted walls and a prominent sound-system, connoting a different set of values for living to those of his parents. Thelma's home environment is also subject to more sustained consideration. The accounts of both the punk flat and Thelma's home suggests a conscious aesthetic in operation, a visual style which is indicative of a chosen cultural stance, whereas the flat in Trellick Towers is depicted as an environment in which neither style nor culture exist in any conscious sense.

The introductory frameworks to the text, in part a highly personal tribute to Sams, support a recognition of the narrative as having a particular conception of youth as its central theme; a story in which the young are doomed to struggle with the forces of age and authority, ultimately destined to capitulate or lose the battle; again deflecting attention away from a possible reading of the novel in terms of class or other social values. This perception is reinforced by the text's allusions to the themes and plot of *Romeo and Juliet* — this aspect of the text is reinforced externally[12] — and, perhaps more obviously, those of *West Side Story*; the fights between the punks and the teds in the text strongly reminiscent of those between the Sharks and the Jets — as, too, is the manner of Adolph and Thelma's death at the novel's close.

The transformations of *The Punk* through the processes of editioning and the changing contexts of reading of the book could be read as a mini-narrative of the cultural transformations punk itself has been said to have undergone.[13] *The Punk's* initial appearance as a limited edition text springing from a network and tradition of underground countercultural publishing and all that involves; its second as a mass-market edition in which its status as a commodity is foremost, published at a time when punk itself was being consumed vicariously via the mass media;[14] its latest edition emerging when punk was being re-established as retro-chic, repositioned and re-commodified as nostalgia — witness the way in which post-cards of individuals in punk regalia are sold in London souvenir shops, removing their subjects from their socio-economic context and rendering them as an unlocated element of the nation's heritage rather like the beefeater or the pearly queen.

The relationship between Richard Allen's work and punk is more often expressed in terms of its reception rather than in terms of its production. Perhaps the best known and certainly most frequently cited of his books is the best-selling *Skinhead*, originally published in 1970, which introduced the character Joe Hawkins. Richard Allen was a pseudonym for James Moffatt, a Canadian writer who produced titles under at least 15 other names. Moffatt was famed for his prolific output — producing to a deadline 10,000 words a day was not uncommon. His fictional work covered an array of popular genres from crime to westerns, he once said of his work 'you had the same plot, except where you had traffic, you had horses' (Romney 1996).

The works published under the name Richard Allen have similar subject-matter: each of these novels dealt with some aspect of British youth culture or what he himself called 'cultism', from the skinhead movement to mods through to glam and punk. The only title of Allen's which directly engages with punk is *Punk Rock*, published in 1977 (see Figure 2.3). The novel centres on the character of journalist Raymond Kerr who has a week to put together the inside story on punk. Meticulously researched in terms of the functioning of tabloid journalism as expressed via the character of Kerr, the novel contrasts this area of the media with the mechanics of rock reporting as expressed in the character of Steve Pepper,

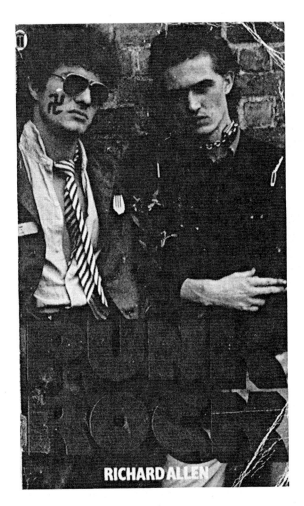

Figure 2.3 Richard Allen's *Punk Rock* (1977). Note plastic fork: very menacing.
Source: NEL Publishing.

columnist for *Spins* magazine (the Steve Pepper character appears to conflate the characteristics of the public personas of Julie Burchill and Tony Parsons at the time they were signed to the *NME* – or certainly characteristics that were often cited in relation to their careers (Beckett 1995)). Steve Pepper is young, barely 19, working-class, streetwise; he has no training or background as a journalist, his sole credentials lie in his marketability as the authentic voice of youth. The novel follows Kerr as he chronicles the punk scene through his encounters with fictional star Danny Boy. (Interestingly, *Punk Rock* was one of the least commercially successful of Allen's titles.)

Allen's titles were originally available in the UK as part of the New English Library (NEL) paperback fiction list. A British imprint owned at the time by the Times Mirror group, NEL specialised in 'exploitation writing'; amongst other NEL authors were Harold Robbins and horror-writer Guy N. Smith. Other NEL authors, such as Mick Norman, also charted subcultures, Norman's specialism was in Hell's Angels. NEL's list was classed as 'pulp', a form of publishing associated with high disposability and morally *transgressive* material.[15]

Richard Allen's work has undergone a number of conflicting valuations over subsequent years. In 1996 Allen was featured in a BBC Bookmark programme, in which it was claimed that he was the authentic voice of British street-culture, and highly popular with teenage readers because of this.[16] Many of those who comprised his core readership appeared to respond to his works through a process of identification – or a desire for such – with youth culture as depicted in his books. This view of Allen's significance is not an uncontested one; in a *Guardian* review of the programme Allen's status as a 'hack' writer is presented as potentially irreconcilable with forms of value outside the commercial and economic (see Romney 1996). This stance in relation to an assessment of Allen's work can be read as a deployment of a dominant cultural position[17] in which there is a conventional opposition between the literary author as artist with a 'unique and transcendent voice' i.e., one whose works have been consecrated as having enduring social or aesthetic value, and the writer as craftsperson – although in Allen's case even in this sense his status is challenged – whose economic success particularly coupled with a prolific commercial output precludes them from the accumulation of the forms of value associated with the author as artist. His appearance on NEL's list would also have been highly significant in contributing to his construction as a 'pulp' writer.[18]

Although Allen's work has not been assigned the forms of value traditionally accorded to the literary, it has been invested with other forms of value. His work has a continuing fan-base for whom his books have great symbolic significance, and he is claimed by his following as speaking for marginalised cultural groupings,[19] via the depictions in his books. This form of value is represented by his inclusion in reference works such as *Cultural Icons* (Parks 1991) where the entry on Allen is

positioned alongside entries on such as William Burroughs and Madonna. The same entry in *Cultural Icons* recognises his novels as the 'staple reading diet of a significant section of bored youth', read illicitly and passed around. This reinforces a notion of a community of readers joined together through Allen's pages.

Stewart Home, polemicist, theorist, novelist,[20] and himself a strong advocate of Allen's works, similarly suggests that they were consumed in this way. In *The Assault on Culture*, he discusses the paradoxical nature of British punk and the tension between 'art-school punk' and the punk of 'kids-on-the-street' (Home 1991: 80–87). This contradiction in punk is mirrored by the shifting registers of Home's own writing: punk is debated using the style of an academic treatise shot through with a highly personalised polemic, the style of this debate seeming, then, to be acting as a container for these two contradictory influences. In the chapter on punk in *The Assault on Culture*, Home argues that the work of Richard Allen was a major and largely unacknowledged (especially by cultural theorists such as Dick Hebdige) influence on the emergence of punk as a less rarefied cultural movement; Allen's titles consumed by the 'blank generation' (see below) in their adolescence, his prose exemplifying the forms of energy that went on to fuel this street punk. Home claims that Allen's influence has been ignored primarily because his work had no 'intellectual pedigree'. This claim links back to attitudes to Allen already mentioned.

Allen's youth novels are currently published in the UK by S.T. Publishing, a small press based in Scotland, who promote themselves as specialists in what they call 'street publishing' and carry a backlist of around 23 titles, three of which are German translations of others on the list. They publish Allen in a six-volume complete collection. This editorial decision functions as an attempt to direct the way in which these novels should be read, in that it traces a progression through the 'youth novels' from *Skinhead* onwards such that Allen's novels are reconstituted as part of an overall *oeuvre* – the choice of term is deliberate. The series runs in sequence forming an impression of Allen's work as producing a coherent and continuous narrative of youth culture in a particular historical context. S.T.'s catalogue copy calls these 'classic' novels, ones that chart the 'changing faces of British youth cults during the seventies'. We get the appeal of realism used here; however, the realism of Allen's work is not that predicated on the notion of the unique individual experience but rather that of the social chronicler. A number of the other titles on S.T.'s list are positioned in relation to Allen, for example Joe Mitchell's *Saturday's Heroes* and Gavin Anderson's *Casual*, which is described as stylistically similar to Richard Allen 'but closer to today's reality'. S.T. also carry a number of titles promoted as punk fiction. The impression created here is that Allen's novels are a prototype for an emergent genre and this signals a shift from mass-market pulp to a more restricted and specialist audience, one which is reached outside trade or commercial book outlets, relying on less formal networks.

Stewart Home's non-fiction work has already been referred to, and is published by small presses such as CodeX and AK.[21] Distributed through the book-trade, it is perhaps most conspicuous in outlets which comprise the (rapidly diminishing) network of independent bookshops in the UK, such as Compendium in London's Camden Town[22] and independent music bookshops, such as Helter Skelter in central London. However, Home's fiction work is part of a slightly different circuit in which it could be defined as 'avant-garde' and, unlike Allen, is reviewed in the literary press and book pages. However, what it does share with Allen is the recognition of its transgressive status.[23] His most recent novels, including *Come Before Christ and Murder Love* and *Blow Job* (both 1997), are published by Serpent's Tail, an independent British publishing house, whose output has been designated 'counter-cultural'.

In the mid-1990s Serpent's Tail launched the High Risk imprint,[24] through their New York office and in London. The New York arm of High Risk has been compared to houses such as Grove Press, publishers of William Burroughs and the Marquis de Sade. Home's work has featured in High Risk anthologies published for the American market where his short stories are presented alongside the work of American writers such as Gary Indiana and Dennis Cooper, both of whom are frequently considered as part of a group of New York-based authors which has been designated as 'Blank Generation';[25] the conjoining of British writers such as Home to this grouping might herald a broadening out of the grouping itself – whether in a cultural or a commercial sense is unclear, perhaps because the two are so intertwined. The name 'Blank Generation' suggests a link to some form of punk tradition, the phrase itself originating with Richard Hell, writer and member of the influential American punk group the Voidoids, as well as a former member of Television.

Originally from Scotland, the novelist Martin Millar[26] moved from Glasgow to Brixton, London in 1977. Millar's works were first published in the late 1980s by Fourth Estate, another independent British publisher.[27] He is perhaps best known for the novel *Milk, Sulphate and Alby Starvation*, first of a loose series of five novels culminating in *Dreams of Sex and Stage-Diving* in 1994. In a review of this last novel at the time of its publication (see Baker 1994), Millar was positioned as the author of 'youth books' similar in subject-matter to Richard Allen's books but radically different in his treatment of it. The reviewer defines Millar's work as 'anti-Allen'; the reason for this epithet appeared to be posited on the fact that Millar's books were 'intelligent' and 'androgynous', possessed of a 'warm, inventive imagination' and 'some . . . erudition'. This kind of response from cultural intermediaries such as reviewers and the fact that he is published by Fourth Estate, a reputable publisher associated with the 'contemporary literary', suggests his potential status as a 'serious' author. The five novels, which are mainly based in Brixton (for example *Lux the Poet* opens with a description of the Brixton riots), steer a course in style

and themes which could be said to move between social-realism and elements of the absurd.

This interpretation of these novels is reinforced by their presentation; for the relaunch of Millar's first four novels, timed to coincide with the issue of *Dreams of Sex and Stage-Diving*, all five were published in a uniform paperback format. This common format, reinforced by a shared visual identity – each cover consisting of a grainy black and white photograph of an urban scene – is part of a process through which the titles were constructed as a novel-sequence, as much a useful marketing device as a suggested reading strategy. The cover images, despite drawing on codes of realism, have a blurred and out-of-focus quality which points to the blurring of the boundaries between the real and the unreal foregrounded in Millar's work; a world in which reality is filtered and distanced. The photographs are overlaid with Millar's name, the most prominent piece of text on the covers. The letters of his name are printed so that they vary in density, moving between solidity and transparency rather like a form of street graffiti, stamped onto a wall where the paint has not quite taken. On the back cover a small inset photograph of Millar shows him wearing a cut-off T-shirt displaying his tattoos, turned towards the camera his gaze is not quite meeting the reader's eye. The pose conveys a sense of the writer lost in thought, the clothing and the tattoos connote his counterculture status. The reviews quoted in conjunction with the publisher's blurb are taken from a number of different/differing areas of the media, from the music press such as *Melody Maker* and *NME*, to the style press such as *The Face* and mass-market news publications such as the *Daily Mail* (which is more commonly associated with the dominant rather than the counterculture). These snippets of reviews signal the possibility that Millar's work generates a range of possible readings; what the reviews also signal is his liminal status, straddling the cultural boundaries between the 'mainstream' and the 'subcultural' – as in one featured extract from the *Literary Review* in which Millar is titled a 'post-punk Tom Sharpe'.

The publicity material introducing Fourth Estate's *The Collected Martin Millar*, published in June 1998 (see Figure 2.4), represents Millar as a 'new-generation British novelist' and 'hero to a new post-punk generation of fiction readers'; perhaps an attempt to relocate Millar's novels for a crossover readership with that of writers such as Irvine Welsh, who has also been styled 'post-punk' and whose phenomenal commercial success has spawned a vast array of publishing look-alikes (not to suggest that Millar is amongst these) – a succession of visually similar publications, their portrayal of 'drug culture' promoted as a major selling-proposition.[28] An attempt at constructing a visible grouping of post-punk writers that is as much evidence of contemporary publishing strategies[29] as it is of a creative movement.

As recently as 1996, a small London press, Spare Change Books, published *Gobbing Pogoing and Gratuitous Bad Language* (Dellar 1996), an anthology of punk

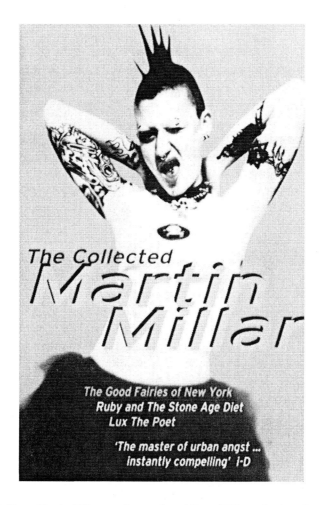

Figure 2.4 Three Martin Millar novels repackaged for a 1990s readership (Fourth Estate, 1998).
Source: Cover photograph by Herman Agopian © Tony Stone. Cover design by Tracy Winwood © Fourth Estate 1998.

short stories. This collection owes a (very obvious) debt to the zine tradition, despite its appearance in book form. The anthology includes work by writers Stewart Home and Mark Perry – who ran the fanzine *Sniffin' Glue* – among others; but it also features a number of writers who appear too young to have participated in the first wave of punk, suggesting an ongoing tradition, one which seems to skip the developments labelled post-punk, instead drawing on the DIY ethos in which producing is as crucial as *what is produced*. This book, whose blurb states that it is a celebration of 20 years of punk rock, has a curiously anachronistic air. This is

reinforced by the choice of layout, and the cover design: a recreation of a graffiti-ridden wall, adorned with a collage of cut-outs from papers such as the *Sun* and London's *Evening Standard* (their headlines and design suggest their 1970s versions) superimposed with a picture of a man who closely resembles Tony Blair (at the time of publication Prime Minister of Britain) in an outfit more usually associated with early media stereotypes of the 'Punk Rocker', adorned with safety pins, swastika, badges and gelled, spiky hair. This imagery revives designs now conventionally associated with punk – and the work of early punk artists such as Jamie Reid – as a way of actively articulating the text's relationship with that past whilst simultaneously asserting the past's continued presence.

The majority of the stories presented in this book are united by the particular activities and environments which dominate the book's pages: gigs and fights, Hackney squats and, of course, the proverbial sex and drugs and rock 'n' roll. The stories are overtly autobiographical in style; many appear almost ripped or at least distilled from the pages of a journal. This work reintroduces the idea of authentic experience[30] as the primary site of creative expression; it does not seem to share any of the devices of ironic distancing from such expression – even whilst drawing on it – which are a feature of many post-punk writings. It is the claim to authenticity shared with other works discussed here. An authenticity sited sometimes in terms of the personas of authors, sometimes in the manner in which the texts are presented materially through the institutions of book publishing. An authenticity which is used to legitimise these works as part of punk as a cultural tradition.

Notes

1 G. Genette's work suggests how certain of the operations of such editorial conventions might function socially and culturally (Genette 1997).
2 Additionally the zine is associated with attempts to reconfigure and/or reject dominant publishing forms and conventions (Duncombe 1997).
3 See entry 'Literature' in Williams's *Keywords*, 1988.
4 For example, his *Cranked Up Really High*. This text, although promoted as a cultural study which engages with academic assessments of punk, draws heavily on Home's own experience of punk through his participation in the British punk scene of the 70s and after.
5 This concept of experience is not restricted to punk but is one in wide circulation; for an analysis of ways in which such claims to experience might operate see Scott's article "'Experience'" (1992).
6 Jay Landesman was an equally prominent figure in American independent publishing (see Landesman 1992).
7 The small press tradition in Britain at the time – a tradition that persists in a less visible

form – like that in America was associated with the countercultural: a number of small presses of the 70s had their roots in 60s underground publishing. In relation to more established mainstream publishers small presses represented a firm adherence to a system of belief in which a commitment to cultural innovation was of greater importance than securing large sales; in marketing terms they could be said to be more producer than market-led.

8 Although Corgi was not considered commercial on the same terms as publishers such as NEL whose list was classed pulp – see section on Richard Allen in this chapter. Corgi's list contained titles by writers associated with the literary such as Simone de Beauvoir and Joseph Heller; however their appearance on Corgi's list represented a shift in their readership, placing them within a frame of reference which signalled their potential for exploitation in more commercial terms.

9 The most recent edition coincided with the final release of a film version entitled *The Punk and the Princess*, directed by Mike Sarne – perhaps best known for directing the film of Gore Vidal's *Myra Breckinridge*.

10 The sketch of Adolph's family environment could be read as a parody of urban working-class lifestyles of the time and is, perhaps intentionally, evocative of similar representations circulating via the popular media at the time the novel was first conceived – for example the portrayals contained in the popular BBC series *Till Death Us Do Part* which in 1975 had been on screen for 10 years. The form of rhetoric deployed by the character of Adolph's father further suggests this.

11 For the benefit of American readers this is a mass-market British newspaper, perhaps representative of the areas of the media in which punk was simultaneously vilified and obsessively documented. Sams seems to be drawing on a perception of the paper as signifier of a particular underlying moral agenda in which punk might have been represented as morally degenerate linking this to the values represented by the character of Adolph's father.

12 See J. Coles's interview with Mike Sarne in which Sarne describes the book as a modern-day *Romeo and Juliet* (Coles 1992).

13 For a concise survey of issues surrounding the analysis of punk as youth subculture, see Lury's *Consumer Culture* (Lury 1996).

14 Burns 1977, is one example of this.

15 For an introduction to the history of pulp publishing see the opening sections of Haut's survey (Haut 1995).

16 One of the many explanations put forward to account for Allen's popularity with a young readership is that his books reached a market in the process of formation. As a publishing category teen fiction, although fairly well-established in the USA in the 1970s, was relatively undeveloped in the UK; although there had been crossover titles from the States such as books by Paul Zindel and S.E. Hinton, few British publishers had developed broad lists to cater for a diversity of teenage readers.

17 Its roots grounded in nineteenth-century Romanticism.

18 The issues underlying these assessments are too complex to do justice to here, although they should be familiar in general terms. For a far more developed discussion of the concepts of cultural distinction which, arguably, are in operation here, Pierre Bourdieu's work is of particular interest (Bourdieu 1993).

19 It would seem that this response to Allen's work requires a certain amount of reading against the grain in some instances: see Author's Note in *Suedehead*, which functions

to distance the persona of the author from the subject-matter of the book. Here he advocates stern legal measures as a means of curbing the 'climate of anarchy' which allows such groupings to persist. Although this note could also be understood as a disclaimer in response to adverse publicity regarding the content of *Skinhead* (1970), London: NEL.

20 Stewart Home's written work is wide-ranging; the magazine *Smile*, International Magazine of Multiple Origins, produced by Home, amongst others, in the early 1980s contains a number of writings which could be understood as a homage to Richard Allen: see for example 'Anarchist' in issue 9, undated.

21 AK is the publishing division of AKA Books Co-op who operate in the UK; and in San Francisco, USA, a city long associated with small, radical presses. AK press's list suggests that a particular political commitment underlies their operations as a publisher: their books are published for their content and find a market rather than the reverse. They are also a part of a wider grouping of small presses whose shared definition is that of books as containers for ideas, an approach which resists the book's commodity-status.

22 N. Fountain's history of the London alternative press (Fountain 1988) is an accessible introduction to the era of publishing from which Compendium emerged – its status and role similar to that of City Lights bookshop in San Francisco.

23 Where transgressive stands for subject-matter, a preoccupation with particular areas of urban existence, and an active violation of prescribed social conventions (Young 1994).

24 High Risk's list has been described as linked through themes of sex, death and subversion; one of its editors, Amy Scholder, is also an editor at City Lights, San Francisco, the publishing house founded by beat-poet Lawrence Ferlinghetti. The other editor, Ira Silverberg, was publicity director of Grove Press.

25 See Young and Caveney's (1992) study of this area of writing. In this comprehensive and persuasively argued work, themes and preoccupations associated with fiction classified as Blank Generation are clearly charted. The discussions in this book demonstrate the vast gulf between the American cultural scene and tradition, which supports and contextualises the writers referred to, and that of Britain's; as well as how this impacts on how such writers are situated in terms of their reception.

26 See Martin Millar's website which includes extracts from recent works at: dspace. dial.pipex.com/town/street/kbh38/mmindex.shtml

27 Fourth Estate, part-owned by the *Guardian* newspaper, also publish Richard Hell. In the 1996 Fourth Estate edition of Hell's *Go Now*, the author biography consists of the legend 'Richard Hell was an originator of punk. He lives in New York City.' *Go Now* is set in 1980, its central character is a punk musician trying to quit heroin. The subject-matter coupled with the way in which Hell is represented suggest an autobiographical text.

28 Irvine Welsh has cited punk music as the greatest influence on his writing, claiming the new Edinburgh writers as 'punk-influenced', although he is also associated with breaking from a punk 'co-opted by a capitalist music industry' (Young 1993). Millar's more recent work featured alongside Welsh's in the bestselling collection *Disco Biscuits* (Champion 1997) where their writing is part of a grouping designated 'Chemical Generation' to which this is an excellent introduction – *Disco Biscuits* has itself been widely imitated.

29 Fiction publishing is one of the highest-risk areas of publishing; establishing fiction titles and fiction writers in the marketplace requires aggressive techniques. Linking together books in relation to previously successful publishing titles or concepts is a common promotional strategy.

30 The reader of such fiction is assumed to recognise the experiences of these writers and so to identify with the realism of the situations and characters represented in their works.

Bibliography

Allen, R. (1971) *Suedehead*, London: New English Library.

—— (1996) 'Punk Rock', in *The Complete Richard Allen, Volume 5*, Argyll: S.T.Publishing.

Baker, P. (1994) 'Selfish Elfish', the *Guardian*, Jun. 21, G2:10.

Beckett, A. (1995) 'Eternal Yoof', the *Guardian*, May 26, G2: 2.

Bourdieu, P. (1993) *The Field of Cultural Production*, Cambridge: Polity.

Burn, G. (1977) 'Good Clean Punk', *Sunday Times Magazine*, Jul. 17: 28–33.

Champion, S. (ed.) (1997) *Disco Biscuits*, London: Sceptre.

Coles, J. (1992) 'Punk, Spunk and Possibly Sunk', the *Guardian*, May 13, features: 37.

Dellar, R. (ed.) (1996) *Gobbing Pogoing and Gratuitous Bad Language*, London: Spare Change Books.

Duncombe, S. (1997) *Notes from Underground, Zines and the Politics of Alternative Culture*, London: Verso.

Fountain, N. (1988) *Underground*, London: Comedia, Routledge.

Genette, G. (1997) *Paratexts*, Cambridge: Cambridge University Press.

Haut, W. (1995) *Pulp Culture – Hardboiled Fiction and the Cold War*, London: Serpent's Tail.

Hebdige, D. (1979) *Subculture – The Meaning of Style*, London: Methuen.

Hell, R. (1996) *Go Now*, London: Fourth Estate.

Home, S. (1991) *The Assault on Culture*, Stirling: AK Press.

—— (1995) *Cranked Up Really High: An Inside Account of Punk Rock*, Hove: CodeX.

Landesman, J. (1992) *Jaywalking*, London: Weidenfeld and Nicolson.

Lury, C. (1996) *Consumer Culture*, Cambridge: Polity.

Marshall, G. (1996) 'Introduction', in *The Complete Richard Allen, Volume 5*, Argyll: S.T. Publishing.

Millar, M. (1987) *Milk, Sulphate and Alby Starvation*, London: Fourth Estate.

—— (1994) *Dreams of Sex and Stage-Diving*, London: Fourth Estate.

—— (1988) *Lux the Poet*, London: Fourth Estate.

—— (1998) *The Collected Martin Millar*, London: Fourth Estate.

Parks, J. (ed.) (1991) *Cultural Icons*, London: Bloomsbury.

Romney, J. (1996) 'Putting the Boot In', the *Guardian* G2: 29.

Sams, G. (1996) *The Punk*, Edgware: Tadao Press.

Scott, J. (1992) '"Experience"', in J. Butler and J.W. Scott (eds) *Feminists Theorize the Political*, London: Routledge.

3

'I'M SO BORED WITH THE USA'

the punk in cyberpunk

George McKay

More so than for other literary genres, a commentator of current
SF has to cope with its very spotty accessibility.

(Darko Suvin 1989: 349)

Spotty exterior, hides a spotty interior.
(The Fall, 'C 'n' C-S. mithering', The Fall 1980; Smith 1985: 40)

The cultural history of the (not only spotty adolescent) body has one clear
contemporary manifestation in the recent science fiction literary practice which
has become known as *cyberpunk*. Critical ways of approaching it have largely
revolved around the interface between technology and the body, a cyborgian
criticism, or in terms of postmodern theories of the simulacrum, a spectacular
criticism, or through postmodern constructions and explorations of *cyberspace*, and
information networks. I'm less interested in these clearly theorised and theorisable
approaches than in looking, as a starting point, at the very term itself. Much critical
attention has been paid to the *cyber* of cyberpunk – but what about the *punk*?
This chapter explores some of the ideological implications of cyberpunk criticism
(and looks *a little* at the fiction of William Gibson), focusing less on cyberpunk
texts than on the critical and cultural debates clustered around cyberpunk, or
fragmenting from it. I question particularly cyberpunk's relation to the wider
socio-critical tradition of science fiction. Does cyberpunk maintain or jettison this
tradition? I approach this question tangentially, by means of comparative analysis
between cyberpunk and punk rock. Does the punk figure represent a figure of
rebellion or resentment against the near-total urban fragmentation of the future,
or does the punk constitute a nihilistic, possibly postmodern, acceptance of a
decentred, multiple, subcultural cityscape? In order to offer responses to questions
like these I look at the retrospective construction of punk rock and its co-optation
by science fiction critics, at problems of this strategy, and at some of the reasons for
problems. This raises issues about the differences between British and North

49

Figure 3.1 The cyberpunk 'look' makes it into the clubs.
Source: Photograph by David Swindells, 1988.

American experiences and constructions of punk rock. By looking at the *punk* in cyberpunk, I also have the chance to be hopelessly/postmodernly/critically (?) nostalgic, even while uncomfortably aware of – was it John Lydon's (Johnny Rotten as was)? He should know – the searing indictment of the 'punk fogey' mentality, that of the sad thirtysomething has-been whose only recent experience of speed is in a life that's fast running out of excitement . . .

Cyber/punk

I want to start by elucidating some current critical thought on the term *cyberpunk*. In his introduction to the *Mirrorshades* anthology Bruce Sterling explains that:

a new movement in science fiction . . . was quickly recognised and given many labels: Radical Hard SF, the Outlaw Technologists, the Eighties Wave, the Neuromantics, the Mirrorshades Group.

But of all the labels pasted on and peeled throughout the early Eighties, one has stuck: cyberpunk.

(Sterling 1986: vii)

Note here that if we periodise punk rock as being a late '70s outburst, by the time the use of the term cyberpunk (coined by science fiction writer and critic Gardner Dozois; McHale 1992: 226) is established, punk's dangerous trajectory has been and gone. A fiction of the future, cyberpunk is already predicated on the past, touched by nostalgia. In fact, one of the points I want to explore is the extent to which cyberpunk often (usually) refers back to a more distant moment in popular music history – the 1960s – bypassing the actual music it signals in its name. According to Brian McHale, cyberpunk 'exemplifies the incongruity principle . . . cyberpunk in general . . . functions . . . on the principle of incongruous juxta-position' (1992: 226). It is this splitness that's interesting, and for two reasons. First, because it points to a multidisciplinarity of cultural reference. William Gibson explains: 'I don't have a sense of writing as being divided up into different *compartments*, and I don't separate literature from the other arts' (McCaffery 1991c: 266; emphasis in original). It's worth observing that this potential for multidisciplinarity in the term is sidelined by, for example, Fredric Jameson, who describes cyberpunk both more narrowly and more grandly as 'the supreme *literary* expression if not of postmodernism, then of late capitalism itself' (1991: 419*n*; emphasis in original). (If it's so important for Jameson, you'd have thought it warranted more than a footnote here.) Istvan Csicsery-Ronay also identifies the term as a site of (multidisciplinary) tension, going so far as to argue that '[a]s a label, "cyberpunk" is perfection' (Csicsery-Ronay 1988: 182). It's perfect because it suggests a centrifugal operation:

The oxymoronic conceit in 'cyberpunk' is so slick and global it fuses the high and the low, the complex and the simple, the governor and the savage, the techno-sublime and rock and roll slime.

(ibid.: 182)

'Heady stuff' indeed (ibid.: 183). But what Csicsery-Ronay carefully calls his 'evocations' here (possibly echoing Sterling 1988) are clearly less theorised or contextualised than metaphorised. Punk is rock 'n' roll, is simple, savage and slimy: I'll argue that these are carelessly conflated equivalences. This raises the second point of interest about the term's splitness. As McHale notes, it is a source of 'incongruity'. This is what really interests me here: the incongruous nature of

a term which yokes together an apparently very specific popular music and style, with a science fictional genre or topos, and these within the larger national discourse of British and North American cultural and critical practices. These incongruities are the concern of the rest of this chapter.

There are a number of earlier, more specifically American, referents of the term *punk*, including its signification as a lowlife, a minor criminal, but it's generally read in cyberpunk as referring more to the spectacular subculture that was punk rock, *c.* 1977. The double reference can be read as significant though: many cyberpunk plots have revolved around detective and crime plot paradigms. This also raises the point that the punk of *punk* rock itself refers to two distinct but related phenomena: punk as figure, as altered body, with its strange ways of dancing, and even of walking and talking; and punk as musical form, as aesthetic production and performance. In a similar way, *cyberpunk* is used to refer *both* to the fictional characters in novels, what Veronica Hollinger describes as 'the (usually male) lone rebel/hacker/punk who appears so frequently as [cyberpunk's] central character' (1991: 206), *and*, less convincingly, to the authors themselves: Richard Kadrey and Larry McCaffery write of 'books by the cyberpunks themselves' (1991: 17), for instance.

Punk rock and cyberpunk

Hollinger's point about youth and gender in the fictive subcultural space of cyberpunk is worth pursuing. In his fragmented analysis, which seeks to map out a 'poetics of cyberpunk', Brian McHale offers brief readings of cyberpunk heroes in relation to medieval romance and to the Western: 'Space-traveling versions of the knight-errant or cowboy abound in cyberpunk', he writes (1992: 249). It's significant for me that there is an absence of engagement with punk itself in the examples McHale offers. Also, his examples display an emphatic maleness. Jenny Wolmark writes that cyberpunk 'cannot escape from a predominantly patriarchal view of social relations' (1994: 126). To an extent this is the case with punk, too, and yet at the same time, as Iain Chambers notes, 'a space for women as active protagonists within the production of the music appeared' (Chambers 1985: 179) – think of bands in Britain like the Slits and the Raincoats, for instance. And for some male groups in punk, 'like the Subway Sect, the idea was to work, not with power, but with weakness and introversion' (Savage 1991: 419). I'm not sure that introversion and weakness are so casually equable, but even if cyberpunk protagonists are introverted, they're generally not so weak. Indeed, for Andrew Ross cyberpunk writing consists of 'a baroque edifice of adolescent male fantasies' (Ross 1991: 145).

In Britain there was an identifiable eschatological impulse in punk: the Sex Pistols declare in 'God Save the Queen' that there is 'No future, no future, no

future for you. No future, no future, no future for me' (1977). In William Gibson's *Count Zero* there is a clear echo of this: 'Over. Done with. This place. No time here, no future' (Gibson 1986, 16). Punk also had a fairly primitive kind of technological eschatology, a do-it-yourself approach, expressed both in the form of the local, home-produced fanzine culture (Rutherford 1992; Duncombe 1997), and in what the fanzines wrote about. Mark P. – later to be the leader of Alternative TV – offered the following famous advice in his seminal punk fanzine *Sniffin' Glue*:

> This is a chord. This is another. This is a third. *Now form a band.*
>
> (Quoted in Chambers 1985: 177)

I think it was Sheffield band the Human League who refined this idea, suggesting that, rather than guitars, electronic synthesisers are *the* punk instrument above all others, because almost no musical ability is needed to produce a convincing and reasonable tone or sound: you don't even need three chords, just one finger. Maybe in this punk argument about basic music production we can see a shift: from Mark P.'s rejection of the received wisdom of musical accomplishment in favour of a guitar-based primitivism, to the Human League's celebration and embracing of (an initially minimalistic) technological possibility as a means of sidestepping accomplishment, *could be* the shift from punk to cyberpunk.[1]

But to suggest such an idea is to infer that there *is* a discontinuity between punk and cyberpunk – which is what I'm doing – *not* to assume that the two are closely related, even connected. The collection of cyberpunk and related writings and illustrations *Semiotext(e) SF* (described modestly by its editors as 'a godzilla-book to terrify the bourgeoisie' Rucker *et al.* 1989: 12), contains an introduction consisting of 14 single-paragraph categories/narratives of science fiction and publishing, which fairly unproblematically rehearse the same thesis of continuity. These include 'NO FUTURE SF' and 'TERRORIST SF':

> The Cyberpunk contingent. . . . One imagines them as crazed computer hackers with green mohawks and decaying leather jackets, stoned on drugs so new the FDA hasn't even heard of them yet, word-processing their necropsychedelic prose to blaring tapes by groups with names like The Crucifucks, Dead Kennedys.
>
> (Rucker *et al.* 1989: 13)

Does one? Isn't there a degree of imbrication here? Do Gibson and Sterling have green mohawks? Does style explicitly link punk and cyberpunk here, or does critical focus on style confuse their differences? The punk obsession with style can be seen in a narcissistic piece like 'How much longer', by the English punk group

Alternative TV. This is a song about the semiotics of British subcultural style and the related forms of discourse, in this quotation first punk then hippy:

> How much longer will people wear
> Nazi armbands and dye their hair
> Safety pins, and spray their clothes
> Talk about anarchy, fascism and boredom? . . .
> How much longer will joss sticks rule
> They grow their hair long and stringy, and wear jesus boots
> Afghan coats, yeah making peace signs man
> Talk about Moorcock, Floyd down the Reading Festival?
> (Alternative TV 1977)

Interestingly enough, the science fiction reference ('Talk about [Michael] Moorcock') is in the subcultural context of the hippy, not the punk. Practically the only contact the early punk scene had with science fiction was via even earlier 1970s David Bowie albums. The song ends with a development of the chorus, which had accused each subcultural group described both of being ignorant and of being unconcerned: 'Well we all don't know nothing and we all don't fucking caaa-aaare'. There's a self-irony here on singer Mark P.'s part, as he includes himself in the final sneer. The song becomes less a celebration of subcultural invention than a (semi-joyful) critique of a lack of a wider perspective and activism on subculture's part.

Cyberpunk writer and critic Sterling connects popular music and the writing practice by means of a number of formal and thematic threads and metaphors:

> Many of the cyberpunks write a quite accomplished and graceful prose; they are in love with style, and are (some say) fashion-conscious to a fault. But, like the punks of '77, they prize their garage-band esthetic. . . . Some critics opine that cyberpunk is disentangling SF from mainstream influence, much as punk stripped rock and roll of the symphonic elegances of Seventies 'progressive rock'.
> (Sterling 1986: viii)

> Cyberpunk . . . favors 'crammed' prose: rapid, dizzying bursts of novel information, sensory overload that submerges the reader in the literary equivalent of the hard-rock 'wall of sound'.
> (Sterling 1986: xii–xiii)

Clearly there is a confusion of musical styles and chronologies here, one which I think is worth taking the effort to unpack. In attempting to guide the reader

through musical versions of the 'ancestral cyberpunks' (ibid.: viii), Sterling refers to a bewildering range of musics: garage-band, punk rock, rock 'n' roll, symphonic/progressive rock, hard rock, the 'wall of sound'. Of course, it can be argued that this range simply reflects the almost inherently decentred nature of popular music, but at the same time is there not a problem with a critical discourse which conflates the 'wall of sound' studio technique, hard rock, and punk rock? These are all significantly different in terms of music, political commitment, social context – for example, dating from the early 1960s, early 1970s and late 1970s respectively. In *Aliens and Others*, Jenny Wolmark addresses Sterling's argument here, identifying 'the kind of overtly masculinist cyberpunk writing that is described by Bruce Sterling as "the literary equivalent of the hard-rock wall of sound"' (Wolmark 1994: 128). Again though, Wolmark's critique is symptomatic of what I am suggesting is a general misreading of cultural production and history when it comes to the discussion of popular music and its relation to literary practice. The origins of the 'wall of sound' studio technique lie with producer Phil Spector; he developed it on hit records by *all-women* vocal groups like the Ronettes, Shangri-Las, and the Crystals (Hardy and Laing 1990: 743–44). So, the musical referent complicates an otherwise simplistic or reductive gendered criticism.

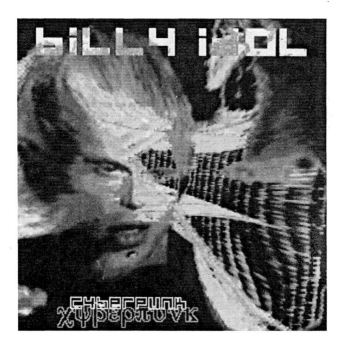

Figure 3.2 Cover to Billy Idol album *Cyberpunk* (Chrysalis Records, 1993). Idol, one of the '76 generation punks, reinvents himself for a new era.
Source: Courtesy of Chrysalis Records.

Surely more should be made of this interesting complication. It's troubling moments like these, where knowledge and understanding of popular music by literary critics seem to be, well, uncertain, that make me want to look in more detail at something like cyberpunk, which, as we have seen, has been defined as a contemporary limit-case of the interface between the two.

(British punk culture was another story)

So says Andrew Ross (1991: 146) – another story of death by parenthesis, apparently. I want to look at a particular critical construction of the interface between cyberpunk and punk in more detail, to suggest that it rests on a problematic, partial, retrospective reconstruction of punk rock, one possibly more suited to North American than to British punk experience.

> Enter cyberpunk, which appropriated punk's confrontational style, its anarchist energies, its crystal-meth pacings, and its central motif of the alienated victim defiantly using technology to blow everyone's fuses.
>
> (Kadrey and McCaffery 1991: 23)

There is a frequent impulse by cyberpunk critics to heroise punk rock, not in order to focus on its transformative or negative possibilities, but so that its perceived authenticity and vibrancy will in turn contribute to cyberpunk's stock. Larry McCaffery's essay 'Cutting up: cyberpunk, punk music, and urban decontextual-izations' (1991b) addresses some of the issues I'm raising here; I want to cut up 'Cutting up'. Both McCaffery and Andrew Ross state that the North American punk experience was different to the British one(s), but both proceed then to ignore the point they have just made, McCaffery in particular offering the North American experience as the universal one.

McCaffery's essay is self-interrupting and -disrupting in its form, constructed as a collage of typographics which aims deliberately to undercut the reading process. One of the epigraphs to the essay – four apt lines from a song by English punk band the Clash, singing about 'the terror of the scientific sun' – is the exact same quotation used by McCaffery as an epigraph earlier in *Storming the Reality Studio* (see McCaffery 1991a: 286 and 1). This paucity of material is symptomatic: it would seem to illustrate the *weakness* of the arguments for thematic connections between cyberpunk literary practice and punk popular music.[2] McCaffery offers a number of formal connections between punk and cyberpunk, including collage and cut-up methods; highly idiomatic lingoes; the use of obscenity, noise, sensory overloads. His rhetoric attempts a cyberpunk criticism: '[p]unk and cyberpunk are

both hard-edged, "roots-oriented" forms developed to return their genres to some mythic, primal source of energy', he writes excitedly (McCaffery 1991b: 291). Two quotations from my own scrawled comments on the page from my first reading of 'Cutting up' illustrate things. First:

> punk as aesthetic — where's the *politics*?!

By this I refer not to the politics of what McCaffery calls 'a new punk poetics', 'the aesthetics of trash' (1991b: 296, 294), which he approaches via the, by now, standard narrative of subcultural *bricolage* of, for instance, Dick Hebdige (1979) and Iain Chambers (1985). Rather, I refer to the absence of the socio-political interventions of punk rock I touch on throughout this chapter. Cyberpunk-infected retrospective reconstructions of punk always erase the bit they are least comfortable with, the byte they may not themselves possess. Second:

> surprise, surprise: America claims everything again.

This one is in response to a breathtakingly casual statement of American cultural imperialism: according to McCaffery, 'Elvis Presley, the first punk rocker' (1991b: 292). Obviously there are links between Elvis and punk through youth, style and popular music, but it's really not that straightforward. For McCaffery, the fact is so clear and so *timeless* that it doesn't even require a verb. For British punks, it was significant that Presley *died* in their year, 1977.[3] *Punk* is McCaffery shorthand for the American literary strategy of urban defamiliarisation, familiar to readers of 'authors like Hammett, Algren, and Chandler' (ibid.: 301). By extension, punk rock is less a critical musical form for McCaffery than simply another mode of that strategy of urban defamiliarisation.

McCaffery offers a heroic description of punk, of 'the debased but extraordinarily *vivid* lives of the disaffected urban youths who must somehow exist in the midst of concrete jungles, casual violence, and towering monuments that threaten to dwarf all *human* perspective' (ibid.: 297; emphasis in original). With cyberpunk, too, there is the urban focus, on 'the Sprawl' and on the opportunity it offers for a 'maximally intimate juxtaposition of maximally diverse and heterogeneous cultural materials' (McHale 1992: 251). Both punk and cyberpunk present the urban street as the romanticised site of activity: one of the narratives of punk revolved around the notion of street credibility, of each punk's authenticity, the right to come from, and be on, the street; Gibson's narratives of cyberpunk are told in what he calls in *Count Zero* 'the language of street tech' (1986: 163). And the urban focus is seen through the music, too: the Clash recontextualise nursery rhymes, sing about 'London's burning' (1977), there's a punk band called London — indeed, an embryonic version of the Clash was called London SS.

But hold on, there: at the risk of illustrating once more the punk obsession with itself as a discourse of authenticity, it's worth recalling that hit single by the English group the Members: 'Sound of the suburbs' (1979). Andrew Ross notes North American constructions of the urban *from* a suburban perspective, suggesting that 'the suburban romance of punk, and, subsequently, cyberpunk, fashioned a culture of alienation out of their parents' worst fears about life on the mean streets' (1991: 146). Names of British bands signalling a suburban rather than urban focus at the time included Sham 69, the Leyton Buzzards, the Merton Parkas, the Newtown Neurotics. Punk invented itself in rural East Anglia in places I knew like Great Yarmouth and Norwich, in fact in seaside town Great Yarmouth *before* the comparative sophistication of small, regional capital Norwich. In neither of these places are there too many concrete jungles and towering monuments. I'm not, though, concerned here to offer another narrative of punk, one with a suburban or even rural angle, but rather *both* to illustrate the partial version of punk on offer through cyberpunk, *and* to suggest that there might be problems, even inaccuracies, in that retrospective reconstruction.[4] I suggest that McCaffery's cyberpunk rhetoric enables him to offer fiction instead of criticism.

I'm so bored with the USA

There was something of an antagonistic relation between Britain and the United States in the punk side of popular culture, as seen in the song 'I'm so bored with the USA' by the Clash, a boredom which understandably lapsed when American stadium rock success and, later, Levi's advertisements came along (Clash 1977). Anarcho-punk band/collective Crass are typically more direct, concluding one song which presents American air bases, fast food and popular culture as facets of a cultural *and* militaristic imperialism: 'E.T. go home / Mickey Mouse fuck off' (Crass 1984).[5] There are more interesting narratives than these, though. Here's the Fall again, with one of Mark E. Smith's 'crap raps':

> In Lancashire . . . the scene started here
> Then was America
> We went there
> Big A&M herb was there . . .
> U.S. purge, rock n pop filth
> Their materials filched . . .
> All the english groups
> Act like peasants with free milk . . .
> Five whacky proletariat idiots

Californians always think of sex
Or think of death . . .
They really get it off on
'Don't hurt me please'
Rapists fill the tv's.

(The Fall 1980; Smith 1985: 40)

There's a (very partial) representation of American difference here, picking up some of the issues cyberpunk also deals with: subculture, multinational power, media. But it's also a song which transforms personal experience into a rather sophisticated and reflexive analysis of class, national and cultural power. On the other hand, McCaffery configures punk entirely in relation to cyberpunk as relying on 'sensationalised, S & M surface textures, its Benzedrine-rush pacings, or its parodically nonconformist stance' (1991a: 13). My contention is that there is a gap here, between British punk practice and an American critical reading of punk. Can the punk of cyberpunk be seen as an *American* construction of punk rock? One that emphasises the cartoon-style of the Ramones, the art-house of Talking Heads, at the expense of the political moment of the Sex Pistols and 'God Save the Queen' topping the charts during the Queen's silver jubilee week in 1977, of Alternative TV and the Fall widening the audience and extending the life of the hippy free festival circuit, of mass anti-racism demonstrations in London and across Britain organised by the far left, of Cross reinventing anarchy and invigorating the peace movement?[6] Bruce Sterling seems to be aware of this; he describes his novel *Schismatrix* as

> like a Ramones three-minute pop song: we're not going to have any pretentious lighter shades of pale guitar noodling here, it's going to be 'Sheena is a punk rocker', blam blam blam.
>
> (Quoted in McCaffery 1991b: 291)

The dumbest rock band on earth (slogan: 'Gabba gabba hey'), who needed to use the word 'punk' in their song titles to remind themselves and their audiences that *that* was what they were supposed to be, strike me either as a problematic *or* as an emblematic cultural referent for a literary practice that's previously been situated in the realm of the social. Problematic because I'm not certain that the Ramones have the social or political concern which I'm arguing was a distinctive feature of punk rock, and possibly emblematic for the same reason: the choice of an apolitical (depoliticised?) cultural referent for a particular style of science fiction writing might well adequately signal that genre's (postmodern) flattening of affect, shift from its expected social situatedness. If we accept the 'parodically nonconformist', the 'blam blam blam' construction of punk offered by cyberpunk critics then we

bypass an opportunity to explore the political problems of cyberpunk precisely because we've just erased the significant political comment from the referent of the musical practice.

Many of the popular musical references in cyberpunk writing *aren't* to punk rock at all, but to the 60s avant-garde of Velvet Underground, Lou Reed and so on. Significantly, in 'Cutting up' McCaffery uses as titles for sections 'A walk on the wild side' (Lou Reed) and 'This is the end' (the Doors), and Gibson's quoted cultural influences are from the 60s: Reed and William Burroughs (1991b: 302–7). Punk is the B-side to the A-side of paternity and origin: Reed and Burroughs are 'punk's twin Godfathers' (ibid.: 302), Rimbaud is 'punk's avatar', Genet and Bukowski are 'protopunks' (ibid.: 296) and Elvis was the first anyway. One of the occasions when there appears to be more contemporary reference is found in Gibson's *Count Zero* (1986), where subcultural gangs apparently related to punk are presented. In the 1980s, a post-punk 'Gothic' music and style developed, revolving around the band Bauhaus's epic single 'Bela Lugosi's dead', with Australian contributions from Nick Cave and the Bad Seeds doing Southern Gothic material about and originally by Elvis Presley. Gibson offers a future version of this:

> At least twenty Gothicks postured in the main room like a herd of baby dinosaurs, their crests of lacquered hair bobbing and twitching. The majority approached the Gothick ideal: tall, lean, muscular, but touched by a certain gaunt restlessness, young athletes in the early stages of consumption. The graveyard pallor was mandatory, and Gothick hair was by definition black. Bobby knew that the few who couldn't warp their bodies to fit the subcultural template were best avoided; a short Gothick was trouble, a fat Gothick homicidal.
>
> (Gibson 1986: 57–58)

In a neat extrapolation, Gibson shifts from music as a subcultural focus of expression and identity to computer-generated scenarios in cyberspace. So, for the Gothicks, their club entertainment features not DJs or bands and music, but programmers with new 'simstim' (simulated stimulus) programmes, like the 'Feelies' from Huxley's *Brave New World* (1932: 38) but covering the whole range of human senses:[7]

> Leon was running some kind of weird jungle fuck tape phased you in and out of these different kinda animals. . . . The Gothicks were into it, whoever. They were thrashing and stomping and generally into major tree-rat identification. Leon's new hit tape.
>
> (Gibson 1986: 59)

In fact, the 'subcultural template' of the Gothicks is one of several on offer, the main other one described being that of the Kasuals. The Gothicks and the Kasuals are elsewhere distinguished as 'greaseballs and whiteshoes' (ibid.: 285):

> black-crested Gothick boys in leather and studs, and . . . blond Kasuals, the latter decked out in the week's current Shinjuku cottons and gold-buckled white loafers. . . . 'They're like natural enemies, it's in the DNA or something. . . .'
>
> (Gibson 1986, 257–58)

The 'subcultural templates' Gibson outlines have as a palimpsestic intertext not the punk style and moment but rather an American discourse of ethnic identity from a quite different conjuncture. This scenario has little to do with 1970s punk rock at all; it's the 1950s, and *West Side Story* telescoped. It could be argued that such a conflation of referents is itself a strategy of subcultural *bricolage*, undertaken by the Gothicks and the Kasuals, or a strategy of postmodern cultural production more generally, as practised here by cyberpunk writers. However, the continuing emphasis on the American – with the essential concomitant erasure of the British – cultural experience by writers and critics should not be disregarded. This is especially so in the case of something like punk, which can so clearly be approached in terms of a discourse of national identity, especially in antagonistic relation to the United States.

On the political problems of cyber/punk

William Gibson talks of the 'dance of biz' (quoted in McCaffery 1991a: 5), which seems to signal a corporate culture in which music – and its connected discourses of the body and pleasure through dance – is simply one more factor in the hegemonic domination of late capitalism. An instance of this is seen in *Count Zero*, when the rival gangs are hired for a joint operation by a powerful agent, representing Maas Biolabs. As a Gothick warlord says, erasing traditional hatred between the Gothicks and the Kasuals in an instant: 'Fuck that . . . we're talking big money here, we're talking *corporate*' (1986: 261; emphasis in original). The slick recuperation of the subculturally oppositional here connects with a reading of punk as constituting the commodification of rebellion. We see the familiar narrative of the recuperation of an oppositional impulse into a marketable commodity. How far does cyberpunk mirror or pursue that? Larry McCaffery identifies 'the paradoxes involved in artistic rebellion when "rebellion" is now a commodifiable *image* that is regularly employed as a "counterculture" marketing strategy' (1991a: 2; emphasis in original). Is it, then, the case that cyberpunk

simply represents quite accurately a postmodern/post-punk condition of political disengagement? Where *Never Mind the Bollocks* is superseded by just *Nevermind?*[8] I don't think this is adequate. It far too quickly jettisons something I am still reluctant to overlook or bypass: the political engagement of much punk rock, which consists of narratives that have still not fully been written/told/sung about. Furthermore it assumes that punk was *about* the commodification of rebellion, when by my reading, rather, that's one of the things that it *became* about.

Other aspects of the political problem are quite unrelated to music, to subculture, or rather have as symptoms an absence of musical or subcultural reference. One is of the distinct lack of *situatedness* of the special site of cyberpunk. Gibson writes of 'the non-place that was cyberspace' (1986: 230), and Samuel Delany has argued that 'it's only as a negative . . . that cyberpunk can signify' (quoted in Suvin 1989: 359). On information technology's potentially different space and time realm, Andrew Ross describes 'the cartographic coordinates of technosimulated space that have no fixed geographic referent in the physical landscape' (Ross 1991: 147). Such decentring or negativity may be a contributing factor to what Fredric Jameson describes as 'the massive dystopian horizon of our collective as well as our individual praxis' (Jameson 1991: 35), a dystopian notion he relates in turn to a 'postmodern sublime' – source of the experience of terror (Burke) and the limits of representation (Kant). A postmodern sublime connects to multinational capitalist terror and to the representation of that in cultural forms that explore what Jameson characterises as 'high-tech paranoia':

> the circuits and networks of some global computer hookup are narratively mobilized by labyrinthine conspiracies of autonomous but deadly interlocking and competing information agencies in a complexity often beyond the capacity of the normal reading mind. . . . *Cyberpunk* . . . is fully as much an expression of transnational corporate realities as it is of global paranoia itself.
>
> (Jameson 1991: 38)

Cyberpunk may be an effort to represent a postmodern sublime, but significantly not a nuclear sublime. Bruce Sterling has noted that one 'distinguishing mark of the emergent new school of Eighties SF [is] its boredom with the Apocalypse' (quoted in Hollinger 1991: 213). Veronica Hollinger sees cyberpunk's lack of concern with nuclear eschatology as a symptom of 'a certain coolness, a kind of ironically detached approach to its subject matter that precludes nostalgia or sentimentality' (ibid.) – or a political engagement? A product of the nuclear age, cyberpunk nonetheless prefers to ignore what Jacques Derrida has described as the hypothesis of 'a total and remainderless destruction of the archive' (Derrida 1984: 27).

Offering what instead? Ironic detachment? Come on! Even punk rockers weren't *that* myopic. Jenny Wolmark, too, has her reservations:

> The ironic detachment of cyberpunk, its 'nonchalance' towards a high-tech future, can be more appropriately ascribed to what Peter Sloterdijk has called 'enlightened false consciousness', a term that accurately describes the ambiguous tone of cyberpunk, critical of what it appears to be celebrating, but also appreciative of that towards which it is most critical.
>
> (Wolmark 1994: 117)

Conclusion

The punk in cyberpunk is a suitably awkward figure. It raises a number of issues about multidisciplinarity in cultural forms and in critical approaches, about the retrospective (re)constructions of punk, about British and North American versions of things. Also it signals the problems of precisely where we situate cyberpunk fictional practice in the political and social realm. While I would agree with Fredric Jameson in his identification of 'that new complex of meanings that bears the name *punk*' (1991: 288; emphasis in original), I'd also suggest that such a widening of the term can be problematic, since it seems to jettison some of the ideas of punk, particularly those political ones offered in my reading of much British punk music. As I've suggested, this can be read as a symptom of the postmodern condition, a waning of effect and a nostalgic review that comes from postmodern cyberpunk in relation to modern punk rock. Punk as modern because it's a last/late utopian gesture (or 'utopian current': see Home 1988), combining an avant-garde aesthetic with a (however ironised or mediated) degree of political engagement. Alternatively, it can be located within a narrative of national culture: a North American cyberpunk reconstruction of punk as comic book alienated boy and his computer, as compared to a British experience of punk interrogating to varying degrees the boundaries of class, social institutions, gender. Of course, these readings – postmodern and national – can be related: Stuart Hall has a terrific description of postmodernism as the way 'the world has dreamed itself "American"' (quoted in Brooker 1992: 24).

And anyway, isn't the *punk* of cyberpunk literature rather a limiting frame of reference? If we read it as referring to a form of music, then I'd quite like to read some cyberrap, some cyberfreejazz – maybe even, in case it's thought that I'm privileging the spectacular or avant-garde in popular music or in subculture, some cyberblues, or cybercountry. If we read the *punk* as referring to the subcultural body itself, that type of person displayed through that hair, clothes, tattoos,

piercings etc., then I'd quite like to read some cyberted, cyberhippy, cybercrustie. And, of course, they're always already there, aren't they: criticism always lags behind subcultural practice. When I first read this chapter as a paper, someone pointed out the unlikely but successful videoed space-age reinvention of Southern American bearded bluesmen ZZ Top as – cyberblues; a week later I read a review of Shriekback, 'an acoustic funk band . . . post apocalypse music . . . like some kind of shamen [*sic*] totem from *Riddley Walker* . . . cyberfolk, someone said' (Hieronymus, S. 1994).

Acknowledgements

This chapter was first written and given as a paper in April 1994, at a British Association for American Studies conference at Sheffield University. Thanks to conference organiser Dr Tim Armstrong, and to Dr David Seed for chairing the session, and thanks especially to all those who commented on the paper, both during the session and in the bar later. I have shamelessly appropriated the good ideas. News of Kurt Cobain's death broke at that conference, I seem to recall, but round that time at least one great rock singer – pre-punk, and feeding it; a voice, music and performance *packed* with energy and style, when these virtues were thin on the ground – sadly died, to a fading coda of short obits. R.I.P. Lee Brilleaux of Dr Feelgood. He's back in the night now. A second version of the paper was given during a visiting lectureship at the University of Southern Maine in September 1994. Thanks to Head of American and New England Studies, Professor Joe Conforti, and to Head of English, Professor Diane Sadoff, for their organisation and hospitality.

Notes

1 Fanzine primitivism and advanced technology can combine to develop further what Jon Savage calls 'Punk's access principle'. See North American desktop fanzine *HOMOture*: 'one of the most exciting evolutions from punk culture and modern technology has been the philosophy that access to a computer or a copier can provide a way to share informational and recreational knowledge' (quoted in Savage 1991: 600). On the other hand, though Stephen Duncombe's recent in-depth study acknowledges the possibilities of computer technology in fanzine production, Duncombe is still more interested in classic fanzine culture, in the somehow authentic, samizdat world 'coming out of cities, suburbs and small towns across the USA, assembled on kitchen tables' (1997: 2).

2 On the subject of epigraphic marginalia, Brian McHale uses as an epigraph for his piece 'POSTcyberMODERNpunkISM' for *In the Reality Studio* a quotation from well-known anarchist punk subversive Paul Simon! Perhaps a more hip sub-editor at Routledge

later gave him some advice: republished as a chapter in *Constructing Postmodernism*, the epigraph is erased. Again though, the serious point is of a literary critic's ostensible lack of wider cultural understanding, in the context of discussing material which apparently demands a multidisciplinary approach by definition.

3 For a less sneering look at the negative and positive discourses of Americanisation see *Yankee Go Home (& Take Me With U)* (McKay 1997). In "Downsizing America", the conclusion to *Yankee Go Home*, I consider Euro-American relations and tensions in the context of subcultural practice.

4 Actually, I kind of feel I *am* tempted to stress the frequently-forgotten rural aspects of youth culture. Elsewhere (McKay 1996) I aim precisely to privilege the provincial and rural, to take issue with the contemporary fetishisation of the urban in cultural studies and subcultural studies alike. In the context of this article, see *The Great British Mistake*, a collection of writings from punk fanzine *Vague*, originally produced in the apple-growing West Country by anarcho-types who called themselves – 'ciderpunks' (Vague 1994).

5 For a recent reaction against the continuing emphasis on British punk rock, arguing that 'American punk predates British punk', see Heylin (1993: xi).

6 Some of the radical narratives of British punk, and punk's relation to sixties hippy counterculture and to the eighties/nineties DIY Culture, are traced in *Senseless Acts of Beauty* (McKay 1996). The book *DiY Culture* (McKay 1998) collects together writings by nineties activists and cultural workers themselves and, interestingly, these new young(er) people actually show *little* connection with the earlier moment of punk rock.

7 In terms of the relation between science fiction and popular music, *Brave New World* is an interesting text: for brief discussion of ways in which Huxley's far-future is actually rather Jazz Age, see McKay 1992. Downing 1976 looks at ways in which rock music has used science fiction themes and topoi.

8 I discuss the relationship between punk rock and postmodernism in 'Postmodernism and the Battle of the Beanfields' (McKay 1994). The problem partly revolves around viewing punk as postmodern due to its self-consciousness of construction and its wilful recuperation by capital, and viewing it as pre-postmodern (the last of the modern?) due to its insistence on the utopian gesture of political engagement.

Bibliography/discography

Alternative TV (1977) 'How much longer'/'You bastard', Deptford: Fun City Records.

Brooker, Peter (ed.) (1992) *Modernism/Postmodernism*, Harlow: Longman.

Chambers, Iain (1985) *Urban Rhythms: Pop Music and Popular Culture*, London: Macmillan.

Clash, the (1977) 'I'm so bored with the USA', on *The Clash*, CBS Records.

Crass (1984) 'Smash the Mac', on *Best Before . . . 1984*, Crass Records.

Csicsery-Ronay, Istvan (1988) 'Cyberpunk and neuromanticism', in McCaffery 1991a: 182–93.

Derrida, Jacques (1984) 'No future, not now (full speed ahead, seven missiles, seven missives)'. Translated by Catherine Porter and Philip Lewis. *Diacritics: A Review of Contemporary Criticism* 14: 2 (Summer 1984): 20–31.

Duncombe, Stephen (1997) *Notes From Underground: Zines and the Politics of Alternative Culture*, London: Verso.

Earnshaw, Steven (ed.) (1994) *Postmodern Surroundings*, Amsterdam: Rodopi.

Fall, the (1980) 'C 'n' C-S. mithering', on *Grotesque (After the Gramme)*, Rough Trade Records.

Gibson, William (1986) *Count Zero*, London: Grafton.

Gibson, William and Sterling, Bruce (1990) *The Difference Engine*. London: Gollancz.

Hardy, Phil and Laing, Dave (1990) *The Faber Companion to 20th-Century Popular Music*, London: Faber & Faber.

Hebdige, Dick (1979) *Subculture: The Meaning of Style*. London: Routledge.

Heylin, Clinton (1993) *From the Velvets to the Voidoids: A Pre-Punk History for a Post-Punk World*, London: Penguin.

Hieronymus, S. (1994) Review of Shriekback, *Venue: Bristol & Bath's What's On*, no. 310 (April 1–15): 35.

Hollinger, Veronica (1991) 'Cybernetic deconstructions: cyberpunk and postmodernism'. In McCaffery 1991a: 203–18.

Home, Stewart (1988) *The Assault on Culture: Utopian Currents From Lettrisme to Class War*, Stirling: AK Press, 1991.

Huxley, Aldous (1932) *Brave New World*, London: Granada, 1977.

Jameson, Fredric (1991) *Postmodernism, Or, The Cultural Logic of Late Capitalism*, London: Verso.

Kadrey, Richard and McCaffery, Larry (1991) 'Cyberpunk 101: a schematic guide to *Storming the Reality Studio*', in McCaffery 1991a: 17–29.

Larkin, Colin (ed.) (1992) *The Guinness Who's Who of Indie and New Wave Music*, Enfield: Guinness.

Marcus, Greil (1989) *Lipstick Traces: A Secret History of the Twentieth Century*, London: Secker and Warburg, 1990.

McCaffery, Larry (ed.) (1991a) *Storming the Reality Studio: A Casebook of Cyberpunk and Postmodern Fiction*, London: Duke University Press, 1992.

—— (1991b) 'Cutting up: cyberpunk, punk music, and urban decontextualizations', in McCaffery 1991a: 286–307.

—— (1991c) 'An interview with William Gibson', in McCaffery 1991a: 263–85.

McHale, Brian (1992) *Constructing Postmodernism*, London: Routledge.

McKay, George (1992) '"Time back way back": "motivation" and speculative fiction'. *Critical Quarterly* 34: 1 (Spring): 102–16.

—— (1994) 'Postmodernism and the Battle of the Beanfields: British anarchist music and text of the 1970s and 1980s', in Earnshaw 1994: 147–66.

—— (1996) *Senseless Acts of Beauty: Cultures of Resistance Since the Sixties*, London: Verso.

—— (ed.) (1997) *Yankee Go Home (& Take Me With U): Americanisation and Popular Culture*, Sheffield: Sheffield Academic Press.

—— (ed.) (1998) *DiY Culture: Party and Protest in Nineties Britain*, London: Verso.

Members, the (1979) 'Sound of the suburbs' / 'Handling the big jets', Virgin Records.

Ross, Andrew (1991) *Strange Weather: Culture, Science and Technology in the Age of Limits*, London: Verso.

Rucker, Rudy, Wilson, Peter Lamborn and Wilson, Robert Anton (eds) (1989) *Semiotext(e) SF*, Edinburgh: AK Press.

Rutherford, Paul (1992) *Fanzine Culture*, Glasgow: Flower Pot Press.

Savage, Jon (1991) *England's Dreaming: Sex Pistols and Punk Rock*, London: Faber & Faber.

Sex Pistols, the (1977) 'God Save the Queen' / 'Did you no wrong', Virgin Records.

Smith, Mark E. (1985) *The Fall Lyrics*, Berlin: The Lough Press.

Sterling, Bruce (ed.) (1986) *Mirrorshades: The Cyberpunk Anthology*, London: Paladin, 1990.

—— (1988) 'Twenty evocations', in McCaffery 1991a: 154–61.

Suvin, Darko (1989) 'On Gibson and cyberpunk SF', in McCaffery 1991a: 349–65.

Vague, Tom (1994) *The Great British Mistake: Vague 1977–92: A Fourteen and a Half Years Struggle Against Lies, Stupidity and Cowardice: A Reckoning with the Destroyers of the Punk Rock Movement*, Edinburgh: AK Press.

Wolmark, Jenny (1994) *Aliens and Others: Feminism, Postmodernism, Science Fiction*, Hemel Hempstead: Harvester Wheatsheaf.

4

FINSELTOWN REBELLION

Punk, transgression and a conversation with Richard Baylor

David Kerekes

Two documentary film shorts *Sex Pistols Number 1* and *Sex Pistols Number 2* (both 1977) provide the stepping stone for a collaboration between filmmaker Julien Temple and Sex Pistols impresario Malcolm McLaren. The result, *The Great Rock 'n' Roll Swindle* (1979), is a fanciful re-enactment of McLaren's manufacture and orchestration of the Sex Pistols.

With a Super-8 camera, Rastafarian DJ Don Letts films bands rehearsing and playing live at the Roxy club in London. He titles the piece *The Punk Rock Movie* (1978).

Lech Kowalski's *D.O.A.* (1981) is a film document of the Sex Pistols' chaotic concert dates through the United States, interspersed with scenes from their Anarchy in the UK tour and vox pop interviews with fans and detractors. Running counterpoint to this is the story of Terry ('I ain't got no friends') Sylvester, an unemployed youth living in London, whose objective in the film is to play a gig at The Golden Shoe public house with his band Terry and the Idiots.

Alex Cox's *Sid and Nancy* (1986) is a fictionalised account of the brief relationship between Sex Pistol Sid Vicious and his groupie girlfriend Nancy Spungen, which ends for both of them in death.

Penelope Spheeris' *Suburbia* (1983) asks the question: 'What Happens When The Punks Rebel?'[1] A movie about alienation, *Suburbia* has a bunch of kids living on the outskirts of town in a run-down shack suffering continual harassment and threats from the irate locals.

Richard Kern's *King of Sex* (1986) sets the Killdozer track of the same name to pictures, showing Nick Zedd flailing around on a bed with two

women, and later in drag attempting to perform oral sex on a flaccid Rick Strange. The film lasts only as long as the Killdozer track.

Punk rock movies are shambolic. Or at least they ought to be. Both Cox's *Sid and Nancy* and Spheeris's *Suburbia* may be feature films which have the veneer of punk – punk characters, punk living, punk music – but neither are essentially punk rock movies. Lech Kowalski's *D.O.A.*, on the other hand, is. Of course, there is a natural divide in that Kowalski is no filmmaker and he lacks the technical competence of Cox and Spheeris, but Kowalski brings to his film an impetuous energy – his shortcomings as a filmmaker result in a form of 'earnest anarchism' and the film itself the visual equivalent of the Three Chord Trick. *D.O.A.* doesn't exist in order to satisfy box office returns or film critics, it exists because to make it excited Kowalski.

It is interesting how closely *D.O.A.* resembles *The Great Rock 'n' Roll Swindle*. As a piece of punk celluloid *Rock 'n' Roll Swindle* is half-right, but McLaren's commercial acumen forestalls director Temple's vision and the thing exhausts itself well before the final reel.

Punk doesn't lend itself easily to the medium of film. Films are rarely impetuous. They take too long to watch and longer still to make. Laborious mechanisms, like plot, characters and timescale are generally required. Any integrity the filmmaker might have is answerable to remote influences such as investors. Of course there are exceptions. Several feature films to emerge on the back of punk rock may be classed as genuine examples of Punk cinema – the aforementioned *D.O.A.*, Derek Jarman's *Jubilee* (1978), and Jack Hazan and David Mingay's *Rude Boy* (1980), for example.[2] Hardly an 'explosion'. Unlike the rock 'n' roll of previous decades, punk rock did not create much of a cinematic splash.

Punk was a transatlantic insurrection, changing the way young people dressed, the way they behaved, and the way they were perceived by their peers.[3] It even inherited some rather curious apocryphal notions.[4] But filmmakers weren't moving in to exploit the fans as they had done in the 50s, 60s and early 70s.[5] Punk films of the punk era are conspicuously thin on the ground. Perhaps filmmakers were unwilling to affiliate themselves with something so crass, something which so vilified patriotism, and indeed, something which appeared to delight in Nazi imagery?[6]

But if filmmakers weren't forthcoming in exploiting punk rock, punk rock was generating its own filmmakers.

It is with the 'New York Underground' that the only true punk celluloid has emerged. Having its origins in the late 1970s, a distinctive core of independent films began to appear in New York which sought to challenge notions of taste, decency, and the social order while promoting aggressive musical soundtracks. By

1984, these films and filmmakers had multiplied to such an extent that Nick Zedd, himself a filmmaker, was able to create around them *The Underground Film Bulletin*[7] and give the movement an epithet: The Cinema of Transgression.[8]

These (invariably short) films, shot on meagre budgets, usually over a period of days, sometimes hours, would often be screened at music venues. There was a common ground in the type of music the films utilised, the often 'shocking' subject matter, and their incestuous nature in that the director of one film might well appear in front of a camera for the director of another.

> I showed *They Eat Scum* at Max's Kansas City and Club 57 in the fall of '79. 1979 was a time of renewed energy in the New York film scene. Simultaneously, people who didn't even know each other were making low budget super-8 features starring members of local bands.
>
> (Zedd 1996: 11)

Perhaps the two names most commonly associated with the Cinema of Transgression are Richard Kern and the aforementioned Zedd, whose *King of Sex* and *Police State* (1987) are landmarks in Transgression. *Police State* (see Figure 4.1) is a savage indictment of authoritarian pig-headedness, bigotry and protocol, while *King Of Sex*, with its writhing naked bodies and gushing theme song – 'I *am* the King of Sex' – is more indicative of the ennui of a generation than half a dozen angry Clash songs put together. (And let's face it, a lot more entertaining, too.)

Kern admits to his life having been changed when he first heard Iggy Pop and David Bowie in the early 70s, while Zedd believed that such music was being kept off the radio in favour of 'bullshit' like Elton John and Michael Jackson, the establishment attempting to suppress another youth culture explosion. Zedd moved from Philadelphia to New York in the hope that things would get more exciting ' . . . and Punk happened' (Sargeant 1995: 59).

Other principal players in the Cinema of Transgression have included Lydia Lunch, Casandra Stark, Beth and Scott B., Tommy Turner, Lung Leg, Tessa Hughes-Freeland and, more recently, Jeri Cain Rossi, Todd Phillips and Richard Baylor.

Perhaps Baylor is a special case. He didn't cut his cinematic teeth in New York with the rest of the Underground but, instead, has produced all of his films in Great Britain. His first exposure to Transgression came when he got in touch with Richard Kern, having found the filmmaker's address in the liner notes to the Foetus All Nude Revue 'Bedrock' 12".

Growing up in a small village in Michigan, outside of a city called Kalamazoo, Baylor admits to being so 'obsessed with the English Punk movement of the late 70s' that he joined the forces, the only way he saw able to make the transition from the United States to Britain.

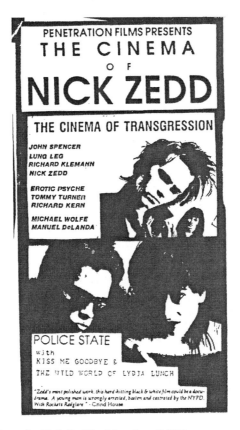

Figure 4.1 Poster advert for Nick Zedd's *Police State* (1987).

Baylor's filmography starts in 1990 with *Our Own Personal Hell*, which follows the misfortunes of a down-at-heel young man as he loses his job, his home and his girlfriend, before getting drunk and threatening to jump off a bridge. The film has no dialogue but a musical soundtrack comprising of Dissecting Table and Einstürzende Neubauten. It utilises as its central character a typical Transgressive 'no wave' anti-hero,[9] while juxtaposing the industrial landscape of the Big Apple for suburban Ipswich.

Thoughts From the White Walls (1990) was soon to follow, a sparse and experimental short focusing upon emotions of bitterness and remorse after a fatal motorcycle accident. With its juxtaposition of narrative and image, it also reveals that Baylor, following the formulaic *Our Own Personal Hell*, was keen to introduce some ideas of his own to the medium.

Dum Dum (1991) (see Figure 4.2) is the tale of a young man who, after the departure of his girlfriend, appears to lose his mind and become emotionally attached to a showroom dummy. When the girlfriend makes an unexpected

Figure 4.2 Still from *Dum Dum* (directed by Rick Baylor), with S. Mackenzie. Did the dummy pull the trigger?

return, she is horrified to find tell-tale signs of coitus between the young man and the dummy.

Good Things Happen to Those Who Love the Lord (1991) (see Figure 4.3) has a clergyman apparently stalking a couple of prostitutes around town. However, when finally he does confront the girls down a sidestreet, they pull a knife and stab him in the balls.

Dead Love (1992) concerns a woman living with an abusive partner. When she buys herself a night dress he explodes into a violent rage, and when she burns the toast he holds a lit cigarette to her arm. But the woman still loves him, and because she can't live with or without him, murders him in his sleep.

Jesus Hates You (1990/92) focuses on a nun taking holy communion, interrupting the sacrament with a succession of rapid-fire sexual and religious imagery. The music includes the sampled line: 'Bend over for Jesus'.

A pastiche of Monroe-like bubbleheadness, *My Funny Valentine* (1992) has a girl running carefree in a summer dress. A sentimental Sinatra refrain plays on the soundtrack.

Figure 4.3 Still from *Good Things Happen to Those Who Love the Lord* (directed by Rick Baylor).

Cirsium Delectus (1993), Baylor's most recent film to date, is also his most accomplished (see Figure 4.4). Loosely based on the Sunset Murders case that took place in Los Angeles in 1980 (Slater 1995: 180–242), the film opens with a young hitchhiker, Richard, being offered a ride by Carol. Shortly after arriving in a town and going their separate ways, Richard is conned out of what little money he has, is unable to find the friend who had offered him accommodation in the first place, and has to fall back on the invitation made by Carol. He turns up at her door and she gladly gives him a place to sleep. But Carol has ulterior motives, becoming frenzied when her new lodger brings a girl back to the house later that night. The following day, after he threatens to leave, Carol drugs Richard and blackmails him into staying, courtesy of some compromising photographs involving a local schoolgirl. She takes Richard to some of her favourite haunts, gets him to partake in her sex games, and eventually implicates him in the murder of a prostitute. The film ends with Carol accusing Richard of the crime and giving his description over to the police.

Figure 4.4 Still from *Cirsium Delectus* (directed by Rick Baylor).

A conversation with Richard Baylor

DK: When did you start making films, and why?

RB: I started making films in 1990. I have always been interested in films, but never really thought about making my own until I was exposed to the work of Richard Kern, Nick Zedd, Lydia Lunch and other 'Cinema of Transgression' filmmakers. What captured my interest was their approach to the media. It was very much 'punk film'. The emphasis was on the content and the expression, not on the technical skills and budgets. They were able to blend intense musical pieces with intense graphics, creating a complete mind fuck. I felt that I could film some of the ideas that I had in my own head and, with Phil Vane from Extreme Noise Terror, embarked on the first few shaky shorts.

DK: How do you decide on what pieces of music to use?

RB: To begin with I was using music by the Swans, Einstürzende Neubauten, Lydia Lunch and Jim Thirlwell, aka Foetus – of that lot, Lydia Lunch was the only artist who gave me permission. My own musical relationships were with punk bands like Extreme Noise Terror, the Annihilated and the Addicts, but their

music didn't lend itself as well to the kind of images I wanted to film. So, it was natural to turn to using music that was scored specifically for the films. I joined up with the Colchester band, Whiteslug, and London-based Dave Bourgoin – who now runs the Works In Progress label – whose sound was more 'industrial wastelands and barren beats'.

With Our *Own Personal Hell*, I formulated part of the visuals based upon Einstürzende Neubauten's 'Fiat Lux'. Although the music fit the scenes, the track wasn't written about the subject matter of the film – suicide – and so didn't work as well as I'd have liked. I realised the music must fully fit the style and theme or it just sounded like you slapped your favourite track over a bunch of images.

DK: So you don't have a specific soundtrack in mind when making a film?

RB: No, after my first film I always brought to the musicians the story or edited together some film clips for them to base the music on. I do have a rough idea of what sounds I think will compliment various scenes, but I seldom film from these – the only exceptions being when I feel a specific piece is vital, as in the seduction scene in *Dum Dum* where the two main characters are dancing in the living room to the sounds of Frank Sinatra.

DK: In many Transgressive films, the music is as important as the visuals.

RB: That's a very valid observation. To me, the film isn't finished with the editing, it continues through the music. The music propels it where the visuals don't or can't go. Looking back at some of my earlier films, I feel that the music often works better than the visuals. Also, my films then were more experimental and contained little dialogue, which emphasised the music even more.

Although I'm not interested in music videos as such, I do like to capture music events around Ipswich – hich have included gigs by Chaos UK, ENT, Red Flag 77. Filming such events has taught me to keep one eye outside of the camera, looking for a good side shot – and avoiding the quick soaking of the camera with lager! – while quickly changing the focus for the action on stage.

DK: Your main motivation in moving to Britain was the punk movement, wasn't it?

RB: Yes, and the only way I could get myself over here was to join the forces! I was sent to Ipswich in early 1984. England lived up to my expectations – I made a lot of good friends, went to a lot of good gigs and drank a hell of a lot of cider and Carlsberg. There was a thriving punk movement in Ipswich at the time and it was a fun place to be. While I was over here, I got married to a French woman, Sophie. At the end of 1985, we had to go back to the States to work until I could quit the forces. In anticipation of that day we bought two one-way tickets for Britain and we've happily lived here ever since.

DK: What was the punk scene like when you arrived?

RB: When I first came to Ipswich, there was a youth club called Muryside. Almost

every weekend, there were punk gigs organised by Geordie, the manager of the Addicts – who were one of the local bands who managed to make it big on the international scene.

DK: They were big *Clockwork Orange* fans, too.

RB: That's right – they wore the same style clothes and even talked in the nadsat language! I think it suited them quite well. Also, they were one of the first – now you have *Clockwork Orange* references from everyone, from Blur to Marilyn Manson.

It was through the Addicts I met Kayce Harding, who appears in a couple of my films. I was quite good friends with the Kid, Pete and Monkey. The band later added James Harding, another friend of mine, as a keyboard player. Later, he became the Addicts' manager, then worked as manager for the Hollywood band, the Fuzztones. While he was over in LA, James met and married Kayce. The two of them returned to Ipswich for a while and Kayce really liked the kind of films that I was making. She has a great screen presence and knows what to do in front of the camera. I think she did great and wish I could use her more, but they've since gone back to Huntington Beach.

DK: Have you been in a band yourself?

RB: Yes, a few. The first was back in the early 80s in Ipswich, called Perfect Daze. We were sort of a punk/glam/trash band influenced by everything from the Stooges to the New York Dolls to David Bowie to the Buzzcocks. We played at a lot of the punk venues around and played with the Addicts in London at the 100 Club. After I left for the two-year period back in America, the members changed to include Wolfe Retard from the Stupids and the Daze later got a record deal with Vinyl Solution. On my return to England in '88, I joined Earth Mother Fucker, which is a much more disjointed, noise-fuck band. We like to take riffs and sounds from a variety of places and then blend them into a wall of hypnotic noise. Apart from a track on a Works In Progress compilation, no one has offered us any deals . . . but then again, we have been together longer than the Beatles and still play the same eight songs!

DK: How do you think underground filmmaking in Britain differs to that of under-ground filmmaking in the US?

RB: That's a hard one to answer since I've only made films in England. I think that the mechanics of it are very similar: you scrape together some money, get together a group of people who are interested in what you're doing. The difference with working over here, I suppose, is in the distribution and screening of films. Unlike in the States where anything goes, there is a constant feeling of 'oppression' in Britain; a feeling that what you're doing is wrong and that you'll be punished accordingly.

DK: In as much as, by law, films have to be certificated over here?

RB: Yes, but even with a certificate it's difficult to show works in public places if

any of the images are considered 'extreme'. But working with film you quickly become aware of the legalities involved, and that you can't be too complacent about the penalties. It wasn't long ago when a nation-wide 'video nasty' bust ended with a Trading Standards official holding a copy of one of my tapes on television as an example of their haul!

DK: Any other problems?

RB: I have occasionally had tapes returned from countries like Germany, with 'VERBOTEN' stamped on the package in big red letters. When they arrive back in Britain, I always wonder why British Customs don't query what must be in the package for it to be forbidden in Germany!

I think my problems lie more in a sense of paranoia than in a physical capacity. If I know that my tapes are being made an example of on TV, I half expect to hear a knock on my door. I've known people who've gone to jail for selling unclassified pornographic videos – while my films are not pornographic, they may still be considered extreme in other moral areas. I have since moved all distribution of my films to Paris. It's more complicated, but it works.

DK: How close would you say you are to the New York Underground scene?

RB: I think in spirit we're fairly close. I'm commonly associated with the Cinema of Transgression, which I feel is mainly due to the fact that I'm an American, working with some of the main themes and in a similar style. But there are wide differences in approach and content within the group.

Many of the original group have fallen away. If any sort of group is left, Jerri Cain Rossi and myself are considered the new members.

DK: Zedd and Kern's most recent films are very free-form, while your own most recent work isn't. In fact, there seems a definite move away from the Transgressive influence with *Cirsium Delectus*.

RB: I enjoy a combination of both the free-form and the narrative. Free-form lends itself very well to hit-and-run visuals that can explore a multitude of topics with the blinking of an eye. Narrative, on the other hand, is more focused. *Cirsium Delectus* is about society's perception of good and evil. It plays on the assumption that a male loner is far more plausible as a killer than a female loner. It's not so much a 'me rebelling' film, but more a case of trying to invoke self-examination in the viewer. I wanted to push myself with *Cirsium Delectus* and so tried to create more elaborate situations in a narrative style – which meant giving greater detail over to the actors and actresses, scene settings, dialogue, etc.

I found that I could come up with some happy accidents in the more experimental style, but had to concentrate one hundred per cent to pull off the narrative. As an example, it was easier to have two women handcuffed, bathed in strobe lights and staring into the camera for *Good Things Happen* than

it was to orchestrate a couple of moments' worth of dialogue between the prostitute, the killer and the accused in *Cirsium Delectus*.

DK: There is also much more light and dark in the soundtrack than on your earlier films.

RB: Well, initially, I approached Rowland S. Howard from the Birthday Party and asked whether his band These Immortal Souls would be interested in working on some music. He turned the project down, but I drafted in the notorious French artist Costes to write some music and there can be no more trangressive artist than him.

DK: How have your own tastes in music changed over the years?

RB: I'm probably stuck in a rut and still listen to most of the music that I did 10 years ago, maybe 20 years ago! I know it sounds sad, but I haven't heard a lot of new music that turns me on. What new music I do listen to is only new to me and has been around for years anyway.

DK: Several of your films have a religious theme.

RB: I have a distaste for the organisation of religion . . . the mixing of religion and politics, the use of religion as a tool of oppression. And, I suppose, I even have fetishistic feelings about the rituals of Catholicism. Like, *Jesus Hates You* was a purging of feelings that I've harboured for years, based upon my own strict upbringing.

DK: Can you tell us more?

RB: I was raised in a small, typically quaint, I suppose, little farming community which had more churches than bars. My childhood was spent at Sunday school, morning worship, evening services and vacation Bible school. As I grew into my early teens, my parents became more involved with the charismatic movement. This involved faith healings, demon exorcisms and speaking in tongues. My father became a self-ordained assistant minister in a small, backwoods church, where they held big tent revivals with loud, barking reverends – and where the country band from the saloon on Saturday night would roll into the church on Sunday morning and strum along to a few religious country tunes! When I look back on my past religious experiences, I appreciate the fact that I went through it. Although I don't subscribe to the dogma, there is something about the aesthetics of the Western religions that still attracts me.

DK: Hence the theme in several of your films. Do you get much exposure in the US?

RB: Most of it has been through various film festivals, including a screening at the Seattle Modern Art Museum and some showings at the Chicago Underground Film Festival. My last featurette won Best International Short at Florida's Cineview International Film Festival, and I have *Jesus Hates You* showing at another Florida festival. I think they treat me as an expatriate extension to

the New York film style. One of my first screenings in Britain was at the Manchester Fantastic Film Festival, followed by the Scala in London, just before they closed down. My most surprising screening was at the Dutch Television and Film Academy in Amsterdam.

DK: So what's your next project?

RB: I'm in the process of applying for funding for a short called *One Of These Days*. It goes back to the non-narrative form and is based upon the compression of time. The setting is any typical Saturday in a city environment, but compresses the 24 hours into 12 minutes. There is no dialogue, apart from the ramblings of the city inhabitants. The idea is to not only show what goes on, but to open up our eyes to the variety of lifestyles that exist. We only know what we are exposed to, we have little or no knowledge about other people outside of our 'space'. The idea is to capture everything from a 16-year-old kid getting his first tattoo, to the market stall holders shouting out their goods, to the upper-middle-class couple having a dinner party with red and white wine, to the youth hostel filled with Kentucky wrappers and cans of Tennents. The point is to juxtapose the more unusual elements with the common, everyday events of the average family across the road. We've had favourable responses from some of the regional arts boards, so hopefully someone will have more money than common sense and give some to us!

DK: Are you as angry now as you were back in *Our Own Personal Hell*?

RB: I'm still as angry as I've always been, but I find that I have less time to think about it. To me, filmmaking, like any form of art, is an expression of the emotional self. Our spoken language allows us to express logic, but fails when we try to describe feelings, moods and anger. My films allow me to express myself in much the same way that the punk movement allowed a generation of youth to vent their feelings about authority and a hypocritical society. I think that's what it's about.

Notes

1 Or at least the jacket for *Suburbia*'s UK video release did.

2 Another documentary, Piers Bedford's *Punk: the Early Years*, was made in 1978. Unfortunately, however, it isn't clear whether it got any kind of distribution prior to 1997 when Screen Edge released it onto video.

3 'I think an awful lot of people who enjoy punk would really like to be back in those days when they could actually see physical people [sic] hacking each other to death,' Jonathan Guinness, heir to the Guinness fortune, speaking in *D.O.A.*

4 A men's top-shelf magazine of the day – memory doesn't extend to actual title or exact date – ran a short piece on how a new craze amongst punk rockers was for them to indulge in totally non-emotive sex; that is, during coitus neither punk partner would register any sign of pleasure or excitement.

5 *Rock Around the Clock*, *The Girl Can't Help It* in the 50s, *Gonks Go Beat* and *A Hard Day's Night* in the 60s, and *Flame* in the 70s, to name but a few.

6 'One of my accoutrements was an armband with a swastika, which was purely out of high camp and nothing else,' Siouxsie Sioux speaking in the BBC TV documentary series, *Arena* ('Punk and the Pistols'), aired 20 August, 1995.

7 '*The Underground Film Bulletin* was ultimately a massive exercise in self-promotion [for Nick Zedd]' (Hughes-Freeland and Williams 1992: 46). Issue No 1 of the *Bulletin* featured 'The Nick Zedd Story', written by Jeriko Orion, which was Zedd under a pseudonym.

8 Amy Taubin, reviewing Zedd's *They Eat Scum* for the *SoHo Weekly News* in 1979, and having difficulty in coming to grips with the film's punk nihilism, said 'The aesthetic operative here is transgression, both in terms of the narrative, and in formal film-making terms' (Sargeant 1995: 25).

9 Look for the obligatory black drain pipe trousers, boots, heavy coat and unkempt hair. Tattoos optional.

Bibliography

Hughes-Freeland, Tessa and Williams, David E. (1992) 'It's Not Dead, It Just Smells Bad' in Williams, David E. (ed.), *Film Threat Video Guide 5*.

Sargeant, Jack (1995) *Deathtripping: The Cinema of Transgression*, London: Creation Books.

Slater, David (1995) 'It's Fun To Kill People!: The Sunset Strip Murders' in Kerekes, David and Slater, David (eds), *Critical Vision: Random Essays and Tracts Concerning Sex, Religion, Death*, Manchester: Critical Vision.

Zedd, Nick (1996) *Totem of the Depraved*, California: 2.13.61.

5

'EVER GET THE FEELING YOU'VE BEEN CHEATED?'

Anarchy and control in The Great Rock 'n' Roll Swindle

David Huxley

Introduction

It is the aim of this chapter to use the film *The Great Rock 'n' Roll Swindle* to elucidate several key issues surrounding the nature of punk. The problem of what is meant by punk will be discussed in this opening section. The issues that will be dealt with are largely dictated by the film itself, and they will include the nature of authenticity in relation to punk rock, and the role of visual style in the construction of meaning within the subculture.

Punk throws up a whole series of problems in relation to even a basic definition of what it actually *is*. For some writers it is more properly punk *rock*, a music-based and music-centred phenomenon. For others, such as Dick Hebdige, it is a wider cultural or rather subcultural movement in which style is:

> . . . pregnant with significance. Its transformations go 'against nature', interrupting the process of 'normalisation'. As such, they are gestures, movements towards a speech which offends the 'silent majority', which challenges the principle of unity and cohesion, which contradicts the myth of consensus.
>
> (Hebdige 1979: 18)

Thus, 'image', in particular clothes and graphics, can be seen as the main site of punk's meaning. Even those who deal with punk *rock* as opposed to the wider phenomenon are not able to agree – in quite a major way – on what they are talking about. For Dave Laing:

In the mid-1980s, punk rock is in danger of being taken for granted . . .
its meaning is that established through the consensus of users in the
1976–8 period.

(Laing 1985: viii)

But at least one of these 'users' takes a very different position. Stewart Home,
former punk fan and musician, wrote in 1995:

. . . that it would be possible to take the position that, in fact, there was
no such thing as a PUNK band, there were only PUNK records.

(Home 1995: 15)

and also states that: ' . . . I shall argue against the notion of the [Sex] Pistols being
a 'PUNK' band at all' . . . (ibid: 10).

Although Home's argument is interesting, the fact that the Sex Pistols are widely
held to be synonymous with punk makes this a difficult position to sustain.
Although this chapter will use the film *The Great Rock 'n' Roll Swindle* as its central
focus, punk will also be treated in its wider context as a cultural and importantly
visual phenomenon.

Punk and authenticity

Before looking at the film in more detail it is useful to consider the concept of
authenticity in relation to musical forms. 'Authenticity' is an extremely complex
and elusive concept. Dictionary definitions are only partially helpful, for example:
'genuine, of legitimate or undisputed origin; trustworthy' (*Webster's Dictionary*,
Chancellor Press, 1992). This may be fairly straightforward when applied to
banknotes, but becomes more problematic, although no less significant, when
applied to cultural artefacts. Furniture, signatures and paintings (and many other
objects) all derive great monetary value from being considered 'authentic' or
'genuine'. Yet all these fields are fraught with misattributions, alterations and
outright fakes. In the field of music the position is even more vague – 'authentic'
tends to be applied to early and original versions of a particular type of music,
which is often considered to be better than later 'debased' forms. Thus 'country
blues' is considered more authentic, and therefore better, than Chicago, or
electric, blues music. Early black jazz is more authentic than white jazz bands like
the Dixieland Jazz Band, who in turn are more authentic (and better) than 'big
band' jazz. This view of authenticity assumes that there is a central 'pure' core in
any given field, which is then dissipated by a series of less authentic, and therefore
'lesser' practitioners.

Hebdige subscribes to this view in relation to jazz:

> As the music fed into mainstream popular culture during the 20s and 30s, it tended to become bowdlerized, drained of surplus eroticism, and any hint of anger . . . While swing represents the climax of this process: innocuous, generally unobtrusive, possessing a broad appeal, it was a laundered product which contained none of the subversive connotations of its original black sources.
>
> (Hebdige 1979: 46)

In a note, however, Hebdige absolves 'authentic' black swing bands (e.g., Basie, Ellington) of these charges. Of course it is true not just in jazz but in other black music forms that white acts have stolen and adapted the style, often making a great deal of money in the process in markets not available to their black counterparts. But it seems harsh to argue that the bands of Count Basie and Duke Ellington necessarily contain subversive connotations which are not there in the bands of say, Benny Goodman or Glen Miller. Part of the widespread appeal of Ellington, for example, was surely based on the fact that he did *not* appear subversive. This is just as true of other widely popular black jazz musicians such as Louis Armstrong.

Although this 'purist' view is quite common it is obviously fraught with problems, not least the fact that it tends to undervalue experimentation, change and potential progress. Even if it is claimed that authentic music is not better, but simply more 'authentic' and original, there are still problems with the very notion of authenticity itself. If what appears to be a very 'pure' form, the 'traditional folksong' is considered, these difficulties are made clear. Dave Harker's in-depth study of this field, *Fakesong*, shows a history of collection, selection, censorship and outright fakery, normally by non-practitioners, which constituted a serious 'mediation' in the art of collection: ' . . . in the very process of so doing their own assumptions, attitudes, likes and dislikes may well have significantly determined what they looked for, accepted and rejected,' (Harker 1985: xiii). Thus, the supposedly authentic folksong does not necessarily conform to any part of the dictionary definition of being 'genuine, of undisputed origin or trustworthy'. Yet music forms such as 'folk rock' are still regarded by many as an inauthentic version of a 'pure form'. When applied to a contemporary music form such as punk, authenticity is still highly relevant and used in a similar way. Thus 'inauthentic' punk is a commercialised and debased form of an original 'street' form of punk. Some of the problems with this view will be discussed later.

Youth culture films

The height of 'inauthentic' Rock 'n' Roll might well appear to be the many feature films made in an attempt to cash in on various subcultures. The history of feature films dealing with any subculture and released contemporaneously to that subculture is a largely unimpressive one. Films like *Hot Rod Girl* (1956); *Juvenile Jungle* (1958); *Beat Girl* (1960); *Beach Party* (1963) and *Hallucination Generation* (1966) are now mainly watched for their 'kitsch' or 'camp' values. Films which capture something of the spirit of a subculture are much rarer. Films like *The Wild One* (1953) or *Easy Rider* (1969) (although many would argue that these are also flawed) are outnumbered by many lesser films.

Amongst the reasons for this widespread lack of quality are the nature of both the filmmaking process and the companies that have traditionally made feature films. Much of the studio hierarchy have normally been the kind of white, middle-aged males whom the relevant subculture was likely to (or indeed designed to) offend. Their potential lack of sympathy or understanding could of course be overcome by a desire to make money.

So the possibility of large profits from the potentially huge youth market meant that filmmakers have jumped on a series of bandwagons. Unfortunately their lack of real understanding of each successive subculture has created unconvincing and often risible results. Many have deliberately set out to cash in on the 'moral panic' surrounding the subculture, and the length of time between instigating a project, and actual release of the film has also militated against even those films which attempt to be sympathetic being at all relevant. Even if somebody involved with a film has some intimate knowledge of a subculture, the collaborative nature of filmmaking and the fact that ultimate power will reside with producers and studio heads has normally meant that little of this insider knowledge makes it to the screen. Equally the fact that many of these films have been made by minor, 'poverty row' companies, has not helped their quality (the five films mentioned at the start of this section were made by AIP, Republic, Victoria Films, AIP and Trans-American respectively).

The few films which have managed to capture something of the qualities of a given subculture have often avoided a studio-based hierarchy as far as possible. *Easy Rider*, for example, was shot with a small crew on a tiny budget (by Hollywood standards) and filmed on location away from direct studio interference. The technological advances (e.g., lighter and more mobile cameras) were even more in evidence by the late 1970s. *The Great Rock 'n' Roll Swindle* was able to take advantage of this technology. It also had the added bonus of being a small-scale film away from major studio interference. The film, or at least the idea of a 'Sex Pistols film' was mooted by Malcolm McLaren as early as February 1977. A fairly detailed account

of the genesis of the film can be found in Savage's excellent *England's Dreaming* (1991), but it is worth summarising some of its main incarnations, if only to stress the chaos from which it was born.

McLaren's interest in film had been there since an early unfinished student film, *Oxford Street*. *Rock Around the Contract* was an early title for the Sex Pistols film, possibly to be written by Peter Cook. Graham Chapman and Johnny Speight then actually produced a rejected script. The most famous false start for the film involved the hiring of cult soft porn director Russ Meyer. He had a script written by a Hollywood scriptwriter, Russ Ebert, under the title *Who Killed Bambi?*, which reputedly went through seven drafts. But the cultural gap between the Hollywood maverick (though highly successful) Meyer, and McLaren and the Pistols soon led to the shelving of the project.

Julien Temple had already been involved with McLaren, directing short films and videos of the Pistols, and was now working on a documentary for him to be called *Four Stars are Born*. This, combined with ideas from earlier scripts of McLaren retelling the Pistols story from his point of view, grew into *The Great Rock 'n' Roll Swindle*. Earlier documentary footage was to be combined with specially shot material and an overall schema, McLaren's 10 'lessons', on how to perform the 'rock 'n' roll swindle'. Jon Savage points out that a key factor in Temple's favour as director of the film was that he 'could provide cameras for free' (1991: 492).

But there were serious problems in the making of a Sex Pistols film – the lack of money was put into perspective by the fact that the group were disintegrating. Johnny Rotten had left the group and refused to have anything to do with shooting new scenes. Sid Vicious also wanted to leave and only performed under duress and with the handicap of his worsening drug problem.

Bricolage and homology in the work of Jamie Reid

The importance of visual imagery to punk can be demonstrated by examining the work of Jamie Reid, who became art director for *The Great Rock 'n' Roll Swindle*.[1] Reid had met Malcolm McLaren at Croydon Art College in 1968. Their common art background meant that when McLaren asked him to work with the Sex Pistols in 1976 there was a feeling that the graphics, packaging and imagery surrounding the group could be of vital importance. Both were interested in, amongst other things, the ideas of the Situationists and Marshall McLuhan. The influence of the former on punk as a whole has been much debated. For some writers, such as Marcus and Savage, the connection is clear:

> It was largely through the SI's influence that they [McLaren and Reid] developed a taste for a new media practice – manifestos, broadsheets,

montages, pranks, disinformation – which would give form to their gut feeling that things could be moved, if not irreversibly changed.

(Savage 1991: 36)

Stewart Home is particularly vociferous in his opposition to the idea that there was any real connection. The second chapter of his *Cranked Up Really High* (1995) is subtitled 'A demonstration of the fact that there are no direct links between PUNK ROCK, the Sex Pistols and the Situationist International'. Home argues quite convincingly that there was no serious or significant sense in which punk was a product of Situationist ideas. He also points out that a key element in the supposed connection, the British *King Mob* group, was expelled from the Situationist International. But, through Reid and McLaren, Situationist ideas and slogans began to feature in punk designs. McLaren may well have just been toying with these ideas for effect, but the link is nevertheless there. Punk, for all its apparent nihilism, was born out of a very specific political situation in 1970s Britain. Even the most apparently empty of punk gestures could be arguably charged with political meaning, and some of the most famous records by the Pistols, notably 'Anarchy in the UK' and 'God Save the Queen' were obviously overt political statements. The direct Situationist influence largely came through Reid, who commented on one of the T-shirts produced:

'Demand the Impossible' was not printed by Warner Brothers, who refused to use it; it was an old Situationist slogan from 1968 and had already appeared on some Sex shirts. Paul Cook wore one to the A&M press conference in March 1977.

(Reid 1987: 95)

This does not mean, of course, that anybody looking at the T-shirt, or even Paul Cook who was wearing it, would be aware of, or even care about, its Situationist origins and meanings.

In relation to the way in which *The Great Rock 'n' Roll Swindle* is constructed as a film, it is illuminating to examine one individual image produced by Reid for the Pistols. Amongst many record covers, posters and flyers that he produced probably the most famous and controversial were the series of images Reid created for the 'God Save the Queen' single. All of them featured a conventional portrait of the Queen with various images overlaid – swastikas in her eyes, a safety pin through her mouth and so on. The portrait itself was blown up large enough to display the halftone dots of the original photograph quite clearly. This in itself has the effect of emphasising the technical nature of a fairly familiar image. In doing this it relates it to a whole series of Pop art images, particularly those of Roy Lichtenstein, which featured exaggerated benday dots, and Andy Warhol's portraits (for example of

Marilyn Monroe or the Mona Lisa). But this effect is confounded by the collaged images placed on top of it by Reid. In one of the most famous versions of this image Reid has placed 'God Save the Queen' across the Queen's eyes and 'Sex Pistols' across her mouth. Although still immediately recognisable as a photograph of the Queen, not least because of her still visible tiara and necklace, the words rob the face of its human characteristics. There is also an inherent violence in the image because the words are placed across black strips that have simply been ripped out of the photograph. The words themselves are rendered in the classic punk style of 'blackmail' type cut-up lettering. For Dick Hebdige, it is this style which is central to punk's imagery: 'Although it was often directly offensive (t-shirts covered in swear words) and threatening (terrorist guerrilla outfits) punk style was defined principally through the violence of its "cut-ups"' (1979: 106). The words 'God Save the Queen' are in four different typefaces and sizes and 'Sex Pistols' in mis-matched mis-aligned individual letters. The connotations of the blackmail type cut-up lettering are various. It implies an anonymous, criminal message, with a hint of threatened violence. Yet for all the apparent 'amateurishness' of the lettering the layout is very carefully designed (even if done at speed, as much of Reid's work for the group had to be). The same letters appear, in almost exactly the same configuration, on the cover of the 'Never Mind the Bollocks' LP and many other products from the group. It is, in effect, a highly recognisable corporate logo.

This was also not the first time that mis-matched letters had been used to create dramatic and shocking typography. In another tenuous link (through Situationism) this type of lettering has overtones of Dada. Just as constructivist graphics influenced Neville Brody's design for magazines like *New Socialist*, so Dada typography prefigures Reid's work. If work like the poster for the *Soirée du Coeur à Barbe* (July 1923) is examined, although there are obvious differences, there is also the strikingly similar use of mixed lower and upper case letters from different faces, arranged, horizontally, vertically and in curves.[2]

There is a curious irony about Reid's work which can also be applied to punk as a whole, including the film of *The Great Rock 'n' Roll Swindle*, and which is described by Hebdige (1979: 113): 'The punk subculture, then, signified chaos at every level, but this was only possible because the style itself was so thoroughly ordered'.

Hebdige solves this paradox by using the concept of homology to describe the way in which apparently random elements of a subculture fit together. Thus apparently 'lawless' subcultures (seen from the outside) actually have an internal sense of order which is perfectly visible to 'insiders'. This becomes very evident if we examine the film *The Great Rock 'n' Roll Swindle* in more detail.

The Great Rock 'n' Roll Swindle

A close analysis of the structure of the film reveals the way in which it interweaves a conventional fictional narrative with documentary and mock documentary footage, animation and the central device of Malcolm McLaren as a narrator. The role of McLaren as narrator and manipulator within the film will be related to his self-professed role as the creator and manipulator of punk itself. Finally the implications of the film for the status of punk as a viable independent subculture in relation to Dick Hebdige's concept of 'incorporation' into mainstream society will be examined. The structure of *The Great Rock 'n' Roll Swindle* is extremely complex. On first viewing it may appear to be an archetypal 'punk' product: anarchic, unstructured and virtually plotless. However, perhaps rather like some other aspects of punk itself, a closer examination of the film reveals a hidden order and system beneath its apparently chaotic surface. The film is like a mobile equivalent of a Jamie Reid collage – for all its apparent randomness and rule-breaking, the pieces are in fact carefully placed and arranged. A closer examination of the sequences in the film reveals a central narrative or 'film within a film', with Steve Jones as a detective chasing McLaren interwoven with McLaren's '10 lessons', mainly delivered directly to the camera by McLaren himself, or in voice-overs. Added to this is documentary footage of various Sex Pistols performances and other events and animated sequences.

Table 5.1 breaks the film down into 40 sequences. One of the main points of the table is to indicate the basic way in which the film is constructed from archive footage, animation and new footage which has been shot specially for the film. Inevitably some of the sequences are slightly arbitrary – the structure of film is a notoriously complex area which has been the subject of much theoretical writing.[3] Some 'sequences', such as 26, are held together by the music track played over them, even though they feature scenes intercut between two different and largely unconnected locations.

One of the striking things about the structure of the film as revealed by this analysis is the way in which archive footage stops being used after sequence 29. This gives the film the impression of almost being in two parts, with the second section virtually without Johnny Rotten, but featuring instead two of his possible 'replacements' – Ronnie Biggs and Tenpole Tudor (see Figures 5.1 and 5.2). This latter section also features the device of the 'film within a film' where Jones as the private eye watches himself on screen in Rio. During the first 20 sequences archive footage is used seven times, and this is backed up by recreations of actual events (in both live action and animation), held together by McLaren's narration. This undoubtedly gives the impression that the film may largely be a documentary despite being shot through with the punk ethos of 'cut-ups'; its meaning created

Table 5.1 Sequences identified in *The Great Rock 'n' Roll Swindle*

Sequence	1	McLaren (in full rubber face mask) with cast list overlaid. He begins to speak about his inventions, including 'punk rock'.
	2	**Lesson 1: How To Manufacture Your Group 1780: The Gordon Riots** The group are burnt in effigy during 'Anarchy in the UK'. Intercut with McLaren and Helen burning Pistols products and newspapers.
	3	1978: Kids Audition: Anyone Can Be A Sex Pistol Intercut with Helen laying out large 3-D letters to form the film's title as a succession of different singers perform the title song.
	4	**Lesson 2: Establish the Name** (Written by Helen on a torso of a naked girl). McLaren (in a bath) talks about creating a group to play in small venues, away from the press. The girl, Sue Catwoman, is turned into a punk.
Archive footage	5	Concert footage of the Pistols singing 'Anarchy in the UK' with McLaren voice-overs, including: 'Forget about music and concentrate on creating generation gaps' and 'Call all hippies boring old farts and set light to them'.
	6	Steve Jones as a private eye, in Soho, is searching for McLaren. He breaks into Glitterbest offices. **Lesson 3: How to Sell The Swindle** comes over the phone.
	7	McLaren explains to Helen that with a venal lawyer and 'a band that can't play' it is possible to make record companies bid against each other. Interviews with Dave Dee and other A&R men. McLaren sums up 'A band that can't play is better than a band that can'.
Archive footage	8	Rotten sings 'Johnny B Goode' over footage of an early Pistols performance. He breaks off: 'Oh fuck it: it's awful, I hate songs like that'.
	9	McLaren explains to Helen about signing to a record company: 'Be as obstructive as possible'. Jones, as the PI, follows them. He sees a music teacher through a window who is interviewed about giving Johnny Rotten singing lessons. **Lesson 4: Do not play, don't give the game away.**
	10	A television with 'Censored by Thames TV' on it is kicked in by a viewer when it plays a recreation of the Bill Grundy/Pistols interview.
Archive footage	11	A collage of newspaper headlines, a bus on tour, the Pistols being refused permission to perform, an interview with McLaren and Bernard Brooke Partridge, Johnny Rotten, intercut with performance footage.

continued

Table 5.1 continued

Archive footage	12	McLaren and secretary sending anti-Pistols letter to *Sounds* followed by anti-Pistols demonstration at Caerphilly.
Animation	13	'Oh You Silly Thing' is played over animation of Pistols going to airport, getting sacked, ending with till showing EMI £20,000.
	14	'Rock Around the Clock' sung by Tenpole Tudor is played over Jones as the PI going to 'Mamie' Records and being insulted by a woman – he craps on the gold disc of 'Never Mind the Bollocks'.
	15	McLaren enters the New Oldies Club where the DJ announces **Lesson 5: How to Steal as Much Money as Possible From the Record Company of Your Choice.** The Black Arabs sing 'Black Arabs Melody'. Jones is refused entry by the bouncer.
Archive footage	16	A&M signing of the Sex Pistols outside Buckingham Palace.
Animation	17	The Pistols cause chaos at the post-signing party at A&M Records.
Archive footage	18	Press interview with McLaren and Rotten about sacking by A&M.
	19	**Lesson 6: How to Become the World's Greatest Tourist Attraction** (in Queen-style voice). Pistols performing 'God Save the Queen' intercut with arrests on Thames.
	20	'Pretty Vacant' performance.
	21	McLaren talking about difficulty of hearing Pistols or buying their records.
Animation	22	Attack on Rotten outside pub.
	23	Attack on Cook on escalator. McLaren: 'I knew we'd cracked it'.
	24	Vicious sings 'Something Else'.
	25	Jones (as PI) visits Ed Berg, 'Mamie Record Boss' at the 'Cambridge Rapist Hotel'. They discuss rock 'n' roll, Jones checks out the rooms and has sex while singing 'I'm a Lonely Boy'. Cook drives him in search of McLaren.
	26	Vicious on a bike singing, 'C'mon Everybody' intercut with McLaren at Marylebone Station. McLaren announces **Lesson 7: Cultivate Hatred: It is Your Greatest Asset** and escapes by train just as Jones and Cook arrive.
	27	Sue (the Punk girl) strangles 'BJ', a rock star, on the train. McLaren and her leave the train in drag. **Lesson 8: How to diversify your business.**

Table 5.1 continued

	28	Cook finds a tape of McLaren with the dead BJ, while in the car the girl's T-shirt has **Lesson 9: Taking Civilisation to the Barbarians.**
Archive footage	29	McLaren's voice over footage of the Pistols in America; performance and interviews with fans and protestors, ending with the Pistols' final concert in San Francisco.
	30	McLaren and Sue arrive at Henley Airport. **Lesson 10: Who Killed Bambi?** is on an aeroplane's wing. McLaren holds a press conference about the Pistols' break-up and Rotten's 'collaboration'. McLaren leaves.
	31	Jones enters a Soho cinema where the attendant (Tenpole Tudor) is singing 'Who Killed Bambi'. On screen there is a mock news item on the demise of the Pistols.
	32	Jones and Cook (in the film within a film) visit Ronnie Biggs in Brazil. They discuss crime.
	33	A Martin Bormann figure encounters them as they play a record. Intercut with the cinema audience watching this 'load of rubbish'.
	34	Jones, Cook and Biggs discuss crime and music in the film, then are shown recording. Intercut with the audience. Jones as the PI has sex with Mary Millington and is interrupted by Irene Handl while Tudor continues to sing 'Who Killed Bambi'.
	35	In 'the film' Bormann is trying to write a song for Jones. 'Belsen was a Gas' is played over footage of Brazilian beaches and the group, including Biggs and 'Bormann'.
	36	Mock cinema adverts for Sex Pistols Popcorn, Rotten Burger, Anarkee-Ora, Vicious Burgers. Intercut with Jones and Millington having sex in the cinema.
	37	Vicious in Paris, mugging for the camera, buying a gun. He signs a girl's tunic 'Sid' and pushes a pie in a prostitute's face. Intercut with the cinema where Tudor sees news of Vicious's arrest on television.
	38	Vicious sings 'My Way', a rich audience is appreciative. He begins to shoot them.
	39	'Friggin in the Riggin' is played over the end titles, intercut with Jones and Millington left in the cinema. Rotten throws Matlock to an 'EMI' shark, McLaren makes Rotten walk the plank to a 'Virgin' shark. Vicious jumps overboard.
	40	Stills of news of the death of Sid Vicious.

Figure 5.1 Still from *The Great Rock 'n' Roll Swindle* (1979). Fake Johnny Rotten number one. Cartoon version by Animation City.
Source: Courtesy of BFI Stills, Posters and Designs.

through this hectic montage. Even the more extreme of McLaren's statements such as ' . . . the most successful of all was an invention of mine called the punk rock [sic]' *can* be seen as 'factual'.

This was certainly the impression that was gained by many viewers. Indeed Jon Savage records that the film was a key element in McLaren's loss of the tangled court case that marked the aftermath of the break-up of the Sex Pistols. For all punks' protestations of being different, the case was remarkably similar to many other 'rock trials' – it was about who was due whatever money remained. It is the height of irony that in the Sex Pistols' case the remaining money had largely been spent on the film itself. The film features a series of tills which clock up the money earned with each new (short-lived) record deal but, according to Jon Savage, the film cost £343,000, leaving only £30,000 in assets. Given the ongoing nature of the film's production during its many previous incarnations, and the piecemeal way in which it was shot, the real costs may have been much more.

For Savage, the case began to centre on 'who *was* the Sex Pistols, their singer or their manager?' He comments:

When the *Who Killed Bambi* script was read out in court, the judge took it as an accurate record of what went on. It was easy to present McLaren as

Figure 5.2 Still from *The Great Rock 'n' Roll Swindle* (1979). Fake Johnny Rotten
number two. Ronnie Biggs as 'lead singer' with the Sex Pistols, in Rio,
1978.
Source: Courtesy of BFI Stills, Posters and Designs.

an evil Svengali . . . of the sort that McLaren himself was attempting to portray in scenes from *The Great Rock 'n' Roll Swindle*.

<div align="right">(Savage 1991: 532)</div>

The fact remains that large elements of the film, in particular McLaren's conceit that he was in charge of events, were patently fiction. Of course it can be argued that fiction can present the 'truth' of events better than actual documentary coverage, but in this case there is much clear evidence that many of McLaren's assertions in the film are fictional.

The film also constructs its meaning by juxtaposing archive footage with recreations and voice-overs. These methods have overtones of both Eisenstein's theories of montage in films and also the 'bricolage' of symbols in the wider punk image. For Eisenstein the meanings of film were created by the juxtaposition of shots, and he was unhappy about a realistic use of sound:

> . . . every adhesion of sound to a visual piece increases its inertia as a montage piece and increases the independence of its meaning – and this will undoubtedly be to the detriment of montage . . . only a CONTRAPUNTAL USE of sound in relation to the visual montage piece will afford a new potentiality of montage development and perfection.

<div align="right">(Eisenstein 1949: 257)</div>

For all its apparent confusion, *The Great Rock 'n' Roll Swindle* is in fact constructed in quite a traditional way at the level of the shot. Its unconventionality lies at the level of its sequences and the way in which it mixes animation, documentary, recreation and fictional scenes almost seamlessly.

If sequence 5 of the film is examined in more detail it is clear how artificial even the apparently documentary sections of the film are. The performance footage of the Pistols is in black and white, and is intercut with colour footage of an excited, 'pogoing' audience of punks. The performance shots have appeared in other documentaries, in colour, without the crowd shots, so it may well be that the audience were from a completely different venue at a different time. Thus the sense of the audience excitement at the group's performance may be totally manufactured. The audience shots are further organised by animated titles labelling their dances ('The Pogo', 'The Grapple'). Finally McLaren's voice-over locates the meaning of all these shots in a context of deliberately planned rebellion they might not otherwise have had. As so often with film, what appears to be 'real' is, in fact, inherently false and manufactured.

As stated earlier this construction of a new meaning from existing elements had overtones of 'bricolage', the process by which punk images were created by joining and re-using objects such as safety pins, swastikas and bondage gear. This,

<div align="center">94</div>

in turn, is reflected in the collage work of Jamie Reid, and helps to underline the importance of visual imagery to punk. If you listen to the soundtrack album of *The Great Rock 'n' Roll Swindle*, many tracks (particularly cover versions of earlier rock numbers such as 'C'mon Everybody') do not sound particularly radical. Even the contemporary material is mainly located within a punk sensibility only by the vocal performances of Rotten or Vicious. It is only when the performances are seen in the film that the image is complete – the clothes, the hair, the *stance* of Rotten are the final and *key* elements in the construction of 'punk'.

Punk and incorporation

> My personal view on punk rock is that it's nauseating, disgusting, degrading, ghastly, sleazy, prurient, voyeuristic and generally nauseating. I think that just about covers it as far as I'm concerned. I think most of these groups would be vastly improved by sudden death. The worst of the punk rock groups I suppose currently are the Sex Pistols; they are unbelievably nauseating. They are the antithesis of humankind. I would like to see somebody dig a very, very large, exceedingly deep hole and drop the whole bloody lot down it. You know, I think the whole world would be vastly improved by their total and utter non-existence.

These words from Bernard Brooke Partridge, a member of the Greater London Council, are delivered to camera part way through *The Great Rock 'n' Roll Swindle* (see Table 5.1, Sequence 11). On one level they are hardly worthy of consideration – their vitriol and lack of understanding of anything about punk make them virtually meaningless. On the other hand, of course, along with many tabloid headlines, they illustrate that in one sense punk *worked*. Its attempt to shock and disturb were hugely (perhaps overly) successful. But there is a problem in the way that it is extremely easy to offend the British establishment, the middle classes, and an awful lot of people over 40, whatever their class or income. Almost anybody can break fashion and behavioural taboos, and when combined with songs which attack the Queen or make jokes about Belsen, they can create an effect which will have people queuing up to be offended. Dick Hebdige sees this outrage as the first stage in a consistent strategy by which subcultures are defused by mainstream society.

The next stage is incorporation, where the images associated with the subculture are re-used and made safe by society. Thus the much vilified safety-pin soon appears in designer dresses by Zandra Rhodes in what she called 'conceptual chic'.

The fact that 'not selling out' was vitally important to punks is highlighted by this quote by 'Nag' from Julie Davis's *Punk* (1977, Unpaginated) a book 'by the fans for the fans':

> In the true sense of the word, it seems that the only punks are the SEX PISTOLS. They say that they're anarchists, (as do other groups) but who else has destroyed not one but two recording contracts? The Damned . . . act as nice clean boys . . . the Clash do very little . . . the Vibrators just vibrate themselves . . . I'm not putting down the others, it's just that the system they claim to want to abolish is swallowing them up. THE SEX PISTOLS *won't* let this happen to them.

But there is a problem with the concept of 'selling out' in relation to punk. As we have seen the concept of 'authentic' punk is fraught with difficulties. Although some would argue that it was a music with 'street origins', committed to the idea that 'anyone can do it', there was at the same time no real problem with the idea of making large amounts of money. From the Sex Pistols, answers to Bill Grundy about the £40,000 they had earned ('spent it didn't we . . . down the boozer') to McLaren's boasting of the money made from record contracts in the film, there is never any embarrassment about discussing earnings and profits.

For Stewart Home, the origins of the Pistols are purely mercenary: 'Malcolm McLaren decided to manage the Sex Pistols because he thought they'd be a good advert for his shop. He wanted to sell a lot of trousers!' (Home 1995: 19). But this is part of his mission to prove that the Pistols were not a punk band, and had nothing in common with 'snotty two-chord garage no-hopers' (presumably the real 'street' punk rock).

According to Hebdige the commercialisation of a subculture is an inevitable part of its incorporation into mainstream culture. For all their protestations, each subculture, no matter how extreme, inevitably undergoes this process. Some commentators who were close to punk did not resist this phenomenon. Caroline Coon, speaking in the BBC documentary, 'Punk and the Pistols' (*Arena*, 1995) commented: 'Once the media gets in it's going to be slightly commercialised. But me personally . . . I love the commercialisation of culture'. If seen as a piece of commercialisation itself, *The Great Rock 'n' Roll Swindle* is something of a mixed bag. For all its twisting of the facts it includes (particularly in the early sections) much interesting performance and interview footage, but more importantly it gives Malcolm McLaren the opportunity to present his own view of the group and the rock industry. Whatever the shortcomings of his account it is a direct insight into the mind of a man who may not have invented punk, but was central to its development in terms of both music and fashion.

Although a conscious piece of myth-making it also touches on notions of class. It has already been established by a number of writers that punk was not 'a movement consisting of underprivileged working class white youths'. Dave Laing estimates that nearly a third of all punk rock musicians had been (mainly art) students. This of course does not definitively establish their class, particularly within the shifting

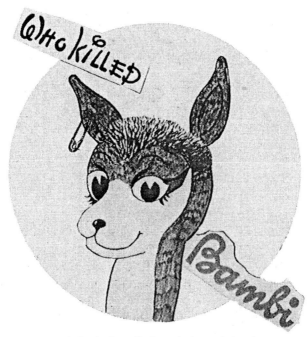

Figure 5.3 Promo artwork for 'Who Killed Bambi?', single b-side (Virgin, 1979).
Source: *Melody Maker* 7 April 1979.

class boundaries of the latter part of the twentieth century. But parts of *The Great Rock 'n' Roll Swindle* underline the working-class ambience in which punk draped itself.

In the film, one illuminating section is the arrival of Jones and Cook in Brazil to meet Ronnie Biggs, where they appear to get on a lot better with Biggs than they had with Rotten. As they discuss the petty crimes of their youth they look nothing so much like three London wide boys beginning an overview of careers. In contrast to this McLaren (and Reid with his work on design) represent an overtly 'art school' sensibility. Of course subcultures are never as homogenous as they can appear from the outside, particularly when portrayed by a hostile press. McLaren sacked the Damned from the 'Anarchy in the UK' tour because they were 'no fucking good' and Siouxsie Sioux comments in the *Arena* documentary, 'Punk and the Pistols': 'The whole idea that it was some camaraderie of a movement really appals me. I really didn't like a lot of bands around at the time.' The closer punk is examined (and this could be applied to many other subcultures) the more elusive it becomes. Subcultures are normally a fluid phenomenon, very loosely tied together and made up of people who disagree quite violently with each other.

Perhaps an accurate sense of what it was to be a punk is expressed in Lech Kowalski's film, *D.O.A.* when a young punk, Terry Sylvester, tries to explain his feelings on camera; but only succeeds in capturing the hopelessness and inarticulateness of youth that could have come from almost any other twentieth-century subculture.

> People like me don't never have friends, because we tell the truth, we don't care a shit about anything else . . . I ain't got no friends, nobody. I want friends. Don't know, it's nice to know you're different from everyone else, but it has as many down points as its good points. A lot of times I wish that I was with people and enjoying myself, but I'm enjoying myself anyway.

This process of incorporation could be said to have gone so far that there is a danger that by the 1990s punk can be seen as just another part of London's tourism industry, appearing only on glossy postcards next to the Royal Family (ironically) and various famous landmarks. In recent attempts to re-evaluate punk by cultural historians and the media in general there has still been little consensus. Those involved certainly do not agree. Julie Burchill, interviewed by Philip Hoare (1991: 14) commented:

> I hate it when old punks come up to me at parties and say 'Oh, wasn't it great, the best days of our lives!' Rubbish. And as for the politics, I gag. I find the politics more embarrassing than the music. We were so naive.

Yet in the same article Malcolm McLaren still appears to be playing the infallible Svengali of *The Great Rock 'n' Roll Swindle* when he comments that in the late 1970s: 'I was a triumphant master of chaos'.

The remaining danger of *The Great Rock 'n' Roll Swindle* is that it can be seen as a reliable documentary, rather than a carefully constructed piece of myth-making, loosely based on a few scattered facts. It is important as a document, but its significance probably resides as much in the lies that it tells as the truth that it reveals.

Notes

1 The credits of the film list Celia Barnet as 'art consultant' but Reid and McLaren's names were taken off the film after the legal wranglings which preceded its completion and release.
2 This late Dada poster is reproduced in Richter (1965: 189) along with many other examples of Dada typography.

3 A sequence can be described as possessing 'the Aristotelian unities of duration, locale and "action", and that it is marked at each end by some standardised punctuation'. Some of the attendant problems are identified in Staiger and Thompson.

Bibliography

Davis, Julie (ed.) (1977) *Punk*, Davison Publishing.

Eisenstein, Sergei (1949) *Film Forum*, New York: Harcourt Brace.

Harker, Dave (1985) *Fakesong: The Manufacture of British 'Folksong'*, Milton Keynes: Open University Press.

Hebdige, Dick (1979) *Subculture: The Meaning of Style*, London: Routledge.

Hoare, Phillip (1991) 'Anarchy in the UK? Forget it', the *Independent*, 28 May.

Home, Stewart (1995) *Cranked up Really High: An Inside Account of Punk Rock*, Hove: CodeX.

Laing, Dave (1985) *One Chord Wonders: Power and Meaning in Punk Rock*, Milton Keynes: Open University Press.

Reid, Jamie (1987) *Up They Rise: The Incomplete Works of Jamie Reid*, London: Faber & Faber.

Richter, Hans (1965) *Dada: Art and Anti-Art*, London: Thames & Hudson.

Savage, Jon (1991) *England's Dreaming: Sex Pistols and Punk Rock*, London: Faber & Faber.

Staiger, J. and Thompson, C. (1985) *The Classical Hollywood Cinema*, New York: Columbia University Press.

6

'I LIKE HATE AND I HATE EVERYTHING ELSE'

the influence of punk on comics

Guy Lawley

Introduction

January 1978: the Sex Pistols have given their last ever performance, in San Francisco, and split up. Steve Jones and Paul Cook are off to Rio with Malcolm McLaren, to muck about with Ronnie Biggs. John Lydon has arrived safely in a blizzard-stricken New York. Sid Vicious, travelling separately, has OD'd on methadone and valium on the plane, and is stranded in a hospital outside the city. Snowed in and abandoned, Sid speaks on the phone to photographer Roberta Bayley. 'What I really want', he tells her, 'is a very, very large pile of Marvel comics.'[1]

The best-known addictive personality in punk wasn't the only one who craved the four-colour fight-fantasies which John Cooper Clarke called 'rich with the gaudy iconography of physical pain'. Many punks loved the 'low culture' medium of comics, and not only Marvels and other US products; in the UK *2000AD* and *The Beano* were also habits of choice. Comics, with their crude vitality and immediacy of communication, but forever excluded from the mainstream of cultural life, seemed to provide an ideal medium for the expression of punk ideas. But did the comics reciprocate their punk readers' passion?

In searching for punk influences in comics, a number of difficulties present themselves. How do we define 'punk influences'? In a graphic medium like comics, do we confine ourselves to those which share a certain drawing style, and if so, what are its defining parameters? Or is it a question of subject matter: punk characters, gigs and bands? Are thematic concerns more important: the rejection of hippy values, the politics of Anarchy, an anti-authoritarian thrust, or the nihilistic rallying cry of 'No Future'? Can we identify a defining punk attitude, and

is it constituted from the above concerns or from a more general desire to shock, offend or subvert? Some comics creators had early punky work published during the late 70s, but are better known for later material which doesn't show its roots very openly. Finally, since punk influenced many a young mind in the late 70s and at all times since, we might seek out later flowerings of punk-tinged sensibilities which may not resemble the earlier varieties very closely. In practice, of course, the answer is 'all of the above' and my own subjective bias, as well as the huge scope of the field, may lead to errors of omission and commission. In particular, I will concentrate on the UK and the USA, as I am aware of only a few isolated European (and no Japanese or other) examples.[2]

Never trust a hippy

Another problem is the legacy of the Underground comics of the 60s. Despite punk's 'year zero' pretensions, it has more similarities with its declared enemy hippy than are sometimes acknowledged. Both encouraged the expression of individual identity in a conformist culture, questioning of authority, and mistrust of the established political process. The 60s rhetoric of 'The Revolution' and punk's rallying call of 'Anarchy' are not so far apart. Hippy hedonism, expressed in the slogan 'Sex'n'drugs'n'rock'n'roll', can be seen in punk too. Altamont and the Manson Family clearly show that the 60s counterculture led in some very dark directions long before 1977's Summer Of Hate. The original underground comics of 1967 onwards played a large part, alongside the music, in expressing and communicating the essence of hippy to a wider world. They included the violent, darkly sexual strips of Greg Irons, S. Clay Wilson, Rory Hayes and Robert Crumb, which many punk creators admired.[3] During the 70s and 80s, some underground creators absorbed punky influences, e.g. Robert Crumb, Robert Williams and Spain Rodriguez. But plenty of influence went the other way, so that later cartoonists who seem to be quintessentially punk may have some or all their roots in the underground.

Another 60s crossover is the European Situationist style, using pictures or whole pages reprinted or traced from straight comics, but detourned by the re-writing of the word balloons. Many British and US underground papers, well into the 70s, took up this simple and graphically exciting way of getting across oppositional political messages (Davidson 1982: 44, 70–73, 82, 94, 151, etc.). It informed the punk graphics of Jamie Reid and some fanzine creators, and has been used by a number of post-punk artists ever since (though it isn't widespread); post-'76 it may be impossible to tell whether the idea came from a 60s original, a punk version, or even arose spontaneously. Certainly punk gave the notion a fresh currency in the late 70s and is probably responsible for most subsequent usage,

but attention must be paid to dates: e.g., the BIFF team, who only came to prominence after 1976, had been doing similar material for some years beforehand.[4]

In the mainstream (mainly superhero) field of 1978, Sid Vicious's favourite American comics were, ironically enough, still crawling with hippy ideology. Since the late 60s, following the lead of Marvel's Stan Lee and influenced by the undergrounds, writers had increasingly incorporated hippy characteristics and civil rights/protest movement rhetoric into their superhero stories. In Europe, the protests of 1968 propelled previously underground themes and subject matter into a new mainstream of adult comics led by France's *Metal Hurlant* (with not a superhero in sight). At Marvel, Steve Englehart's *Captain America* (1972–75) and *Doctor Strange* (1973–76), and Steve Gerber's *Howard the Duck* (1975–78), brought sex'n'drugs'n'rock'n'roll and political/social satire into the four-colour mainstream. Admittedly this phase had burned out by 1978. Conservative forces rallied in the editorial offices and an era came, for the time being, to an end.

Blondie shows her roots

In some important ways, the origins of punk itself are closely linked to the comics medium. By the winter of 1975–76, the new music coming out of New York's CBGBs club (Ramones, Television, Blondie, Patti Smith etc.) was generating an intense local buzz, but little wider acclaim. People were calling it things like 'street rock', until *Punk* magazine (see Figure 6.1) appeared in December of 1975 to give the scene a catchy name and (the appearance of) a unified identity. Editor and cartoonist John Holmstrom had studied at the New York School of Visual Arts, where he'd taken Harvey (*Mad* magazine) Kurtzman's comics classes, and been impressed when Kurtzman brought in copies of France's *Metal Hurlant* and *Charlie Hebdo*. Underground stalwart Bill (*Zippy*) Griffith also influenced Holmstrom to publish his own comic, but Ged Dunn Jnr. (*Punk*'s publisher) was more inclined to start a review magazine.[5] *Punk* magazine was the result: less of a compromise between their two visions, more a unique hybrid that was to influence hugely much that followed. Early names like 'The Electronic Comic' and 'Teenage News' (after a New York Dolls song) were discarded when their friend Legs McNeil suggested *Punk*. Holmstrom enthusiastically adopted the name; it had been attached to garage bands of the 1960s, especially by *Creem* magazine, and had a lineage including Shakespeare, gangster movie and prison slang. It hadn't been widely used on the new NY scene; when posters advertising the new magazine went up proclaiming '*Punk* is coming!' many assumed it was a new band (see McNeil and McCain 1996: 249–60; Savage 1991: 130–33.)

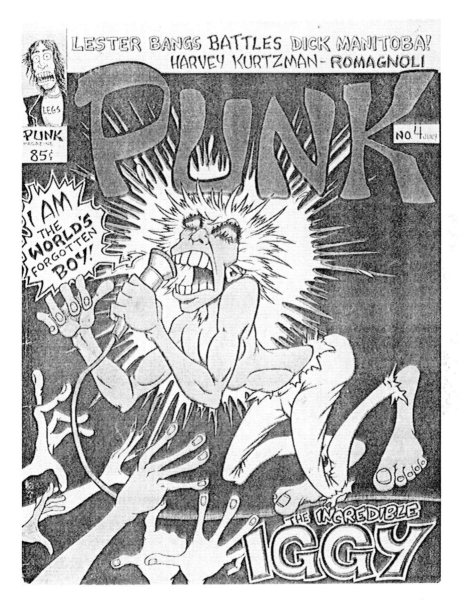

Figure 6.1 Cover to *Punk* magazine. The magazine that gave the scene its name was also big on comic strips and cartoon art, largely thanks to editor/cartoonist John Holmstrom, who drew this Iggy Pop cover for no. 4.
Source: © John Holmstrom.

Holmstrom was a fan of the Stooges, the Ramones and the Dictators; *Punk's* promotion of the new NYC bands played a vital part in securing record deals and wider exposure. The big story for *Punk's* first issue was an interview with Lou Reed, which Holmstrom wrote up partly in hand-lettered text and partly as a cartoon strip, with some photos. Comic strips, drawn by Holmstrom, Batton Lash, Ken Weiner and others (or in photo-fumetti format) and similar cover drawings of Reed, Iggy Pop, the Pistols, the Clash etc. remained a strong part of *Punk's* look to the end (no. 17, 1979) (Holmstrom 1996). Underground giant Robert Crumb appeared a few times, Harvey Kurtzman was interviewed by Holmstrom, and Lou Reed and Dee Dee Ramone mentioned their liking for comics in interviews. The Ramones are often cited as presenting a 'cartoon' version both of street culture and American dumbness; the name Blondie itself comes from a perennially successful newspaper strip.

Punk quickly boomed from 2,000 copies to 10,000, and netted a publication deal with Tom Forcade of *High Times*.[6] Later keepers of the punk and post-punk flame like *Real Fun*, *Forced Exposure* and *Chemical Imbalance* in the 80s also maintained a mix of music and comics.

Imported by Rough Trade, more copies of *Punk* were sold in London than New York at one point, and the magazine undoubtedly influenced punk fanzine styles in both the UK and the US. Holmstrom-esque comics of varying quality are a common feature of the zines, to be found even in more intellectual examples like *Scumbag* (a UK zine which concentrated on punk poetry) (see also Vague 1994: 10–13, 34, 41). A fine UK example by an unknown artist, reprinted from a 1977 fanzine called *Skum*, graces the cover of one early Sex Pistols bootleg LP. The strip is a history of the band; its crude, amateurish drawings are typical fan product, but the caricatures are serviceable and the strip has undeniable verve. The fortuitous match of style to subject matter seems more than appropriate both for the rough-and-ready bootleg quality of the disc and the very essence of punk itself.

You're so savage

The same thing might have occurred to the editor of *Sounds*, the first British music weekly to embrace punk wholeheartedly. *Rock 'n' Roll Zoo*, a strip by then-unknown Savage Pencil (a.k.a. music journalist Edwin Pouncey) first appeared in *Sounds* in February 1977 (see Figure 6.2; Pencil 1992). Pouncey, while a fan of much punk music (especially US varieties), was even more cynical about the music business, especially the marketing and hype associated with punk, than his New York contemporaries. His animal characters, closely observed caricatures of bands, fans, record company execs etc., had their roots in his self-published comics of 1973–74 and British children's comic illustrators like Leo Baxendale and Ken Reid.

Figure 6.2 Savage Pencil's *Rock 'n' Roll Zoo* (1977). Though his images remain iconic for many, Edwin 'Savage Pencil' Pouncey was sharply critical of the punk scene in his 1977 *Sounds* strips.

Source: from *Sounds*, © Savage Pencil.

Pouncey eschewed slick technique, using a 'ratty' line which was soon to become the defining feature of a whole school of punk cartooning. He has illustrated record sleeves for the Lurkers, Sonic Youth and others, and played in punk and noise groups like the Art Attacks and Pestrepeller. In the *NME*, Ray Lowry's cartoons also took on punk subject matter, especially influenced by his liking for the Clash (Lowry 1980 and Green 1997).

Other notable strips followed Pouncey in *Sounds*, including Alan Moore's first nationally published work, under the punning punkish pseudonym Curt Vile. Moore was heavily into punk music at the time, though his background was in the underground press and the Arts Lab scene, and he never sacrificed his trademark beard and long hair to the punk style. Brendan McCarthy was at Chelsea School Of Art when some of the earliest Pistols gigs were played there. His self-published comics of the period show the punk influence clearly, e.g. John Lydon as Number Two in his warped version of *The Prisoner*. The extraordinary *Electric Hoax* in *Sounds*, started by McCarthy on script and art, joined later by scripter Peter Milligan, also featured Lydon and 'Vicious Sidney'. Milligan and McCarthy went on to the pages of *2000AD*, their own punk-attitude *Strange Days* comic and DC's Vertigo line in years to come. As with many artists and writers who used the energy of punk, these two had other strong influences in their creative mix, including Dada, Surrealism and Skinhead. Their 1992 graphic novel *Skin* (the hard, economically told story of a thalidomide skinhead and his revenge on the establishment) is arguably a punk comic in everything except subject matter.

the guardians of the ratty line

Around 1979, Edwin Pouncey met kindred souls drawing comics in a 'ratty line' style in Los Angeles; Gary Panter and Matt Groening also had links with LA's punk scene. In 1977 Groening worked in a pioneering punk record shop soaking up influences, including fanzines like *Search & Destroy*, *Flipside* and *Slash*; he must have been exposed to *Punk* magazine too. Panter's early *Jimbo* strips appeared in *Slash* in 1978. Jimbo is a spiky-haired youth in a tattered vest, equally at home (or equally alienated, more to the point) in hellish punk-ridden LA alleyways and futuristic or prehistoric dreamscapes. Groening's seminal *Life in Hell* humour strip, formerly self-published, started in 1980 in alternative newspaper the *L.A. Reader*. Groening/Panter collaborations for punk fanzines, under pseudonyms The Fuk Boys and The Shit Generation, are incredibly crudely drawn, violent and scatalogical. They could well have been the work of 14-year-old punks off their heads on solvents (evidently the effect the artists were after).[7] Both Groening and Panter progressed to book collections and ongoing cartooning careers, and considerable success in TV, Groening with *The Simpsons* and Panter designing *Pee Wee's Playhouse*.

Panter is still thought of as a punk artist, a label he doesn't reject, though he wouldn't use the word punk himself. He has agreed that his drawings have 'tried to embrace all the smudges and mistakes. That's analogous to punk' (Panter 1985: 221–22). It was almost certainly Panter who came up with the term 'ratty line' (a 1979 *Jimbo* strip bears the dedication 'To the Guardians of the Ratty Line', listing Pouncey, Groening, Jay Condom and others). Robert Williams, one of the original underground artists, who considers himself influenced by 'Nu-Wave Punk comix', calls Panter 'the father of punk art' (Williams 1988). Groening's punk roots are generally forgotten, not surprisingly when *Life in Hell* and *The Simpsons* lack any identifiable punk subject matter. Only themes and attitude (including a desire to subvert while entertaining) (Groening 1991) link his commercial work back to punk (though his style can be seen as having a Holmstrom/Weiner influence). Still, when his Simpsons spin-off comics were successful, Groening also gave Panter his own *Jimbo* comic (1995). Punk chickens came home to roost . . . and Panter's characters spent several pages cutting their heads off.

Parallels between punk music, with its up-from-the-streets, back-to-basics, anyone-can-do-it attitude and these energetic, primitive drawing styles are easy to make, but we should remember that Holmstrom, Panter, Groening and Pouncey had all been to art school, as well as reading a variety of comic strips for years. The ratty line echoes the naive drawings of children, the look of African and Polynesian art so beloved of Picasso and Matisse, and the cave paintings of Lascaux etc. In the cartooning media, we can also find primitive stylists like Thurber and Schulz to add to Kurtzman, Baxendale and many others who influenced the punk generation. Just as the various strands that made up punk music did not come out of nowhere, so the comics styles which accompanied it had their own rich lineage.

Up from the Underground

Despite a shrinking market in the late 70s, Berkeley publisher, Last Gasp, was still managing to bring out an occasional issue of the seminal underground comic *Zap*. In 1978 they launched another infrequent title, *Anarchy Comics*. Editor Jay Kinney clearly hoped to pick up a share of the punk market with this very political comic. His Situationist-flavoured strip in issue 1 is either post-1967, post-1976 or a bit of both. Panter gets into 3, and the front covers of 2 and 3 feature archetypal punk characters.[8] In Kinney and Paul Mavrides's *Kultur Dokuments* in no.2, 1979, the clean-cut *Archie Comics* crew are punked-up as 'Anarchie' and friends. Many of the strips, despite an international variety and vitality, had no actual punk connections, though the comic probably broadened the mind of many a young punk reader.

Both the the ratty line crew and *Anarchy* have far more direct links with punk than *Raw*, launched in Autumn 1980, which is often thought of as a punky

magazine. *Raw*'s stated aim was to present comics as art, and New York was its milieu. Certainly the art world there was no stranger to punk influences, but *Raw*'s editors, Art Spiegelman and Francoise Mouly, seemed keen to avoid the dreaded P-word. In 1975–76 Spiegelman had co-edited the revered underground anthology *Arcade* with Bill Griffith, but he came to see the undergrounds in general as too obsessed with adolescent concerns – 'sex, violence, drugs, cheap thrills, shit jokes, whatever'(Spiegelman 1981: 102) – and a desire to shock that was well past its sell-by date. They were failing to advance the comics medium to its potential heights as an artform; how much more debased the New York punk comics must have seemed to his refined taste. Spiegelman also fell out early on with Holmstrom, over Ramones and Dictators songs which Spiegelman saw as glorifying Nazism. *Raw* published underground comics artists, and younger Americans like Charles Burns and Gary Panter, alongside numerous European creators. Few of its contributors, Panter aside, had much to do with punk. Spiegelman was, however, editorial consultant on Mark Newgarden and Paul Karasik's more punky *Bad News* (1984), featuring strips by Kaz and others.

Cars and Girls

In late 1980 John Holmstrom, with another young dropout from the School Of Visual Arts called Peter Bagge, started *Comical Funnies*, a broadsheet newsprint comic. The Ramones appeared on Holmstrom's cover for no.1. Unlike *Punk* magazine, it was nearly all humorous, cartoony comics, mostly dropping the interviews, articles and reviews. Its 3-issue run saw strips by Holmstrom, Bagge, Ken Weiner, Kaz, J.D. King and others developing the comics style of *Punk* in new directions; less specifically to do with punks, more with cars, girls, beer and vomit in a wider sphere. Peter Bagge introduced enduring characters like suburbanites-from-Hell the Bradley family, and also gave a positive review to a new comic from England called *Viz*.

Stop! magazine followed, published by Holmstrom and edited by J.D. King. Its 9-issue run again mixed comic strips by King, Bagge, Kaz, Weiner and Bruce Carleton with interviews, reviews and articles. S. Clay Wilson and Bill Griffith were interviewed, lest further evidence is needed of the underground/punk crossover.

2000AD and beyond

Another comic which has been linked to punk made its debut in 1977 in Britain. *2000AD* (featuring Judge Dredd) was a children's science fiction comic, a huge

success in the post-*Star Wars* market, also with a big adult and student readership. It followed directly from a comic called *Action*, a previous hit for writer/editor Pat Mills, launched in February 1976. Since kids couldn't see X-rated (today's 18 Certificate) films, *Action* offered cut-price, accessible, very violent versions of *Jaws*, *Dirty Harry*, *Death Race 2000* etc. It was also committed to a street-tough anti-authoritarianism; this political aspect, as much as the blood and guts, caused widespread controversy and the comic was closed down (see Barker 1990: 8–10). *2000AD* applied the *Action* formulae, but in a futuristic setting, e.g., Judge Dredd was a Dirty Harry for the twenty-second century. Concerned parents and the media all but ignored it, because it seemed like harmless fantasy. In fact, strips like *Judge Dredd*, and later *ABC Warriors* and *Nemesis the Warlock*, were able to question the authority of police, army, state and church on a regular weekly basis.

Neither comic was actually influenced by punk, though they could be said to have much of the same attitude. They grew in the same soil as punk – the cynical 70s, the hippy dream in tatters, unemployment rampant. Violence was popular on the streets, in the cinema and in books like Richard Allen's *Skinhead*. *2000AD*'s notable early writers (Mills, Alan Grant and John Wagner) had forged their politics and their styles in the late 60s and early 70s. It's hardly surprising that they ended up in a subversive creative space not a million miles from Malcolm McLaren, that punk readers loved their comic and that *2000AD* later gave a home to younger creators who really were punk-influenced (e.g. Grant Morrison and Brendan McCarthy).[9] However, Judge Dredd's short-lived punk sidekick Spikes Harvey Rotten aside, direct engagement with late 70s punk subject matter is virtually absent from *2000AD* altogether.[10] The comic did however influence strongly the 1981 film *Mad Max 2* (*Road Warrior* in the USA), which also derived style and fashion from punk and Heavy Metal. *Mad Max 2* was a huge hit which fed back a punky look into many areas of the culture, including US superhero comics themselves.

1978–80's 5 issues of *Near Myths*, an independent Scottish underground/science-fiction synthesis, included the first published work of Scottish writer Grant Morrison. None of Morrison's work concerns itself much with overtly punk subject matter. Like Milligan and McCarthy he has an awesome array of other influences in his arsenal, and also moved on to *2000AD* and DC Comics, where he has consistently been one of the best comics scripters published in the mainstream. However, Morrison has stated that punk's impact on him in 1976, at the age of 16, was 'Total. Complete. I was just utterly transformed by it' (Morrison 1995: 55). He told the same interviewer that he hoped his new comic *The Invisibles*, about a group of psychic-powered anarchists, would have the same impact as 'Anarchy in the UK', and that 'pop music has abdicated its responsibility to talk about that kind of stuff' (ibid.: 81).

Here comes the New Wave

In 1978 US Underground comics columnist Clay Geerdes announced in the English *Graphixus 1* (an alternative comics magazine) that there was an emerging US New Wave of post-underground cartoonists breaking new ground. In issue 2, punky young English artist Andy Johnson (a.k.a. Andy Dog) lambasted the new US material as the 'same old drivel'. In 1977 Johnson had written an article in a fanzine, *Kidz Stuff*, called 'Brave New Wave' and he accused Geerdes of stealing the term, as applied to comics, from him. Geerdes did not see fit to answer back; the term had almost certainly been co-opted independently in the US.[11]

The US and Canada saw a boom in self-published comics from 1980 onwards, many in the photocopied mini-comics format (photocopied pages cut in half by hand, sometimes two or three times, to produce progressively smaller page sizes). It was in this area that the term New Wave, derived from French cinema and attached to the more commercial punk era music from its early days, stuck to comics. By 1982, comics historian Jay Kennedy was using the term Newave, rather than New Wave, so as to distinguish these comics from any musical phenomenon (Kennedy 1982). Some American 'newavers' were heavily punk-influenced, e.g. Matt Feazell whose stick-figure mini-comics like *Cynicalman* (1982) were very influential in their own right. 'I want to do to comics what the Clash, the Ramones and the Sex Pistols did to rock music', he said in 1985, 'Newave comics are one of the few examples of anarchy in real life' (Feazell 1985). Kennedy and Geerdes continued to see the Newave as a continuation of the underground. In 1985, leading US critical magazine *The Comics Journal* produced a massive alphabetical listing under the title The Newave Comics Survey (issues 96–102). This acknowledged punk or new wave music as just one amongst many influences on a widely disparate group of creators; the term 'newave' itself was already thought to be on the way out, being replaced by 'alternative' or 'small press'.

UKBD

The self-publishing boom struck the UK as well. Pioneers of this time included John Bagnall (who was strongly influenced by punk, and continues to produce music zines to the present day), Eddie Campbell and Phil Elliott. Elliott played in a band doing Pistols covers, and sees definite links between the Do-It-Yourself attitude of punk and the rise of the DIY or 'small press' comic (personal communication 1997). A similar DIY approach had produced the Underground comics, but post-punk there was a greater acceptance of the basic, even primitive, level of ability so long as it had something worthwhile to say. Despite this evident

link, many prominent creators had no direct punk influences themselves. There was some crossover with punk fanzines, but obvious punk subject matter in DIY comics was in a minority, even in the work of Elliott himself (Phil Laskey's comics like *Nerk* were notable exceptions). The 'punk style' of Panter *et al.* was largely avoided too, in favour of European 'clear line' influence and fun with Letratone dots. However, the small press comics did share with Punk a desire to reflect the real lives of their creators and their readers, rather than the overblown fantasies of the superhero mainstream; this is directly analogous to punk's assault on the pompous post-hippy subject matter of prog rock, the fantasy romance of glam and the facile superficiality of disco.

One other factor probably fuelled the small press boom more than punk: the photocopier, increasingly available in offices, libraries and high street shops after 1980. The small press equivalent of punk fanzine *Sniffin' Glue*'s famous rallying call, 'This is a chord. This is another. This is a third. *Now form a band*' would be, 'This is a felt tip pen. This is a piece of paper. This a photocopier. *Now start a comic*'. Paying a printer to produce a comic or zine usually meant printing hundreds of copies which weren't going to sell, as printers would only take on larger print runs. Photocopiers meant you could print as few as you needed, then give them away or sell a limited print run to break even or make a modest profit.

Networks emerging from selling copies on the street, at comic marts and market stalls and by mail order consolidated around two centres in London and the South. From 1980, Fast Fiction was both a distribution service and a small press anthology comic of the same name (edited by Elliott, then by Ed Pinsent from 1984 to its demise in 1990). Secondly, *Escape* magazine was started by Paul Gravett and Peter Stanbury in 1983. *Escape* liked *Raw*, sharing its respect for the undergrounds, classics of the past like *Krazy Kat*, and European comics, but was also proudly British, running strips by Elliott, Campbell, Pinsent, Bagnall and others. It didn't much like the New Wave tag,[12] preferring its own label 'UKBD' (after the French BD for Bandes Dessinées (comic strips)). *Escape* 6 (1985) is the punkiest issue, with an Andy Johnson cover, and strips by Savage Pencil and Phil Laskey.

Escape also published graphic novels, including *Violent Cases* (1987, with co-publisher Titan), written by Neil Gaiman. Gaiman was 15 in 1976, played in a punk band, and states that 'The DIY attitude of punk has certainly informed all of my career, including comics. Without punk I probably would have gone through with my original plans to become a comparative theologian while dreaming wistfully of becoming a writer' (personal communication 1997). His later work for DC/Vertigo included the hugely successful *Sandman* (1989–96), whose lead character and his sister Death resemble punks (though they are usually thought of as Goth-like figures). That aside, Gaiman's work, as with others we have seen, doesn't wear its punk influences near the surface.

Fart, willy, shit, etc.

The only big commercial success to emerge from the UK small press was outside the Fast Fiction network: Newcastle's *Viz*, started in 1979 by teenagers Chris and Simon Donald. They initially intended to do a punk fanzine, but were advised by local punk personality Arthur Comics to do humour strips instead. Their winning formula was a close copy of a bland UK children's comic like *The Beano*, plus scatological jokes (Johnny Fartpants), swearing (Roger Mellie, The Man On The Telly) and lots of violence (Skinheed). By this time the UK punk scene was becoming in large part a beer-monster hooligan nightmare, with many record releases relying on a novelty humour/pub knees-up aspect. *Viz* strips appeared in serious punk zine *Vague*, but *Viz* suited the mood of the times in a much wider sense, and went from photocopied local success to runaway nationwide best-seller. It sold about a million copies (every two months) at its peak, and spawned a slew of imitators.

Love in the time of rockets

In the USA, independent publishers took up many self-published comics, including the acclaimed and highly successful *Love & Rockets*. Brothers Jaime and Gilbert Hernandez, of Mexican immigrant stock, were immersed in the records of the Pistols and the Clash, and the live bands of the Los Angeles punk scene: X, The Germs and Black Flag. They drew flyers for punk clubs, as well as their own comic strips, influenced by a wide variety of artists including Robert Crumb, and Dan DeCarlo of Archie comics (Hernandez and Hernandez 1989; 1995). From 1979–81 they produced the pages which ended up in the self-published *Love and Rockets* 1. Local publisher of *The Comics Journal*, Fantagraphics, published it from 1982 to the final issue in 1996.

Jaime's strips show the punk influence most directly, with his characters Maggie and Hopey in the LA barrio and beyond (see Figures 7.3 and 7.4, pages 132 and 137). Street gangs and punk bands are their milieu, as the strip's original science fiction trappings are forgotten, and stories concentrate on the personal lives of the two girls and their friends. *Love & Rockets* was the first comic to bring genuinely punk subject matter before a wide audience, both in the US and the UK (as opposed to the successful *Punk* magazine, which for all its strip contents was not widely embraced by the comics fan community, and the relatively narrow exposure of *Jimbo* and *Comical Funnies*).

1986 and all that

1982 saw the launch of the UK anthology magazine *Warrior*, a valiant independent attempt to take the success of *2000AD* forward into more adult fantasy and science fiction. Here, Alan Moore and David Lloyd's anarchist *V for Vendetta* used a graffitti 'V' in a circle which echoed closely the punks' favourite 'A' for Anarchy, perceived at the time as an obvious punk link. It appears that this is spurious, however; Moore recalls its origins in Zorro's famous 'Z' and artist Lloyd says he had no knowledge of the 'A' symbol while drawing the strip.

Moore's iconoclastic revision of the superhero comic form in Warrior's *Marvelman*, and DC's *Swamp Thing* (1984) and *Watchmen* (1986), went on to be a major reviving force in US mainstream comics. As with *2000AD*, his dark, subversive approach had much in common with the punk attitude. Frank Miller used a similar mode for his mega-successful 1986 Batman series *The Dark Knight Returns*, in which a gang of mutant punks terrorises Gotham City, only to be subverted as a force for social change by a newly politicised caped crusader. Again, Miller's anarcho-libertarian take on Batman may have had little direct punk input, but certainly reflected a post-punk mood.

The influence of *Love & Rockets* was clearly seen in Jamie Hewlett and Philip Bond's 1987 fanzine *Atom Tan*, and then *Deadline* magazine (1988–95). They were also influenced by Brendan McCarthy and his former collaborator Brett Ewins. The tough, mohican-haired Tank Girl, Hewlett's most enduring creation (with writer Alan Martin), shows definite punk influence and attitude. *Deadline*, mixing post-punk and dance music with comics, was originally the brainchild of *2000AD* artists Brett Ewins and Steve Dillon. Peter Milligan and Ewins's Johnny Nemo, *Deadline*'s amphetamine-fuelled private eye of the future, also mohicanned, radiated punk-ness. Frank Wynne, editor from 1993–95, brought in many small pressers, and punky artists like Savage Pencil and Andy Roberts. *Deadline* also reprinted *Love and Rockets* strips.

I like Hate

While still a contributor to *Stop!*, Peter Bagge took over as editor of *Weirdo* magazine from Robert Crumb in 1984. Crumb was a major driving force in the original underground comics, and highly influential on creators like Holmstrom, Bagge, Alan Moore, the Hernandez brothers, and virtually everyone in the small press. Following the demise of *Arcade*, *Weirdo* was Crumb's own vehicle for developing a new underground vision, 'inspired by the punk movement. Different from the old "psychedelic" craziness. I was attracted by punk graphics, even the

records and music. With punk, this whole thing of being politically correct, of being beautiful or anything; this was all challenged' (Crumb 1986: 68). Crumb started by publishing his own controversial strips and photo-fumettis, and punk material by J.D. King, Bagge and Dave Geary. From issue 10 Bagge also used work by Savage Pencil, Kaz, King, his own *Martini Baton* (written by NYC fine artist David Carrino) and many others both known and unknown. Later issues edited by Crumb's wife, Aline Kominsky, continued *Weirdo*'s provocative, uncompromising stance until its demise in 1993.

Bagge also had his own magazine of humour strips, *Neat Stuff* (Fantagraphics, 1985–89), but his most successful project was *Hate* (1990 onwards, see Figure 6.3). Here problem teenager Buddy Bradley, from *Comical Funnies* and *Neat Stuff*, grew up and relocated from New Jersey to Seattle (where both Bagge and Fantagraphics then resided). One of its promotional lines was 'I like *Hate* and I hate everything else'. The name originated in Bagge's perception that the post-punk generation defined itself more by what it hated than by what it liked. Buddy, living amongst post-Nirvana rock losers and Seattle slackers, has been seen as epitomising the 'grunge' generation. Bagge's New York punk sensibility lends an ironic detachment to his observations of the Seattle scene, with what he calls its 'mere after-shock' of late 70s punk. *Hate* has been one of Fantagraphics' biggest successes and was optioned by MTV for an animated series.

Anarchy in the UK (again)

The small press has become a flourishing international network in the 90s, going far beyond its Underground, punk and Newave roots. Distributors like Britain's Slab-O-Concrete are getting increasingly involved in small-scale publishing. The mini-comic fad, mainly part of the US scene, also spread back to Britain in the later 80s. Here the well-known *Tom Anarchy* (1989), for example, retains a punk influence. The 1994 'Anarchy in the UK' festival was accompanied by a Slab-O-Concrete comic book, including a situationist strip by 80s small-presser Gavin Burrows and the anti-fascist punk work of the youthful Simon Gane. Gane's self-published *Arnie* comes from a 90s punk scene with its own bands and fanzine culture, proving that the spirit of UK Punk has survived through the Goth, Traveller, Crusty, Riot Grrl, Queercore and Teen-C years to re-emerge in a form immediately recognisable to veterans of '76. Gane's comics also hark back to both Savage Pencil and *Viz*, and his success in the 90s small press comic scene underlines how very much at home there his punk subject matter is (see Figure 6.4).

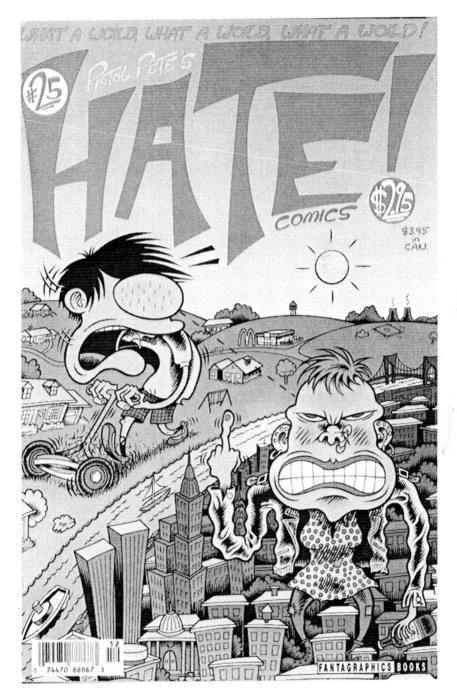

Figure 6.3 Cover to *Hate* comic (1996).
Source: © Peter Bagge.

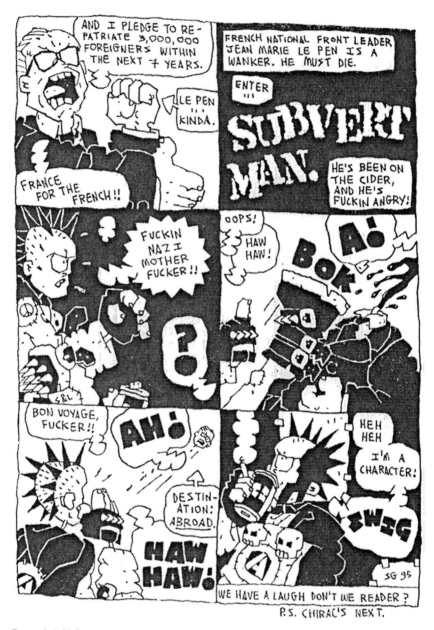

Figure 6.4 'Subvert Man' from Simon Gane's self-published *Anarchy Comics*, 1995. The spirit of '76 lives on into the 90s. Gane was four years old in 1976.
Source: © Simon Gane.

Wrap this turkey up

If the moribund pop/rock music of the mid-70s was in dire need of the kick up the arse given to it by punk, it's fair to say that comics needed one too. Between 1976 and 1986 there was a fundamental shaking up both of the comics mainstream and alternative publishing. Since 1986, US publishers have struggled to consolidate and continue those advances. The entry of British writers like Neil Gaiman, Grant Morrison and Peter Milligan into the mainstream (directly following from the successes of Alan Moore and Frank Miller) brought punk-influenced subject matter like oppositional politics, alternative sexuality and the everyday life of ordinary people into the medium more widely than ever before. Today's numerous independent publishers continue to mine the small press for new talent, and the small press itself flourishes internationally.

Though punk played a part in these changes, it was not as dominant in comics as it was in music, nor as all-pervasive as the input from hippy had been before it. The 60s counterculture was arguably more easily assimilated by the mainstream than punk for many reasons. Though opposing 'straight' society, it had some positive goals (e.g., ending both racist inequality and the Vietnam war); it preached flowers and love, so was prey to sentimentalisation; LSD and marijuana gave it a taste for fantasies and stories. Punk offered an angry, nihilistic creed and a doctrine of hatred. Much as the business sector tried to channel it into guises like New Wave and Power Pop, punk's negative credoes were always likely to be commercial liabilities in any mass market.

For a storytelling medium like comics, there was perhaps another fundamental problem: fuelled by beer, amphetamines and solvents (in the UK at least), punk lived for the spiky moment. As Tony Bennett, publisher of England's Knockabout Comics, puts it, 'Punk wasn't about narrative' (Personal communication, 1997). Nonetheless, it has managed to leave notable marks, if often indirectly, on the graphic narratives of the comics medium.

Acknowledgements

With thanks to: Peter Bagge, Tony Bennett, Gavin Burrows, Phil Elliott, Ruth Endicott, Neil Gaiman, Simon Gane, Paul Gravett, John Holmstrom, Paul Jones, Gerard Kingdon, Andy Littlefield, David Lloyd, Steve Marchant, Alan Moore, Ed Pinsent, Frank Plowright, Edwin Pouncey, Richard Reynolds, Andy Roberts, Roger Sabin, Dez Skinn, Steve Whitaker and Kent Worcester.

Notes

1 *Punk* magazine 14, May 1978; also quoted in Holmstrom (1996: 92) and Savage (1991: 466).
2 e.g. *Peter Pank* by Max, from Spain; Italy's *Ranxerox*; Serge Clerc's strips about the Clash and Blondie in France's *Metal Hurlant*, and the work of French punk 'Y5P5'.
3 Many punks enjoyed hippy comics like *The Fabulous Furry Freak Brothers* simply because their characters lived in squats, took drugs and hated the police.
4 BIFF is the nom de plume of Chris Garrett and Mick Kidd, whose weekly strip now runs in the *Guardian* newspaper on Saturdays.
5 Personal communication from Holmstrom, 1997.
6 Forcade's suicide is cited as a major reason for *Punk*'s demise. Holmstrom is today the publisher of *High Times* himself.
7 See *Chemical Imbalance* 6 (1987) and *Go Naked* 1 (Last Gasp, 1993) for reprints of these strips.
8 Beware, the second printing of *Anarchy* 1 is incorrectly labelled no. 2 on the front cover.
9 As the 'traveller' and 'crusty' lifestyles succeeded punk in the 80s and 90s, Mills in particular responded with the likes of mystical eco-warrior Finn. The 'adult' spin-off from *2000AD*, *Crisis* (1988), also developed Mills's political and ecological concerns in a decidedly post-punk setting.
10 *2000AD*'s 'punk' reputation remains strong; when the *Judge Dredd* movie was made in 1995, real-life punks were employed as extras to populate the street scenes.
11 Johnson's own comics *oeuvre* remains small, though he collaborated with Savage Pencil and Chris Long as Battle Of The Eyes, and did cover art for records by The The (a.k.a. his brother Matt Johnson), notably *Soul Mining* (1983) and *Infected* (1986), developing a Panter-like style with a full-colour palette.
12 Independent UK publisher Harrier picked up the term for a short-lived line of Harrier New Wave titles in 1988, including *Gag!* and *Vignette Comics* by the *Escape/Fast Fiction* crew.

Bibliography

Barker, M. (1990) *Action: The Story of a Violent Comic*, London: Titan Books.
Crumb, R. (1986) *The Comics Journal* 106, Seattle: Fantagraphics.
Davidson, S. (1982) *The Penguin Book of Political Comics*, Harmondsworth: Penguin. (First published 1976 as *Beelden Storm: De Ontwikkeling van de Politieke Strip*, Amsterdam: Van Gennep.)
Feazell, M. (1985) *The Comics Journal* 97, Seattle: Fantagraphics.
Green, J. (1997) *A Riot of our Own*, London: Indigo.
Groening, M. (1991) *The Comics Journal* 141, Seattle: Fantagraphics.
Hernandez, G. and Hernandez, J. (1989) *The Comics Journal* 126, Seattle: Fantagraphics.
Hernandez, G. and Hernandez, J. (1995) *The Comics Journal* 178, Seattle: Fantagraphics.
Holmstrom, J. (ed.) (1996) *Punk: The Original*, New York: Trans-High Corporation.

Kennedy, J. (1982) *The Official Underground and Newave Comics Price Guide*, Cambridge, MA: Boatner Norton Press.

Lowry, R. (1980) *Only Rock'n'Roll*, Manchester: New Manchester Review.

McNeil, L. and McCain, G. (1996) *Please Kill Me: The Uncensored Oral History of Punk*, London: Abacus.

Morrison, G. (1995) *The Comics Journal* 176, Seattle: Fantagraphics.

Panter, G. (1985) *The Comics Journal* 100, Seattle: Fantagraphics

Pencil, S. (1992) *Rock'n'Roll Necronomicon*, London: Shock Publications.

Savage, J. (1991) *England's Dreaming: Sex Pistols and Punk Rock*, London: Faber & Faber.

Spiegelman, A. (1981) *The Comics Journal* 65, Seattle: Fantagraphics

Vague, T. (ed.) (1994) *The Great British Mistake: Vague 1977–92*, Edinburgh: AK Press.

Williams, R. (1988) *Forced Exposure* 14, Waltham, MA: Forced Exposure/Jimmy Jones.

7

CONCRETE, SO AS TO SELF-DESTRUCT

the etiquette of punk, its habits, rules, values and dilemmas

Mark Sinker

> Yet these may ye eat of every flying creeping thing that goeth upon all four, which have legs above their feet, to leap withal upon the earth; Even these of them ye may eat; the locust after his kind, and the bald locust after his kind, and the beetle after his kind, and the grasshopper after his kind. But all other flying creeping things, which have four feet, shall be an abomination unto you.
>
> Leviticus 11: v 21–23 (King James version)

> There are always two reasons for anything. There is always the good reason and there is always the real reason.
>
> Michèle Bernstein (Marcus 1989: 373)

> I've got a little book/which tells me what to do . . .
>
> Rob Hind, unrecorded song lyric

Imagine the ensuing centuries of Judaeo-Christian moral debate had Moses returned from the mountain carrying not two stone tablets inscribed with five commandments each, but the first Siouxsie and the Banshees LP. Imagine a community evolving to encompass such a debate, its unspoken shared assumptions, the taboos it defined itself against. Now imagine long, wrangling, churchly decades collapsing into distracted teenage days – what would the moves and looks and passions and refusals of this community be? Their Right, their Wrong, the boredoms they'd tolerate, the slights they wouldn't?

So call it misplaced intellectual extrapolation, so call it an exuberance of ungrounded projection, so call it plain arrested – but welcome to my daft life of these 20-odd years: where the momentary sayings and doings of a few minor popstars long ago became Tablets of Stone, Testaments *and* Talmud to me. Calling this silly won't make it not true. And if I'm a sorry specimen mired in lost time, this only shows the distance by which our project failed to root (its success, you could say).

By establishing ritual purities and purifications, the Book of Leviticus boundary-marks biblical Israel as a tribe, with taboo-breakers cast out and excluded. Now *my* kind – Witnesses to Landings across Britain and the world since 1970 or thereabouts – share likes and dislikes, tastes and tics – but are we in truth marked out, by values, taboos and exclusions, as a tribe? Leviticus 18.22: 'For a man to lie with a man as with a woman is abomination'.[1] Those who live by and through such a rule have their everyday possibilities shaped by it. '*My body's an oasis to drink from as you please,*' sang Siouxsie in 'Mirage' in 1978. What possibilities does *this* injunction shape? What sort of community is needed, that such questions can be central to its self-defining rituals?

Far more lucid and daring than I was at her age, here's Colette, 15-year-old editor/author of Cape Cod fanzine *Looks Yellow Tastes Red*, writing in 1995 as Witness to a recent Landing:

> If punk means truth and dedication to ideals and saying 'fuck you' to the backwards attitudes and customs that hold us back, if punk means kid power and energy and music and sense of community, I would sell my soul for it. If punk means wearing 'punk' clothes, having the most body piercings, the oddest hair or the best record collection, if it means competing to be the coolest and the most noticeable or doing the most illegal 'fuck society' things, I would rather not have anything to do with it.

So now it's 1977: The Banshees are still only rumour outside London, and I'm 17, watching TV with my Dad, as Eddie and The Hot Rods gurn their way through 'Do Anything You Wanna Do'. Something Dad says, or just a look, tells me that he hates this noise, this message. At other times, I will naively defend Patti Smith, Iggy Pop, or whoever: 'Oh no, they only *look* as if they take drugs!' Now I'm silent. For I too disapprove of the Rods and their oafish pub-rock racket, embarrassed on behalf of things I can't yet name.

As a message, 'Do What Thou Wilt' was no problem: indeed, it was already so basic a motto for me that to give the Rods any credit for it was blandly to approve all of rock. Within months, as the Rods began a resentful descent into obscurity, The Banshees would step into long-term chart success – while Subway Sect, that most self-occluding of the ur-punk London voices, put out their second (and final) single, titled 'Ambition', in ironic homage to the exit from history they were then engineering for themselves. '*I won't be tempted by vile evils, because vile evils are vile evils*' is the couplet that ends the song – as my second motto, well, it plain contradicts the first. But contradiction was my thing. The Sect's bleak suicidal glee appealed to me as pure paradox. And if the Rods couldn't work at proper internal tensions of impossibility, I wasn't going to work at being bothered with them.

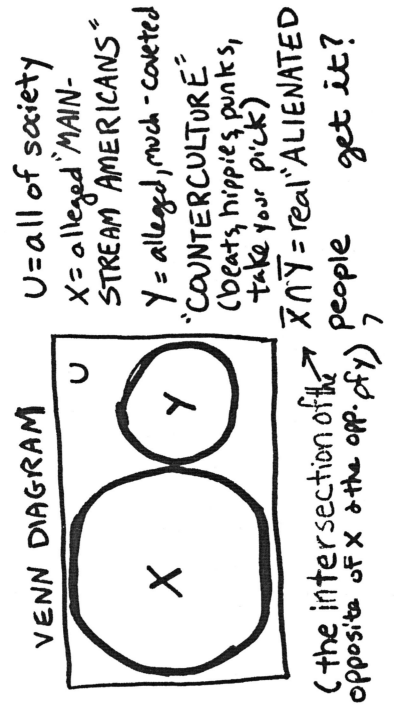

VENN DIAGRAM

U = all of society

X = alleged "MAIN-
STREAM AMERICANS"

Y = alleged, much-coveted
"COUNTERCULTURE"
(beats, hippies, punks,
take your pick)

$\overline{X} \cap \overline{Y}$ = real "ALIENATED
people → get it?
(the intersection of the
opposite of X & the opp. of Y)
?

Figure 7.1 Detail from *Looks Yellow Tastes Red* fanzine (1995).
Source: © Colette R. Hall.

Do what thou wilt: vile evils are vile evils. In all unspoken earnestness, I began to live my life as if this were tattooed on me where all could read it – and to hunt, no less desperately for not being aware of it, for similar unconscious routes towards the same tension, for formulations, contradictory and unwitting, marking out a tribal sibling (as in Colette's 'I would sell my soul for it').

After 'our' Landings, we Witnesses listened and learned, and we *did* do anything we wanted to do, publicly, with clear effect in music, movies, art, politics, eating, adverts, writing, fashion, drugs, TV, and sometimes just the way we walked or talked or looked in the city street. And all the while the full-on punky libertarianism arrived wrapped in more arcane rules and restrictions than *any youth cult* before or since – an endless miasma of codes, guides and forbiddings. In the name of absolute moral and social freedom, don't be such a fucking hippy . . .

For my secret double injunction was just one among a thousand ways to formulate the axioms of punk life. And since what you do tells who you are – since public rituals define the tribe – there had also emerged, over the years, a system of speed-read surface pointers to deep identity. Visible-invisible shortcuts to recognition, the same as any other band of outsiders flip into in tricky times: the keychain codes of the year-zero *autonome*.

Except that in this etiquette of punk, any ordinary way to distinguish surface from depth, the trivial from the serious, the anomaly from the essence, would also lack that all-important intractable layer of demonic paradox. If these fast-track systems of signs existed, they existed to ensure that the well agreed dresscode ('Cut That Hair') registered as tellingly as the minor and personal reaches of politics and lifechoice ('No More Babies'). If the founding axioms were way too primary directly to arbitrate on the everyday – on what you're to wear, or when and how (and to who) you curse – that was also a proof that the contradictions of the everyday – the etiquette – trumped the consistencies, intentions, causes and legacies grounding them.

Walking the walk

Let neither rank nor fortune, nor the finest order of intellect, nor yet the most winning manners, induce you to accept the addresses of an irreligious man.

(Anon *c.*1900: 36, 'Courtship')

'Against the Kingdome of the Beast
Wee witnesses do rise . . .

(Leveller Marching Song, 1640s)

In his overlong, gloomy, histrionic essay 'The Shadow of our Night'[2] (Fowler 1996: 153), working-class 60s rock-kid Pete Fowler offers a single perfect anecdote of punk-think. By the 70s a teacher, eager that his art students should think for themselves, Fowler had them discuss 'fancying': that is, what makes X attractive to Y, and so on. In the class of '79, the 18-year-old with the pink hair and the safety-pinned bondage gear hadn't yet opened up. So Fowler asked him this: 'You're at a party, and three girls are on a sofa, all naked, all hot for you: one looks like Debbie Harry, one like Charlotte Rampling, one like the tall one in Hot Gossip. Which do you go for?'

'None of them,' answers Pink-Hair.

'None? Are you sure? Why?'

'Because in the morning I might find I went with the one that wears flares.'

As described, Pink-Hair strikes me as a sad and becalmed *fake* punk at this date (safety-pins? in 1979?), but I would sell *my* soul to have given so well formed an answer, unprepared, to so lamely constructed a question: not only to have refused assent so easily, so *artfully*, to the pathetic selection of choices on offer, but to have overturned – so sweetly, so *ruthlessly* – the entire system of judgement that birthed it, the assumptions about order and possibility behind Fowler's economy of desire.

To have overturned them, as here, by choosing at once precisely and absurdly: by respecting rules – your own rules – so flamboyantly, you could reveal how ridiculous rules were, and how compromised. You could crack open the carapace and glimpse power, denuded, wriggling within. With what? A stream of acts and moves, based on systems of value and etiquettes of behaviour so mad and yet so exacting in their concrete being, and effect, that etiquette at least (being a value-system's collusions with its defining demons, and disguises thereto) would self-destruct.

Was the total fuck-off look – spiky hair, big boots, spitting – sometimes less a weapon than a crutch? (Is there a difference?) 'They only wanted to be noticed. They only wanted to be loved,' said a friend of mine, perhaps of herself at half her present age. But 'only' is wrong, a too-broad hindsight hit: sure it was love they were after, but there were prices they would *not* pay.

For part of what they wanted was no longer to be noticed. Dressing-to-shock (zips, rips, binbags, tattoos, the pretty-slut tease, fetish-wear taken casually public) is adopted against the instant society *stops* being shocked. Stops being shocked by surface gestures anyway: the moment when the occasion of reaction wasn't silly kids capering in horror masks, but genuine evil, currently lurking unnamed or overlooked. They only wanted a world where what you wore was all just fashion: where how you look isn't who you are. A world healed, a world purged. When right prevailed, these signs would pass unmarked – and until then, we lived in unreal time.

Hence Sid's or Siouxsie's Nazi chic; hence the wayward declarations of fondness for (for example) Myra Hindley. For Hitler and Hindley had *lost* their respective wagers against the future. To present oneself as blithely unmoved by the crimes of outcasts so complete – the defeats of losers so complete – is to deny oneself the reactionary comforts of community; and in the denying, to force those who decry such crimes towards better reasons for this than the need to remain comfortable in the bosom of a suspect 'us'. Backing the known winner is an unearned shortcut to approval – which approval generally comes at a price: a faith in a certain gorgeous future, if only you brush your teeth in the politically correct direction. That future generations may be spared complacent and tainted options, you sacrifice your own reputation to their instant contempt (kind of neat, whispers a self-destructively punky part of me, still).

Anyway, once you accept the fact that Sid and Siouxsie wore swastikas because they *weren't* Nazis, the dresscode for the truly punk was clearly anything but pink hair, safety-pins and bondage gear. The only acceptable function of fashion was the overthrow (for all time) of the very metaphysics of 'fashion'. All choices – what you ate, how you walked, when you slept, who you liked – were to be rated primarily against their likely immediate effect; what reaction they provoked from who. No act was non-public, no decision non-political. A complex calculus: easier just to say, 'Who cares?' Life's too short and energy too limited for totality at all times. After all, 'all choices' includes all spur-of-the-moment decisions about which bits of your total rule-system you can make a point (or a production) of overriding, just for tonight. Nothing so un-punky as absolute intransigence (because nothing more quickly becomes unquestioned routine).

This nonchalantly committed regime of mindfuck detail *can* be shorthanded: it's topsyturvy-dom as unending strategy (as Malcolm McLaren had said, on the release of 'Anarchy in the UK': 'Of course, the *real* fans aren't buying it'). Which is why anyone who couldn't see beyond the random naffness of my outward appearance in most of the 80s, who couldn't see how crap clothes and haircut were *totally* punk, wasn't worth trying to persuade. Those who mistook such non-gesture gestures for fence-sitting, timidity or laziness – well, let's just say that the strong points they may have had were *always* outgunned by stronger ones they were missing. In my head.

Combining the hip dicta of a sub-branch of 70s teen pop culture with ordinary adolescent fear and shyness (and only slightly less ordinary adolescent strictness), I'd evolved a line as anti-teen as any grown-up could ever have hoped for – or feared. Caught in the contradictory cross-ply of my Two Commandments, I was as nay-saying as any Puritan Iconoclast, as indirect in my pleasure-seeking as any medieval flagellant – except of course that all my forbiddings only ever applied to me. The better to enjoy the amplified specifics of teendom right up to the last possible moment – why *pretend* to be adult before we *had* to be? – I committed

myself to cranky little-old-man-dom. *No* drink, *no* smoking, *no* drugs, *no* sex: bargaining fun's deferral against being untrapped and untricked, the only controller of such futures as this self-isolated, self-punishing, self-denying, way-too-clever teen was prepared to permit himself. Or, as Minor Threat sang in 'Straight Edge', their 1981 song of ranging abstinence, 'Always gonna keep in touch/Never want to use a crutch . . . '[3]

Never wanting to want

> In the street great quietness of manner should always be observed.
> (Anon *c.*1900: 17, 'Deportment And Manner In Walking')

> No bondage is worse than the hope of happiness.
> (Fuentes 1996: 1)

All vanguards are cadres of the selfish, preening themselves in the future's fond spotlight. The purest expression of punk community may be the refusal to reach out, to express the desire that the community should continue, to set out obligations of duty towards its nurturing. If to give notice of wanting the other is to risk the immediate dissolution of all ties, the micro-community must be taken to exist somehow by chance alone, never design. To want it, to build towards it, is to betray it.

The most detailed study of how-to-do and how-to-be, punk-wise, is the comic *Love and Rockets*, by Gilbert and Jaime Hernandez, published in 50 issues between 1982 and 1996. Jaime's section, on two lovers, Hopey Glass and Maggie Chascarrillo, from California's chaotic-bohemian community, exalts their battle to discover new ways to be adult without betraying their adolescent choices. Parted by circumstance, then reunited, they discover their readings of punk principle – Hopey's hyper-anarchic ('Do What Thou Wilt'), Maggie's ultra-romantic ('Vile Evils Are Vile Evils') – are no longer in sync. An etiquette has intervened: the generalisations and explanatory shortcuts of once-inseparable allies no longer mesh; blurred by mutual idealisation during separation, unspoken assumptions about identity – about belonging – suddenly fail.[4]

Hopey knows that what she does is not who she is: her capacity to fuck women she dislikes proves (at least to her) that the feeling she has toward Maggie by contrast transcends the merely physical. Wanting to be wanted for herself, Hopey knows such emotions are hardly remarkable. So she's mad that Maggie beats herself up as irredeemably conventional (and un-Hopeyish) for wanting only Hopey. This *isn't* uncool and un-punky; this *isn't* anti-lesbian. The solution? Only an open declaration of what Maggie is to her, sounding forth all deep hopes about what she is to Maggie.

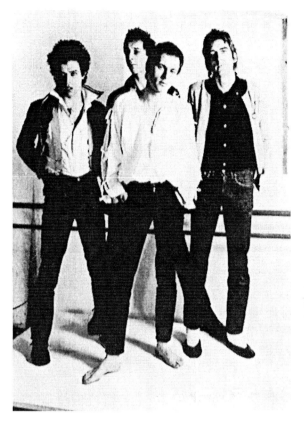

Figure 7.2 Wire look the part (1977).
Source: Photograph by Annette Kemp. From *Wire . . . Everybody Loves a History* (1991).
 Courtesy of Kevin S. Eden.

Yet to hint that your other half might sometimes feel vulnerable, might want and be wanted, would vastly betray the specifics of mutual punk loyalty, the private political purpose of this radical project of coupledom, the never-ending public demonstration of total individual autonomy.

And besides, to revive the indivisible tribe-of-two would be to diss the identity-gangs each hangs with in the absence of the other (Hopey's East Coast art-fags, Maggie's MexiCali proles). Totally self-centred in their unwillingness to be so 'selfish', the two lovers let the duo fail again.

If the devil comes

We have to attack the 'enemy' at his base, within ourselves.
(Alexander Trocchi, quoted in Marcus 1989: 173)

What's beautiful is to change, tirelessly. Because every change is an advance, every permanence a grave. Contentment and resignation are a single despair, and anyone who stops and gives up becoming something else has already opted for death.
(Arsan 1975: 173)

'Perhaps inherent in gay desire is a revolutionary inaptitude for heteroised society,' writes Leo Bersani in *Homos*:

This of course means sociality as we know it, and the most politically disruptive element of the homo-ness I will be exploring in gay desire is a redefinition of sociality so radical that it may appear to require a provisional withdrawal from relationality itself.
(Bersani 1995: 7)

If gay liberation is at the core of any revolutionary social transformation, as Bersani insists, he leaves little room for inclusionary redrafting or metaphorical (i.e. 'de-gaying') generalisation from the male-on-male: no *vive-la-différence* celebration of mutuality, no fuzzy-sappy yearning to be one with the Other. The book is a daring, exhilaratingly nihilistic attack on the affirmative etiquettes of identity politics, the repressive sentimentalities of the gay community, and from its unsettling focus on the central fact of gay desire, and the most commonly occluded: that it means men who want cock and women who don't.

But – though he barely uses the word – what's most punk about *Homos* is the contradictory extremism of its demands. That the word 'punk' derives from prison slang, for the 'boys who give up their asses to the "wolves"' (Savage 1991: 123–40),[5] is not news. In mid-70s New York, the Ramones and Richard Hell took their barely coded look from the boy hustlers on 53rd and 3rd Streets, ripped jeans and T-shirts, adorably mussed-up hair. It was the refusal to recognise any community politics in this self-locating gesture, the emphasis on hostility and self-loathing and extremes of relational withdrawal, that gave this scene its pulling power.[6]

In 1978, in *Those Were Different Times* (1979), her memoir of the punk milieu of Cleveland, Ohio – of Pere Ubu and the Dead Boys – Charlotte Pressler wrote:

There was no reason why they should not have effected an entry into the world of their parents. Yet all of them turned their backs on this world, and that meant a number of very painful choices . . . I would like to know

too the source of the deep rage that runs through this story like a razor-edged wire. It isn't, precisely, class-hatred; it certainly wasn't political; it went too deep to be accepting of the *possibility* of change . . . It should be remembered that we had all grown up with Civil Defence drills and air-raid shelters and dreams of the Bomb at night; we had been promised the End of the World as children. And we weren't getting it.

(quoted in Savage 1991)

Five years/that's all we got . . .

On UK television in the early 90s, a cheerful crustie-punk convoy girl is interviewed. She explains, badly, why she's chosen to be an unmarried mother, and how supportive and understanding *her* mother (married, and very straight, rural middle class) had been. On the wall is a poster: 'Children are God's way of telling the world it can go on.'

Distilled in this slogan can be found everything latently dangerous in an apparently radical lifestyle: the reactionary sediment precipitating out of so manifestly courageous a life-choice. Children as a blank-slate projection of the world things we hope are coming, failsafe machinery for generating 'love' and pre-programming destiny. This is why (as Colette insists) punk *has* to mean kid-power, refusing both puppet-dom and God the ventriloquist. Listen again to the resignation and the glee in Johnny Rotten's croak, as he slips from venomous particularity through self-assault to metaphysical nihilism, his attack on monarchist reverence a plea for his own removal as movement figurehead, and a declaration of war on the very concept of tomorrow: '*No future, no future, no future for you/No future, no future, no future for me . . .* '

Nothing is more un-punky than the belief in guarantees, than the ceding of moral autonomy. Punk's freedoms are absolute, if only in this sense: no-one else's rules apply to you. You take full responsibility for the consequences of your own rules, your own beliefs. You choose to obey or disobey for your *own* reasons. You do not complain when the consequences come down slantwise, or worse.

Faith in any better future – in class or race or GenderPref revolution; in history's and philosophy's end; in the Messiah's return in glory – is a trapdoor back into the order opposed and abhorred. Except perhaps for little kids – my dad's harder than yours; my mum loves me more than yours; my progress is more historically objective than yours – there is no unconditional love, and there are no guarantees.

To wish for a future is to dream a social context in which the endless contest for self-definition ceases, for a care and a calm in which one can 'simply' be oneself: projecting the social around our own want, this faith desires the rest of the world reconfigured as balm for *our* hurt, filler for *our* lack. To tolerate 'difference' is to tolerate all the things that keep difference alive, hurting: yet to amplify antagonism

between genders (races, classes), that a 'we' be brought 'together' out of such founding trauma, is to be enjoined to wallow in our extended community of pain – and to excoriate those deemed untouched by it – that this same pain one day magically dissolve itself, somehow, maybe.

Certainly as a model of unselfish service and policed togetherness, 'family values' are the wound not the balm, a repressive grief even after the Christian-Fascist definition of 'family' is rejected. Tenderness dies when it's made a duty. Better the profound anti-communitarian impulse in homo-ness (the desire of the same for the same) than the divisive exchanges and transactions that an 'ordinary' breeder couple affirms. Preferable to the control-freak ego-megalomania at work in ordinary relationality is the location and valorisation of the ego-shattering, suggests Bersani, that is entailed in becoming the passive partner in the male-on-male sex act, the fuckee, the 'female'.

OK, so generalising here with a jump to *Love and Rockets*'s take on gay life and love may seem tricky, given the centrality of the comic's two (non-symbolically) female lovers. Cute softcore dykes getting it together easily and often: this is work sharing a primary market (adolescent heterosexual males) with Emmanuelle Arsan's mid-70s *Emmanuelle* novels. Soft porn disguised as radical social philosophy, Arsan (though a better writer and thinker than Anaïs Nin, say, and funnier too) is de Sade Lite at best. Her readers get what they pay for, lovingly imagined and described fuck-scenes without *too* much plot or discourse between. Emmanuelle has increasingly extreme sex with various pretty girlfriends (and with countless faceless and interchangeable men) in a guilt-free, trouble-free, disease-free erotic utopia, an imaginary Thailand of the unburdened colonial mind. By contrast, with onscreen sex so rare, *Love and Rockets* – radical punk philosophy disguised as bohemian Mills & Boon – puts its readers through the wringer.

As David Halperin, reviewing *Homos* with approval and exasperation, glosses Bersani: 'Gay desire points the way to the possibility of defetishising difference without denying it. It thereby offers a superior ethical alternative to the repressive hypocrisies of multiculturalism' (Halperin 1996). It's precisely this 'superior ethical alternative' that the Hernandez Brothers explore: how being punk means you get to be a new 'kind' of female (or lesbian, or Mexican); how being a girl – or gay, or not white – is always already a better way to be punk, if you're insistently, selfishly subjective about it. So what if Hopey and Maggie first sprang from an adolescent breeder fantasy of softcore polysexual nirvana? Given that they're both handsome, healthy California girls in relatively unfettered sectors of society, theirs is an erotic *counter*-utopia of some bleakness: the nightmare mechanics required to keep just *one* unspoiled punk relationship going for two nights in a row are more than apparent.

Should punks always tell the truth?

No! Not just *anytime*! Only if it's *funny*!

(Roger Rabbit)

It is an unchristian action to tell us some hard things our
acquaintances have said of us, because 'we ought to know'. We
ought NOT to know, and would be very much happier if we had
never known.

(Anon *c*.1900: 10, 'Candour and Cheerfulness')

For 'funny' (and for 'unchristian'), read instantly effective, or atmosphere-
charging, or ludicrous, or self-denying, or generally wrong-footing of such of the
world as obtains in one's immediate vicinity. When you have no opinion on an
issue, it cannot be 'wrong' to invent one, if only to explore what happens when you
make it known.

Like your shoes: how about it?

No young lady ever engages in a correspondence with a gentleman
who is neither her relative nor her betrothed without eventually
lessening herself in his eyes. Of this she may rest assured.

(Anon *c*.1900: 83, 'Correspondence With Gentlemen')

Every etiquette ever laid down is actually a summary of the current codes within a
given community on who you get to fuck, and how. Within a 'straight' community
(any group a *Fuck-the-Future* face-tattoo excludes you from) such codes still feed
straight into the political economy of babymaking, a profound subservience to the
proprieties of property. Writes Bersani: '[I]f a community were ever to exist in
which it would no longer seem natural to define all relations as property relations
(not only my money or my land, but also my country, my wife, my lover), we *would
first have to imagine a new erotics*' (Bersani 1995: 128, my italics). But etiquettes
flourish everywhere, as speed-read grounding in the communication of shared
outsider identity, as security-guarantee of the foundations of such identity. Rules
make things easier, not harder. You devise them to avoid things, thoughts, yourself
sometimes. Etiquette is a device to ensure that the pleasures of identity aren't
always prefaced by such terrified, potentially fatal enquiries ('Am I in the place
where it's OK for boys to do boys?') that the looked-for comfort never emerges. In
French, 'etiquette' means (just as it sounds) 'ticket' – that is, 'label'.

Figure 7.3 Panels from *Love and Rockets* comic, issue 38 (1992). Who you do is what
 you are: Hopey becomes the Tucker household's pet
Source: © Jaime Hernandez, courtesy of Fantagraphics Books.

So who you are (who you can get yourself to be labelled as) still determines who
you can get to love. Which is why etiquette is also always the vector by which the
resisted power-system is re-introduced. Which is why the only acceptable punky
pick-up line has ever been the intolerably unmannerly 'Wanna fuck?'

'Homosexual desire is desire for the same from the perspective of a self already
identified as different from itself' (Bersani 1995: 59). Thus, any definition of
homosex that requires public gestures of relationality is less keychain code than
dungeon door. A friend – at the time a member, like me, of the world-wide if
atomised community of the celibate – noted how others defined her in terms of the
absent sexual relationship, the coupledom she conspicuously lacked. Breeders
assumed it was a boyfriend she missed, benders that she somehow hadn't yet dared
reach towards the solace of a girlfriend. 'My identity,' she stated one day, in a
climax of amused and illogical exasperation, 'has nothing to do with who I am.'

'Punk,' wrote another friend, 'is a mental machinery for manufacturing a series
of NEW moral choices/stand-offs, to make life more interesting when those

already in existence have lost their freshness. What these new moral alternatives actually are – and which ones you choose and reject – does not actually matter.'

But it *does* matter – because what's at issue is new kinds of social relationships, newly imagined erotics (and economics). Bersani's 'homo-ness' strives for a conscious tension-in-paradox, its pridefully nihilist specificity veering occasionally towards exactly the punkier-than-thou pretensions that Colette rejects in dismay (see Figure 7.1). If future community – community 'after the revolution' – is to derive from the particularities of homosex, complete with radical doubt about the definable nature of such community, all the more reason to treat flight into non-breeder desire as a foundational generalisation (and punk as a radical metaphor for this same generalisation). Because a commitment to a certain asociality is also the *only* route through to any mutual tenderness that isn't merely scripted by outsiders: so that the degree of asociality achieved is an invaluable marker of the limits of the promises of this or that rival community-as-salvation. Communities are shaped to accommodate genres of argument: a community that can accommodate Bersani's 'homo-ness' (a 'punk' community, a community untouched by sentimentality towards itself as a community) demands a world rescued from need itself.

On a hot night after the landing

> The man or woman who is wilfully late at a dinner party must simply be conscienceless.
>
> (Anon *c*.1900: 48, 'Duties Of Guests')

Now the scorching breeze comes off the flats again, and my honey's eye-fur begins rippling, in soft waves of blue and purple. Usually I like to spoon a little first, but of course it's too late for that – her gill-slits are already flicking hungrily open, her psychic palps whipping forward into me, at chest, cheekbones, temples . . .

We are strangers in a strange land: its laws are not ours. Obeying them is a courtesy (if we choose to respect courtesies). What does a guest gain by breaking a rule that they don't know *is* a rule? Which is the more subversive? Looking like a slut and then being one, or looking like a slut and then *not* being one?

'No Future' was never a threat; it was a *promise*. It was – it is – a moral fact, a fundamental conundrum: how to behave in the last days, when authority is ended. Life during wartime; how to live happily and decently when this is as good as things may ever get. Making babies is making excuses: an appeal to the future that simply defers the conflicts of the present. Welcome to unreal time.

It should be remembered that we had all grown up with dreams of the Bomb at night; we had been promised sex with Others – with aliens, mutants, the unimaginably brilliant and strange future – and we WEREN'T getting any.

Selling her soul for it

> If one person is becoming uppermost in your thoughts, if his
> society is more and more necessary to your happiness, if what he
> does and says seems more important than that of anyone else, it is
> time to be on your guard, time to deny yourself the dangerous
> pleasure of his company and indeed time to turn your thoughts
> resolutely to something else.
>
> (Anon c.1900: 37, 'Disappointed Love')

> I don't really know what punks do after punk.
>
> (Hernandez 1989: 81)

How do we know right from wrong when community has no call on us? When
Maggie leaves, Hopey can cherrypick the company she keeps – but since to choose
at all is to choose all, when she does, she discovers what it is of herself she won't,
at last, sell to survive.

Effectively a rentgirl all her adult life, she has gotten fed and a bed in trade for
her company if not her body, so now cheerfully allows herself to be trophy-slut to
a cabal – headed by an ageing Lucille Ball-type – who like to toilet-train and
discipline the 'infants' they hire young hookers to play. To ultra-punky Hopey, such
kinks are (necessarily) 'supercool' – besides, there's cross-cut here to her memory
of her aspirant Colombian mother pimping her (that is, Hopey's) infant cuteness
to advertising agencies. As justification, as projection, as denial, children are a
damage in endless directions: the enactment of *any* adult desire on a child is an
abuse of some kind.

Consensus S & M insists on the strictest possible rules, on escape-hatch etiquettes
that ensure the fantasy can be ended (see, for example, Califia 1994). But here, with
mass-culture stars owning street-whore slaves, no such escapes exist. This fantasy,
no more consensual than 'real' family values, is not supercool.

Incomplete control

> I identified with Ulrike Meinhof. The same blocked emotions that
> turn some people into junkies turn others into terrorists . . . 'I
> won't have it! I won't stand for it! This is totally unacceptable!'
> . . . A form of idealism that leads down different paths.
>
> (Marianne Faithfull, quoted in Marcus 1994)

> Tell me who you love, and I'll tell you who you are.
>
> (Creole proverb)

Is the expression of love and commitment, as opposed to momentary desire without obligations ('Wanna fuck?'), always simply to place others intolerably in your debt? Hopey's libertarianism frees her from rules aplenty – a non-judgmental, sexually experimental viewer, she passes through the mirror of TV-flavoured authoritarian mom-ism into a fine pervy utopia, only to discover that there are rules here too, all the more unpleasant for being unspoken, and when you're all alone in the world – a circumstance Hopey has actively fostered for years – those who enforce them are much harder to dodge. Identity – along with labels, tickets, etiquettes – is a terrain of secrets, exploitation and manipulation. And sometimes it's punkier to cede control, to compromise over absolutes, to shut down on the totality and just chill.

Hopey discovers solo mindfuck spite won't always function as a Force for Good, won't generate the instant etiquette that concords with her unstated punk values. Yes, without Maggie she can get herself labelled however she chooses; but look who she has to get to do the labelling. And with physical assault on less agile friends comes the shattering of her belief that World Justice can always be called up merely by her self-absorbed dance of intuitive provocation, that atmosphere-charging badness alone will ever actually punish the rich and the powerful.

This dance, of directness and obliqueness, of posture and evasion, of obscure attack and sometimes startling tolerance, is the punk's private argument with him/herself, only made public for specific and possibly irrelevant effects as it circles justification, legitimation and rationalisation: the sorting of the 'good' reason from the 'true'. It has rules only for the fun of feeling naughty when you later break them; it has rules (or anyway habits) whose entire purpose is to charge the atmosphere, which stick or change according to the effect they'll have; it has rules so ludicrous that they mock the whole notion of rules (punk is a close cousin to consensus S & M in this respect); it has rules to help one hurt or deny oneself; it has rules to smash through all limits of who one allows oneself (and who others allow one) to be. In this tangle – otherwise known as the rethinking of everything – Bad Faith is a constant companion. Bad Faith towards ourselves, that is – because who else is paying this much attention?[7]

Hopey's 'do the right thing' is obliquely visible at best in the ordinary etiquette of Hopey-ness. But even she knows from the outset that this particular adventure, this adventure in dodgy bonding, was always a cop-out, an easy option, a betrayal of self.

Hence her need for Maggie, absent centre of her self-satisfied self-absorption. For the dance only works its magic when Hopey's comfortable with herself: and if Maggie isn't comfortable with her, maybe she can't be either.

Reluctant to impose a shape on the future, to be ruled by desire, hungry for new ways to relate, the couple had dissolved their world-of-two. To be two again would be to celebrate a success in the world's eyes (their own, small, weird world); to

cheer a small but significant win. And punk is not (and cannot and must not be) about winning, or even making shift to win.

In pursuit of ideals so constructed as to be unattainable – punk as the active embodiment of contradictions which others disguise – your only friend is the knowledge of Bad Faith's unavoidability. Knowledge that failure must always follow – that death is final and planning futile – is what keeps us human. That success is always only ever a matter for the present; that there is no future; no life after death; no dashing prince or beautiful princess or funky proletariat come to shower happy-ever-after on us, no revolution to palm off responsibility for the consequences of my beliefs onto. To accept myself as a True Punk would be heaven indeed; to be a Punk Traitor is what makes me human, what keeps me sane. All punk codes were always intended to fail. Our failure is our essence. We only wanted not to need.

Shadow behind the heart

The Sex Pistols sang 'No Future', but there is a future, and we're trying to build one.

(Allen Ravenstein of Pere Ubu)

Know this, Emmanuelle: the future of the earth will be what your body's power of invention makes it. If your dream should darken and your wings fold, if, by a strike of misfortune, your curiosity should falter, your insight and perseverance should fail, then that will be the end of Man's hopes and changes: the future will be eternally like the past.

(Arsan 1975: 173–74)

How often do we see a dress exquisite in all its parts, utterly ruined by the wearer, for instance, by the adoption of vulgar gloves!

(Anon. *c.*1900: 13, 'Importance Of Adjuncts')

If the abomination of compromise that is ordinary coupledom is the only way to be an adult, then ye are to refuse adulthood.

Perhaps you assume I'm mad at the world for disrespecting my capabilities, my mind. That I veer constantly towards callous frivolity because I resent the neediness beneath the surface of respect. You can and will, wheedle the respectful, deliver. We look to you one day to save us.

And how's this *my* job?

Passivity leans in here, and laziness, and narcissism – and fear, always fear, the bitter kindness of staying silent. Misplaced extrapolation? Ungrounded projection? *Do What Thou Wilt Shall Be The Whole Of The Law. Vile Evils Are Vile Evils. No Future. No Future. No Future.*

Figure 7.4 More *Love and Rockets*, issue 39 (1992). Family Values/Tough Love: We are strangers in a strange land, its laws not ours.
Source: © Jaime Hernandez, courtesy of Fantagraphics Books.

'None? Are you sure? Why?'

'Because in the morning I might find I went with the one who thinks identity is for life, not just for Christmas . . . ' Concrete, 'To Self-Destruct'.

Acknowledgements

This chapter is dedicated to two that I lost: Rob Hind, whose code was far stricter and more self-effacing than mine (he took his life 12 years ago now, which hurts still and is not forgiven); and CJS who, more than anyone and despite all, taught me enough about myself to inch out of unreal time at last. Most emerged from discussions in 1996/7 with AB, NB, CC, LF, KH, PH, NJ, NM, LN, COR, DQ, JR, BS, JS, JS, MS, RS, RS, BT, JT, BW and others, and with Colette of *Looks Yellow*

Tastes Red (who gave me permission to quote her and to reprint the Venn Diagram on p. 122). and Frank Kogan of *Why Music Sucks*. But it's dedicated also to the girls of 14 Regent Street long ago – Steph, Cath, Zoe and Vicky – who I worshipped and envied and modelled myself on. Their absence – the living, the dead – made it harder to get this right, and far more important.

Notes

1 Not all translations/interpretations of Leviticus 18.22 are pretexts for extermination: otherwise rigorously orthodox rabbis have argued that, since the 'abomination' at issue is the unfruitful waste of semen, gay male seed-spillers can atone by adopting kids.
2 'The Shadow of Our Night' is an afterword-update to Fowler's much-anthologised 1972 howl of disillusionment, 'Skins Rule'.
3 Straight Edge arose in reaction to LA Hardcore, which had been crazed, abandoned and suicidally self-indulgent. In December 1980, Darby Crash of The Germs injected a massive shot of pure heroin, to be found the following day, cruciform and dead, at just 22. With Minor Threat as flagbearer, non-coastal America cleaned up in the revolutionary name of punk – a higher, nobler path towards, well, what, exactly? ('Straight' itself meant drug-free rather than non-gay – to the celibate, GenderPref hardly signifies.)
4 The key issues are *Love and Rockets* Nos. 30–39, particularly the eight episodes of 'Wig Wam Bam'.
5 Savage is quoting from New York's *Punk* magazine, No. 3.
6 McNeil and McCann's aural history of New York punk, *Please Kill Me*, named after a notorious T-shirt slogan Richard Hell forced pretty-boy guitarist, Richard Lloyd, to wear round town, rams the point home.
7 For a decade at least, Hopey functioned as my own projection of the asocial daring I still tend to punish myself for lacking. So I'm Maggie at heart – so fuck off.

Bibliography/discography

Anon (*c*.1900) *The Etiquette of Modern Society*, London: Ward Lock & Co.
Arsan E. (1975) *Emmanuelle*, London, Sydney, Toronto, NY: Mayflower/Granada.
Bersani, L. (1995) *Homos*, Cambridge, MA: Harvard University Press.
Califia, P. (1994) *Public Sex: The Culture of Radical Sex*, Pittsburgh, PA: Cleis Press.
Colette (1995) *Looks Yellow Tastes Red*, No. 6 (available, for $1 and a stamp, from PO Box 1275, Wellfleet, MA 02667, US).
Eddie and the Hot Rods (1977) 'Do Anything You Wanna Do', Island Records.
Fowler, P. (1996a) 'The Shadow of Our Night', in C. Gillett and S. Frith, *The Beat Goes On: The Rock File Reader*, London: Pluto Press.
Fowler, P. (1996b) 'Skins Rule', in C. Gillett and S. Frith, *The Beat Goes On: The Rock File Reader*, London: Pluto Press.

Fuentes, C. (1996) *Diana: The Goddess Who Hunts Alone*, London: Bloomsbury.

Halperin, D. (1996) 'More or Less Gay-Specific', *London Review of Books* (23 May).

Hernandez, G. and Hernandez, J. (1982–96) *Love and Rockets*, Nos 1–50, Seattle: Fantagraphics Books.

Hernandez, J. (1989) Interview in *The Comics Journal* no. 126.

Kogan, F. (1991–98) *Why Music Sucks* (available, for $7 or a written contribution, from 1449 Valencia Street, San Francisco, CA 94110-3716, US).

Marcus, G. (1989) *Lipstick Traces*, London: Secker & Warburg.

Marcus, G. (1994) 'Marianne Faithfull: Fighting Hard & Losing', *Days Between Stations* column, *Addicted to Noise* netzine, http://www.addict.com/issues/back

McNeil, L. and McCann, G. (1996) *Please Kill Me*, London: Little, Brown.

Minor Threat (1981) 'Straight Edge', *Minor Threat*, Dischord Records.

Savage, J. (1991) *England's Dreaming: Sex Pistols and Punk Rock*, London: Faber & Faber.

Siouxsie and the Banshees (1978) 'Mirage', *The Scream*, Polydor.

Subway Sect (1978) 'Ambition', Rough Trade Records.

Part II

EXPERIENCE, MEMORY AND HISTORIOGRAPHY

8

DISTRESS TO IMPRESS?

Local punk fashion and commodity exchange

Frank Cartledge

J.D. and myself decide we're punks. Out go the Oxford Bags and eight-button high-waister flared trousers; out go shirt collars the size of 737 wings and Mum's knitted 'Starsky' cardigan. Take in a pair of cords so they're drainpipes; wear an old school blazer with narrow lapels – no safety-pins so wear paper clips down both lapels. Tie knot reduced from obligatory four-feet wide to a straight peanut (put the kipper end down your trousers). Small lapel badges from shop in town. J.D. going to get his mother to knit me a bright red mohair jumper. Later J.D. and M.B. persuade me to bleach hair with Nestlé Light pre-colour, make me leave it on for two hours, Mother goes mad. Range of techniques from sugar and water, soap, then finally hairspray to keep my hair stood up. Later blue and red cochineal, out of cupboard at home (for cakes and things), put on hair but get sweaty and it dribbles down my face at concert.[1]

Mistakes, disorder, then practice makes imperfect, was how I lived punk. This experience stands apart from the historical and cultural theories I have read, in its fractured and chaotic assembly of an identity, constructed within a particular locality, over a number of years. In contrast, punk as a recent historical episode has necessarily been simplified to its principal components in order to decipher and legitimise it as a cultural phenomenon. Since 1978, research and documentation on punk fashion has taken two paths. First, textual and visual histories centred on London, working within a framework of 'avant-garde' bands, designers and their coterie, such as the Sex Pistols, Malcolm McLaren and Vivienne Westwood,[2] and second, a theoretical reading of punk style as an ideological 'resistance'. Both have come to determine punk style in a series of fixed iconographic images and cultural symbols, cutting a swathe through the urban landscape like a motorway. In these readings historical linearity has subsumed spatial difference: those locations

bypassed in the original readings have come, through absence, to be determined in the same image as the motorway.[3] The 'magical' space created by this matrix has accorded punk fashion a homogeneity that was absent within 'real' urban cultures of the time.

In a myriad local sites the dull round of everyday existence was played out, punctuated alternately by monotony and excitement. In real urban spaces, the site – shop, nightclub, school, text and image – accommodated the evolution, and manifestation, of a new youth cultural code, through a process of active consumption. And as a 'lived' experience, for the vast majority, this did not directly involve the King's Road and drinking with the Sex Pistols; nor the heavy symbolic readings imposed on the culture in an attempt to distance an 'authentic' punk from its apparent antithesis: commodification. Instead, locally, punk as cultural production was a crossover between media representations of

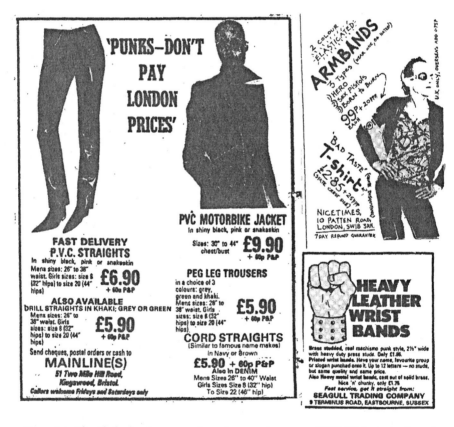

Figure 8.1 Classified adverts, as seen in various music papers, 1977–78 (note 'real punk machismo style' wristband).

Source: Melody Maker, Sounds.

punk fashion, the commercial clothing available and the 'Do It Yourself', jumble sale, 'make and mend' philosophy.

The entry level to punk was inextricably tied to bands and records and their corollary, the music press. With this emerged a dress code from raids on jumble sales and charity stores or bought through shops and mail order. Within Sheffield, the flow of style information was linked to an infrastructure in flux, venues and shops opening and closing, posthumously stamped in the memory of local punks. Venues frequently hosted well known bands, the Clash, the Ramones and the Buzzcocks, providing a visual dress guide emanating from outside the city. These ranged in size from The Roxy, a large one thousand-capacity Top Rank-owned nightclub, the large-ish university and polytechnic halls, down to a few hundred-capacity, intimate gob-soaked clubs and pubs. Less obviously commodified and more insular, places such as the Limit Club, The Penthouse, The Crazy Daisy, The Hallamshire, The Marples and The Black Swan played host to mainly local bands and bands yet to break. Trawling the streets for punk records took you across the city, word of mouth leading you to the fifty-pence bargain bins of department stores and chains such as Woolworths, Debenhams and Rediffusion, and bizarre locations such as car spares shops for picture sleeve-less ex-jukebox records. New releases could be bought from record shops such as Virgin and Violet Mays, or Revolution Records which dealt specifically in punk titles. Information on new record releases and tours was obtained by word of mouth or through the music papers, *Sounds*, the *NME* and *Melody Maker*, which provided listings for gigs, record reviews and band interviews. All operated within a wider commodity culture, driven to different degrees by profit. From a series of urban encounters, producer and consumer alike could ingest punk's changing dress codes.

> Started wearing Dad's old pyjamas, and some of the old shirts he wears for decorating. Get into slashing and mutilating anything I can get my hands on. Jumble sales open up new world of clothes; dye old string vests orange, get an old suit and some collarless shirts, which I stencil. Find Revolution Records on the balcony of the Haymarket. Talk about a rough place!!! But loads of punks inside and interesting records; buy old Vibrators and Only Ones singles – better than Virgin and Violet Mays put together. Start buying *Sounds* or *NME* every week for concerts, interviews and 'what punks are wearing' type of information. Later scrutinise *NME* photography of riots in London after Clash concert was cancelled. Buy fake leopardskin trousers off a mate and send off for punk PVC motorbike jacket from back of *Sounds* music paper. Get it back and I'm disappointed because it looks crap – remedy situation by daubing it with graffiti. Buy Italian army trousers from surplus store and Doctor Martens: tempted to spray them green but resist. Stencil the Clash, 'Complete

Control', onto my jeans (which have also been taken in, have to step on them to pull them off). Cut collar out of T-shirt and stencil 'Bored' on it. Root around army surplus stores for big US army-issue trousers.

Within Sheffield, punk clothing could be purchased from a range of establishments: leather jackets and trousers from Lewis Leathers, a motorbike-clothing retailer; Doctor Martens and army fatigues from army surplus chains. Catering specifically for punks were shops such as Promotaprint that sold mohair jumpers and PVC trousers and T-shirts, mostly made-up by the owner, inspired by what punks were wearing. Clothing was also acquired from trips to shops such as X-Clothes in Leeds, which stocked bondage trousers, mohair jumpers, T-shirts, and Crazy Colour hair dye. Another source appeared in the back of *Sounds* and *NME*, in the from of mail order advertisements, offering plastic punk PVC motorbike jackets, bondage trousers, punk badges and an array of fake Westwood and McLaren 'Seditionaries' merchandise. Through these outlets punk fashion grew and mutated, sited within, and inextricably linked to, a much broader culture. The synthesis between real urban space as the site of commodity exchange, and style as a determinant of youth culture, was solidified within the networks of information that swam between them. As a result punk clothing was rapidly commodified, and in order for both producer and consumer to differentiate themselves, this process was reflected in the evolution and mutation of punk fashions, simplistically defined as follows:

1 *c.*1975 and onwards nation-wide. Dress influenced by David Bowie and Roxy Music. Pre-punk, 1940s suits, peg trousers, winklepickers and jelly shoes. Introduced within an arena of various 'do-it-yourself' modifications and experimentations.
2 *c.*1975–78: An exclusive London style based on the clothes available from Sex, Seditionaries and later Boy. The King's Road ex-art school scene of Vivienne Westwood and Malcolm McLaren, fully conversant with the workings of commodity culture promoted ceaselessly through the media.
3 *c.*1976–79. A 'street level' look which co-existed alongside the above: old narrow suits with narrow lapels, straight-leg trousers, dresses and shirts (small or no collar) from jumble sales and charity shops, plastic sandals, home-made T-shirts and stencilled slogans, combat fatigues and mohair jumpers.
4 1979 onwards. An iconic punk look derived in part from traditional male rock 'gear', black, studded, leather jackets, and Doctor Marten boots, bondage trousers and a predominance of black.
5 *c.*1980 onwards. Much the same as above but Mohicans exaggerated in both size and colour, more extreme body piercing and adornment, a culture related to the political doctrines of both the Left and Right promoted by bands such as the Exploited, Crass and Discharge.

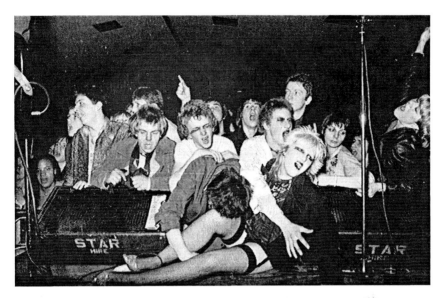

Figure 8.2 View of the audience at a Ruts gig, 1979 (note vastly differing modes of
hairstyles and dress).
Source: Photograph by Syd Sheldon.

Though there were a series of stylistic identities, both temporally and spatially
diverse, the visual history of punk has generated an iconographic look, frozen
c.1979. Adopted late in the cycle of punk fashion, its iconic status is a reflection of
its 'shock' value, a visual, highly charged version of punk, which could be sold to
both the tourist and the media, by posing for the camera. The repetition of such
images in publications has resulted in the establishment of a homogenous punk
'style'. As a consequence, other dress codes less visually exciting, but perhaps
more typical, have disappeared from such publications, presenting a partial and
inaccurate history of punk fashion. The spiked Mohican haircut, bondage trousers
and studded leather jacket (see Laing 1989: 95) have become 'commodity punk',
the resale value of punk culture. Punks today literally buy into this image – it is
now an iconic code, serving as a medium for the expression of a particular youth
cultural lifestyle.

> Get Lewis Leather, best motorbike jacket in the world. Told to piss on it
> to make it look old. Sorely tempted, but use saddle soap instead.
> Persuade mother to buy me bondage trousers for birthday. She comes
> with me, shameful, and 'oohs' and 'aaahs' about price and lots of zips and
> straps and you'll trip up. Buy 'London Calling' Clash T-shirt which gets
> nicked in frantic dance session and also a mohair jumper knitted with

broomsticks according to Mum, which falls to bits. Bondage trousers ditched after about two times, look too new and make me feel crap, too commercial. Buy PVC trousers from shop near station, and jumper like Captain Sensible's made out of bathroom rug: itches like fuck. Introduced to what I later come to know as homosexuality when a man asks me where I got my trousers from and then proceeds to feel them for what, to me, appears to be an unusual length of time. White with blue stripe Adidas basketball boots are the new flavour – but badges on them. Borrowed Stiff Records 'If it ain't Stiff it ain't worth a Fuck' T-shirt: has to be sneaked in and out of the house.

Within the two axes under discussion an unresolved tension lurks, between, on the one hand, a historiography that seizes upon a highly visual, commodified version of punk dress, and a cultural theory which appears frozen within a non-commercial environment. This presents a scenario where the presence of either undermines both. Published in 1979, now in its fifteenth reprint, the key theoretical text in relation to punk style is Dick Hebdige's seminal account *Subculture: The Meaning of Style* (1979). In this, Hebdige reads subcultures, particularly punk, as an ideological resistance to the dominant hegemony based on the notion of subcultures as a typically working-class phenomenon. Cordoning off an uncommodified punk style by looking towards an 'authentic' period never specifically defined, yet magically achieved, Hebdige removes it from the everyday cycle of commodity exchange.[4] In this space, dress is then read as a symbolic resistance to the hegemonic order, reflected through the art of 'bricolage', the mixing and matching of hitherto unrelated clothing and objects, resulting in the appropriation of, and altering of, these objects' meanings, which oppose the standard hegemonic, or dominant, readings.

Such a landscape, however, provides a static picture that fails to recognise difference, change and evolution related to both individual and physical space, reducing punk style to a single simple paradigm. The pre-eminence given to symbolic resistance within Hebdige's work centres discussion upon the vague determinants of style highlighted through marauding raids on a wider culture where mundane objects (the safety-pin and dog collar) can, through the magical alchemy of semiotics, be elevated from their traditional humbleness to signs of a culture's resistance. Yet such readings too often fail to chime with those within punk culture. As Joe Strummer of the Clash suggests, bands, who were the visual style guides of punk culture, were not necessarily aware of the precedents, or symbolic legacy, of punk fashion:

After the Pollock look we got into stencils and stuff. Bernie Rhodes was guiding and packaging. . . . He probably suggested that we write words

on our clothing: I never knew much about that Situationist stuff, still don't today, but that's where it came from.

(Savage 1991: 230)

Whilst band managers such as Bernie Rhodes[5] and Malcolm McLaren manufactured the image of groups like the Clash by raiding past cultural movements for inspiration, they distanced themselves from Hebdige's 'symbolic resistance' through the act of commodity promotion. This commodity, the 'look' and 'style' of the group, was then disseminated through the media as an 'authentic' punk look.

Figure 8.3 More classifieds, music press 1979. By now punk gear was a mini-industry. *Source: Sounds.*

And, like many of the bands, this 'symbolic resistance' attached to punk dress was lost to the vast majority of fans who could relate to punk's oppositional values only in vague terms of difference or shock, often already codified from outside by the wider media.[6] Though Hebdige acknowledges the possibilities of differing readings and levels of understanding amongst punks he still looks towards an ill defined 'elite', the '*first wave of self-conscious innovators*' (Hebdige 1979: 122), the 'authentic' punks, who understood the significations Hebdige puts forward. For the 'average' punk a more likely scenario would be that clothing was regarded as an expression of style, a cultural language that formed a community. Style and taste, or fashion, not being a homogenous construct, was expressed on both group and individual levels, within differing spatial and temporal sites. And, as Hebdige argues, the potential to inscribe or create meanings within clothing is multiple or polysemic, which allows any group or individual the possibility of attaching their own meanings and signification to a garment. The resultant dress codes differed from individual to individual, city to city, while groups, such as, for example, the Stranglers[7] had fans who adopted particular styles falling outside the standard remit of 'punk fashion'. Just as mods had 'ace faces' there were those punks who dressed 'stylishly', attempting to stay 'ahead of the pack' in fashion terms. Thus the reasons for the adoption of particular styles are multiple and not tied to a single preferred reading such as 'symbolic resistance', rendering Hebdige's proscribed reading of punk fashion at best opaque.

In many ways the undercurrents within Hebdige's work on punk imply a return to the same high ground as many twentieth-century cultural theorists who saw 'resistance' in a 'space' standing outside the dominant culture in avant-garde art, music and literature, in essence an uncommodified high culture. In a mirror inversion of such models, Hebdige locates this space/retreat, in 'authentic' punk which, like high culture, is seen to undermine the dominant culture by working outside its paradigmatic formation. However, this desire for a magical authenticity existed not only within Hebdige's work but also within punk culture itself. The 'part-time punk', 'weekender' and 'poseur' were themselves targets for potential exclusion from the 'authentic' culture. Yet with neither rules nor norms that could satisfactorily distinguish the 'true' punk from the 'poseur' such claims were determined subjectively. Working or unemployed, at college or at school, the micro-climates punks inhabited mediated and shaped their own individual experiences. Moving from the micro- to the macro-environment, any claims to identifying an 'authentic' punk, without likewise ascribing the practices that make one so, must also be read subjectively.

Meet punks from other side of the city at Angelic Upstarts concert, they're great but can tell they resent us because of where we're from. See Ramones, Clash and Stranglers in same week. Two 'punkettes' scare the

shit out of me. One goes to private girls' school and other's dad's a vicar. Both spit, drink, swear constantly, have sex constantly, much scarier than anyone I've ever met. I dye my hair black (doesn't take properly), shave half eyebrows off on one side, half on other, lopsided face, looks great, but teachers not impressed, sent home. Have fight with J.D. because I call him a part-time punk. Bloke turns up at concert with dog collar on as worn by vicars. Misunderstood 'dog collar' but still looks good.

Hebdige's location of the 'authentic', as a rapidly lost symbolic challenge to the practice of commodity exchange, fails to recognise punk's ongoing symbiotic relationship with such exchange and the need for that relationship to reflect wider cultural formations. Moving towards alternative interpretations, 'authenticity' can be viewed as a commodity contingent upon a set of both learnt (education in dress codes, music, the taste preferences of others) and unlearnt (innovation, style) variables which locates punks within its own system of fluid values.[8] Using Bourdieu's *Distinction: A Social Critique of Taste* (1984) one comes to see 'authenticity' as being revealed through processes of interaction, of finding symbols with a shared cultural value, which are both temporally and spatially bound to one another. Bourdieu classifies different cultural groups by their taste formations, which are expressed through, and established within, their chosen patterns of consumption. Following on from Guilianotti's work, if one inserts punk youth culture in place of Bourdieu's definition of a new petit bourgeois, one can see how through 'transmitting or appending meaning to cultural significations before wider consumption' (Guilianotti 1993: 158), punk has expanded and widened 'the range of legitimate cultural goods leading to the dismantling of the old symbolic hierarchies' (Bourdieu 1984: 337). Like Bourdieu's petit bourgeois, punk created new cultural references through music and dress, identified within changing parameters of consumption and production.[9] Within such a system, to specify a point or period of 'authenticity' is impossible. Whilst punk's cultural identity can be interpreted as resistance, it can also be regarded as an assertion of difference, implying not only an antagonistic relationship to a broader culture, but an internal construction of an identity that could also be termed *pro*-active as opposed to *re*-active. Such a model replaces Hebdige's pessimistic view of the commodification of punk into mainstream culture by a model of a culture expanding and challenging the old values and norms of wider society. Thus, rather than seeing the cycle as one of ultimate recuperation and loss of 'authenticity', as 'struggle', it can now be measured in terms of its success or failure in introducing new codes of dress and behaviour.

Like any culture, punk was a 'production', the final product created from a series of possibilities. However, this production, once monopolised by youth cultures, was borrowed from and used by other groups in the formation of new

social parameters of dress and style. Starting off with a range of dress styles, which evolved spatially at different rates before the amalgamation and fixing of a 'punk dress code', punk fashion was a process of discrimination and rejection. Discussed solely in terms of authenticity and symbolic resistance, punk dress loses the fluid boundaries that were constantly being redefined by members of the subculture. Choosing to see this process as a series of spatial and temporal events allows room for such fluidity, related to specific forms of information flow, be they through individuals, record sleeves, music magazines, live concerts or actual retailers displaying 'new' clothes. Within such a dynamic culture the best one can do is point out differences by articulating a position which does not attempt to override time and place and which acknowledges the tentative nature of punk style created out of so many indeterminate social matrixes. This does not necessitate the dismissal of either the present historical interpretations of punk or the cultural theory centred around punk as 'symbolic resistance'. However, there needs to be a willingness to acknowledge youth cultures as an integral part of the wider system of production and consumption, for it is within this arena, and not one of mythical 'authenticity', that youth cultures grow and consolidate.

> Tired of spitting and swearing all the time and I know I was late becoming a punk but even I can't help feeling it's getting a bit dated. Pogoing's stupid and I don't like the new bands. Getting bored with punk, into the Specials, think I'll become a mod: that's new. Crashed M.M.'s party last week with Jam shoes on. Bloke comes up and says 'I'm a Mod let me wear them and you can wear my "Docker" boots'. What a weirdo, should get out more and get a life, but I do it anyway because he looks hard. Puts me off becoming a Mod if that's what they're like.

Notes

1 These are an amalgamation of the author's memories from 1978 onwards. They are not in a strict chronological order nor are they a complete account.
2 There are exceptions which, whilst concentrating mainly on London, look to other urban areas, see Savage (1991) and Boot and Salewicz (1997).
3 For an argument on the uneven historical relationship between space and time see Harvey (1989).
4 D. Hebdige acknowledges the process of commodification and locates punk's resistance through appropriation, ending in mail order clothing in the summer of 1977, (1979: 96). However, three pages prior to this he claims 'the media's sighting of punk style virtually coincided with the discovery or invention of punk deviance' (ibid.: 93).
5 Immortalised as a band manager of certain repute in the Special AKA (later Specials) first single, 'Gangsters'.

6 For a fuller argument on the role the media plays in shaping youth culture, see Cohen (1980), and for an exploration of the reading of clothing see McCracken (1990).
7 Stranglers fans, like the band, adopted 'The Men in Black' look. This alongside their dancing style, imitating the bass player Jean-Jacques Burnel, differentiated the fans from other punks.
8 The problematic nature of the division between 'learnt' and 'unlearnt' and the distinctions between environmentally learnt and 'pure' aesthetic judgements, cannot be adequately developed in such a short article, but I acknowledge the immense difficulties involved in using such terms.
9 Guilianotti (1993), in his study of soccer casuals, and Thornton (1995), in her study of club cultures, have both used Bourdieu's work to reinterpret the relationship between youth cultures and patterns of consumption.

Bibliography

Boot, Adrian and Salewicz, Chris (1997) *Punk: The Illustrated History of a Music Revolution*, London: Boxtree.

Bourdieu, Pierre (1984) *Distinction: A Social Critique of the Judgement of Taste*, Cambridge, MA: Harvard University Press.

Cohen, Stanley (1972; rev. edn. 1980) *Folk Devils and Moral Panics: The Creation of the Mods and the Rockers*, Oxford: Martin Robertson.

Guilianotti, Richard (1993) 'Soccer Casuals as cultural intermediaries', in Steve Redhead (ed.), *The Passion and the Fashion*, Avebury.

Harvey, David (1989) *The Condition of Postmodernity*, Oxford, Blackwell.

Hebdige, Dick (1979) *Subculture: The Meaning of Style*, London: Methuen.

Laing, David (1985) *One Chord Wonders: Power and Meaning in Punk Rock*, Milton Keynes: Open University Press.

McCracken, Grant (1990) *Culture and Consumption*, Bloomington, IN: Indiana University Press.

Savage, Jon (1991) *England's Dreaming: Sex Pistols and Punk Rock*, London: Faber & Faber.

Thornton, Sarah (1995) *Club Cultures: Music, Media and Subcultural Capital*, Cambridge: Polity.

9

'CHEWING OUT A RHYTHM ON MY BUBBLE-GUM'

the teenage aesthetic and genealogies of American punk

Bill Osgerby

I met her at the Burger King
We fell in love by the soda machine
So we took the car downtown
The kids were hanging out all around
Then we went down to Coney Island
On the coaster and around again
And no one's gonna ever tear us apart
'Cos she's my sweetheart
All right
Oh yeah

(The Ramones, 'Oh, Oh, I Love Her So', 1977)

'Well, I don't care about history / 'Cos that's not where I wanna be'

The distinguished British historian E.H. Carr could never, by any stretch of the imagination, be thought of as a crazy rock 'n' roller – too fast to live and too young to die. Nevertheless, though Carr was never spotted pogoing at the Marquee Club, charged up on sulphate and the latest Adverts' single, his observations on the nature of history provide an insightful pointer to the way particular narratives have struggled to constitute themselves as the authoritative account of the nature and genealogy of 'punk rock'.

For Carr (1987), the practice of history is not the straightforward collection of elemental 'truths' but is, rather, an active process of selection. Instead of being the simple curator of a corpus of ascertained 'facts', Carr argued that the historian is engaged in practices of active judgement and interpretation – processes which

154

inevitably embrace marked dimensions of debate and controversy. And nowhere has the debate been more acrimonious than in the excavation of the heritage of 70s punk. Peter Marsh's early (1977) reading of British punk as 'dole queue rock' – the voice of a desolate and dispossessed generation – was quickly discredited as woefully off-target. Greater accuracy came with Simon Frith's account of punk's bohemian lineage and its place within the traditions of British radical art (Frith 1978; Frith and Horne 1987). Greil Marcus's (1989) more fanciful speculations on the links between the Sex Pistols and European movements of artistic sedition have commanded respect in some quarters[1] but in others they have met with scorn. In a particularly acerbic critique, Stewart Home (1995) attacks Marcus for 'pandering to intellectual posers', delivering a rain of swingeing blows to what he sees as Marcus's historical inaccuracy and lack of intellectual sophistication. Nor has John Lydon been impressed by attempts to bracket punk with Left Bank bohemia, dismissing Marcus's thesis as 'bollocks' – an erroneous fantasy contrived for coffee-table revolutionaries (Lydon 1994: 4).

In contrast, relative accord seems to have settled around the historiography of the American branch to punk's family tree. Conventional wisdom on the history of American punk receives its fullest explication in Clinton Heylin's *From the Velvets to the Voidoids* (1993). Heylin identifies several distinct moments in the germination of American punk. In the early 70s he cites a range of important precursors – most obviously the jagged fury of the MC5 and the Stooges in Detroit, in Boston the stripped-down intensity of the Modern Lovers and, in New York, the artistic vanguard that formed around Andy Warhol and the Velvet Underground – a milieu that bore later fruit in the glam-trash of the New York Dolls and Wayne County. Heylin recognises two separate 'waves' in the subsequent evolution of American punk. The first saw artists such as Television, Patti Smith, the Ramones and Blondie make their debuts in 1973–74 at New York clubs such as Max's Kansas City and CBGB, while in Cleveland pre-punk exponents the Mirrors, the Electric Eels and Rocket from the Tombs were honing their art. Heylin's 'second wave' followed swiftly on their heels. Centred on New York, the ranks of this contingent were drawn from bands that had either gravitated to the verve of the developing scene (the most notable example being Talking Heads) or had been formed from fissures and splinters among the original trail-blazers – for example, the Heartbreakers, Richard Hell and the Voidoids, Pere Ubu and the Dead Boys.

A meticulously researched and compelling narrative, there is much to commend in Heylin's account. Yet his interpretation – like all historical writing – is selective and partial. In particular, two key areas of omission and bias demand redress. First, Heylin's interest in New York's artistic underground is understandable, yet it leads towards an unduly blinkered frame of reference which underestimates the contribution of other, decidedly less avant-garde, influences. Specifically, his 'pre-punk history for a post-punk world' says little on the role played by 60s surf,

garage and fuzz bands in shaping the attitude and style from which many American punk artists later took their cues. Second, the polarity Heylin establishes between an 'art crowd' (Patti Smith, Television, Pere Ubu, Talking Heads, Suicide) and a 'fuck art, let's rock!' mentality (Dictators, Ramones, Blondie, Dead Boys) is not only simplistic but ultimately leads to a cultural hierarchy in which the former are valorised as 'serious, creative artists', while the latter are implicitly belittled as good-time lightweights.

Overall, then, it is the 'pop sensibility' in the history of American punk that requires deeper scrutiny. Greater recognition needs to be given to the way artists such as the Dictators, the Ramones, Blondie and Johnny Thunders drew influence not only from the post-progressive fall-out of the Stooges and MC5, but also from a pop heritage that encompassed the bobby-soxed girl groups of the 50s and the rough-and-ready surf, 'frat rock' and garage bands of the early to mid-60s. Moreover, while the 'fuck art, let's rock' brigade may not have pondered on existential philosophy and conceptual art, in other respects they remain of crucial significance. Specifically, these bands were masters of mischievous camp – subscribing to a set of aesthetic codes defined by Andy Medhurst as a 'playful, knowing, self-reflexive theatricality' (1991: 154). Plundering the vaults of American popular culture, bands such as the Dictators and the Ramones created a playfully ironic pastiche of suburban adolescence. Here, the stereotypes and iconography of 'teenage' life – one of the great mythologies to emerge from the clear-eyed confidence of American consumer culture – were both blissfully celebrated and mercilessly parodied.

'Pleasant Valley Sunday': the mythologies and music of teenage suburbia

'Punk rock' is not a particularly illuminating label. A contrived and superficial category, it blurs across a diversity of genres and sub-genres, often obscuring more than it reveals. Similarly, as Stewart Home (1995: 44) observes, the fluidity and sheer amorphousness of 'punk' makes attempts to fix precise points of origin a futile exercise. However, to make sense of the 'teen aesthetic' that was the pole star in punk's pop sensibility, we must turn to the green-lawned suburbs of America during the 50s and early 60s – for it was here that punk's immediate predecessors (surf, garage and fuzz) first surfaced. Here, too, emerged 'the teenager'. A mythologised version of American adolescent life, 'the teenager' encapsulated the consumer society's hedonistic fantasies of unbridled leisure, pleasure and carefree fun – a set of images and stereotypes that 70s punk both relished and lampooned.

The 'teenage' mythology was spawned from the matrix of profound economic and social changes in white, middle-class life after 1945. Traditional middle-class virtues of hard work, moderation and thrift (already looking dated in the 1920s) became an anachronism during the 50s and early 60s as American capitalism prioritised consumption and immediate gratification. The burgeoning middle-class suburbs (whose population surged from 21 million in 1950 to 37 million by 1960) saw the rise of a lifestyle that consciously embraced a world of hedonistic leisure and conspicuous consumption – a comfortable and reassuring universe of station wagons, backyard barbecues and Little League ball games.[2] As the Cold War super-powers squared up, suburbia became a metaphor for the vitality and virtue of American free-market capitalism. It was no accident that the centre-piece of the American National Exhibition in Moscow in 1959 was a life-size model of a six-room ranch-house stocked full of American consumer goods. As Vice President Richard Nixon and Nikita Khrushchev toured the exhibit, Nixon lectured the Soviet Premier on how the social order in the United States approached perfection, insisting that 'American superiority in the Cold War rested not on weapons, but on the secure, abundant family life of modern suburban homes' (Tyler May 1988: 16–17).

Nixon could equally have pointed to the growth of adolescent consumption. By the late 50s the growth in young people's disposable income had highlighted them as a distinct cultural group with specific consumer demands and an array of industries scrambled to cash-in on youth spending.[3] *Life* magazine was already stating the obvious in 1959 when it pronounced that:

> The American teenagers have emerged as a big-time consumer in the US economy. . . . Counting only what is spent to satisfy their special teenage demands, the youngsters and their parents will shell out about $10 billion this year, a billion more than the total sales of G.M.[4]

Social reaction to post-war youth culture was initially ambivalent. The late 40s and early 50s, for example, saw considerable anxiety about possible links between the growth of mass culture and an apparent rise in juvenile crime. However, as James Gilbert (1986: 213) argues, the growing scale and economic importance of the youth market made it impossible to draw a simple equation between commercial youth culture and delinquency. Instead, by the beginning of the 60s, advertisers and political pundits were presenting patterns of youth consumption as 'an innovation to be celebrated' (ibid.: 195). Above all, it was the notion of 'the teenager' that crystallised this more positive type-casting of youth. Throughout the 50s and early 60s an avalanche of books, magazines and newspaper articles revealed to the American public a new 'teenage' caste with its own culture and lifestyle. However, more than a simple descriptive term, 'the teenager' was an ideological

vehicle which – like Nixon's prosperous suburban home – stood as a symbol of America's bold march into a new age of hedonistic and leisure-oriented consumption. The myths of abundant teenage fun epitomised the ideals of the American consumer lifestyle – and it was these myths that 70s punk would disinter and reconstitute as camp bricolage.

The mythology of a prosperous, teenage America exaggerated and distorted social reality – large sections of the youth population always being excluded from the affluent 'teenage' lifestyle.[5] Yet, during the late 50s and 60s the figure of the affluent and carefree 'teenager' stood as a powerful image of American confidence and prosperity. Moreover, like all mythologies, notions of 'teenage affluence' contained a kernel of truth. The growing prosperity of white suburbia sustained not only a flourishing commercial youth market, but also a range of new youth cultures and subcultures – in particular, a wide array of grassroots music-making cultures that were the progenitors of 70s punk.

Especially significant were the plethora of surf-oriented instrumental bands that emerged from the beach towns and suburbs of California. Rooted in the rock 'n' roll guitar styles of Duane Eddy, the Ventures and Link Wray, surf music found its own figurehead in Dick Dale. 'The King of the Surf Guitar', Dale was himself a surfer and perfected his distinctive playing style – a double-picked staccato, heavily doused with reverb – at the Rendezvous Ballroom in Balboa where, between 1959 and 1961, his shows attracted audiences of thousands. Between 1962 and 1964 a legion of young surf bands followed in Dale's wake. The success of Californian bands such as the Chantays and the Surfaris spawned imitators all over the country, young surf bands finding a niche playing at town dances and 'Battle of the Bands' competitions, shopping malls, fraternity parties and high school hops. Radio stations (and in some cases even local TV networks) played their part in promoting surf, while America's established history of independent record production allowed young unknowns to press as few as several hundred copies of their tracks to either sell or give out at gigs. Such was the impact of surf music that surf-oriented combos sprang up in even the most unlikely locations. The Astronauts emerged from Colorado, Michigan boasted the Rivieras, while Ronnie and the Daytonas hailed from that little known beach town – Nashville.[6]

Tales of mid-western collegians driving to town dances with surf boards strapped to the roof of their pick-up truck are apocryphal. Nevertheless, taken to its peak in 1963 by clean-cut high-school boys Jan and Dean and the Beach Boys, the surf scene was a defining moment in the evolution of American teenage mythology – 60s surf finding resonance among middle-class youngsters who wanted to recognise themselves in the 'promised fantasy land of woodies and wet-suits, baggies and bikinis – of golden flesh and innocent sex' (Hoskyns 1996: 57). A potent signifier of the American Teenage Dream, this adolescent beach utopia

would be revisited in the 70s, bands like the Dictators and the Ramones reconstructing it partly in celebration and partly in camp parody.

By the mid-60s the tide of surf music was ebbing as Beatlemania and the British invasion swept through the tastes of young America. Yet the grassroots music traditions of surf lived on in the garage, fuzz and 'frat rock' bands of the mid-60s. According to pop folklore the garage (that abiding signifier of homely suburbia) was the place where aspiring guitar legends thrashed through their rehearsals – thus 'garage' became a sobriquet for the crude and raucous sounds pounded out by a legion of three chord wonders wielding Vox and Fender guitars and Farfisa organs, the mixture always heavily spiked with fuzztone distortion.[7] From the myriad mid-60s garage bands a few managed to get regular gigs on local high-school, college and dance-hall circuits and some even got as far as cutting a record – many subsequently exhumed in album collections such as *Nuggets*, *Pebbles*, *Back from the Grave*, *Garage Punk Unknowns* and innumerable other compilation series.[8] The better garage punk bands made it to bigger venues and some managed to attract the interest of major labels, the garage role of honour featuring such luminaries as the Wailers, the Standells, the Sonics and the Kingsmen – the latter's version of 'Louie, Louie' being hailed by Dave Marsh (1993: 165) as punk rock's defining ur-text. The Trashmen also deserve special mention. Beginning life as Minneapolis's leading surf quartet, the Trashmen's finest moment came at the end of 1963 when their 'Surfin' Bird' (a track that bore more than a passing resemblance to 'Papa-Oom-Mow-Mow', released a year earlier by the Rivingtons) became a coast-to-coast hit – later to be covered by both the Ramones and the Cramps as these 70s punk stalwarts paid their dues to their garage/surf forebears.

By 1966/67 the exuberant fervour of the garage scene was still maintained in the 'garage psych' rawness of bands such as the Seeds – but overall the slide into progressive rock saw the rise of a more self-conscious, indulgent (even pretentious) style of performance. However, at the same time as psychedelia and countercultural protest took hold of college campuses, the teen-fantasy of innocent good-times remained alive and well as 'bubble-gum' pop funsters took up where the likes of the Trashmen had left off.

Bubble-gum pop was derided by its critics as puerile pap – pre-packaged and instantly disposable. Indeed, there is no denying the calculating commercial stratagem behind the bubble-gum stables sired by pop moguls such as Kasenetz and Katz and Don Kirshner. Nevertheless, manufactured bubble-gum bands like the 1910 Fruitgum Company, Ohio Express, the Archies and, of course, the Monkees turned out deftly executed pop hits distinguished by a pumping dance beat and simple but catchy chorus hooks and instrumental riffs. Moreover, built around the simple images of sweet-toothed candy, zany cartoons and comic book romance, the soft-centred bounce of 'bubble-gum' was the purest manifestation of the American teen aesthetic. And it was from here that punk's pop sensibility drew many of its

motifs and reference points as it elaborated a theatrical parody of the mythologies of teenage suburbia.

'teenage lobotomy': Pop sensibilities and punk pastiche

In his painstaking history of British punk, Jon Savage (1991) highlights the movement's origins in the leafy environs of London's commuter belt, locating punk in a suburban thread that runs through the history of British pop. Drawing on Savage's work, Vicky Lebeau further highlights British punk's relationship with suburbia, suggesting that punk embodied 'an attempt to expose the madness and perversity' of suburban culture (Lebeau 1997: 283). The pop sensibility in American punk was equally rooted in a set of suburban cultural traditions – though was more specifically grounded in an encounter with the mythologies and icons that had come to surround *teenage* suburban life. American punk elaborated a tongue-in-cheek pastiche of drive-in movies, high-school proms, beach parties and the whole iconography of carefree 'teenage kicks'. Here, the kitsch emblems of post-war America's consumer-culture were simultaneously parodied and celebrated for, as Simon Frith observes cogently, a suburban sensibility 'means a camp sense of irony, a camp knowingness, a camp mockery, a camp challenge: *do they really mean it?*' (Frith 1997: 272).

The pioneers of punk's playful satire on the teen mythology were the Dictators. Formed in 1973 in upstate New York by Dictator-in-Chief Andy ('Adny') Shernoff and guitarists Ross 'The Boss' FUNichello and Scott 'Top Ten' Kempner, the Dictators crafted a sound and image that became the trademark of American punk's pop sensibility. A Stooges and MC5 fan, Shernoff made his first sortie into rock 'n' roll with *Teenage Wasteland Gazette*, a fanzine whose sardonic humour he soon injected into the Dictators. Fed up with the 10-minute concertos that had become the staple of American rock, the Dictators' sound was stripped to the bone – a loud, fast, three-chord tornado that harked back to the golden age of garage and fuzz. Visually, the Dictators were a cross between a New York street-gang and the Hair Bear Bunch, while their first album, *Go Girl Crazy!*, was a hymn to the junkyard of American teen culture (see Figure 9.1). A world of hangin' out, hamburgers and 'B' movie schlock was deified in tracks like 'Teengenerate', 'Master Race Rock', 'Weekend' and '(I Live For) Cars and Girls' – a song which both satirised and lovingly caricatured the American teen idyll with the immortal line 'Cars, girls, surfing, beer / Nothin' else matters here'.

The Dictators were a band ahead of their time. Quickly signed to a major label, Epic, their first album was recorded in 1974 and released in 1975 – thus pre-dating the ferment of New York's CBGB/Max's club scene. At this stage, however, a wider audience for the Dictators' brand of wit and energy did not exist. According

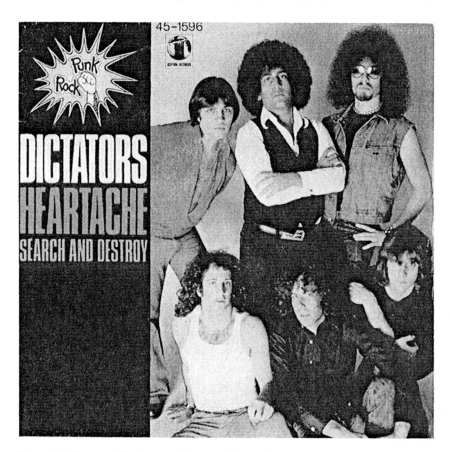

Figure 9.1 Sleeve to The Dictators' 'Heartache' single (Asylum Records, 1977). The band were a cross between a New York street gang and the Hair Bear Bunch (note explanatory 'Punk Rock' stamp on this Spanish pressing).

to Shernoff, 'the satire and irony were misunderstood. It was a little too out front'[9] – and as a consequence a lack of radio air-play meant the album never caught on and the band were dropped from Epic's roster. A period of re-assessment followed, and a line-up change saw 'Handsome Dick' Manitoba assume the role of front-man. Larger-than-life and a gargantuan party animal, 'Handsome Dick' had formerly been the Dictators' roadie, tour manager and 'Secret Weapon' – a bath-robed Manitoba taking to the stage for the band's ribald encores of 'Wild Thing'. An ex-wrestler, gourmet chef and self-styled 'handsomest man in rock 'n' roll', Dick Manitoba was the living, breathing embodiment of the ethos of adolescent good-times – and with 'the Handsome One' promoted to lead vocals, the Dictators found a new lease of life in the New York punk scene that emerged in 1976.

Possibly the most unsung heroes of rock 'n' roll, the Dictators' combination of freneticism and knowing irony laid the ground-work for the seventies punk explosion. Without the Dictators, for instance, Legs McNeil claims that he and John Holmstrom would never have established their hugely influential magazine, *Punk*:

> It wasn't until I heard *Go Girl Crazy!* that I thought someone else shared the same sensibilities that we did. After we heard that record, John and Ged and I kept saying, 'We got to find these guys! We got to meet these guys!' My only ambition in life became to meet Handsome Dick Manitoba. That's why we started *Punk* magazine, so we could hang out with the Dictators.
>
> (McNeil and McCain 1996: 334–5)

Launched in January 1976, *Punk* was conceived by McNeil and Holmstrom as a magazine devoted to 'rock & roll, like the Stooges and garage-rock, basically any hard rock & roll' (Holmstrom, cited in Heylin 1993: 242). However, *Punk*'s focus quickly zeroed in on the CBGB's crowd and the magazine became an intrinsic element to New York's subterranean music scene. According to Holmstrom, the name 'punk' was originally chosen for its shock potential: 'Punk was a dirty word at the time. Us putting Punk on the cover was like putting the word fuck on the cover. People were very upset. It was controversial' (Holmstrom, cited in Heylin 1993: 242). Yet the tone of *Punk* was always tongue-in-cheek rather than belligerent. *Punk* was packed with satirical stories and snippets, goofy cartoons and spoofs of teen-mag photo-strips, the latter culminating in *Punk*'s 'Monster Beach Party' issue – a 43-page beach-movie epic that starred Joey Ramone, Debbie Harry and a retinue of figures from the New York punk circuit (see Figure 9.2).[10] In its content and posture, then, *Punk* paralleled the ironic pop sensibility pioneered by the Dictators – an aesthetic style that reached its apogee in the Ramones.

Had comic-book bubble-gummers the Archies ever taken PCP they would, one suspects, have mutated into the Ramones. With their tight hooks, simplistic images and raw brevity the Ramones were a nightmare vision of a bubble-gum band – the bouncy tempo reduced to a mean buzz-saw frenzy and the catchy choral refrains twisted from 'Sugar, Sugar' and 'Yummy, Yummy' into 'Gimme, Gimme Shock Treatment' and 'Lo-bot-omy! Lo-bot-omy!!'.

The Ramones exemplified the 'camp knowingness' of Frith's 'suburban sensibility'. The band both revelled in and reviled the inane absurdities of life in New York's middle-class suburbia – as one of their early press releases explained: 'The Ramones all originate from Forest Hills, and kids who grew up there either became musicians, degenerates, or dentists. The Ramones are a little of each' (Bessman 1993: 16).

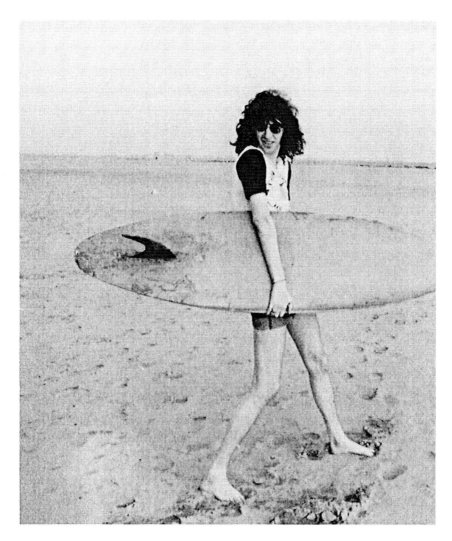

Figure 9.2 Joey Ramone goes surfing (1978).
Source: Photograph by Roberta Bayley.

Standard-bearers of CBGB's punk vanguard, the Ramones took the Dictators' gleeful, cartoon-like parody of American adolescent culture to new extremes.[11] Borrowing an alias used by Paul McCartney in his early Beatles days, band members (Johnny, Joey, Tommy, Dee Dee and later Marky, Ritchie, C.J. and – for one brief, fleeting moment – Elvis) adopted the surname 'Ramone' as a source of unity. The 'Ramone' appellation, however, could also be read as a jokey play on the schmaltzy sibling groups of the 60s and early 70s – the Osmonds, the Partridge Family and the Jackson Five.[12] 'Da brudders'' outfits of battered leather jackets,

ragged drain-pipe jeans and soiled sneakers also wryly echoed the twee uniforms favoured by the early Beatles, the Beach Boys and the Monkees. But whereas these 60s teen favourites had the image of fresh-faced and loveable 'boys next door', the Ramones proudly cultivated the image of geeky losers – as Johnny Ramone was later to quip: 'We wanted to write songs about cars and girls – but none of us had a car and no girls wanted to go out with us. So we wrote about freaks and mental illness instead'.[13]

The Ramones drew lyrical inspiration from the most tawdry corners of American trash culture. References to cheap drugs, delinquency, side-show freaks and lurid horror comics punctuated songs like 'Cretin Hop', 'Chain Saw' and 'Beat on the Brat'. Yet this was always underpinned by a knowing sense of dark humour. As Dee Dee Ramone once sniggered when quizzed on the wisdom of writing a song like 'Now I Wanna Sniff Some Glue':

> It's good for you. It expands your mind (laughter). Now we're all successful, happy people (laughter). . . . It was funny, though. 'Now I Wanna Sniff Some Glue' – *Nobody* would write a song like that. We thought it was *hysterically* funny.[14]

The Ramones' universe was always distinguished by a droll duality. Alongside their smirking caricatures of the dire fears lurking in the basement of the suburban consciousness, the Ramones also blissfully celebrated all the clichés and stereo-types of American teen mythology. As well as drawing influence from the likes of MC5, the Stooges and the New York Dolls, the Ramones were also inspired by the heritage of 60s pop and bubble-gum – their enthusiasm for all the signifiers of teen innocence and pleasure affectionately acclaimed in such songs as 'Oh, Oh, I Love Her So', 'I Wanna be Your Boyfriend' and 'Rockaway Beach'.[15] Yet even here the Ramones found it hard to keep a straight face. These anthems to the teenage myth were always part glorification, part ironic send-up. As rock critic Tom Carson explained with consummate insight in 1979:

> 'Rockaway Beach' is an East Coast take-off on a California surf epic – since Rockaway beach, in Queens, is one of the few beaches in America you take the subway to get to – but it breaks the parodic mold to become a genuine celebration of the place; there's the palpable delight in the very absurdity of this artificial teenage paradise stuck in the middle of the urban concrete.
>
> (Carson 1979: 111)

Although the Dictators and the Ramones were the main – and finest – exponents of the teen aesthetic in American punk, they were by no means alone. Blondie's

roots also lay in a camp reconstruction of 50s and 60s teen culture. Blondie began life as a reconstituted version of an earlier band, the Stilettos, whose act had been based around an exaggerated imitation of 50s and 60s girl groups. Aspects of this 'True Confessions'-style trash survived into Blondie's early material,[16] though these elements were soon buried under the band's commercial success and the stardom of Debbie Harry, their photogenic lead singer.

Camp pastiche had also been the forte of the New York Dolls. Though the 'Lipstick Killers' owed more than a little of their visual and musical style to the Rolling Stones, they were more than the simple 'Stones Clones' they were often dismissed as. As Van M. Cagle argues, the Dolls were recklessly brilliant in the way they careered through a spectrum of tacky retro, so that 'if Phil Spector's girl groups represented a glamorous sense of ocular vulgarity in 1962, by 1972 it was as if the Dolls had suddenly (re)discovered the male version of the lesson' (Cagle 1995: 158). After the Dolls' demise Johnny Thunders (who always owed more to the Shangri-Las than he did to Keith Richards) carried his vogue for camp trash though into the Heartbreakers. Following Richard Hell's early departure from the band, the Heartbreakers immersed themselves in camped-up garage pop. Unfortunately, under the pressure of band members' pharmaceutical excesses, the project barely left the launching pad.

Like Thunders, Stiv Bators also had a finely-tuned pop sensibility. As front-man of the Dead Boys, however, this was subsumed under his swaggering Iggy Pop mimicry. It was only in the solo material he produced after the Dead Boys folded in 1980 that Bators's affinity for the aesthetics of 60s pop was fully realised, his two solo albums fittingly released on Bomp Records – a label which had grown out of Greg Shaw's *Who Put the Bomp!*, a fanzine that had championed early 60s garage and pop since 1969.

Neither Thunders nor Bators, however, managed to capture the genius for irony and humour exhibited by the Dictators and the Ramones. The only band to come close were West Coast *idiots savant*, the Dickies – the second most unsung heroes of rock 'n' roll. Late-comers to the punk scene, the Dickies were formed in 1977 by a group of friends from Los Angeles's San Fernando Valley (California's answer to Bromley) – though it was singer Leonard Graves Phillips and guitarist Stan Lee who formed the band's nucleus. As legend has it, Graves Phillips saw the band as a good way to 'get laid, make money and get out of his bedroom' (Richmond 1991: 32) and the Dickies quickly established a reputation for camp humour and surreal theatrics. Their sound was a self-acknowledged mixture of the Ramones and the Monkees, mixing manic versions of children's TV themes ('Banana Splits', 'Gigantor', 'Toxic Avenger') and break-neck renditions of well-known rock standards ('Eve of Destruction', 'The Sound of Silence', 'Nights in White Satin'[17]), together with the band's own deranged compositions ('She's an Infidel Zombie', 'I'm Stuck in a Pagoda with Tricia Toyota', 'Stukas Over Disneyland').

Dickies performances also became legendary for Leonard's masterful one-liners and demented stage props – including various threadbare glove puppets and a giant, talking penis called Stuart.

In the Dickies, then, punk's simultaneous parody and celebration of commercial teen culture reached its apex – though by the late 70s the punk 'movement' (always an unstable amalgam of diverse concepts and influences) had splintered into a range of mutually suspicious sub-genres. Yet punk's teen aesthetic retained influence, surfacing both in British surf punk bands such as the Barracudas and the Surfin' Lungs and in the army of American bands who took the surf, garage and fuzz eras as their defining points of stylistic reference.[18] The revival of interest in punk in the late nineties, moreover, saw a 'new wave' of bands (Green Day, the Offspring, Pennywise)[19] elaborating a pastiche of the teen mythology similar to – indeed fundamentally indebted to – the earlier camp ironies of the Dictators, the Ramones and the Dickies.

Conclusion: 'There's No Stoppin' the Cretins From Hoppin''

This, admittedly polemical, treatise has sought to establish two key points about American punk rock. First, while there *is* truth in accounts which cite bohemia and radical art as an influence on the 70s punk milieu, the role of less cerebral cultural forms must also be highlighted – specifically the suburban pop tradition that runs from 60s surf, through garage and fuzz rock, to the bubble-gum ebullience of the early 70s.

Second, those punk bands often dismissed as little more than a silly, juvenile pantomime actually produced keenly observed (even poignant) commentaries on American cultural life. Yes, they were funny. But, more than this, bands like the Dictators, the Ramones and the Dickies also elaborated a camp parody of America's teenage myth – and in so doing they sent-up (even subverted) many of the mythologies of unabashed consumption and confident affluence that had been at the heart of Nixon's 1959 suburban fantasy.

Up until 1996 the Ramones were still there – four middle-aged men in biker-jackets, belting out three-minute eulogies to being a 'teenage schizoid'. To some it seemed vaguely surreal. But that was the point. That was always the point. As Tom Carson observed of 'da Brudders' 20 years earlier: 'American myths are never so immediately recognizable, and irresistible, as when they're turned into a joke' (Carson 1979: 108).

Gabba Gabba Hey!

Notes

1 Marcus's influence can be detected in many subsequent attempts to chart the development and significance of punk. See, for example, Neil Nehring's (1993) exploration of the volatile relations between literature, rock music and post-war youth subcultures.

2 Though the origins of suburban growth in America lie in the inter-war period, these patterns of development were significantly intensified during the late 50s and early 60s. See Boyer (1995: 130–37) and Palen (1995: 49–67).

3 As Paula Fass's (1978) extensive survey of youth in inter-war America shows, an identifiable youth culture already existed in the 1920s. Yet, during the 50s and early 60s, the commercial youth market expanded significantly, giving greater definition to young people as a distinct cultural group. For overviews of the growth of the commercial youth industries during this period see Gilbert (1986: 196–211); Doherty (1988: 17–41); Palladino (1996: 96–174).

4 *Life*, August 31, 1959, cited in Doherty (1988: 52).

5 The 'teenage' experience was, for example, essentially a white, middle-class universe. As Grace Palladino argues, the iconography of 'teenage' America was almost exclusively white and 'black teenagers remained invisible as far as mainstream society was concerned' (Palladino 1996: 175–6).

6 Details of surf music's taxonomy and lineage are still largely the preserve of a small band of surf cognoscenti, yet the best historical surveys of the genre can be found in Burt (1986); Dalley (1988); Blair and McParland (1990); and Blair (1995).

7 The definitive history of early and mid-60s garage and fuzz is yet to be written. Until then, Vernon Joynson (1993) provides a detailed and accurate collection of discographies. The garage punk scenes of the south and mid-west, meanwhile, are devoutly chronicled in such fanzines as Derek 'Deke' Dickerson's *Show-Me Blowout!* and Andy Brown's *Brown Paper Sack*.

8 Though the mid-60s garage was a largely male bastion, it was not exclusively so. Retrospective compilations such as Romulan Records' *Girls in the Garage* series (currently in its seventh volume) testify to the numerous number of girl bands active on the early to mid-60s garage scene.

9 Andy Shernoff, interviewed in *RAMONES: UK Fan Club Newsletter*, No. 9, May 1996.

10 In many ways the concept of a 'Punk Beach Movie' was emblematic of the 70s kitsch pastiche of teen culture. Selected extracts from the history of *Punk* magazine, including an abridged version of the beach movie, can be found in Holmstrom (1996).

11 Indeed, the ironic/trash dimension to the Ramones is underscored by the cover art to both their *Road to Ruin* (1978) album and their *Greatest Hits Live* (1996) collection – each depicting the band as cartoon characters.

12 A further analogy could be drawn between the Ramones and the Beach Boys, who were, of course, the brothers Wilson. Indeed, it would not be pushing the analogy too far to say that the Ramones were the Beach Boys with a bad attitude.

13 Johnny Ramone makes this sardonic reminiscence on the 'New York Punk' edition of *Rock Family Trees*, screened on BBC 2 in 1996.

14 This is taken from a radio interview included on *Youth on the March*, a live bootleg album of the Ramones playing at Northwestern University, Illinois in October 1979.

15 The Ramones' love affair with 60s teen culture climaxed with their starring role in the movie *Rock 'n' Roll High School* (directed by Allan Arkush, 1979), a playful send-up of Roger Corman-esque teen-pics. Involvement with the film also led to the

Ramones working with legendary 60s producer, Phil Spector, on their album *End of the Century* (1980).

16 For example, 'In the Sun', the B-side to Blondie's first single release in 1976, is a camped-up surf anthem.

17 As a benchmark of the Dickies' irreverent humour, the initial cover for their 'Nights in White Satin' single depicted the band bedecked in Ku Klux Klan robes. Their record label, however, was not amused and the disc was quickly withdrawn.

18 Timothy Gassen's *The Knights of Fuzz* (1995) provides a useful overview of the garage/fuzz revival, though the book amounts to little more than a survey of Gassen's record collection. Fortunately, this collection is impressive – though Gassen's research is less than meticulous and his guide is peppered with references such as, 'Untamed Youth: a band highly recommended in some circles, though I haven't found any of their product yet' (Gassen 1995: 223).

19 Though these are certainly the most successful of the 90s 'pop/punk' revivalists, better exponents of the sensibility are lesser-known combos Chixdiggit, the Riverdales and Screeching Weasel.

Bibliography

Bessman, Jim (1993) *Ramones: An American Band*, New York: St. Martin's Press.

Blair, John (1995) *The Illustrated Discography of Surf Music, 1961–1965*, Ann Arbor: Popular Culture Ink.

Blair, John and McParland, Stephen (1990) *The Illustrated Discography of Hot Rod Music, 1961–1965*, Ann Arbor: Popular Culture Ink.

Boyer, Paul (1995) *Promises Still to Keep: The United States Since World War II*, Lexington: D.C. Heath.

Burt, Rob (1986) *Surf City/Drag City*, Poole: Blandford Press.

Cagle, Van M. (1995) *Reconstructing Pop/Subculture: Art, Rock and Andy Warhol*, London: Sage.

Carr, E.H. (1987) 'The historian and his facts', in E.H. Carr, *What is History?*, Harmondsworth: Penguin.

Carson, Tom (1979) 'Rocket to Russia', in Greil Marcus (ed.), *Stranded: Rock and Roll for a Desert Island*, New York: Knopf, pp. 107–17.

Dalley, Robert (1988) *Surfin' Guitars: Instrumental Surf Bands of the Sixties*, California: Surf Publications.

Doherty, Thomas (1988) *Teenagers and Teenpics: The Juvenilization of American Movies in the 1950s*, London: Unwin Hyman.

Fass, Paula (1978) *The Damned and the Beautiful: American Youth in the 1920s*, Oxford: Oxford University Press.

Frith, Simon (1978) 'The Punk Bohemians', *New Society* 805 (43) 9 March: 535–6.

—— (1997) 'The suburban sensibility in British rock and pop', in Roger Silverstone (ed.), *Visions of Suburbia*, London: Routledge.

Frith, Simon and Horne, Howard (1987) *Art into Pop*, London: Routledge.

Gassen, Timothy (1995) *The Knights of Fuzz: The Garage and Psychedelic Music Explosion, 1980–1995*, Telford: Borderline.

Gilbert, James (1986) *A Cycle of Outrage: America's Reaction to the Juvenile Delinquent in the 1950s*, Oxford: Oxford University Press.

Heylin, Clinton (1993) *From the Velvets to the Voidoids: A Pre-Punk History for a Post-Punk World*, Harmondsworth: Penguin.

Holmstrom, John (ed.) (1996) *Punk: The Original*, New York: Trans-High.

Home, Stewart (1995) *Cranked Up Really High: An Inside Account of Punk Rock*, Hove: CodeX.

Hoskyns, Barney (1996) *Waiting for the Sun: The Story of the Los Angeles Music Scene*, London: Viking.

Joynson, Vernon (1995) *Fuzz, Acid and Flowers: A Comprehensive Guide to American Garage, Psychedelic and Hippie Rock* (1964–1975), Telford: Borderline.

Lebeau, Vicky (1997) 'The worst of all possible worlds?', in Roger Silverstone (ed.), *Visions of Suburbia*, London: Routledge.

Lydon, John (1994) *No Irish, No Blacks, No Dogs*, London: Coronet.

Marcus, Greil (1989) *Lipstick Traces: A Secret History of the Twentieth Century*, Cambridge, MA: Harvard University Press.

Marsh, Dave (1993) *Louie, Louie*, New York: Hyperion.

Marsh, Peter (1977) 'Dole-Queue Rock', in *New Society* 746 (38) 20 January: 112–14.

McNeil, Legs and McCain, Gillian (1996) *Please Kill Me: The Uncensored Oral History of Punk*, London: Little, Brown & Co.

Medhurst, Andy (1991) 'Batman, deviance and camp', in Roberta Pearson and William Uricchio (eds), *The Many Lives of the Batman*, London: Routledge.

Nehring, Neil (1993) *Flowers in the Dustbin: Culture, Anarchy and Postwar England*, Michigan: University of Michigan Press.

Palen, John (1995) *The Suburbs*, New York: McGraw-Hill.

Palladino, Grace (1996) *Teenagers: An American History*, New York: Basic Books.

Savage, Jon (1991) *England's Dreaming: Sex Pistols and Punk Rock*, London: Faber & Faber.

Tyler May, Elaine (1988) *Homeward Bound: American Families in the Cold War Era*, New York: Basic Books.

Richmond, Mike (1991) 'The Dickies', in *Spiral Scratch*, No. 11, June: 32–35.

10
'LEAVE THE CAPITOL'

Paul Cobley

Among the many myths of punk rock[1] probably the most insidious is that it was an entirely London-based phenomenon. Jon Savage's account (1991) – which has been fêted as 'the best book about rock and pop culture *ever*' (*NME*), 'definitive' (the *Times*), 'superb' and, most disturbingly of all, 'the best cultural history of the '70s to be written yet' (*i-D*)[2] – threatens to be the worst perpetrator of such a myth. It is true that Savage devotes an obligatory space in his tome to the Manchester 'scene' (1991: 404–07). However, his book is simply a celebration of the 'great and the good', an account in which the King's Road supplants Bloomsbury and, instead of learning what Virginia said to Leonard, we are offered what Vivienne said to Malcolm as the authentic and original 'meaning' of punk rock throughout the land. In light of the way that London is made to stand for all the cultural and socio-economic formations throughout the country, it's hardly surprising, then, that Savage's book is called *England's Dreaming*.

More recently, Michael Bracewell (1997) has surveyed 'Pop Life in Albion', bracketing sociology and opting for textual material – novels, cinema, pop music and a small amount of TV – in order to generalise about Englishness through the prism of pop sensibility. His analysis consists of a highly 'individual' and 'personal' response, betraying the imprint of sixth form and undergraduate English Literature which is alive even though its inspiration, F.R. Leavis, is long dead. Yet, in spite of his valorising *belle lettrist* impulse to canonise – clearly driven by a belief in some spurious notion of textual 'value' – Bracewell rightly points to the importance of the regions and their peoples in the constitution of punk rock. To be a punk, go to a club and get the bus home in a provincial town, he writes, 'was to run the gauntlet of beery men and their jeering girlfriends who wished the non-conformists injury and humiliation for mocking their cherished domain of Saturday night on the town' (ibid: 97). This is a potent image for those who can remember being a provincial teenager in the late 70s (although it's not an uncommon one now outside London).

London's cosmopolitanism as a capital city – even in its furthest reaches: Bromley, Ealing, Barnet, Barking – could act as a buffer against violent conformism in a way that was impossible in the provinces. Being a punk in a small Northern town in the late 1970s, on the other hand, was an affront to an assortment of deep-rooted values: class, masculinity, 'decent' behaviour, locality and 'tradition'. That punk had to negotiate a set of pre-existing national attitudes is well known; but, as we will see, the fact that these attitudes were even more formidably entrenched outside the major urban centres meant that being a provincial punk represented a considerable leap of faith. The social context of the provinces therefore made the punk 'phenomenon' a much different proposition from that which has been so slavishly rehearsed in written accounts.

Hit the North

In the late 1970s Wigan had a population of around 80,000 people. Lying in the heart of Lancashire, almost directly between Liverpool and Manchester (both about half an hour or so away by train), Wigan's main claim to fame was probably as the home of the great rugby league team, the origin of Uncle Joe's Mint Balls (now available as a retro item at Harrods and Habitat), the butt of numerous music hall jokes or post-Orwell references and, in later years through the work of the Casino Club, the mecca of Northern Soul (see Nowell and Winstanley 1996). At this time, the lion's share of jobs in the area was provided by the 'Big Three': Rank, Hovis, McDougall; Heinz; and British Mail Order (a.k.a. GUS). Meanwhile, leisure was provided by the most dense population of pubs in Britain, a network of political and working men's clubs, and, if you were really pushing the boat out, a series of more upmarket night spots situated out of town where it was possible to delight in the talents of the Barron Knights, Cannon and Ball, Stu Francis, Vince Hill, the Black Abbots and other high-class turns.

What it is important to remember about a provincial town such as Wigan in the 1970s is not just its physical distance from metropolitan centres but its mental distance from them (and even itself in the present). Although cinematic entertainment was provided principally by the Wigan ABC in Station Road, the local three-screen cinema just out of town in Pemberton profitably devoted one of its screens to regular weekly runs of soft-porn double-bills such as *Clockwork Nympho* and *Sextette*.[3] In a similar vein, amateur comedians in local clubs referred to 'coons' without the slightest self-consciousness. As these examples should testify, the not too distant past is, in short, a foreign country.

It was in this milieu which I have telegraphically outlined – and probably many more like it – that punk rock struggled to breathe. Furthermore, it is probably precisely *because* of this struggle that the fate of punk rock in the provinces is so

much more historic and emblematic than the comparatively glitzy phenomenon venerated in published accounts of London punk. In general, subcultural theory, rock journalism (and what passes for cultural history) report the evidence of a public 'scene'.[4] Such reports invariably revolve around performers, press releases and easily available journalistic sources. Wigan, of course, is not renowned for harbouring such a scene in respect of punk rock; yet, in 1977, the Casino Club played host to the following bands: the Stranglers, the Jam, Slaughter and the Dogs, the Nosebleeds, the Drones, Eater, the Slits, Deaf School, Count Bishops, the Damned and the Adverts. Round the back of this venue, at Mr. M's in Millgate, the floor was given to the likes of Big in Japan and the Crabs. Meanwhile, the Bier Keller in King Street, following its summer inauguration of Monday and Wednesday punk rock nights, played host to North West bands such as Spitfire Boys.[5]

Nevertheless, what is striking about punk rock as it existed in Wigan in comparison to the famous London version is its seemingly muted tones. One has only to watch the routinely trotted-out Granada footage of punk performances (mainly from *So It Goes*) to gain a taste of the subtle flavour of punk rock outside the capital.[6] Filmed at Manchester venues like The Electric Circus and The Elizabethan Rooms at Belle Vue, the crowd at such gigs – almost certainly from all over the North West – are far from being the King's Road fashion victims revered in punk literature. There are denim jackets, shirts with big collars and – horror – long hair. This distance between provincial punks and their metropolitan predecessors is stated nicely by Osgerby when he emphasises the art school/middle-class London-commuter belt background of those who frequented punk clubs like The Roxy and The Vortex. 'Indeed', he adds, 'the "outsider" posture of Britain's initial punk "moment" is best seen as a piece of radical theatre, a calculated attempt to enflame and outrage establishment sensibilities' (Osgerby 1998a).[7]

The kind of punk subculture that existed in the provinces, by contrast, did not have to work as hard to provoke onlookers. As a result it tended to embody 'bricolage' and 'DIY' culture out of necessity and often for more private reasons rather than for the purposes of post-Westwood 'confrontation dressing' (Hebdige 1979: 107). One Wigan punk rocker reports the way that 'the entire top deck of a passing bus gave me "the finger" as I set out to see Slaughter and the Dogs at Wigan Casino' and how he would, for safety's sake, usually get changed into punk gear with his friends in the toilet of a pub in the centre of town (Maconie 1994: 2). Clearly, it was one thing to be a spectacular punk rocker in the safety of a club in central London, and quite another to attempt to be one in a small provincial enclave.

In a place like Wigan, confrontation in general is assisted neither by the potential anonymity, nor the cultural heterogeneity which might be offered by a big cosmopolitan city. As a result, evidence of cultural struggle is often hidden and

to register the presence of punk rock's influence in the former kind of milieux, one needs to dig deeper. For example, if one studies the same Granada footage mentioned above, it becomes apparent how many of the artistes wear shirts and ties – Johnny Rotten, Pete Shelley, the Jam (of course), Elvis Costello and, especially, Tom Robinson. This small element of sartorial style meant a lot to young people who couldn't afford to buy a pair of bondage trousers.[8] Rather than exhibitionism it embodied a more vulpine approach to rebellious affect. It meant the appropriation and subversion not just of mainstream style, but of school uniform and all that went with it, most specifically, the homogenising effect of comprehensive schools' education and rules.[9]

For analogous reasons, the reported ostentatious violence inherent in the punk rock of the London set was simply untenable outside the confines of the capital scene.[10] While it is all too easy to make connections between masculinity, work and physically aggressive behaviour, it must also be noted that London, in the traditionally affluent South East, has customarily offered a wide range of occupational possibilities. In small towns dominated by a manual labouring workforce which (especially in the late 1970s) has a majority of men, violence as a concrete rather than histrionic phenomenon becomes much more probable. Referring to the work of Tolson and Dunning et al., Segal notes that:

> Just as there is a Black underclass, so too a white underclass exists, in which the men are the most likely of all men to adopt aggressive masculine styles and values whereby status is imparted to those who display loyalty and bravery in confrontation with 'outsiders'.[11]
>
> (1990: 265)

At the time of a disturbingly sharp rise in unemployment, the scenario Segal describes created an increasingly fraught atmosphere in which to display the outsiderism demanded by full punk regalia. Outside London, then, punk rock may seem to be significantly downbeat.

the madness in my area

Yet, if provincial punk rock is less spectacular than its London counterpart, this is no reason to write it out of history. There is evidence of a strong desire for punk rock's singular kind of revolt even if its most frequent manifestation is the trenchant opposition to it in Britain's regions. Punk rock embodied a threat beyond that of routine teenage rebellion, a fact which is evident from the way punk came to be represented in the mainstream media as a national menace.[12] This is a point worth emphasising, especially as the national representation of punk rock would

inevitably be filtered for use in specific localities and within specific networks of relations. (Parents, for example, might be horrified by the same *Daily Mirror* articles which might inspire their children to attend a punk rock night at a local club).[13] In a manner which can be misleading, writing on subcultures has tended to focus on the media thought to be exclusively consumed by subculture's participants while being dismissive about mainstream coverage consumed, potentially, by all. (This is frequently because subculture's participants themselves profess to eschew the mainstream[14]). It should be remembered, however, that mainstream media often serve a significant purpose for those who find a given subculture congenial as well as for those who cultivate hostility towards it.

No matter what Savage or other 'insiders' may suggest, punk rock first surfaced in the nation's consciousness with the aftermath of the Grundy interview in December 1976. As is well documented, the national tabloid dailies made much of the swearing on live television (London area only) but it has rarely been mentioned that the newspaper which – by a long chalk – made the most of the Sex Pistols at this time was the Labour-Government-supporting (and, by association, consensus-upholding) *Daily Mirror*. The *Sun*, for example, only ran the story on page three rather than the front page. In fact, the *Mirror*'s coverage of punk rock throughout the next year was by far the most exploitative and hysterical of all the newspapers. The local evening papers in the North West followed the agenda-setting of the *Mirror* cautiously: Grundy was initially, after all, largely London news. Nevertheless, the *Lancashire Evening Post* devoted half of its 2 December front page to the story of 'Banned! "Filth" row Punk group' (Wigan's *Evening Post and Chronicle* carried the story in the 'stop press').

Sex Pistols stories continued to run in the *Mirror* and this lead was soon to be followed by the locals in the North West.[15] Yet it was the tone and the modulated frequency of the press coverage which were, arguably, more resonant than the subject matter. Reporting the Grundy incident, the *Lancashire Evening Post* borrowed liberally from a *Sun* feature of 15 October 1976 on 'the craziest pop cult of them all'. The Sex Pistols were characterised as 'sick and filthy', 'the country's most outrageous and depraved pop group' who 'produced the filthiest language ever heard on television . . . ' (*Lancashire Evening Post* 1976: 1, 'Who are the Punkers [sic]?' the *Post* asked. 'Punkers have been known to spit at audiences and one Birmingham group singer specializes in vomiting on stage and throwing tampons to fans' (ibid.). As is evident, the stress in national and local dailies was on the 'filth' and the perceived cultish nature of punk (parents: fear for your children).

The hyperbole of the mainstream press was bound to gain attention of various kinds for punk rock.[16] But the press, in the way that it foregrounded filth and what we might call *abjection* (vomit, snot, spitting, menstrual blood, fetishism, obscenity, perversion, violence, unreason), and made them synonymous with

punk rock, carried out ideological work which was slightly more specific than simple sensationalism. The rhythm of news stories about the Pistols and punk rock in general also played its part in the process: just enough gaps appeared between successive stories of outrage for readers to be allowed to contemplate the inhuman nature of the new cult which must be expelled – or better still – destroyed at all costs.

Although this perspective on the psychological role of abjection is now pretty standard in cultural studies[17] it also has a political dimension in respect of punk rock. The chief issue, I believe, is the collapse of consensus in British post-war life.[18] In one of the key fictional texts of the British post-war settlement, Ealing films' *The Blue Lamp* (1950), an almost fully co-operative post-war national community is portrayed as an ideal, with police work as a paradigm of mutual aid. However, from the outset, a quasi-sociological voice-over in the film warns of the danger of young men, reckless after the war, who are embarking on lives of crime so meaningless that even the established criminal underworld abhors them. One of these youngsters, Tom Riley (Dirk Bogarde), shoots a policeman after a robbery and becomes public enemy number one, a neurotic character cast out beyond the boundaries of the community. Clearly Riley is *abject*; yet he is also the only figure in the narrative who demonstrates any sexuality whatsoever and is, as such, also fatally attractive.

Like Riley, punk rock represented the other side of consensus, that which must be repressed or expelled. It threatened to overturn cherished ideals, their symbols and institutions. When Wigan hosted its first punk rock gigs in June 1977 (the Stranglers, the Adverts, the Jam, the Damned) the *Post and Chronicle*'s front page ran an article a month before the bands played which reported the comments of the Rev. Ray Whittle, Chairman of Wigan Council of Churches Youth Committee. 'The reputation of the punk rock groups is repugnant in the extreme', he is reported as saying. 'I very much regret that these groups are coming to our town and I would urge all young people of Wigan to stay away' (19 May 1977: 1). Juxtaposed with this was a quote from Brian James of the Damned: 'We give the audience a great time. We swear and blaspheme just like anyone else and throw things like cakes and pizzas at the audience. We hate conforming to society. We've freaked out' (ibid.). The young people, of course, did not stay away and it is easy to suggest that the warnings were delivered by an insignificant clergyman who was without real influence. Nevertheless, they are indicative of a peculiar ideological battleground whose landscape, made up of manifest disgust at abjection, betrayed latent fears of a more explicitly political nature.

PAUL COBLEY

New English scheme

If one reads the local papers of the time, or if one lived there during that period, it is clear that Wigan was a town desperate to shed its cloth cap image, to bathe in the benefits of modernisation that the post-war consensus still had to deliver. Bound up with this desire was a need to keep a stake in the nation, a sense of belonging rather than of being left behind. At the same time, though, the consensus which promised so much was also insuperably stifling. It is easy to forget that this was a period when the 'pound in the pocket' was worth so little, when British licensing laws were unfeasibly draconian, when the quantity of television broadcasting was heavily constrained, when consumer goods were relatively limited and when long-haul travel to foreign destinations was out of fiscal reach of the bulk of the population. Life outside London was especially insular and peer pressure often worked to restrict cultural life to local amenities and traditional activities.[19]

The internal difficulties of the cultural consensus were compounded by the overarching economic problems. Unemployment in Britain doubled in the period 1975–77 from 700,000 to 1.4 million, putting pressure on post-war governments' commitment to full employment. The North West, with its heavy industries, was hit particularly badly and it was in this climate that fears about public spending started to get expressed. In the midst of this growing unease, the Jubilee year of 1977 might have served to unite the nation. The Jubilee street parties – which, in Wigan, were legion, and reported at great length in the local press[20] – undoubtedly celebrated nationality and the flag more than the fact of the Queen's reign. For communities such as Wigan, which were off the royal beaten track,[21] such celebrations were potent emblems of national belonging, embodying, as Anthony D. Smith suggests, the 'basic concepts [of nationalism], making them distinct for every member, communicating the tenets of an abstract ideology in palpable, concrete terms that evoke emotional responses from all strata of the community' (1991: 77).

Nevertheless, there was opposition to the Jubilee in this staunchly old Labour town. In January 1977, the *Post and Chronicle* reported that 'Young generation hit out at Jubilee', citing a teenage consensus in Wigan that the cost of the celebrations was out of proportion to the nature of the event. Within a month the newspaper itself was editorialising on the front page about the council's plan to spend thousands of pounds on issuing all the area's schoolchildren with Jubilee mugs, a plan that was found ludicrous in light of the severe unemployment among the local population.[22] The brooding dissent beneath the veneer of nation leads one to think that punk rock and the Jubilee were made for each other. However, where most commentaries on punk are keen to point out that 'God Save the Queen' was banned, sold enormously, and was then prevented from reaching the top of the

singles charts in Jubilee week, or that McLaren hired a boat for a Sex Pistols gig on the Thames, or even the post-Jubilee attacks on Lydon and Cook (see Savage 1991: 251–73; Boot and Salewicz 1996: 83–87; Gibbs 1996: 173–77; Gimarc 1994: 68–69; 'Punk and the Pistols' 1996), it is worth mentioning something more. Punk rock's dissenting struggle was also being enacted in Wigan at this time – and undoubtedly elsewhere in Britain – as the Stranglers and the Jam played at the Casino on Jubilee weekend, people continued to buy the Pistols single and the street parties staggered on interminably outside.

Exit this Roman shell

It is not the matter of the star names coming to town, however, which is at issue in reclaiming the story of punk rock in the name of subcultural struggles beyond London. A number of matters are at stake. Chief among these is the way that punk rock in Wigan became one potent instance of the merging of the personal and the political during the early Autumn of 1977. In September, an uncanny combination of events forged an inexorable connection between the punk movement and the epithet which had become anecdotally attached to it – 'dole queue rock' (Marsh 1977 pp. 112–14).[23] A 'Right to Work' march of over 1,000 unemployed made its way from London to Blackpool to lobby the Trades Union Congress (TUC) at its annual conference over the issue of mounting unemployment. One stopping-off point for the march was Wigan, where entertainment organised by The Casino Club in conjunction with the recently formed Rock Against Racism was to consist of a number of bands. These included the Drones and the Nosebleeds, both from Manchester. At the same time, however, it was well known that the Sex Pistols, after a bout of inactivity, had set out on a 'secret' tour of Britain, turning up at venues with a minimum of warning. The only publicity which might precede the gigs would be for a band called the SPOTS (Sex Pistols on Tour Secretly).

In the week preceding the march speculation mounted about the Sex Pistols playing Wigan. The *Post and Chronicle* fanned the flames on 1 September with its front page headline, 'MYSTERY OF SEX PISTOLS WIGAN DATE', cementing along the way punk rock's 'established affiliation to the dole queue set'. The following day the *Post and Chronicle* ran another article on the front page about the warnings of Rock Against Racism's Bernie Wilcock who predicted large-scale disappointment as a result of the newspaper's speculation regarding the Pistols.[24] On the Saturday of the march, the evening edition of the paper put the finishing touches to its fusion of punk rebellion, discontent at mounting unemployment, local colour and organised protest with the headline story 'Punks in on work march' (see Figure 10.1). However, there was no happy ending in sight for this particular story.

Evening
Post & Chronicle

The South West Edition of the Lancashire Evening Post

25,139 · SATURDAY, SEPTEMBER 3, 1977 · 8p

Punks in on work march

MORE than 50 punk rockers led a "Right to Work" march along the main roads of Skelmersdale today.

In all, nearly 500 angry campaigners brought traffic to a standstill as they made their way towards Wigan.

Leaflets and hand outs were distributed to spectators and chants of "We demand work" filled the air.

Several open vans accompanied the marchers carrying punk rockers and playing their music.

The march stopped at Skelmersdale's shopping concourse for dinner before moving on to Wigan tonight.

Catering organiser Mr Tommy Doures said: "We expected about 750 and that's what we've got — a really great turnout."

At teatime tonight the campaigners will camp on playing fields in Montrose Avenue, Norley Hall, Wigan, before attending a punk rock concert at the Wigan Casino in the evening.

One of the march organisers Mr Ferenc Assmann said: "More than 100 unemployed have come up from London specially for the march. These include about 50 punk rockers who are helping us to raise cash for the campaign along the route."

It is estimated that today's march has cost more than £12,000 for the organisers. Most of the money has been raised by donations and sponsorship from over 400 trade union organisations.

This afternoon Skelmersdale police reported that the march had gone off quietly with no problems so far.

ABOVE: Right to work marchers in Skelmersdale. BELOW: Punk rockers leading the protest.

Figure 10.1 'Punks in on Work March'.
Source: *Evening Post and Chronicle* 3 September 1977.

On the evening of 3 September, in spite of the huge queues of fans from out of town which had assembled in mid-afternoon, the Pistols did not play.[25] More significant and more worrying, though, were the events at the end of the night: 'Gang riots, two stabbings and countless arrests followed the weekend meeting between musical forces worlds apart'.[26] In a sense, the Casino punk nights were an accident waiting to happen. Invariably taking place on a Saturday evening from

eight until midnight, punters would leave the club just as the regular soul all-nighter crowd were queueing for admission. Because the Casino was the spiritual home of Northern Soul and the all-nighters very much a 'tradition' in spite of their relatively short-lived existence, it was hardly surprising that punk rockers might be seen as outsiders, especially on a night when there were so many people in Wigan who had actually come from out of town. The main fights that night – including a stabbing – took place directly outside the club.

The real – as opposed to 'theatrical' – violence involved the subsequent treatment in Wigan Infirmary of two separate punctured lungs. This is not to say for a second that a normal Saturday night on the town does not usually result in a queue at the local Casualty department. However, events of this kind which incorporate the reality of experience with the political dimension of punk rock have been systematically omitted from punk history because they do not conform to predetermined concerns of rock journalism or subcultural theory.[27] Their absence from orthodox accounts of the subject simply serves to paper over the real issues that made punk rock a movement rather than a brief fad. The exigencies of 'authenticity' and origins – where did punk begin? Who was the first punk rocker? Why is 'first wave' better than 'second wave' punk rock? Why was punk rock so much more 'precious', 'exciting' and 'important' before the media and the 'masses' got hold of it? – avoid the crucial matters. What should be on the agenda is the way punk rock challenged, antagonised and threw into crisis the contradictions inherent in desperately held, but vulnerable, consensus values throughout the nation.

the N. W. R. A

The history of punk rock in Britain's regions is yet to be written.[28] Yet, in light of the fact that punk stands at such a pivotal point in the social and cultural life of post-war Britain such a history urgently needs to be undertaken. Utilising oral history methods and theoretically informed research into the specificities of events and lives in different areas of the country, there is a need for a revaluation. There is a need for accounts which will eclipse the very 'unpunk' perspective of the starstruck valorisers whose 'cultural histories' threaten to become the 'common sense' of the subject by default.[29]

Postscript

The final drafts of the above were completed in the climate of hysteria which attended the death and subsequent funeral of Diana, Princess of Wales. All through

this period I could not help thinking how much more apposite it would have been if John Lydon had prevailed over Malcolm McLaren and his song had retained the title 'No Future' rather than 'God Save the Queen'. As TV reports showed, thousands of people attended the funeral of Diana which was conveniently arranged to take place on a Saturday, 6 September 1997.[30] Many had travelled by bus to London from the provinces. On this occasion, it was not the monarchy *per se* which became the focus for the national response; indeed, the monarchy was under fire in the wake of Diana's death. Instead – in a Britain ravaged by the post-Thatcherite regime of overwork, rampant materialism and tyranous marginalisation/eradication of those who possess little or no stake in the present fragile and limited concord – the lifeblood of meaning was suddenly located in what is, ultimately, an equally remote and ethereal figure.

There could be no more timely reminder of the need to remember punk rock and the way it touched people's lives under the yoke of nationhood. Nor could there be any doubt that 'there is no future in England's dreaming'.

Acknowledgements

Thanks are due to the following people who read drafts or provided material or who have been my patient interlocutors over the years with regard to the subject, or all three: Zillah Ashworth, Adam Briggs, Chris Hill, S. P. McGarty, Alex Ogg, Bill Osgerby, Alison Ronald, Roger Sabin and Nick Spencer.

Notes

1 These are that *it was a Situationist strategy* (Vermorel and Vermorel 1987: 213–25; Frith and Horne 1989: 129–38; and, especially, Marcus 1996); that *it was a style/fashion rather than a musically led movement* (see York 1980; McRobbie 1994; Vivienne Westwood: 'The extension of my business was the Sex Pistols' quoted in Savage 1997a); that *it was self-conscious bricolage* (see Hebdige 1979: especially 103–06; Evans 1997a); that *it was short-lived, barely lasting beyond 1976* (see Clarke 1995: 500–01; Savage 1997b; Martin and Thrills 1986; Burchill and Parsons 1978); that *it was invented in the U S A* (see Snow 1986; Gammond 1991: 474; Boot and Salewicz 1996: 11–25; Heylin 1993; 'Rock Family Trees: New York Punk', BBC 2, 1995; McNeill and McCain 1996; Smith 1996 and the risible comments of Richard Hell, most recently repeated in 'Punk and the Pistols', *Arena*, BBC2, 1996).

2 The quotes are from the blurb to the book except 'superb' which comes from Smith (1996, p. 9).

3 In 1977 the ABC closed for several months, temporarily making Unit 4 in Pemberton the only reachable cinema.

4 The most obvious instance of this with regard to punk rock is the way that the Manchester 'scene' is covered (see, for example, Savage 1991, and Morley 1986:

14–15). However, as Mick Middles has suggested, 'Despite the often-cited notion that Manchester was a musical "hot bed" during the punk era, there just weren't that many bands' (1996: 52).

5 All of the bands mentioned played the town in addition to a plethora of rock acts which were not explicitly aligned with punk or new wave: for example the Edgar Broughton Band, the Scorpions, Budgie, Stray, Motorhead and others.

6 See *The Way they Were* (Channel 4, 1986) and *Punk* (Channel 4, 1991). See also the comments of Tony Parsons on the Sex Pistols' Leeds audience in 1976 (in Parsons 1994: 3). It should also be noted that it is the availability of this specific footage from Granada – and not footage of other bands and people – which has lent to the canonising process.

7 Osgerby also draws attention to the continuities of 'punk's more dandy-esque elements' with the birth of early 80s club culture (Blitz, Hell, etc.), both, of course, championed by style commentator, Peter York.

8 Even if they wanted to and even if there were shops within the space of half a day's train ride which would sell such items. An article by Caroline Evans (1997b), demonstrates the pitfalls of an understanding of punk rock based on accounts which focus on the capital city or punk myths. Evans calls for fluidity but remains fixated on taxonomy: punk is defined by its 'in-your-face esthetic' (178) and the article quotes Sarah Thornton (1995) on the topic of the threat to subculture's integrity lying with the media rather than the police. The unspectacular nature of punk in the provinces during the late 70s is, in fact (and as we will see), due to a different and very real threat: other citizens, often working-class men, who engaged in repressive coercion rather than a Gramscian winning of consent.

9 This fact of British education is cited with vehemence by punk rockers: see, especially, Lydon *et al.* (1994: 24–27).

10 Much of the violence of punk rock revolves around the myth of Sid Vicious, especially the glass-throwing incident at The 100 Club; see Savage (1991: 166–68, 177–78, 222–23); the comments of Severin in Lydon *et al.* (1994 pp. 213–14); note, also, Tony Parsons's comments: 'Sid only ever beat up girls and junkies' (1986: 28).

11 Justine Armitage, a punk rocker and performer, stridently asserts that 'The most threatening people were straight looking suburban soul boys; they are the most scary violent people there are' (Ashworth 1997: 43). Other respondents in Ashworth's oral histories testify to the same threat of straight violence in the suburbs of London and the Home Counties. It should also be remembered that the Punks vs. Teds conflict, dreamed up by the press, was fuelled by quotes from Teds such as Jimmy 'Elvis' Smart: 'I hate the punks. They are skinny little bleeders and half of them are queer . . . They should not be allowed to walk on the same streets as ordinary people' (see 'Why I hate the punks', the *Sun*, 28 August 1977: 5).

12 Compare the frivolity of an early report in the *Sun*, '"Freakin' on". Punk Rock is the craziest pop cult of them all', 15 October 1976: 16–17 with the hysteria of newspaper accounts through 1977.

13 'The Sex Pistols were supposed to play The Talk of the Town, so my father rang to book a table for me – suffice to say it was one of Talcy Malcy's little japes – but shortly after this John Blake of the *Evening News* wrote a piece called "The sickest cult of them all" and it had a description, you know – cropped hair, safety pins, and the fact that we vomited everywhere. You try convincing your irate parents that you don't go vomiting over complete strangers or when you have sex, let alone that you don't have

sex in the first place! Needless to say, their attitude changed and it was a war of attrition until the day my father died.' (Michelle Archer, punk rocker and performer, quoted in Ashworth (1997: 30).)

14 See, especially, Thornton (1995). Yet, as Osgerby (1997) demonstrates, mainstream media can actually act to lend coherence to the disorganised elements of subculture. Ken Gelder also observes that 'by identifying with a place (a club or a football terrace, for instance), [subcultural] participants can lay claim to a sense of belonging, even exclusivity. But subcultures are by no means always defined through their local-ness. They can produce alliances with peoples in other places: *other* cities, other nations' (1997: 315). One obvious way that this takes place is through the use of media: for a specific example of how globality and locality are negotiated in subculture see Briggs and Cobley (forthcoming).

15 For example the story of the Derby council veto (*Lancashire Evening Post*, 4 December 1976: 1; *Evening Post and Chronicle*, 4 December 1976: 1); a story of no damage by the Pistols while staying at a Leeds hotel (*Lancashire Evening Post*, 6 December 1976: 1); reports of Sir John Read's consternation at EMI (*Lancashire Evening Post*, 7 December 1976: 1); Grundy's praise for press coverage (*Lancashire Evening Post*, 10 December 1976: 11); Radio Luxembourg's decision to pre-record a Pistols interview (*Lancashire Evening Post*, 11 December 1976: 1).

16 Being at a school where pupils constantly called each other every fucking cunt under the sun, I was unable at the time to imagine what the 'filthiest language' might possibly be. Moreover, vomiting and spitting did not seem the most enjoyable of activities even when the pleasure of upsetting authority was factored into them (see also the comments of Michelle Archer, note 13, above).

17 See Kristeva (1980) whose reading of Lacan's seminar generated this kind of approach. See also Oliver (1993: 55–62). A celebrated example of Kristeva's perspective extended to popular culture is Creed (1993). (The famous story of the vomiting Pistols at Heathrow which is generally thought to be a lie (and, according to Gimarc, a Situationist prank inspired by the New York Dolls – Gimarc (1994: 47); *cf*. Boot and Salewicz (1996: 25) and, contra both, Lydon *et al.* (1994: 221)) is a good example of the press's obsession with abjection.)

18 A useful summary of consensus politics as a combination of the mixed economy, winding down of Empire, commitment to welfare, trade unions' role in the social contract and provision of full employment is contained in Kavanagh and Morris (1996).

19 For some, the only escape from these suffocating surroundings – apart from a physical one – was flirtation with right-wing politics or its imagery. In punk rock, the latter has been frequently misunderstood. Siouxsie points out that her use of swastikas was a protest against the post-war consensus in being directed at 'older people – not across the board but particularly in suburbia – always harping on about Hitler, "We showed him", and that smug pride', quoted in Savage (1991: 241); see also, Tony James on the same topic quoted in Parsons (1994: 21); Bob Gruen quoted in Lydon *et al.* (1994: 131); Severin (ibid.: 212); interviewee in Lech Kowalski's film, *D.O.A.* (1981); and Sabin, Introduction to this volume.

20 See, for example, *Wigan Observer*, 10 June 1977 and *Evening Post and Chronicle*, 9 June 1977.

21 Although the Queen did come to Wigan on a whistle-stop visit on 20 June 1977.

22 'Young generation hit out at Jubilee. Long to reign over us?' *Evening Post and Chronicle*, 14 January 1977: 4; editorial comment, *Evening Post and Chronicle*, 7 Febuary 1977: 1.

23 See also Johnny Rotten quoted in an article as early as 15 October 1976: 'Life's not going to get any better for kids on the dole until it gets worse'; 'Freakin' on', the *Sun*: 17; see also Murray 1986: 24 (written during record unemployment in the period of the second Thatcher government). Another side of the dole queue theme involves those punks who used improvidence as provocation: see, for example, 'I despise love says rude Judy Nylon', *News of the World*, 5 December 1976: 3; 'Here come the punkesses [sic]', ibid., 16 January 1977: 3, featuring the Slits.

24 'Mystery of Sex Pistols Wigan date', *Evening Post and Chronicle*, 1 September 1977: 1; 'Punk promoter warns of Sex Pistols backlash' ibid., 2 September 1977: 1.

25 In addition to the Nosebleeds and the Drones, China Street (from Lancaster) and reggae band Exodus *did* play. The Sex Pistols were never actually booked.

26 'Violence casts shadow over punk's future', *Evening Post and Chronicle*, 6 September 1977: 3; *cf.* 'Punk rock gang fight stabbing', *Wigan Observer*, 9 September 1977: 3.

27 In the existing literature of punk rock there is no mention of the 3 September Casino gig. The one place that one might expect an outside chance of it gaining a mention – Gimarc's often hilariously error-riddled chronicle (1994) – is silent. The usual place to begin research about punk rock is the contemporary music press which helped disseminate it. *Record Mirror*, *Sounds* and *Melody Maker* make no mention of the events of the Right to Work march. The 10-year anniversary 'calendar' of punk rock in the *NME* also omits the event (see Martin and Thrills 1986). However, at the time, *NME* carried a journal of the march in which it reported the Wigan gig – see the report by Phil McNeill in the *NME*, 10 September 1977: 7–8. In spite of the naively right-on stance of this inkie – in fledgling form at that time – its work proves that evidence of these kinds of episodes are hardly irrevocably buried from the gaze of the would-be cultural historian.

28 This snapshot of punk in Wigan is, of course, far from complete, and there is much that might be discussed. Not least is the fact that, in November 1977, the police banned punk rock concerts in Wigan with the Buzzcocks being the first victim of the new edict.

29 This is no reason to get dewy-eyed, however: in their execrable coffee-table book, Boot and Salewicz (1996: 8), claim, *pace* Thatcherism, that 'the exceptional and extra-ordinary events of this time marked a watershed not only in music and culture, but in attitudes and sensibility. In this overturning of the past, a new, more egalitarian world began to emerge'! Such a perspective is embodied in another major myth of punk rock: that *it was a close ally of reggae* (see, especially, the comments of Don Letts in Boot and Salewicz 1996: 59–60; Gibbs 1996: 166–67; Hebdige 1979: 26–29; Savage 1991: 300). In respect of this myth it is interesting that the performance of reggae band Exodus at the Casino (see above) was accompanied by violent heckling from some of the audience (see, for example, McNeill's report in the *NME*, 10 September 1977: 7–8. See also Roger Sabin's chapter in this volume).

30 Where were the voices of dissent at this time? Certainly not in the media. But you didn't have to go far to find them: pubs and work would do.

Bibliography

'"Boycott punk shows" call', *Evening Post and Chronicle*, 19 May 1977: 1.

'"FREAKIN' ON". Punk Rock is the craziest pop cult of them all', the *Sun*, 15 October 1976: 16–17.

'Banned! "Filth" row Punk group', *Lancashire Evening Post*, 2 December 1976: 1.

'Here come the punkesses [sic]', *News of the World*, 16 January 1977: 3.

'I despise love says rude Judy Nylon', *News of the World*, 5 December 1976: 3.

'Mystery of Sex Pistols Wigan date', *Evening Post and Chronicle*, 1 September 1977: 1.

'Punk and the Pistols', *Arena*, BBC2 (1996).

'Punk promoter warns of Sex Pistols backlash' *Evening Post and Chronicle*, 2 September 1977: 1.

'Punk rock gang fight stabbing', *Wigan Observer*, 9 September 1977: 3.

'Rock Family Trees: New York Punk', BBC 2 (1995).

'Violence casts shadow over punk's future', *Evening Post and Chronicle*, 6 September 1977: 3.

'Why I hate the punks', the *Sun*, 28 August 1977: 5.

Ashworth, Z. (1997) 'Typical girls: women's experience of punk rock', unpublished BA dissertation, London Guildhall University.

Boot, A. and Salewicz, C. (1996) *Punk: The Illustrated History of a Musical Revolution*, London: Boxtree.

Bracewell, M. (1997) *England is Mine: Pop Life in Albion from Wilde to Goldie*, London: HarperCollins.

Briggs, A. and Cobley, P. (forthcoming) ''I like my shit sagged': fashion and black musics', *Youth Studies*.

Burchill, J. and Parsons, T. (1978) *'The Boy Looked at Johnny': The Obituary of Rock and Roll*, London: Pluto.

Clarke, D. (1995) *The Rise and Fall of Popular Music*, Harmondsworth: Penguin.

Creed, B. (1993) *The Monstrous-Feminine: Film, Feminism, Psychoanalysis*, London: Routledge.

Evans, C. (1997a) 'Street style, subculture and subversion', *Costume* No. 31: 105–10.

Evans, C. (1997b) 'Dreams that only money can buy . . . Or, the shy tribe in flight from discourse', *Fashion Theory* vol. 1, pp. 169–88.

Frith, S. and Horne, H. (1989) *Art into Pop*, London: Routledge.

Gammond, P. (1991) *The Oxford Companion to Popular Music*, Oxford: Oxford University Press.

Gelder, K. (1997) 'Introduction to Part Six', in K. Gelder and S. Thornton (eds), *The Subcultures Reader*, London: Routledge.

Gibbs, A. (1996) *Destroy: The Definitive History of Punk*, London: Britannia.

Gimarc, G. (1994) *Punk Diary 1970–1979*, London: Vintage.

Hebdige, D. (1979) *Subculture: The Meaning of Style*, London: Methuen.

Heylin, C. (1993) *From the Velvets to the Voidoids: A Pre-Punk History for the Post-Punk World*, Harmondsworth: Penguin.

Kavanagh, D. and Morris, P. (1996) *Consensus Politics from Attlee to Major*, Oxford: Blackwell.

Kristeva, J. (1980) *Powers of Horror: An Essay on Abjection*, New York: Columbia University Press.

Lydon, J. with Zimmerman, K. and Zimmerman, K. (1994) *Rotten: No Irish, No Blacks, No Dogs*, London: Coronet.

Maconie, S. (1994) 'Get Happy!', in J. Aizlewood (ed.) *Love is the Drug*, Harmondsworth: Penguin.

Marcus, G. (1996) *Lipstick Traces: The Secret History of the Twentieth Century*, London: Picador.

Marsh, P. (1977) 'Dole queue rock', *New Society*, vol. 38, 20 January: 112–14.

Martin, G. and Thrills, A. (1986) '1976 and all that: the rise and fall of the blank generation', *New Musical Express*, 1 February, pp. 26–7.

McNeil, L. and McCain, G. (1996) *Please Kill Me: The Uncensored Oral History of Punk*, London: Abacus.

McRobbie, A. (1994) 'Second-hand dresses and the role of the rag market', in *Postmodernism and Popular Culture*, London: Routledge.

Middles, M. (1996) *From Joy Division to New Order: The Factory Story*, London: Virgin.

Morley, P. (1986) 'Oh, how we laughed', *New Musical Express*, 15 February, pp. 14–15.

Murray, C.S. (1986) 'I fought the biz and the biz won. How we got here from there', *New Musical Express*, 1 February: 24.

Nowell, D. and Winstanley, R. (1996) *Soul Survivors: The Wigan Casino Story*, London: Robson Books.

Oliver, K. (1993) *Reading Kristeva: Unraveling the Double-bind*, Bloomington and Indianapolis: Indiana University Press.

Osgerby, W. (1998a) *Youth in Britain Since 1945*, Oxford: Blackwell.

—— (1998b) '"The good, the bad and the ugly": post-war media representations of youth', in A. Briggs and P. Cobley (eds), *The Media: An Introduction*, Harlow: Longman.

Parsons, T. (1986) 'The boy looks back at Johnny', *New Musical Express*, 1 February, pp. 28–9.

Parsons, T. (1994) *Dispatches from the Front Line of Popular Culture*, London: Virgin.

Savage, J. (1991) *England's Dreaming: Sex Pistols and Punk Rock*, London: Faber & Faber.

—— (1997a) 'Vivienne Westwood: Rich pickings at the World's End', in *Time Travel. From the Sex Pistols to Nirvana: Pop, Media and Sexuality, 1977–96*, London: Vintage.

—— (1997b) 'Punk five years on', in *Time Travel. From the Sex Pistols to Nirvana: Pop, Media and Sexuality, 1977–96*, London: Vintage.

Segal, L. (1990) *Slow Motion: Changing Masculinities, Changing Men*, London: Virago.

Smith, A. (1996) 'Who patented punk?' *Sunday Times*, 29 September, p. 9.

Smith, A. D. (1991) *National Identity*, Harmondsworth: Penguin.

Snow, M. (1986) 'Blitzkrieg Bop', *New Musical Express*, 15 February, pp. 10–11.

Thornton, S. (1995) *Club Cultures: Music, Media and Subcultural Capital*, Cambridge: Polity.

Vermorel, F. and Vermorel, J. (1987) *Sex Pistols: The Inside Story*, London: Omnibus.

York, P. (1980) 'The post-punk mortem', in *Style Wars*, London: Sidgwick & Jackson [originally in *Harpers and Queen*, July 1977].

11
THE WOMAN PUNK MADE ME

Lucy O'Brien

It's 1977. 'I choked Linda Lovelace' T-shirts are everywhere, Fleetwood Mac's 'Rumours' is at No. 1, Italian drummer Cerrone has a disco hit with 'Love in C Major' and a host of girls in let's-get-physical boxer shorts and tight vests, Ronnie Spector is referred to in Sounds as 'the little jean-creamer', Stevie Nicks, Elkie Brooks, Lindsay Wagner and Olivia Newton John hold sway, along with the Eagles, Starsky & Hutch, Led Zeppelin and those die-hards, the Rolling Stones. Guitars come in all shapes and sizes, including pistols. An advert for Kasuga guitars features two naked women with instruments placed strategically over their private parts alongside the line: 'Ecstasy at your fingertips'. Jenny Darren is billed as 'raunchy and ready to rock . . . one of the new breed of lady rockers'. Two of the most popular T-shirts are 'Yea though I walk through the valley of the shadow of Death - I shall fear no evil: for I am the meanest Son of a Bitch in the Valley', and the mushroom cloud 'Suppose they gave a war and nobody came'.

'We were trying to find a new vocabulary' (personal communication 1997), says Linda Sterling, or Linder, art terrorist and former lead singer with avant-garde punk Manchester group Ludus, who once sang at the Hacienda covered in pigs' entrails and wearing a large black dildo. 'We just wanted to take the whole thing to its logical extreme' (personal communication 1990), said Siouxsie Sioux, who screamed of a suburban relapse and went into a Bromley wine bar in fetish gear with her friend Berlin on a leash and all fours. There were the Slits, defiantly naked and daubed in mud, on the cover of their debut album, *Cut*, and other girl groups like the Raincoats, the Mo-Dettes, and my own, the Catholic Girls, knots of resistance surrounded by incomprehension and hostility. Against this was the backdrop of tiered flowery skirts, flicks and flares, and the crushing conformity of what it meant to be female in a Britain still tinged by post-war austerity.

Despite the assertion that the hippies were the first to slough off old values, punk was the test case, the first modern generation. In just three years, from 1977 to 1979, and then another social leap to 1980, the gender map had radically begun to

alter. The unpicking that started with celebratory abandon on the underground 60s freakscene became a giant unravelling with punk. It was during punk that the 'sex wars' went overground, that the battle for territory on stage, on the street and in the workplace began to pierce the mainstream. That was the context that made us.

The orthodoxy was that punks hated hippies, and that the era of sexual permissiveness, 'sexual liberation' had been a big con, just a way of getting women into bed more easily. Punks objected to what they saw as hippie idealism and naiveté, the 'grow your own hi fi' approach that failed to take account of the rigours of late twentieth-century urban life. Before the acid house boom of the late 80s and the second 'summer of love', it was presupposed that swinging 60s ideals had collapsed in the face of growing cynicism and materialism.

It was the 60s and early 70s counterculture movement, however, that opened up pathways for punk feminism. In 1970, for instance, Germaine Greer put the politics of female sexuality firmly on the agenda when she guest-edited the special 'Cuntpower' issue of the underground magazine *Oz*. Included in the issue was a women's liberation manifesto, a piece on female masturbation, instructions on how to make your own 'Cuntpower' bikinis, and a Greer polemic on the power of 'cunt' confrontation. No longer were women to remain 'chaste guardians of their husbands' honour'. In a characteristic clarion call, she wrote: 'Cunt is knowledge . . . Skirts must be lifted, knickers . . . must come off forever. It is time to dig CUNT and women must dig it first' (Greer 1970: 24)

Despite the rhetoric of sexual liberation, though, women were still finding equality an uphill struggle. Twenty-seven years after that special issue of *Oz*, Greer admitted that because production of the magazine had ultimately been controlled by men, she had to tolerate her ideas being 'tidied up' and smoothed over in the name of 'professionalism'. Greer felt compromised in presenting women as they really are:

> Hairy, smelly, energetic and strong. Up till then women had been represented in Oz principally by wispy bare-breasted flower children and the pneumatic creations of Robert Crum [sic]. The sixties was the hey-day of male display; the most successful sixties women were scented, decorative and slender, voluptuously dressed in diaphanous chiffons, old embroideries, baubles, bangles, beads and boots, and spoke in blurred voices – if they spoke at all.
>
> (McQuiston 1997: 6)

They also assisted the revolution by doing the washing up, rolling the roll-ups, making coffee and taking the Pill. As 60s Black Panther, Stokely Carmichael, once said, the position of women in the freedom movement was 'prone', and lines like

'A pretty girl is like a manifesto' over wide-eyed naked sylphs on the cover of an edition of *International Times* bear this out. For women the new sexuality was a muddled mix of old-fashioned passivity and experimental self-assertion. Queen of 60s pop, Marianne Faithfull, for instance, recalled a time when Rolling Stone Brian Jones unexpectedly came on to her:

> I was in his flat, I was a pretty girl . . . it [was] almost de rigueur that he make a pass at me, it was the new sexual politesse. For my part, I thought, Oh, he's making a play for me. I really should let him. . . . Hippie etiquette. You just sort of went along, didn't you?
>
> (Faithfull 1994: 65)

To resist a potential lover, it seemed, you were holding up the revolution. 'Reichian ideas of sexual liberation were quite powerful at that point. The theory was that if you free yourself sexually, you free humanity,' says psychoanalyst and prominent 60s campaigner Juliet Mitchell. 'The trouble was that sexual liberation hadn't taken account of psychological liberation. You don't get freed of all the jealousy and pain that infidelity and promiscuity cause. There was a psychological time lag' (personal communication). For Mitchell, although men 'were having a hard time readjusting to the women's movement', there were genuine freedoms for women.

> The availability of the Pill and relatively safe abortion made a huge difference. There was much greater pleasure in the body. You could see it in the clothes, for instance. Until the early '60s women wore wasp waists, stiletto heels, beehive hair -- very, very constricting. Then clothes became much more whacky and liberated. I remember Mondrian squared skirts, long flowing hippy Indian fabrics and a lack of restriction.
>
> (ibid.)

Not wearing make up, going bra-less and barefoot, the emphasis was on expansion and experimentation. But, as Mitchell concedes, 'we were a very privileged generation, coming into our own in near enough full employment'. By 1976, amid increasing economic uncertainty, the hippie look had been mass marketed and diluted to the point where it became the new conformity. To find fresh meanings as a woman it was necessary to overturn the pastel shades of post-60s femininity and make an overt statement on a newly emerging, more aggressive understanding of female sexuality. Punk provided the perfect opportunity.

From the slinging of bras and girdles into the Freedom Trashcan at the 1968 Miss America Contest, to Barbara Kruger's late 80s ProChoice slogan 'your body is a battleground', women have understood the need for a visual vocabulary.

Women are so regularly evaluated in physical terms, it is hardly surprising that much of the gender battle takes place in terms of image. Up to the mid-70s traditional notions of female beauty remained pretty much intact, and even within the excesses of hippiedom a 'natural' look was maintained. With punk, leading characters like Vivienne Westwood, Jordan and Siouxsie Sioux systematically set about dismantling these standards, while former 60s beauties such as Marianne Faithfull and the German Velvet Underground chanteuse, Nico, destroyed the looks that had led to their initial success. Beauty, like sex, was debased currency.

With the shops Sex (opened in 1974) and Seditionaries (1977), Westwood and partner Malcolm McLaren popularised the mood of the new brutalism. Playing with the paraphernalia of pornography, Westwood devised confrontational rubberwear, ripped slogan-daubed T-shirts and the infamous bondage trousers. Everything was 'studded, buckled, strapped, chained and zippered' (Martin 1995: 545–47). Unlike the loose-limbed, hippie 60s, punk celebrated the rigours of restriction, constriction and sado-masochistic denial. 'Not that I strapped myself up and had sex like that . . . but I wanted to get hold of those extreme articles of clothing and feel what it was like to wear them', explained Westwood (ibid.).

Underwear as outerwear became her motif, one modelled with brazen self-containment by Sex assistant Jordan.

> I used to take real pride in the way I looked and because I could do the job. Sometimes I'd get on the train and all I had on was a stocking and suspenders and a rubber top, that was it. Some of the commuters used to go absolutely wild, and they loved it. Some of the men got rather hot under the collar, paper on the lap.
>
> (Savage 1991: 95)

Westwood's designs playfully made the vocabulary of porn explicit, but though keen to 'seduce people into revolt', she shied away from making links with porn's female exploitation. In graphic art, Linder, meanwhile, tackled 'the last taboo' with a more focused feminist statement. Her cover design for The Buzzcocks' 1979 single 'Orgasm Addict', for instance, was a cut-up collage featuring a naked woman with an iron for a head, and teeth where her nipples should be. Inspired by punk fanzine culture and the way anti-fascist artist John Heartfield used montage, the former Manchester art student created pictures from shopping catalogues, porn mags and pictures of household appliances as a disturbing comment on the sex roles (see Figure 11.1). Collages included: a woman in lacy lingerie with a hoover for a head and a camera poking out from her dressing table; a courting couple, she with a fork in her eyes; and a girl masturbating a hoover where the man's penis should be. Linder recalls:

Figure 11.1 Collage by Linder, 1977.
Source: © Linder.

It was like doing a peculiar jigsaw puzzle. I had two piles of magazines – trashy men's stuff and trashy women's. I noticed that in both women were high profile. Men's magazines were filled with pictures of women. And the invisible man was present by his absence. I was fascinated by the fact that I as a woman was supposed to be in all these worlds, I was represented in two separate male/female views of the world. These montages became an explicit diary of my feelings at that time.

(Personal communication 1997)

Like many women during punk, Linder made a connection with the writings of the early 70s feminist movement, Greer's *The Female Eunuch* (1970) in particular. 'For me at 16 reading that re-arranged my molecular structure. It was fantastic. Then later there was a neat collision of my anger and frustration and punk coming along. The book must have been a catalyst' (ibid.). Linder made explicit women's bodily processes and obssessions, from eating disorders to the mechanics of menstruation. One of her best known songs is called 'My Cherry Is In Sherry', for instance, while the cover design for Ludus album The Seduction features the bottom half of a woman wearing the traditional garb of soft porn seduction – fishnet stockings and suspenders – but with an unglamorous belt and sanitary towel.

The fact that so many punk girls refused to regulate or disguise body size was also an acknowledgement, for Linder, of women's real physicality, or 'cuntpower'.

There were lots of clothes coming out of Sex, and women like Jordan, over Size 12, daring to wear fantastic clothes. Up North, too, there were big lumpy punks around. A lot of the punk women weren't 'ideal' prizes, but they had small skirts on if they wanted. Punk was about being looked at, creating a temporary celebrity. There was something glorious about all those shapes and sizes of bodies on show.

(ibid.)

Punk was also a place where women felt free to express difference. 'It was more about being a freak than a punk,' says Liz Naylor, co-editor of the Manchester punk fanzine *City Fun* (see Figure 11.2), and later on, manager of the UK's leading 90s Riot Grrrl band, Huggy Bear. She feels that punk revolutionised her generation in the same way that the Pill had done for women in the 1960s, and that women interpreted punk very differently from men. 'It wasn't immediately: "OK, I can form a band and be like The Clash." It was about knowing you could escape to be something bigger' (personal communication 1997). It also gave women a place to rage. Before the mid-1970s women who expressed seething anger were ostracised as misfits, Janis Joplin being a prime high-profile example of the girl whose refusal to be first the good prom queen and then the acquiescent rocker left her isolated,

191

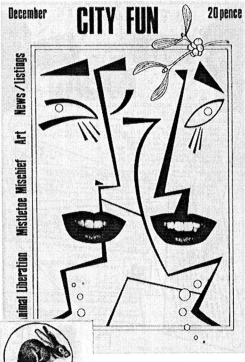

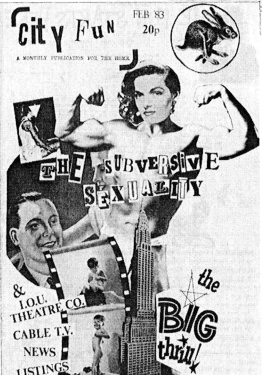

Figure 11.2 Covers to *City Fun* fanzine (1982, 83). *Source*: © Linder.

with a debilitating anger that had nowhere to go. It cannot be over-emphasised, then, how much punk in the 1970s was a visible threat. Naylor recalls:

> There is a rosy view of ye olde punks, but there was actually a lot of painful stuff going on around it. You were seen as deviant. There was a lot of anger and self-mutilation. In a symbolic sense, women were cutting and destroying the established image of femininity, aggressively tearing it down.
>
> (ibid.)

Shortly after Naylor left school, a bewildered mother had her committed to a mental hospital for six months. 'I was fucked up, but my "therapy" was the doctors asking me, "Why do you feel you have to be anti-social?" If a kid wore punk fashion now, it would just be seen as part of growing up. You forget the impact it had' (ibid.).

For many punk women the streets became a battleground, as if by dressing in a certain way you gave up your 'rights' as a woman to be respected and protected. 'We got picked on in the street, our lead singer Ari was stabbed – just because of what we looked like,' remembers Viv Albertine, guitarist of seminal girl band the Slits.

> We'd be dressed half in bondage fetish gear, half in Doc Martens with our hair all out there, scowling at everybody. People didn't know if we were a pin-up or what. It freaked middle aged men particularly. That mixture of rubber stockings, DMs and fuck off you wanker what are you staring at. They didn't know if they were coming or going.
>
> (O'Brien 1997)

Often this confusion resulted in violence. I remember as a teenager in the late 70s, playing a gig in Kingston with our all-girl band the Catholic Girls, and being bottled by an audience of skinheads. After the show a crowd of around 20 of them followed us outside and attacked us as we were loading up the van. During gigs there were regular cries of: 'fuckin' cows, who do you think you are?', while at one pub gig we barely got through the first number when a brick was thrown through the front window, tables were overturned, and Wild West bar-room mayhem ensued. 'We'd have Hell's Angels and skinheads coming to our gigs. If you don't show fear, they're not a problem. You had to have a hell of a front,' recalls Albertine. All the punk women I spoke to talked of that sense of running the gauntlet every time they went out the front door, and the relief when they got to the safety of a gig or a club. 'There was that joy when you arrived at the venue. Here I am among the dispossessed, all punks together', says Linder.

Punk also had its own sexual codes. Despite the prevalence of fetish gear and provocative clothes, it was curiously asexual. In hippie culture, the emphasis on 'permissive' freedom meant that many people felt compelled to be heterosexually active, but punk choices to be asexual, gay, androgynous or celibate were usually accepted without comment. This was particularly liberating for young women. 'I hated discos and all that handbag, boys and make-up stuff. I loathed it. For me punk was like fresh air', says Judith Roche, former bassist with the Catholic Girls (personal communication 1997). There was no pressure to 'couple up', in fact, romantic love was frowned upon as something wishy washy and sentimental, and sex was just something you got on with. 'By the time you're twenty you just think – yawn – just another squelch session', John Lydon languidly remarked in 1976 (Savage 1991: 189).

In the first year we were together as the Catholic Girls, none of us was interested in having a boyfriend. As Anjali, lead singer of 90s Riot Grrrl band, Voodoo Queens, once said 'Who needs boys when you got guitars?' (personal communication 1993). There was the heady optimism of being part of a girl gang – for once we were tasting the joy that a group like the Clash had as The Last Gang In Town, being able to walk down the street as an invincible unit. 'Part of being in a band was learning about that female solidarity,' recalls Roche. And for many that sense of strength was intoxicating. 'We'd walk down the street as a bunch and feel very very powerful', says Albertine of the Slits, 'It was very exciting. I don't think many girls get to do that'.

It was important for girls on the punk scene to find some kind of solidarity. Contrary to myth, punk was not necessarily woman-friendly, and it was hard to make an impact as a female musician. Apart from a few high-profile acts like Siouxsie and the Banshees, Pauline Murray, X-Ray Spex, the Slits and the Raincoats, women suffered the same discrimination they had always done, treated as novelty, decoration and not as serious contenders. In a 1977 *Sounds* round-up of all the key punk bands, for instance, there were only five female acts out of 36 (2 April: 23–28). On the positive side, the lack of emphasis on technical expertise meant that many women felt able to enter a world from which they'd previously been excluded. Once there, however, few made it above groundlevel. And those that signed record deals often found themselves at loggerheads with a music industry that was still locked into marketing women as disco dollies or raunchy rock chicks. A few entered the commercial mainstream, but at that point the pressure was to be like Debbie Harry, the pneumatic pretty punk, or Chrissie Hynde, one of the guys.

The punk scene itself, also, was not always one of halcyon acceptance. While there were men wrestling with questions of masculinity and feminism, there were just as many content to leave it unreconstructed. 'A lot of the punk boys were just regular knobheads who happened to have spikey hair', remarks Naylor. This view

of girls as chicks and men as the real deal was perpetuated through the sexist lyrics of such bands as the Depressions, singing 'Screw Ya', and ridiculing the woman with options in 'Career Girl', or Adam Ant's ditty 'Fat Fun', or the Stranglers, with strippers at their Battersea Park show (see Figure 11.3) and demeaning songs like 'London Lady', 'Princess of the Street', and 'Peaches'. 'Rather than being socially progressive, Punk Rock contained a provocative ambiguity. It doesn't care if it offends' (Home 1995: 73).

In response to this women often relied on a fierce sense of individuality to buttress themselves, whether it was Siouxsie Sioux confronting crowds with her black-eyed stare – 'everything felt so abrasive, you'd have missiles thrown at you on stage, your head was in the block. You needed a protest voice to survive within that' (O'Brien 1995: 137) – or the 14-year-old Slits vocalist Ari Up pissing on stage, or Lora Logic blasting the saxophone her way in day-glo punk band X-Ray Spex. Palmolive, the Slits drummer with the wayward, pummelling style, recalled the kind of thing they were all up against when describing how Malcolm McLaren, the main male svengali on the scene, approached them. '"I want to work with you because you're girls and you play music. I hate music and I hate girls. I thrive on

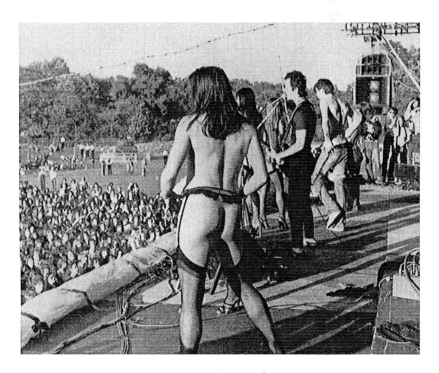

Figure 11.3 The Stranglers at Battersea Park, 1978, plus strippers.
Source: Photograph by Pennie Smith.

hate. I wanna work with you." I said, "No thank you". He was trying to break us' (Appelstein 1995: 3).

Carving a definitive style separate from male expectation also meant embracing 'ugliness'. Poly Styrene, for instance, X-Ray Spex's half-Somalian, half-British lead vocalist, sang with a spiralling shriek and appeared on *Top Of The Pops* in a little soldier's outfit and a large brace on her teeth. 'I was very conscious of the brace. I wasn't one of the pretty punkettes. I was rebelling. Although I could actually sing, I didn't want to sing – I wanted to be an anti-singer' (O'Brien 1995: 133).

After the shock tactics of the first summer of punk, the scene settled into various sub-divisions such as New Wave, psychobilly, and 'art school' post-punk, characterised by bands like Gang of Four and Delta 5. A more intellectual feminist element grew alongside the development of political punk campaigns such as the Anti-Nazi League, Rock Against Racism and Rock Against Sexism, the latter a benefit network set up to raise money for organisations like Women's Aid or Rape Crisis. Like mixed-gender, splintered dance outfit the Au Pairs, the Raincoats directly tackled feminist issues directly. Their song 'Off Duty Trip', for instance, told the true story of a soldier tried for raping a teenage girl and acquitted by a judge concerned about his army career. The Catholic Girls, too, came together after going on the National Abortion Campaign's Anti-Corrie Bill march in 1978. 'I remember being excited by the Sex Pistols' antics, because it was anti-authority', recalls Judith Roche. 'Before we formed the group we'd already done demonstrations. We had a political edge. Since 16 we'd been doing Hunt Saboteurs, Friends of the Earth, CND – and punk reinforced it' (personal communication 1997).

One of the attractions of punk was having an outlet for that political outrage, that disaffection with the status quo which was cemented by the early years of a Conservative Government hostile to dissent, and a leader, Margaret Thatcher, who took great pride in disassociating herself from 'shrill feminism'. For women this revolt was present not just in words, but music that deliberately veered away from standard rock 'n' roll time. 'We were trying to find a way of looking at the world that was personal and different', says the Raincoats' founder member, Gina Birch, of their scratchy, cyclical, compelling sound. 'We'd improvise around things, pull them out and make spaces. We wanted to bring in an element of discovery and discomfort' (personal communication 1994).

They were one remove from the more theatrical approach of the Banshees or X-Ray Spex, deliberately dressing down, appearing dowdy even, as a way of counteracting the sexy female star syndrome. Ludus, too, made few concessions to chart-dom, with their complicated rhythms and Linder's off-kilter vocals. Her final gig at the Hacienda in Manchester perhaps sums up how far, in terms of intellectual and visual resistance, women in punk could go.

Bucks Fizz had just won the Eurovision Song Contest. At the end of their song the men pulled off the girls' skirts, and that ticked off an outrage in me. Oh no, I thought, it's still going on. At the same time at the Hacienda they were showing lots of soft porn and they thought it was really cool. I took my revenge. I was a vegetarian, I got meat from a Chinese restaurant, all the discarded entrails. I went to a sex shop and bought a large dildo. I didn't tell anybody about it.

(Personal communication 1997)

Just before the show, she and a few female friends 'decorated' the club, tying tampons to the balconies and handing out to the crowd giblets wrapped in pornography. 'The Hacienda was still this male preserve. They were panicking – "it's going to mark the floors", they said. And they refused to do a Bloody Linder cocktail in the cocktail bar'. Then Ludus played the gig, with Linder upfront, covered in meat. At the crucial moment, just like the Bucks Fizz girls, she pulled off her skirt to reveal the shiny black dildo.

I remember the audience going back about three foot. There was hardly any applause at the end. And that was a crowd who thought, nothing can shock us, we see porn all the time, we're cool. When that happened, when they stepped back, I thought, that's it, where do you go from here?

(ibid.)

Linder had done the ultimate in making the implicit explicit, her imagery not acceptably contained on the video screen. Through the use of meat and tampons she was showing the 'reality of womanhood', and with the dildo: 'Here's manhood, the invisible male of pornography. That it can be reduced to this, a thing that sticks out like a toy.'

By the time of Linder's final gig, punk was going through its last incoherent blast. Nancy Spungeon, the 'little broad from Philadelphia', died a junkie's death, allegedly murdered by her boyfriend Sid Vicious. She represented the most powerless, timeless example of women in rock 'n' roll – the woman as groupie and victim. Punk's essential exuberance was dissolving into nihilism and factional fighting, while punk as high fashion was beginning to show up on the catwalk. When Zandra Rhodes showcased her bejewelled safety-pin and delicately torn evening dress, *Woman's Own* magazine ran a feature on DIY punk, and PVC trousers were available at Miss Selfridge, it was obvious that the movement was rapidly being assimilated into the mainstream.

What survived though, and continued to evolve long after the mediated version was pronounced dead, was punk's meaning for women. It reacted against, yet at the same time re-defined 60s feminism, resurfaced in the 90s with grunge and Riot

Grrrl, and still has an impact on the way women operate, not just in music, but culture generally. 'Twenty years on, our vocabulary is still forming', says Linder. Those of us who experienced that battleground have been shaped by it. We still find it difficult to shake off the questioning rigour that the scene demanded, and maybe we don't want to. That's the women punk made us.

Bibliography

Appelstein, M. (1995) 'Interview', Paloma Web site, Nonstop Productions, jen@non-stop.com. Faithfull, M. (1994) *Marianne Faithfull*, London: Bloomsbury.

Greer, G. (1970) 'The politics of female sexuality', *Oz* No. 29.

Home, S. (1995) *Cranked Up Really High: An inside account of punk rock*, Hove: CodeX.

McQuiston, L. (1997) *From Suffragettes to She Devils*, London: Phaidon.

O'Brien, L. (1995) *She Bop: The Definitive History of Women in Rock, Pop & Soul*, London: Penguin.

——— (1997) Unpublished interview with Viv Albertine for the *Guardian*.

Savage, J. (1991) *England's Dreaming: Sex Pistols and Punk Rock*, London: Faber & Faber.

Steele, V. (1995) 'Vivienne Westwood', in R. Martin (ed.), *Contemporary Fashion*, Detroit: St James Press.

12

'I WON'T LET THAT DAGO BY'

Rethinking punk and racism

Roger Sabin

Histories of British punk, 1976–79, have been unanimous about the movement's relationship to racism. Whether these histories be in the form of academic texts, commercial books, magazine articles, or tv and radio accounts, the conclusion has always been the same: that despite some posturing with swastikas, punk was essentially solid with the anti-racist cause. Its alliances with the reggae scene on the one hand, and the twin organisations of Rock Against Racism (RAR) and the Anti-Nazi League (ANL) on the other, are taken as irrefutable evidence of this, and have enabled historians to co-opt punk into a more long-term tradition of counter-cultural – left-wing – dissent.

In this chapter I want to question this orthodoxy, and to challenge some of the underlying assumptions about punk's political leanings. By taking a fresh look at sources from the time – music papers, lyrics, political literature, and especially those repositories of unguarded comment, fanzines[1] – I'd like to take issue with the twin ideas that punk somehow transcended the societal forces that gave birth to it, and that it can be judged as being ideologically commensurate with the 'politically correct' standards of the 1980s and 90s. Thus, I want to show how the movement's involvement with anti-racism has been exaggerated, how its political ambiguity left ample space for right-wing interpretation, and how its overtly racist aspects left a legacy for the fascist music scene of the post-punk era.

First, an unavoidably brief word about the background to race relations in the late 1970s,[2] a period more tense in this regard than at any point since the Second World War. This was thanks in no small part to the rise of the National Front (NF), the biggest of Britain's fascist parties. By 1976, after doing increasingly well in local elections, it was the fourth largest political party in the country (though still a long way from gaining a parliamentary seat), and was concentrating its efforts on a campaign in the run-up to the general election which involved making its presence felt in areas of high non-white populations by a series of high-profile

street-marches. The party additionally had a policy of recruiting from subcultures, and especially from punk – more about which later.[3]

Racism was 'on the map' in other ways, too. The Conservative Party, then in opposition, proved itself anxious to steal the NF's fire by making race a key issue. The Labour government itself was far from non-racist, and made little effort to tackle racism in other organs of the state (especially in the police and the courts), or indeed in the employment market and in schools. Racism was an issue in the media in a sense that it had never been before, with pundits like Enoch Powell of the Conservatives and Martin Webster of the NF, invited to contribute to debates in newspapers and on radio and TV (typically compromising the media's self-image of 'neutrality'). Culturally, racist gags were everywhere – from TV shows like *Love Thy Neighbour*, *Mind Your Language* and *The Comedians*, to the 'Best Jokes' series of books available in every high street bookstore (*Best Jewish Jokes*, *Best Pakistani Jokes*, *Best Coloured Jokes*, etc.).[4]

Against this background, the need to create a myth that punk was somehow anti-racist was understandable, and the process began almost as soon as the movement itself did. Most journalists on the music papers, for example, considered themselves to be 'left wing', and many hailed from the same tradition as the countercultural publications of the previous musical era (*Oz*, *IT*, *Frendz*, etc.) – some, like Charles Shaar Murray, had also written for them. Thus, there was a caucus of journos who were pro-punk and eager to claim it for their own political world-view. Such names at the two big 'inkies', *NME* and *Sounds*, included: at the former, Murray, Julie Burchill, and Tony Parsons; and at the latter, Jon Savage, Vivien Goldman and Garry Bushell.[5] *Sounds*, by far the most punk-orientated of the two, even went so far as to devote an entire issue to the racism debate (25 March, 1978; see Figure 12.1).

Reporting of punk in the mainstream press tended to follow the lead of the inkies. True, early on there was something of a moral panic in the tabloids, but once the 'Filth and the Fury' headlines had played themselves out, the press was content to borrow stories – and this meant parroting the anti-racist line. In time, many of the music writers themselves would be poached. Meanwhile, high street bookshops began to stock the first histories of punk, invariably written by those same rock journos (for example, Burchill and Parsons (1978) and Coon (1978)).

The 1970s also saw a significant contribution to the anti-racist myth from academia. Even before the last power chords of punk's first wave had died away, Dick Hebdige's *Subculture: the Meaning of Style* appeared (1979), taking a semiotic approach to the movement, and making a case for seeing the history of British subcultures since the war as a response to the influence of black youth styles. This point was particularly relevant for punk, he argued, because of its associations with reggae, and since, 'at the heart of the punk subculture, forever arrested, lies this frozen dialectic between black and white cultures . . .' (1979: 69). The book was

200

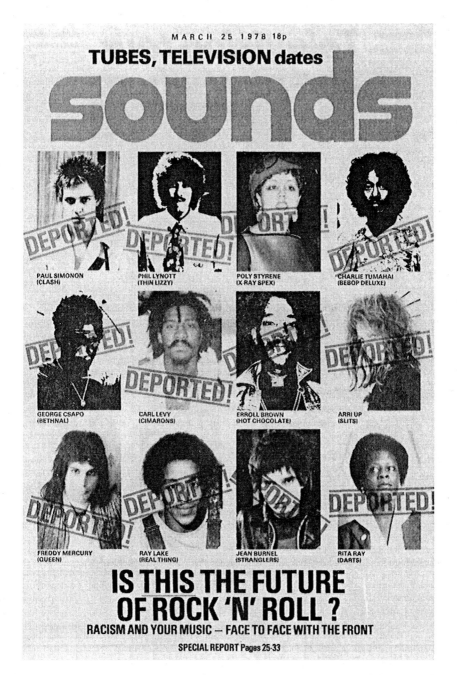

Figure 12.1 Cover to *Sounds* (25 March 1978) – a special racism issue.

extremely influential (to the point where it has been re-issued almost annually), and would become a set text in the developing field of Cultural Studies.[6]

The process of mythmaking continued into the 1980s. The music press, now dominated by the *NME*, continued to romanticise punk in retrospect, with prominent socialist journalists like Steven Wells and X Moore taking up where the first crop of writers had left off. Once more the mainstream press, including the new 'style press', followed suit, especially at the time of punk's 10th anniversary (1986–87), when celebratory special issues and supplements abounded. TV and radio were also quick to air retro documentaries. But whether the image was of a photo-spread of a punk band juxtaposed with a shot of a 'Stop the Nazis' poster, or of footage of the Vibrators segued with that of an ANL march, the impression was the same.

The 1980s saw another important book on the issue, David Widgery's *Beating Time* (1986), a history of RAR (and to a lesser extent of the ANL as well) written by one of its founders.[7] Although making no secret of the fact that these two organisations were specifically socialist, and had backing from the Trotskyist Socialist Workers' Party (SWP), it put punk at the centre of the story, claiming that it was a natural (class) ally of socialism, and therefore an ideal conduit for combating the fascist tide. According to Widgery, 'Punk expressed a political moment' in terms of anti-racist activism (1986: 117).[8]

Finally, the 1990s have seen the myth brought up to date, with yet more retrospectives (notably during the latest anniversary, 1996–97) which have been no more critical than their predecessors: indeed, they tended to cannibalise them quite shamelessly. Meanwhile, the market in punk nostalgia, especially compilation 'Best of' CDs and videos, has boomed, though sometimes edited of 'controversial' and racist material. And, of course, there have been more histories – over 30 at the last count, if you include band biographies – the vast majority of which have been content either to avoid politics, or to repeat what has been said before.

The myth has therefore taken on its own momentum over the years, acquiring layers of respectability along the way. Even if, to be fair, some of its shortcomings have been taken into account by the better histories that have been published (Laing (1985), Savage (1991) and Home's – admittedly ragged – (1995) among them), nevertheless it has solidified into an orthodoxy – the 'historical truth'. But history is nothing if not a selective presentation of the facts, and if we take it upon ourselves to foreground less 'PC' evidence from the period, a totally different picture begins to emerge.

Punk and Anti-racism

'Don't Back the Front'

(song title, Desperate Bicycles, 1977)

Before looking at punk's relationship with reggae and RAR/the ANL, there is an area that requires more urgent consideration, not least because what punk didn't say about (anti-) racism was often more important than what it did. Specifically, punk's biggest failure in the political sphere was its almost total neglect of the plight of Britain's Asians. For it has been forgotten over time that the focus of attention for the far right in the late 1970s was directed primarily at them, and not, as most accounts assume, at British Afro-Caribbeans.[9] There were specific historical reasons for this, having to do with the bursts of immigration from 1976 onwards as Asians (with British passports) were expelled from Uganda, Kenya and Malawi. These unfortunate people had typically experienced racism before – hence their exile. Now, in their new homes in Britain's inner cities, they would face more.

The racist backlash was immediate. The NF, newly energised by the 'crisis', systematically redirected its propaganda away from its traditional enemies (Jews foremost among them) to Asians. New leaflets explained the threat from their 'rapid family growth', uncleanliness ('filthy Asians' being a stock phrase), and above all from their 'stealing' of jobs at a time of high unemployment. The only answer, the NF claimed, was to 'Stop all immigration and start phased repatriation' (see Figure 12.2). The Conservative Party, for their part, began to speak 'on behalf' of the white working class (an unprecedented move for them until this point) and called for much tighter immigration controls: Margaret Thatcher, leader of the party, even expressed her sympathy for whites who felt that they were 'being swamped'.

One result of this heightened atmosphere, and especially of NF fear-mongering, was an exponential rise in the number of street attacks on Asians (a phenomenon known as 'Paki-bashing' – though, of course, only a few of the victims were ever from Pakistan). Firebomb attacks on Asian homes similarly became commonplace. Today, figures are hard to gather, not least because most incidents were never reported: but it is a certainty that the majority of racist murders in the late 1970s were of Asians.

What was punk's response? The most striking impression is one of silence. In general, articles in music papers and fanzines didn't mention the Asian situation, punk musicians didn't talk about it in interviews, and punk lyrics didn't acknowledge it. This could have been because of ambivalence, or even hostility, towards Asians. Or, more likely in most cases, it was because the issue wasn't a

Policies for winning back our country

- Stop all immigration and start phased repatriation
- Get Britain out of the Common Market
- Restore our links with the White Commonwealth
- Root out corruption. Restore honest government
- Encourage free enterprise that serves the national interest
- Combat unemployment by buying British
- Create genuine incentives to work hard and invest in our country
- Modernise our trade unions; crack down on union extremists
- Get tough with criminals. Bring back Capital Punishment
- Put National Defence before Foreign Aid
- Welfare: Put our old folk before aliens

A message from SQUADRON LEADER JOHN HARRISON-BROADLEY DFC (RAF Retd.), President of the National Front

"Don't be frightened by the lies of people who tell you we are 'Nazis'. The people who tell that lie are the people who are murdering our country. Millions of people support our patriotic policies, yet our opponents try to pretend that to support them is to be a 'Nazi'.

"Let's have an end to this nonsense. We're British. We're against dictatorship; we support parliamentary democracy and individual freedom. We're a party of the present — and the future.

"The 'Nazi' talk is just a pack of lies cooked up by Labour politicians terrified of losing their votes. The idea is to stop you exercising your own independent judgement of NF policies. Find out more about us for yourself by filling in the form below and we'll send you information about all the policies on which we're fighting this election."

```
To: The Secretary, National Front,
              73 Great Eastern Street, London E.C.2.
Please send me details about National Front election policy.
Name ..................................................................
Address ..............................................................
          ..............................................................
```

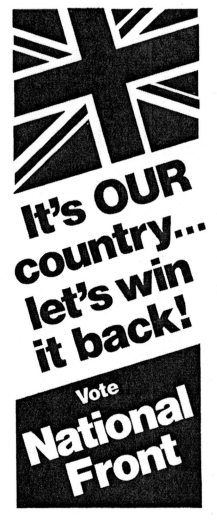

Figure 12.2 National Front leaflet, General Election 1979, Ilford, Essex. The word 'immigration' in this context refers mainly to Asians.

'hip' one. Asians simply didn't have the same romance as Afro-Caribbean youth — especially in terms of the latter's reputation for being confrontational with the police — and what was equally problematic, they had no music comparable to reggae with which punks could identify. As fellow 'rebel rockers' they were a dead loss.[10]

On the very rare occasions when journalists did raise the subject, the response could be surprisingly unsympathetic. Thus, in a *Record Mirror* interview with the Clash, the band are busy outlining their anti-racist views when the subject of

anti-Asian violence arises, and manager Bernie Rhodes chips in: 'There's a lot of Pakis that deserve it . . . ' (Anon 1978). He's soon corrected by other members of the group, but the idea that such a comment could have been made about Afro-Caribbeans is unthinkable.

If anti-racism could be selective in this sense, then it indicates that we also need to look more carefully at the supposed solidarity of punk's association with reggae culture and with RAR/the ANL. The reggae scene, as we have noted, was perceived as being 'in tune' with the punk ethos, to the point where 'it seemed every punk rocker started to walk with a skank'.[11] Symbolically, punk bands like the Clash, the Slits, and ATV incorporated reggae rhythms into their music, while the compliment was returned in other ways by reggae artists: Bob Marley's 'Punky Reggae Party' summed up the alliance by saying that both punks and rastas were 'rejected by society' and 'treated with impunity', yet were both 'protected by their dignity'.[12]

But there is evidence that the union could be a superficial one – and that the 'punky reggae party' was not that well attended. Undeniably, in some areas, and at some points in time, it was important. But, in general, it only affected very few punk performers and fans, and indeed reggae was a tiny minority interest among music devotees in general. For example, notwithstanding the success of Marley, reggae albums sold in miniscule amounts, and in most parts of the country they were simply unavailable. Press coverage of the scene was correspondingly thin, with only the occasional half-page in the inkies, and nothing at all in most fanzines. Even when space was given over, the response from (punk) readers could be hostile, as the almost weekly letters of complaint to *Sounds* bear testimony. Similarly, most punk bands refused to touch reggae, and continued to play music that seemed, as Jon Savage has rightly pointed out, 'to eradicate almost every trace of pop's black origins' (Savage 1991: 243). Likewise, most club DJs ignored it – contrary to legend[13] – while on the national airwaves, John Peel, who played as much as he could, received what he's called 'sackloads' of hate mail. When reggae acts played on the same bill as punk bands, it was the same story. In the big urban centres, perhaps, they'd be treated with a degree of tolerance: but not necessarily so elsewhere (see p. 183 for the unfortunate fate that greeted Exodus when they played in Wigan).

Even when the alliance was most visible, there was still the question of how, exactly, liking reggae music equated with anti-racism. Again, no doubt it did in some circumstances (though the idea that reggae was 'authentic' was, of course, a kind of racist stereotyping in the first place). But in others, pro-reggae punks could hold racist/fascist views without even pausing over the contradictions. With this in mind, it seems likely that that the alliance was more often romanticised as 'anti-authority' than 'anti-racist'. The Hebdigean 'dialectic' did exist in this sense, but within highly defined boundaries.

As for punk's alliance with RAR and the ANL, this raises further questions. According to many accounts, these organisations' ideological input 'gave punk something to fight for' (Bushell 1986: 15) and 'punks tended to align themselves with them' (Shuker 1998: 236); and indeed they did their utmost to harness punk to their cause. The method RAR chose to spread the word ('Love Music, Hate Racism') was to organise hundreds of gigs throughout the country featuring a variety of bands and musics, mixing black and white acts – often punk and reggae bands. Due to their perceived status as 'authentic voices' of the working class, punk artists were encouraged to 'tell the truth' about the state of the nation; the joint RAR/ANL carnivals headlined with punk bands, and were, indeed, the biggest anti-fascist actions since the war. Similarly, punk stars were interviewed for *Temporary Hoarding*, an RAR publication modelled on punk fanzines.

Yet punk's role *per se* was not as dedicated as the Widgery account makes out. There was certainly a lot of genuine commitment. But, rather obviously, we could ask how many punks went to the gigs to support the cause? Journalists who attended were often very sceptical. Less obviously, how many bands played for that reason? Some did, but some did not, and there is plenty of evidence of cynical behaviour. Thus, Nick Knox of the Vibrators could respond quite bluntly to a question from a fanzine writer thus: 'Q: "Why did you do the RAR gig? Because you believed in it?" Knox: "No, actually what most people don't realise is that bands do get paid for it. We just did it because it was a gig to do . . . ".' (*Teenage Depression* No. 8, 1978). Similarly, a member of the Art Attacks in another, more recent, interview: 'We did the RAR gigs because they paid good money. . . . They paid full expenses: to us, that was a lot of money'.[14]

Even for the more committed punks, there is the question of how far anti-racism was perceived in the same way as RAR/ANL. The aim of these organisations was to combat *all* racism, but for many punks the cause was thought of in terms of anti-racism towards Afro-Caribbeans rather than towards other ethnic groups. This comes back to our previous point about the anti-Asian problem: thus, the Clash's manager may have had problems with 'Pakis', but he was happy enough to allow the band to play on the same bill as Misty in Roots. The audiences reflected this contradiction, and despite RAR's efforts to put on gigs in areas of high Asian populations (e.g. Southall), writer Simon Frith is right that their methods had 'an offputting effect for Asian youth' (1992: 69). Other RAR-supporting bands were equally capable of making racist gaffs about Jews, hispanics, Arabs, you name it (e.g., Joy Division, Sham 69, the Art Attacks, and Adam and the Ants – see below).

Also, within the punk camp, there was sometimes open hostility to RAR/the ANL. Often this had to do with punk's broadly anti-authoritarian ethic – expressed both as an untheorised hatred of being told what to do and in more sophisticated anarchist terms. In short, there was a resentment of being seen as the 'authentic

voice' of anything, and a distrust of being used (especially as a tool in a socialist revolution) – a feeling that was quite justified, as the Widgery book makes unintentionally clear. There were other objections, too. For instance: the image of RAR/the ANL as 'middle-class', 'hippie' and 'for students'; the way in which RAR included other musics under its umbrella which did not chime with punk (jazz, soul, etc.); the fact that the carnivals were festivals by any other name (how hippie could you get?); and the 'fakeness' of *Temporary Hoarding* (closer to traditional left-wing newspapers than punk fanzines, despite its pretensions).

Leading punk figures were not slow to make their feelings known. Mark Perry of ATV and *Sniffin' Glue* put it this way: 'RAR preach against the NF but on their badge is the red star, which has caused as much trouble and animosity as the swastika. I don't need to be told by a commie organisation to love blacks . . . the SWP and NF are as bad as each other . . . ' (Boyd 1977). J.J. Burnel of the Stranglers called RAR/the ANL 'racist', adding, 'the standard left-wing pose is easy, not futuristic' (Denselow 1989: 144).[15] And though Johnny Rotten gave an interview to *Temporary Hoarding*, the Pistols pointedly never played an RAR gig.

Punk and racism

> Y'know what they said
> Well some of it was true!
>
> (the Clash, lyric from 'London Calling', 1979)

If punk's attitude to anti-racism could be contradictory and eclectic, then there is also plenty of proof of openly racist behaviour within the subculture. To begin with, some punks were attracted by what the far right had to say. Indeed, part of the NF's late 1970s offensive was to attract youth to their cause, and to this end they looked to subcultures – and particularly to the hip one of the moment. NF newspapers like *Bulldog* tried to put a fascist spin on punk songs and to claim leading figures – including the openly hostile Johnny Rotten – as their own, while NF shops began to sell punk clothing.[16] Martin Webster was similarly very happy to do interviews with the music papers – notably the 'racism' issue of *Sounds* mentioned above – and made clear his aim to recruit what he called 'robust young men' to the NF, chiefly for the impression they would make on marches.

To a limited degree, the strategy worked. Such recruits as were made came both from punk *per se* and from the resurgent skinhead movement, which was an integral part of it.[17] Plus, a fair deal of money was made from the sale of NF badges and paraphernalia. There were other, minor, manifestations of support. For example, there were fascist fanzines (such as *The Punk Front*), fascist clubs (at which, reportedly, the favoured dance was the goose-step (*NME* 1978: 5)), and

a few fascist bands, who made no secret of their links with the NF and other far-right parties, and who actively encouraged fascists to come to their gigs. These included a clutch of bands based in Leeds, among them (according to *Sounds*), the Dentists, the Ventz, Crap and Tragic Minds, who played songs with titles like 'White Power', 'Kill the Reds' and 'Master Race'. In March 1979 they linked together, with NF backing, to form 'Rock Against Communism' (RAC) – an obvious riposte to RAR, and also the name of a regular column-cum-insert in *Bulldog*. How many gigs were played under this banner at this time is not known, but certainly a few.[18]

Was this fascist stance a pose? For some bands and fans, undoubtedly – just as anti-fascism could be. We have seen how some top stars had expressed their disaffection with RAR, and it was not surprising that some punks took things further: soon it became fashionable to flirt not just with the NF, but with other factions like the British Movement (BM) and Column 88. Conversely, for some involved with fascist rock, their engagement was unquestionably sincere: they saw it as an opportunity to express a view on what was wrong with the country – to 'tell the truth' (very punk) about the 'race problem'. In other words, it's worth bearing in mind that political commitment was not the sole province of the left.

Less focused politically, there were other forms of racism within punk. For example, prejudice did not begin and end with Asians. There were other blind spots, and anti-semitism could be one of them. Take Siouxsie and the Banshees' often-quoted lyric that there were ' . . . too many Jews for my liking' (from 'Love in a Void'). Hardly a cryptic message, and made less so by the singer's penchant for swastikas, goose-stepping and right-arm salutes on stage, not to mention songs that included 'oi-oi-oi' *sieg heil*-type chants (e.g. 'Make Up to Break Up'). In 1977, Siouxsie tried to justify the line by saying it was really about 'too many fat businessmen' – which did not make things any better, and came perilously close to echoing the NF's view that 'Zionists' controlled the economy (see Goldman 1977).

Other anti-semitic evidence is not hard to find. Take, for instance, Rat Scabies's (of the Damned) dismissal of Dick Manitoba (of the Dictators) as 'a fat Jewish slob' (*NME* 30 July, 1977). Or the Clash's constant ribbing of their Jewish manager – the above-mentioned Rhodes. Or Sid Vicious, provocatively and idiotically wandering around the Jewish quarter of Paris in his swastika T-shirt (as filmed for *The Great Rock 'n' Roll Swindle*).[19] No wonder the fans could sometimes get confused: as one writer for the fanzine *Ripped and Torn* explained, 'I wore a swastika and an iron cross . . . it was starting to interest me . . . I was starting to stand up for the insults people made about the Nazi stuff. You know, people would say "fucking Jew hater", and I'd stick up for Jew killing . . . '[20]

Racism was directed at other ethnic groups, too, though this was not as common. One cringeworthy example of anti-Hispanicism was the Adam and the Ants song 'Puerto Rican'. The 'tongue-in-cheek' lyrics run: 'You get off on his

greasy hair . . . /you got a small apartment and central heating/Why go waste it on a Puerto Rican?/ . . . Gonna strike a matchstick on his hair/ . . . Girl, you're gonna make me cry/ I won't let that Dago by . . . '.[21] The Ants were another band who messed with swastikas, and who never really threw off criticisms of what Adam called 'the Nazi thing'. Other punk targets included Arabs (e.g., the Art Attacks' 'Arabs in 'arrads'), the Chinese, and the Irish. The latter, it seems, were automatically amusing, and doubly so when bands themselves were from Ireland: as one *Sounds* review of the Radiators from Space put it: 'Irish punks? Will it start "One, tree, faw, two"?' (Lewis 1977).

The examples go on and on. Moreover, the fact that racism of this kind was so prevalent, especially in the context of the contemporary political situation, must raise questions about other aspects of punk – and especially its ambiguity. The flirtations with Third Reich imagery, for example, merit a fresh approach – despite the stock dismissals of it by punk historians as simply a manifestation of the punk desire to shock, to 'say the unsayable' – sometimes unsatisfyingly theorised as some kind of postmodernist triumph of style over content.[22]

The wearing of swastikas, for example, certainly did contain an element of 'shock', but that word could encompass within it many meanings. For instance: two-fingers to the 'peace and love' ethic of the hippies; the same to parents, who were of an age to have experienced the war; a nod to the 'camp' S & M aesthetic of films like *The Night Porter* and *Cabaret*; an ironic symbol of living 'in a fascist regime'; or simply a nice bit of hip (anti-) fashion. But it could also very possibly mean some degree of sympathy with fascist aims – as our quote from *Ripped and Torn* demonstrates. We can't know which motivation was more important at any point in time, or in any geographical location,[23] but it does seem reasonable to argue that there was a fair amount of disingenuousness in what was going on. To put it another way, with racism at such a pitch in society, and the NF actively recruiting from subcultures, many punks would have been well aware of the 'mixed' signals they were putting out.

The same line of argument could be applied to bands who were fond of other kinds of Nazi imagery, or who wrote ambiguous lyrics. We've noted the example of the Banshees already, but there were many more. Joy Division, famously, chose their name for its holocaust connotations, dressed like Nazis, and had a Third Reich-fixated singer who, on their first recording, can be heard asking the audience 'Have you all forgot [sic] Rudolf Hess?'[24] Less prominently, one can think of 'satirical' songs such as the Models' 'Nazi Party' (as in 'I wanna form a . . . '); the Vibrators' 'Nazi Baby'; the Cortinas' 'Fascist Dictator'; and the Spitfire Boys' 'Mein Kampf'; and group names like Martin and the Brownshirts, London SS, and Stormtrooper.

Apart from the Nazi material, other punk symbolism and lyrics were up for grabs. The Union Jack, for instance, also a ubiquitous fashion item, could be worn

ironically (especially around the time of the Jubilee e.g., the Pistols, Clash), could be a homage to the mod era (e.g., The Jam and their fans), or, much less commonly, could be a statement against American influence (and American punk). But, similarly, it could be a symbol of the NF: by 1977, the party had pretty much made the flag its own (see Figure 12.2). Furthermore, in terms of song lyrics, anybody who used the word 'white' could be asking for trouble. The Clash's 'White Riot' and 'White Man in Hammersmith Palais' were indistinct enough to be left open to interpretation, while, later on, the Stiff Little Fingers song 'White Noise' had similar problems (none of the three was intended to be racist, but all became *Bulldog* favourites).

This issue of ambiguity had other implications. If punk's outward appearance could be problematic, then so too could some bands' treatment of openly fascist fans. Most bands, especially in the 'lower divisions' could not afford financially to actively put off this element ('cos fascists are money', to re-phrase the Pistols). Others were ambivalent for different reasons. Sham 69, for instance, an RAR-supporting band whose following was closely associated with the NF, had a policy of welcoming 'kids' of all political persuasions to their gigs in a spirit of working-class solidarity and revolution. This could lead to some confusion, and was compounded by Sham's statements to the press. Thus, in a typically contradictory interview with *Sounds*, singer Jimmy Pursey explained during the course of outlining his anti-racist philosophy that 'Some of the fans are NF or BM . . . but they come from places where the black population is way over the limit . . . ' (Robertson 1978). Other Sham bloopers included employing a (reportedly) racist crew; inviting NF-ers onto the stage to dance and backstage afterwards for a drink; and playing 'Land of Hope and Glory' as an intro tape. Their fascist fans, for their part, felt vindicated by the band's behaviour, and continued to come to gigs (the Sham chant became: 'What've we got? Fuck all! National Front!').

One final point: What is particularly interesting about this welter of evidence concerning punk's racist leanings (intentional or otherwise) is how much of it has been 'edited out' of history over the years. Sometimes this happened very quickly: for example, the Banshees' offending lyric was swiftly changed, while the Models' 'Nazi Party' never made it onto vinyl (nor did the offerings of the neo-fascist Leeds bands, to the best of my knowledge). More often, things have been toned down more recently, both to conform to the anti-racist myth (for the political reasons outlined above), and because of commercial imperatives. Thus, 'Puerto Rican' mysteriously disappeared from the Ants' *Strange Fruit* session compilation (1991) (it evidently didn't square with Adam's subsequent career as a teenybop star), and the track that included Ian Curtis's outburst was never collected on any of the 'definitive' Joy Division compilations. Even in fictionalised accounts, things have had a tendency to change: in the movie *Sid and Nancy*, for example, Sid's T-shirt becomes a hammer and sickle.

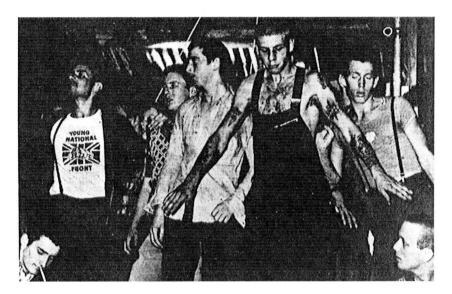

Figure 12.3 Typical stage invasion at a Sham 69 gig (1977)
Source: Photograph by Adrian Boot.

The same 'editing' has taken place on a more subtle level in recent histories of punk where ex-stars are taken at their word (especially true of the 1990s boom in band biographies). These are characterised by an uncritical acceptance of denials of any interest in the far right, of explanations given without context (Siouxsie saying she wore the swastika purely out of 'high camp'[25]), and of devious excuses (Joy Division's label boss saying that they were merely 'making a connection with those oppressed by fascism' (Tony Wilson quoted in Simpson 1997: 75)). To be fair, many punk stars distanced themselves very swiftly from any mistakes they may have made in their early career, and some, admirably, went on to do valuable work for the anti-racist cause (the Banshees and Joy Division among them). But those who re-invented themselves after the fact were simply being dishonest, and were complicit in further clouding our understanding of the punk moment.

Conclusion

The story of punk and racism, 1976–79, is thus one of selective anti-racism, casual racism, pseudo and genuine fascism, naiveté, confusion and ambiguity – a story overlain by vast differences in experience in different parts of the country, and changes over time. It's a complicated relationship, and not one that lends itself easily to analysis. Moreover, there are difficulties with placing it in the context of

racial politics in general. It could be argued, for example, that racism within punk was mainly verbal and symbolic, and therefore had little effect on power relations in the spheres that really 'mattered' – unemployment, housing, etc. But this is to ignore the fact that such behaviour 'normalised' a set of assumptions about society – assumptions which had a huge effect on social relations – just as they do today. (The lyrics and remarks surveyed above, for example, rely on stereotypes – social constructs which themselves socially construct.)

Accepting that such racism did have an 'effect', should we be surprised that punk was so compromised? As we've noted, mainstream culture was racist, and punk was bound to pick up on this to some degree. After all, the movement was born out of the same political recession that had produced the rise in far right activity, and subcultures have historically mimicked their parent cultures as well as rebelled against them. Also, the fact that punk was so 'young' must have been a factor. Band members were often not out of their teens, while fans were younger still (in researching this chapter, for example, it was noticeable how juvenile-looking the fanzines were). This meant that a significant proportion lived at home with their parents, in an environment where any racist views might arguably have been absorbed by osmosis (where, as Jimmy Pursey said at the time: '9 times out of 10, you're gonna believe in the same things that your dad believes in' (Robertson 1978)).

Indeed, if punk was reflecting the racist *zeitgeist* in this way, we might expect similar controversies in other youth subcultures. And to a degree, this was true. Within heavy metal circles, for example, there was debate over the wearing of Hell's Angel-style Nazi regalia (iron crosses, swastikas – again!), the 'SS' lightning strikes in the Kiss logo, and dodgy lyrics (e.g. Ted Nugent's 'Stormtroopin'). And within the rockabilly scene, about the use of Confederate flags, and 'inappropriate' 1950s lyrics. This is not to mention the racist and/or fascist outbursts of those more mainstream rockers, Eric Clapton, Rod Stewart and David Bowie (see Savage 1991: 242–43).[26]

So, even if conclusions are difficult to arrive at, we can say that, on balance, punk was probably no more or no less racist than the society that birthed it. To argue that any subculture was, or is, any more 'progressive' politically than the mainstream culture it complements is highly contentious, and punk certainly exhibited no fundamental, gravitational pull to the left. To put it in more dramatic terms: sure, punks were angry about lengthening dole queues, the privileges of royalty, the anguish of boredom, and police brutality. But they were also angry about 'Pakis' moving into their neighbourhoods, Arabs buying everything in Harrods, Puerto Ricans nicking their girlfriends, and there being too many Jews for their liking. This aspect to the movement existed, and was very vibrant. To underplay it by ignoring punk's historical context is not only a failure of investigative rigour, but a disservice to those who fought against racism at the time.

Postscript

Read it in the papers
About the National Front
They go out and they do it
They're such a bunch of cunts.
(Crass, lyric from 'Major General Despair', 1977)

There is an addendum to the story, of course, because punk begat many offshoots after 1979, one of which became associated with hardcore fascism. Without going into detail, the early 1980s saw the rise of the so-called 'Oi' movement, a version of 'street punk' described by historian Dave Laing as 'a music for racists, if not a music of racism' (Laing 1985: 112). This then transmogrified into something even nastier, with the establishment of the NF's 'White Noise' record label, and then the 'Blood and Honour' organisation (the name being a translation of an SS slogan), an umbrella framework for 30 or more skinhead bands, which also published a magazine, and ran a mail order service for 'white pride' paraphernalia.[27]

The question is, does all this have any connection with punk's first wave, and specifically with its racist aspects, as outlined above? The answer is, unsurprisingly, yes, although this has been virtually ignored by histories because the later fascist wave was associated with skinheads rather than punks. But let's be clear, there were, and are, significant links. Most obviously, many of the fascist skins had originally been punk fans (many having been followers of Sham 69), and the music the fascist bands played was identifiably punk: it may have had racist lyrics, but the sound of fascist rock in the late 1980s was not that much different to the sort of thing you might have heard in the Roxy a decade earlier. Similarly, neo-Nazi fanzines like *Strength and Will*, *British Oi!*, and *Boots and Braces* were modelled on punk zines, and played a similar role in spreading information and giving the scene a sense of coherence.

More than this, the racist/fascist obsessions of the new subculture were hardly different to those espoused by the radical right-wing punk groups, and indeed, the links first made by the Leeds groups and Rock Against Communism with political parties like the NF were merely duplicated and reinforced.[28] Arguably, the fact that punk had a blind spot for anti-Asian prejudice meant that this was an area that was left open for exploitation: 'skinhead' became increasingly associated with 'anti-Asian', and the most popular of the neo-fascist songs were anti-Asian diatribes – couched, as ever, in the (punk) language of 'authenticity' and 'telling the truth'.

The final evidence is that the careers of certain bands verify this account, none more so than that of Skrewdriver. This was an outfit that shared the bill at the Roxy in 1977 with Sham 69, and wore its punk swastikas with, if not necessarily

216

Figure 12.4 Skrewdriver in 1977, with Ian Stuart Donaldson on far left. Note felt-tipped swastikas.
Source: Photograph by Shirley Hill.

'sincerity' at this time, then at least pride (see Figure 12.4). Led by Ian Stuart Donaldson, the band went through various line-up changes, and eventually declared itself for fascism in 1982: by now, they were skinheads, and so was their following. With songs like 'White Warriors', 'Race and Nation', and 'Invasion', they became the most influential of the new fascist bands: it was Donaldson, plus a few others, who founded Blood and Honour in 1987.[29]

Skrewdriver were effectively finished when Donaldson was killed in a car crash in 1993, but their fellow bands have continued to be a force in fascist politics across Europe and in the United States – not least because a proportion of the money that is made from CDs, fanzines and gigs is channelled back into the coffers of fascist political organisations. Although the neo-Nazi skinhead scene in Britain has died down since the mid-90s, the far-right is again on the rise in places like Southern France, and, especially, Eastern Germany, where, as a recent *Guardian* report put it: 'The underground music and concert scene is the glue binding neo-Nazis together . . . ' (Traynor 1998).

The point is that 1980–90s 'hate rock' (Blood and Honour and the 'white noise' scene in general) was not an aberration from the early days of punk. All the elements – the politics, the music, the subcultural infrastructure – were there from the start: all that happened was that they were amplified. Today, historians are fond of attributing any left-wing or humanitarian musical movement since the

1970s to the groundwork laid by punk (Red Wedge, Live Aid, Anti-Apartheid festivals, anarchist indie-rock, etc.): but there was an alternative, right-wing, lineage – one that continues to be menacingly significant, not just in music but in wider political life.

Notes

1 It's risky to concur with the stereotype of a fanzine as an arena where contributors could say whatever they wanted, unhindered by the restrictions prevailing in the mainstream media. For many this was true, but some were heavily edited (for various reasons), and some cultivated their links with the music biz in order to secure interviews, advance copies of records, etc., and were therefore open to 'persuasion'. Nevertheless, for this chapter, I have found them very useful. I researched my own collection, that of Teal Triggs (with thanks), and that of the Victoria and Albert Museum Library (thanks to librarian Simon Ford).

2 A word on terminology. Any usage of the words 'race', 'racism' and 'anti-racism' is controversial: within Cultural Studies, race is understood in terms of social construction rather than biological difference. Other terms are equally difficult. Here, 'Asian' is used to describe the diaspora from the Indian subcontinent (including those born in Britain); 'Afro-Caribbean' for the diaspora from the Caribbean islands (including British-born); and 'black' for 'Afro-Caribbean' (as opposed to the definition of the National Union of Journalists, for example, which encompasses all people of colour on a 'strategic' basis). The best theoretical background to race politics, for our purposes, is Gilroy (1987).

3 A useful recent history of the NF can be found in Thurlow (1987, revised 1998), especially Chapter 10. The most detailed earlier text is Walker (1977).

4 On the role of the Conservative Party, see Barker (1981). For useful perspectives on racism in the media during this period, see Cohen and Gardner (1982) and the accompanying video of the same name, made in 1978, which contains footage of an RAR carnival. On racist humour, see Wagg (1998: ch. 15).

5 Some readers may be surprised to see the name of Garry Bushell in the list of 'left-wing' journalists. But, despite his later association with the Oi! movement (see below) and his subsequent employment on the right-wing *Sun*, his views at the time were often socialist: he had just left the SWP, and some of the most impassioned anti-racist articles of the period were penned by him.

6 Hebdige has since disowned many of the points in his book, and his theories have been questioned elsewhere – see, for example, pp. 148 and 180 of this book, and Anne Beezer's impressive critique in Barker and Beezer (1992: ch. 6).

7 Ostensibly, RAR and the ANL were separate groups, the former being an 'independent' organisation, the latter an offshoot of the SWP. However, both shared members and organisers, and worked very closely together – the union being made official by their joint Carnival, in April 1978, in Victoria Park, London.

8 For more critical perspectives on RAR/the ANL see Frith (1992), Savage (1991: 480–85), and Gilroy (1987: 115–35).

9 As well as 'racial' enemies, other NF targets included feminists, gays, communists, anarchists, and anybody associated with the Irish Republican movement.

10 The nearest Asian musical equivalent to reggae was bhangra (a mix of folk melodies – often Punjabi – and rhythmic dance beats), which was growing in importance among Asian youth, but which was totally ignored by both punk and RAR. (The meshing of Asian and (white) 'alternative' music did eventually happen, with encouraging results: this chapter is being written at a time when Cornershop are having their first taste of success with 'Brimful of Asha'.)

11 Commentary, *Dancing in the Streets*, BBC TV, 1996.

12 Bob Marley, 'Jamming/Punky Reggae Party', Island, 1977. The two key books on the 'reggae alliance' are Hebdige (1979) and Jones (1988), but for a contemporary view see also *Sounds*, special feature, 3 September, 1977.

13 The publicity given to rasta DJ, Don Letts, of Roxy club fame, has certainly skewed the picture.

14 Steve Spear of the Art Attacks, interviewed by Stewart Home on the sleeve notes to *Outrage and Horror*, Overground Records, 1997.

15 The Stranglers were another contradictory band concerning racism. Singer Hugh Cornwall was notorious for goading audiences with racist comments, but the group was also known to take on fascists in fist-fights. Their song 'I Feel like a Wog' was written as a comment on RAR/the ANL – and was immediately misinterpreted by the NF (See Buckley 1977).

16 See, for example, *Bulldog*, 'The Newspaper of the Young National Front', No. 10, November 1978: 5.

17 Punk's relationship with the skinhead movement was a symbiotic one, though with tensions. Skins tended to see themselves as 'hard punks', distanced from what they saw as a middle-class influence within punk, and followed certain bands (though never exclusively) – e.g., Sham 69, Skrewdriver, Menace, Cock Sparrer, etc. – many of which were later co-opted by the Oi! movement (see below).

18 There was also, for a very brief period, an 'Anti-Paki League', though what form this took organisationally is unclear.

19 This was the man who co-wrote the lyrics for the tasteful 'Belsen was a Gas' (released 1979).

20 Anonymous writer (probably 'Skid'), *Ripped and Torn*, No. 7, August 1977. The piece goes on to warn against the dangers of wearing 'Nazi paraphanalia' [sic].

21 The lyrics to 'Puerto Rican' are from a bootleg of 1977/78 session recordings entitled *Madam Stan* (c.1986). The song has been interpreted by Stewart Home (1995: 72) as being ironic. However, the song may have been 'humorous', but not ironic, and its suspect nature was reinforced by Adam's gleeful introduction to it during gigs: 'Light a beacon with a Puerto Rican!'.

22 Recent histories that have stated the swastika was for shock, without going further, include: Echenberg and Mark P (1996: 118); Boot and Salewicz (1996: 33); and *Arena*: 'Punk and the Pistols', BBC TV, 1995.

23 Where I grew up, in Ilford, there was a big Jewish population and a rising Asian one. The NF and BM would hold meetings in local halls, and groups of flag-carrying NF-ers would try to sell us newspapers and 'debate' with us on our way home from school. Here, the meaning of a swastika could be very different to that in a trendy London club. It would have been different again, of course, in a (white) rural area.

24 'At a Later Date', Joy Division, on the LP *Short Circuit: Live at the Electric Circus*, Virgin, 1978. Curtis is quoted elsewhere saying ridiculous things, e.g. calling Hess 'the Prince of Peace' (Ward 1996: 157).

25 For example, on the *Arena* documentary 'Punk and the Pistols'.
26 Siouxsie was, of course, a Bowie fan.
27 The history of the neo-Nazi music scene has yet to be written. The best source at the
 moment is back issues of *Searchlight*, the anti-fascist magazine.
28 Indeed, 'Rock Against Communism' is a name that has been revived in the last
 two years to describe an organisation styling itself as the successor to Blood and
 Honour.
29 For a taste of what Skrewdriver were about, see any of their 'tribute' websites; Home
 (1995) also has a chapter on the band.

Bibliography

Anon (1978) 'Talking Clash', *Record Mirror*, 1 July.

Barker, Martin (1981) *The New Racism*, London: Junction Books.

Barker, Martin and Beezer, Anne (eds) (1992) *Reading into Cultural Studies*, London:
 Routledge.

Boot, Adrian and Salewicz, Chris (1996) *Punk: the Illustrated History of a Musical Revolution*,
 London: Boxtree.

Boyd, Lindsey (1977) 'Interview with Mark Perry', *Sounds* 24 December.

Buckley, David (1997) *The Stranglers: No Mercy*, London: Hodder & Stoughton.

Burchill, Julie and Parsons, Tony (1978) *The Boy Looked at Johnny*, London, Pluto.

Bushell, Garry (1986) 'Youth! Youth! Youth!', *Sounds*, magazine insert.

Cohen, Phil and Gardner, Carl (1982) *It Ain't Half Racist Mum*, London: Comedia.

Coon, Caroline (1978) *1988: The New Wave Punk Rock Explosion*, London: Omnibus.

Denselow, Robin (1989) *When the Music's Over*, London, Faber & Faber.

Echenberg, Erica and Mark P. (1996) *And God Created Punk*, London: Virgin.

Frith, Simon (1992) 'Rock Against Racism and Red Wedge: From Music to Politics,
 from Politics to Music', in Garofalo, R. (ed.) *Rockin' The Boat*, Boston, MA: South End
 Press.

Gilroy, Paul (1987) *There Ain't No Black in the Union Jack*, London: Century-Hutchinson.

Goldman, Vivien (1977) 'Interview with Siouxsie and the Banshees', *Sounds*, 3 December.

Hebdige, Dick (1979) *Subculture: the Meaning of Style*, London: Routledge.

Home, Stewart (1995) *Cranked Up Really High: An Inside Account of Punk Rock*, Hove:
 CodeX.

Jones, Stephen (1988) *Black Culture, White Youth*, London: Macmillan.

Laing, Dave (1985) *One Chord Wonders*, Milton Keynes: Open University Press.

Lewis, Alan (1977) 'Review of "Television Screen"', *Sounds*, 7 May.

Robertson, Sandy (1978) 'Interview with Sham 69', *Sounds*, 29 April.

Savage, Jon (1991) *England's Dreaming: Sex Pistols and Punk Rock*, London: Faber & Faber.

Shuker, Roy (1998) *Key Concepts in Popular Music*, London: Routledge.

Simpson, Dave (1997) 'Torn Apart', *Uncut*, December.

Thurlow, Richard (1987) *Fascism in Britain*, Oxford: Basil Blackwell.

Traynor, Ian (1998) 'Neo-Nazis rule the East', *Guardian* 21 January.

Wagg, Stephen (1998) *Because I Tell a Joke or Two*, London: Routledge.

Walker, Martin (1977) *The National Front*, Fontana: Glasgow.

Ward, James (1996) '"This is Germany! It's 1993!" Appropriations and constructions of "fascism" in New York Punk/Hardcore in the 1980s', *Journal of Popular Culture* 30 (3): 157.

Widgery, David (1986) *Beating Time*, London: Pluto.

13

WHAT DID I GET?

Punk, memory and autobiography

Andy Medhurst

Music constructs our sense of identity through the experiences
it offers . . . experiences which enable us to place ourselves in
imaginative cultural narratives.

(Frith 1996: 275)

Autobiographical memories may be accurate without being literal
and may represent the personal meaning of an event at the expense
of accuracy.

(Conway 1990: 9)

I could be the teacher in a classroom full of scholars.
(Ian Dury and the Blockheads, 'What A Waste', Stiff 1978)

When you teach, as I do, university courses which look at the history of popular
culture, there is one kind of student you learn to dread. This is the student who
knows exactly what it was like during a particular aspect of a particular period
of that history because they took part in it, because 'I was there'. Such a claim is
a pre-emptive strike that seeks to dismiss all the claims of retrospective thinking,
all the writers and theorists who have subsequently put forward interpretations
of cultural events, in favour of the apparently unchallengeable testimony of first-
hand experience. 'I was there' is a badge proclaiming the authoritativeness
of autobiographical authenticity, and it's a difficult badge to dislodge. Eventually,
however, the student-who-was-there can usually be persuaded to recognise that
critical hindsight may have some value, that simply inhabiting a moment is no
guarantee of fully comprehending it, and that personal recollection is but one
discourse among many. Knowing this as well as I do, it is very disconcerting when
I read academic accounts of 1970s punk, because all of my intellectual convictions
shrivel and wither under the onslaught of more emotive and irrational imperatives.
Reason and distance are subsumed by the urge to shout – no, I know more about
this than you, because I was there.

This chapter is an attempt to unravel some of the implications of that paradox. All teachers of popular culture are liable at some point to find themselves confronted with the contradictory feelings generated by turning one's own past or present leisure activities into matters of intellectual debate, and indeed those contradictions should, ideally, form part of the subject matter of what and how we study, offering a chance for productive self-reflection. This process often involves encountering readings of texts that deconstruct and even undermine the meanings they have for you, and in every case but one this causes me no grief. That exception, above all the other cultural forms and practices which have attracted me over the years, is punk, and over the next few pages I want to explore why it still arouses in me such a fierce, absurd protectiveness. What I hope to achieve by tracing my shifting relationship to punk (put at its crudest, a 20-year journey from a teenage fan to an academic on the alarming threshold of middle-age) is to open up some broader issues about the roles played by autobiography, memory and nostalgia in the field of Cultural Studies.

A not-quite-punk looks back

To begin with, then, I need to revisit my memories of the late 1970s in order to see what lingers, what traces of punk's initial impact stay with me 20 years later. Needless to say, these memories, like all memories, are bound to be selective, partial, even capricious. Furthermore, it's only fair to confess that my 'I-was-there' of punk is pretty small beer. Unlike Jon Savage, who so brilliantly uses auto-biographical material to contextualise the wider cultural analysis of his punk history (1991), I did not worship early at the church of the Ramones, I did not witness the rise of punk first-hand, I did not start my own fanzine and I never saw the Sex Pistols play live. Indeed I cannot lay claim to being any kind of proper punk at all in the strict sense of adhering to dress codes (true confession: I wore flares to see the Vibrators) or hurling phlegm and venom at passers-by. My involvement was simply that of an enthralled consumer – buying the records, reading the magazines, seeing the groups – yet being outside the subcultural elite didn't diminish the intensity of my attachment. As Gary Clarke has pointed out in an invaluable corrective to the more sweeping claims of subcultural studies, most young people never plunge entirely into subcultures but 'draw on particular elements of subcultural style and create their own meanings and uses of them' (1990: 92). The 'meanings and uses' I found in punk music were immense and irreversible, whatever the shortcomings of my wardrobe, however much of a fellow traveller I must have seemed, and may still seem now, to punk purists. I may not have had the bondage trousers (and even if I'd wanted them, the compulsory amphetamine slenderness of the time made them a dubious proposition for those of us whose

waists demand an Extra Large) but that didn't stop punk seizing, shaking and rearranging my sense of self and the world I lived in.

Punk erupted into my life in the autumn of 1977. I knew about it before then from the music press and the radio, I even had a few of the records (the Adverts' 'Gary Gilmore's Eyes' was one of my favourite singles that summer and I'd been playing Patti Smith's *Horses* album obsessively all year), but I'd never felt the urgency of its call to arms, even when glancing up from my tea to watch the now-legendary Bill Grundy interview with the Sex Pistols, even though my council estate was only a mile or two from the one where Mark P. hatched the fanzine *Sniffin' Glue*. The decisive break came when I went away to university, a change in circumstances which offered a radical opportunity for self-reinvention. The new me, surrounded by new friends, involved in new activities, inhabiting a new landscape, demanded a new soundtrack – and punk, with its passionate commitment to the intensity of immediacy, was there for the taking. 1977 was a fantastic year to be 18, and I gorged myself silly on its riches. Swathes of my existing record collection had to be disavowed, of course, but other parts of it were suddenly reinvigorated under punk's new rubrics of credibility. I'd been right all along to like Bowie and hate Yes, I'd been presciently hip in buying *Horses* when I did, it was OK to have three Van Der Graaf Generator albums because Johnny Rotten said he liked their singer, Peter Hammill.

My first year as a student unfolded to a soundtrack of what now seems like an impossible profusion of wonderful records – the rallying cry of the first Clash album, the shimmering pure-pop poise of the Buzzcocks' 'What Do I Get?', the raw jolt of X-Ray Spex's 'The Day The World Turned Day-Glo' (on orange vinyl!), the fathomless caverns of Wreckless Eric's 'Whole Wide World', the sly perversities of Wire, Pere Ubu's cross-pollination of Beefheartian angularity and nameless dread, the knowing kitsch of Generation X's 'Ready Steady Go', the comedy and pain of Ian Dury's 'New Boots and Panties', Patti Smith raging and howling against the limits of gender and desire and the body, the skanked-up malevolence of Elvis Costello's 'Watching The Detectives', the crystalline splendours of Television's 'Marquee Moon', and towering over them all, totemic and definitive, *Never Mind the Bollocks*. Not all those records were classically 'punk', some sat better under the vaguer umbrella of 'New Wave', but to me then they all made sense together, united despite surface differences by their shared rhetoric of nowness and newness, and, perhaps more tellingly, by their shared rejection of the staleness and sterility of most previous musical styles. Provided a record sounded like it had been made by people who wanted to kill Pink Floyd and the Eagles, and had received the all-important sanction of my weekly bible the *NME*, it could be welcomed into the punk fold. The meanings of the music were still in flux, not yet fixed into manageable categories by the classificatory sobriety of history. Back then, in the middle of it all, everything felt intoxicatingly up for grabs.

The most vivid images people tend to have of their own pasts are not calm, measured narratives but sudden snapshots and erratic fragments, what psychologists working in this area call 'flashbulb memories' (Conway 1990: 61–88), which may help to explain why there are three moments from that year which burn brighter for me than any other.[1] Firstly, the Students Union decided to occupy an administration building in protest at some injustice which I can (significantly?) no longer remember. Once we were on the seventh floor, the windows were thrown open, huge speakers rigged up and 'Anarchy In The UK' boomed out across the campus. Looking back, this seems touchingly naive, especially given the somewhat piquant fact that I now teach at the same university and attend committee meetings in those very rooms, and even at the time it felt a little self-conscious, but the wanton theatricality of the gesture, its strenuous attempt to marry our local dissatisfaction to a broader cultural dissent, makes it iconographically unforgettable.

The second flashbulb is seeing the Tom Robinson Band play in the Union building and joining the communal singing of 'Glad To Be Gay'. Most of the other students probably sang out of mild liberal rebelliousness, but I was a gay teenager on the brink of coming out and it meant more to me than I care to disclose. In terms of subsequent generic codification, few songs sound less 'punk' than 'Glad To Be Gay' (if anything, it's a folky protest song), but I had no doubts then or now that such a song would never have been so widely known without the cultural climate punk had made possible. When the band's live EP containing 'Glad To Be Gay' was released some months later, the back cover stated (with a punkish typography that spurned capital letters) 'recorded live nov/dec '77 at high wycombe town hall, sussex university, & the lyceum london' (see Figure 13.1). Which tracks came from which venues wasn't specified, but High Wycombe and London stood no chance: in my mind the recording of 'Glad To Be Gay' was the one with me on it – me and a few hundred others. Coming out, after all, is primarily a process of affirmation, and what better way to be affirmed as a late 70s gay man than to take part in the recording of that song ?

Both those flashbulbs are concerned, revealingly and influentially, with the relationship between music and politics, a linkage which for me has been punk's most lasting legacy. My third flashbulb, the most vivid memory of all, centres on subcultural inconsistencies and Caroline the campus punk. Caroline and her boyfriend Nigel (and non-British readers should note that those two names, particularly in tandem, connote a background of considerable class privilege) were the highest-profile punks at Sussex. Festooned in Westwood threads, twin visions in mohair sweaters and leather trousers, hair dyed electric blue or bilious green, they would parade around striking the requisite poses. I can see her now, pulling him around the campus supermarket on a dog lead, and I can also hear her, with those giveaway Kensington vowels she usually took care to conceal, complaining in

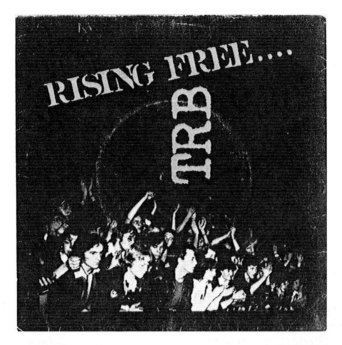

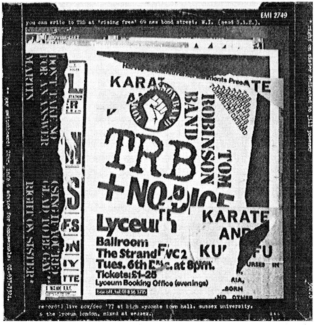

Figure 13.1 Front and reverse of sleeve to Tom Robinson Band EP, *Rising Free* (EMI, 1978).

our hall of residence kitchen because I was playing loud music while she was trying to write an essay. Not just any loud music either – I was playing my tape of *Never Mind the Bollocks*. It's this image more than any other that makes me suspicious of retrospectively romanticised accounts of the purported coherence of youth subcultures. There we were, me (side-parting and flares) and my mate Steve (collar-length hair and rugby shirt) enjoying 'God Save the Queen' and 'Bodies', getting yelled at by a head-to-toe punk to turn down the Pistols. I had already grasped, from my own juggling act of loving the music and its cultural implications but declining to sign up to full subcultural involvement, the key point that being *into* punk didn't necessarily entail being *a* punk, but here, gift-wrapped with ribbons of irony, was proof of a related realisation: that dressing up in a subculture's trappings can be the most superficial of engagements with its deeper possibilities of meaning. Or, as I think I would have put it at the time, being a punk didn't stop you being a prat.

the seductions of nostalgia

According to Christopher Lasch, 'the victim of nostalgia . . . is worse than a reactionary, he is an incurable sentimentalist. Afraid of the future, he is also afraid to face the truth about the past' (quoted in Lowenthal 1989: 20). This is a chastening rebuke, especially for someone who has enjoyed writing the previous paragraphs as much as I have, and it has a particular force when the object of such nostalgia is a discourse as rabidly unsentimental as punk. A central thread in punk's semiotic and ideological repertoires was its scorched-earth, year-zero attitude to tradition and the past ('No Elvis, Beatles or Rolling Stones in 1977', crowed the Clash; 'No future in England's dreaming', warned the Sex Pistols; 'Smash it up', suggested the (ever-helpful) Damned; 'Jesus died for somebody's sins but not mine', snarled Patti Smith), whereas nostalgia often springs from an attempt to seek consolation and security in times gone by. Getting nostalgic about punk is worse than a contradiction in terms, it's a kind of betrayal, trading in punk's forensic nihilism for a rose-coloured cosiness. Yet the situation is more complex. Of course my account of the punk era is saturated in nostalgia (anyone my age who isn't nostalgic about being 18 didn't deserve to be 18 in the first place), but nostalgia only takes hold out of 'some sense that the present is deficient' (Shaw and Chase 1989: 3). When I look at the way many of the most successful British groups of the current moment, whether shrewd tunesmiths like Oasis or cretinous reactionaries like Kula Shaker and Ocean Colour Scene, court acclaim on the basis of their ability to look only backwards, or when I read a review in a music magazine that smugly begins 'Weren't the punk years tyrannical and horrid?' (Prior 1997: 116) – and, to compound the offence, the review in question is a celebration of

Supertramp, a paradigmatically loathsome outfit who occupied a deservedly high place in punk's demonology – the deficiencies of the present make nostalgia feel like an irresistible temptation.

It would be wrong to suggest, however, that my nostalgia for the late 70s is so all-encompassing that my tastes have remained stuck there. In fact I listen to punk so rarely now that the retrospective trawl I made through my collection for the purpose of researching this chapter was the first time I'd heard some of those records for years. It was exciting and reassuring to discover how fantastic many of them still sounded, but they're not going to resume a central place in my musical environment, since what gave them such a revolutionary impact on first release – their discordancy and disrespect, the seditious fury of their unforgiving confronta-tionalism – still seems largely and impressively intact, and that sits uneasily with the listening habits I have today. Punk as a visual sign may have been co-opted over the years into wider consumerist frameworks,[2] but that late 70s noise still strikes me as very resistant to assimilation. Radio stations that specialise in playing past hits tend to agree with me, treating punk as a pariah genre, excising it from pop history. It still sounds like such a hell of a racket – a fact which delights the old fan in me enormously while simultaneously ensuring that I'll choose other sorts of sound to accompany daily domestic life. X-Ray Spex's 'Oh Bondage! Up Yours!' was never designed to be background music, and it still refuses, with commendably magnificent stroppiness, to occupy that role.

So if my nostalgia for punk doesn't take the form of wanting all music to be strapped to a late 70s template, in what sense is it nostalgic at all? Another flashbulb memory may be useful here. In the summer of 1978 I had a vacation job in a public library acquisitions department (which shows you exactly how much of 'a punk' I wasn't) and was chatting about favourite records to a fellow worker. She listened while I outlined my punk canon, considered it patiently, then smiled and said 'But you couldn't really call it music, could you ?'. At the time I was outraged, but now I think she had a point, albeit not the point she thought she had. Punk was never just 'music' – if it was then I could only satiate my nostalgia by ploughing through those old singles. Music was the focus, the entry point, but punk went broader and deeper, offering a set of rules and a structure of feeling applicable way beyond the confines of sound. When, for example, anti-punk types sneered at my records by saying 'they can't play their instruments' they were quite right, in the sense that Emerson, Lake and Palmer were more instrumentally dextrous than X-Ray Spex, but those criteria meant nothing in the heat of the punk moment. The standard response of punk rhetoric to the charge of instrumental incompetence was 'it doesn't matter', a response which gratifyingly infuriated ELP fans and their ilk on two levels. First, it was a deliberate slap in the face for established pop aesthetics, declaring generational independence through a carnivalesque inversion of musical value, to the extent where not-being-able-to-play became a part of

punk's holy writ – the punk-ness of anything could be determined by its not-being-able-to-play-ness. Second, and more importantly, 'it doesn't matter' established that the medium was secondary to the message, that popular culture could and indeed should be a vehicle for social and cultural intervention. Music, in other words, was political – no, more than that, it was a form of politics itself, a politics that concretely engaged with contemporary issues.

That, above all, is the seed that punk planted deepest within me, leaving me with a set of expectations that form the core of my nostalgia. It's not a matter of wanting every record released now to sound like the Clash or the Adverts – far from it, since to do so, and this is a crucial point woefully misunderstood by groups who try to recreate and re-inhabit that early punk sound, would be profoundly un-punk, since punk was about the here and now, and now is no longer 1977 – but there will always be a part of me that requires new music to sound contemporary, to be political, to have something to say about the world around it. In that sense the Pet Shop Boys, Stereolab and Pizzicato Five are immeasurably more 'punk' than any set of retro-pogo punk revivalists.

the poetics of punctum

There are obvious theoretical and methodological problems with using personal autobiographical memories as a way into thinking about broader cultural phenomena, the first of which is the very fact that they are personal. Can such memories have any standing, any credibility, any relevance to anyone except the person whose past they recall? It isn't possible in a chapter of this length to explore all the ramifications of that question, but it's a question that needs airing if only because so much work in Cultural Studies springs, acknowledged or unacknowledged, from that autobiographical impulse.[3] A related problem concerns the reliability of memory. Given the selectiveness of remembering, the ways in which some images and moments stick while others have faded, surely memory is too hopelessly subjective a discourse to carry any lasting intellectual weight.

I'd suggest two possible responses to those problems. First, I am not offering up this handful of memories as unduly important or exemplary, but as evidence of how one individual negotiated his way through a particular set of cultural circumstances, one micro-story to be fed into the weave of all the other accounts of the punk era. They have no special status (except, of course, for me) and the 'weight' they carry will, quite properly, be decided by those who read this book. Secondly, the selectiveness of memory seems to me not a reason for disqualifying it from serious consideration but forms in fact one of its most interesting aspects. 'Memory', Annette Kuhn has argued, in a book to which this chapter is greatly

indebted, ' . . . has its own modes of expression: these are characterised by the fragmentary, non-linear quality of moments recalled out of time. Visual flashes, vignettes, a certain anecdotal quality, mark memory texts' (1995: 5), and the flashbulb memories I have drawn on above attest to the persuasiveness of this description.[4] Such events and images lodge and linger because of their intensity of signification, their ability to condense to a single point a wider array of meanings, suggesting that memory is above all a creative process, an interpretation of the past not an inventory of it. The psychoanalyst Leonard Lamm has likened some kinds of memory to poetry, in terms of their tendency to operate 'in terms of concepts and images whose value, utility and veridicality [the extent to which they can be proved] are always subordinate to the contemplative delight that they afford' (1993: 92).

This contrast between 'utility' and 'delight' versions of the past, between an approach to past events centred on proof and accuracy and one which surrenders to the pleasures of recalling indicative, focal moments, can be fruitfully developed using a terminology outlined in Roland Barthes' book on photography, *Camera Lucida* (Barthes 1984).[5] Barthes suggested two ways in which a text might be interpreted, giving them the Latin names 'studium' and 'punctum'. Studium implies study, and Barthes intended the term to describe a logical, rational, linear understanding of a text, a solid grasping of its meaning, a straightforward making sense of the evidence. Punctum, by contrast, occurs when one detail in a text assumes sudden, unexpected intensity, reaching out to pierce (or puncture, hence 'punctum') the viewer, listener or reader. Punctum, in effect, is the discourse of the electrifying fragment – irrational, unpredictable, dislocating and destabilising. By applying Barthes' schema to a study of her own family album photographs, Annette Kuhn (1995) has insisted that the fragmentary, emotional, unsettling qualities of memory place it squarely under the sign of punctum. I would further argue that this is especially true of memories associated with music – we construct our musical pasts not through a learned studium-style tracing of generic developments and histories, but through explosive punctum-bursts of remembering our obsessions and affiliations, the stars we desired, the lyrics we sang, the songs we fell in and out of love to, the shards of sound that flew from the records and pierced our hearts.[6]

This, I suspect, is one of the major reasons I find academic accounts of punk so troubling – their studium is radically at odds with my rapturously nostalgic punctum (or should that be 'punktum'?). They threaten to throw cold analytical water on my most feverish reveries. That feverishness is all the harder to shed since punk was so patently a discourse of sincerity and passion, even though those qualities tended to manifest themselves in the twisted, disaffected forms of sarcasm (listen to the excoriating bile of Johnny Rotten's 'We mean it, maaaaan/We love our Queen/God saaaave' in 'God Save The Queen') and, perhaps the truest punk

trope of all, boredom. Analysing punk through the chilly lenses of academia can only subject that passion, my passion, to scepticism and challenge. It could be argued that scepticism and challenge are exactly what should constitute the core of politically responsible academic practice, and ninety-nine times in a hundred I'd completely agree, but I still flinch from taking an analytical scalpel to punk. Which, I guess, returns me to the problem that kicked off this chapter.

Memory, affect and repression

The importance of these debates over memory and nostalgia for academic studies of popular culture is that they provide a way of thinking constructively about emotion and affect. Theoretical perspectives which drain popular texts and experiences, or our memories of them, dry of their affective dimension can only ever tell part of the story. Popular culture is, after all, only truly *popular* culture if it connects meaningfully with audiences on an emotional level, and the intensity of that meaningfulness is often disclosed by discovering which texts recur significantly in people's memories as opposed to simply attracting high ratings or sales when first available. Nostalgia, which runs through British popular culture like the name of a seaside town through a stick of rock, is not a matter of conscious choice but a response to emotional needs, offering refuge in what David Lowenthal has called 'a time when folk did not feel fragmented . . . when life was wholehearted . . . a past that was unified and comprehensible, unlike the incoherent, divided present' (1989: 29). That description fits my nostalgia for the punk era extremely neatly – I recall it as a time of strongly drawn boundaries, a time when people took sides (quite probably making it feel tyrannical and horrid for Supertramp fans, but then Supertramp fans deserved everything they got), a time when I drew sustenance and prestige from being in tune with the prevailing cultural aesthetic.[7]

And time, I think, is the most crucial issue here. My reluctance to submit punk to the kind of analysis I happily apply to other cultural forms stems above all not because of what it was but because of when it was. Punk happened to me at the same time as a number of major changes in my life (leaving home, coming out, taking another few steps on the conveyor belt of embourgeoisement which was shuttling me away from a working-class childhood towards middle-class professionalism), indeed it has become intimately bound up with them through the processes of memory, to the extent where the opening bars of a record can plunge me back directly into those feelings of thrilling transition. Punk, as backdrop and touchstone, soundtracked those vertiginous shifts.

Moreover, my investment in punk marked my last wholly 'innocent' involvement in a cultural moment, in the sense that I was a fully-fledged consumer rather than an ambiguously-placed academic. I could, in other words, submit to the

infatuation without half an eye on teaching about it later. Simon Frith has, somewhat tartly, characterised academic studies of popular culture as populated by 'intellectuals longing, daring, fearing to transgress; intellectuals wondering what it would be like *not to be an intellectual*' (1990: 231–32, italics in original) and I suspect that this fantasy underpins my nostalgia for punk, my yearning to return, to regress, to a fanhood unsullied by intellectualisation. Such pining bears out David Lowenthal's argument that nostalgic desires are not a search for 'the past as it was or even as we wish it were; but for the condition of *having been*' (1989: 29, italics in original). Living in the past, however, isn't really a viable option for those of us who make a living out of analysing contemporary culture, as Dick Hebdige conceded in his flashbulb-memory account of complaining about the disruptive noise made by a party held in a house full of squatters:

> The absurdity (and the irony) of this exchange between the members of 'an anarchic youth subculture' and a 'former expert on subcultural resistance' was lost on me at the time but walking back towards my house five minutes later, I felt strangely elated, lighter on my feet: I was turning my back not only on a quieter scene, but also on an earlier incarnation.
>
> (1987: 66)

In other words, even Cultural Studies academics have to grow up some time.

Notes

1 Most studies of 'flashbulb' remembering focus on the impact made on people's memories by shocking public events — the assassination of John F. Kennedy is the classic instance, perhaps now to be joined by the death of Princess Diana. I would, however, argue that in the sphere of youth culture, flashbulbs might be triggered by memories of being in the right place at the right age to participate at some level in a seismic upheaval like punk.

2 I'm thinking particularly here of the marketability of punk imagery in tourist memorabilia, where punk becomes simply another variant of quaint Englishness. Hence all those postcards of mohican-sporting youths bearing the caption 'London' are stocked alongside cards showing red buses or Union Jacks, while it was possible a couple of years ago on Brighton seafront to buy 'punk dolls', part of a series that also included Tower of London Beefeaters and 'British Bobbies'. The only example I've seen of punk *music* being so domesticated into charmingness was an episode of *Sesame Street* where one of the 'counting songs' was performed as a full-on punk thrash — though the referent here must presumably be the 1990s neo-punk of Green Day *et al.* rather than 70s punk itself.

3 For an excellent survey of debates over the intellectual validity of autobiographical approaches to culture and history, see Swindells (1995).

4 Thanks to Joanne Lacey for shrewdly pointing me in the direction of Kuhn's rich, productive and moving study.

5 It may be worth stressing here, given this chapter's concern with memory and retrospection, that any interpretation of a photograph is an investigation of the past, since every photograph (even a Polaroid) is a backward-looking text, an image made prior to its contemplation, a trace of something that was but no longer is.

6 For a definitively, deliriously punctum-crazed account of pop's emotive powers, see the splendid first chapter of Smith (1995), which consists of one long, breathless, smitten list of the moments, fragments and memories of pop which have meant the most to him.

7 In fairness, I should point out here that punk and its neighbours were not the only things I listened to in the late 70s. I was (assisted by the rantings of ex-punk Danny Baker in the *NME*) an avid consumer of disco, a genre many have since dismissed as either irredeemable kitsch or apolitical hedonism. Yet for many gay men at the time disco had enormous sexual-political importance – looking back it strikes me that Sylvester's 'You Make Me Feel (Mighty Real)' was, in some ways, a far more radically queer record than 'Glad to Be Gay'. More in tune with punk orthodoxies, I became besotted with reggae (few singles of the period pitch more punctum at me than Althea and Donna's 'Up Town Top Ranking'). Indeed it may well be the case that punk's most important and long-lasting influence on white British popular culture was its alliance with reggae. The punk/reggae interface was hardly devoid of ideological problems, but since it introduced me to Burning Spear, Culture and Lee 'Scratch' Perry, as well as generating what I now see as the greatest record to emerge from the whole punk saga – the Clash's perpetually astonishing 'White Man In Hammersmith Palais' – I can only regard it with gratitude.

References

Barthes, Roland (1984) *Camera Lucida*, London: Flamingo.

Clarke, Gary (1990) 'Defending Ski-Jumpers: A Critique of Theories of Youth Subcultures', in Simon Frith and Andrew Goodwin (eds), *On Record: Rock, Pop and the Written Word*, London: Routledge.

Conway, Martin A. (1990) *Autobiographical Memory: An Introduction*, Milton Keynes: Open University Press.

Frith, Simon (1990) Review article of books on popular culture, *Screen* 31: 2.

Frith, Simon (1996) *Performing Rites: On the Value of Popular Music*, Oxford: Oxford University Press.

Hebdige, Dick (1987) 'The Impossible Object: Towards a Sociology of the Sublime', *New Formations* 1: 1.

Kuhn, Annette (1995) *Family Secrets: Acts of Memory and Imagination*, London: Verso.

Lamm, Leonard Jonathan (1993) *The Idea of the Past: History, Science and Practice in American Psychoanalysis*, New York: New York University Press.

Lowenthal, David (1989) 'Nostalgia Tells It Like It Wasn't', in Christopher Shaw and Malcolm Chase (eds), *The Imagined Past: History and Nostalgia*, Manchester: Manchester University Press.

Prior, Clive (1997) Review of reissued Supertramp albums, *Mojo* 43: 116.

Savage, Jon (1991) *England's Dreaming: Sex Pistols and Punk Rock*, London: Faber & Faber.

Shaw, Christopher and Chase, Malcolm (1989) 'The Dimensions of Nostalgia', in *The Imagined Past: History and Nostalgia*, Manchester: Manchester University Press.

Smith, Richard (1995) *Seduced and Abandoned: Essays on Gay Men and Popular Music*, London: Cassell.

Swindells, Julia (ed.) (1995) *The Uses of Autobiography*, London: Taylor & Francis.

14
IS THAT ALL THERE IS?

Suzanne Moore

I am too old to be a punk. But then I always was. During that long hot summer I saw it all happen and I wished I was younger. To be a punk you had to be a school kid, maybe 14 or so. I was three years older and had been variously employed and unemployed. I couldn't suddenly embrace a manufactured subculture. I was far too self-conscious for that. Besides I had curly hair and to be a punk it was compulsory to have straight hair. So that was that.

Not everyone thought the way I did, however, and I despised them for it. When I went back home I would find gathered outside the post-office steps of my small, dead town, a member of each subculture drinking cider together. One hippy, one punk, one skin. It was pathetic. I knew people who, and even now I can scarcely believe it, in their twenties had been total hippies, dope-dealers, who turned into punks overnight. Cut their hair, bought some combat trousers. Had they no shame? Me? I had my second-hand dresses and my neon colours and a tie because Patti Smith had a tie but no tits. A tie with tits I found just didn't look so cool. And I listened to the music and felt sometimes so sad, not because the end of the world was nigh and it was all too late or any of that bollocks, but because I knew in my heart that I had been born too early.

I had left school at 16 for serious reasons of ambition – so that I never had to do PE again in my entire life and so that I could take acid every day of the week instead of just at weekends. Punk filled in the long gap between school and returning to education as a mature student at the grand old age of 24. It had even accompanied me across the Atlantic and back. I remember asking a busker in Mexico City to play 'Anarchy in the UK' for me because I was feeling homesick. Like many others I was suprised to find that punk itself was an object of study. So I began to understand that some of my feelings about false punks or fake punks were not entirely driven by personal spite but arose possibly because punk was the last true subculture. It was media-conscious, and so perhaps my own self-consciousness about where I fitted in was simply another sign of the times.

Whilst deconstructing something that had been part of my life I wrote essays on signifying practices and bricolage following Dick Hebdige. I began to believe in memories, not in my own drunken incoherent recollections but in the memories of others. Their memories had so much more form and function and finality than mine. So I wrote of myself and my friends as if we were members of some newly discovered tribe. I wrote as if we knew what we were doing, and I was surprised to find grown-ups were also writing long and serious books about it all, each of them claiming in some way to have been there, to have found some truth in the confusion.

These new chaos theorists started to annoy me, not because I was anti-thought but because I was anti the hierarchy of authenticity that this form of history takes, anti the privileging of one version of events over another. In truth I was anti-anything that didn't tally exactly with my own experience. I wanted to be a subject not an object. So did everyone else who says 'I was really there'. At that gig. Hanging out with Malcolm. Right up at the front. So let me just say this: some of the time I was really there and some of the time I wasn't there at all, but the only sound that reverberates in my ear is the everlasting fuck-offness of it all. One band used to come on stage and just tell us all to 'fuck off' for a good 20 minutes or so until a fight broke out and the band did fuck off.

If punk was the ultimate fuck-off then what kind of truth are we trying to tell these days? That I truly understand the meaning of fuck off? That I fucked-off first? That once upon a time 'fuck-off' meant something that it just doesn't mean these days? Wandering around an exhibition of punk graphics in the Royal Festival Hall I bump into some people my own age. A trip down memory lane. Weird flashbacks, man. It was kind of touching in its way to think we could shock and be so easily shocked. There was really only one shocking spectacle at the exhibition and we turned and stared at it: the 20-year-old in full bondage gear with a blue mohican. These replicants repel us. They are not the real thing, which is why we are so desperate to claim that we were.

It always amazes me that when you turn everything into culture, nature always sneaks back in through a side entrance. Nature though is present in any romantic myth and all the great writers on punk are intensely romantic. The romance of the *real* is present in whatever narrative of punk you choose. One can interpret the present through the past and delve into the medieval depths that an alchemist like Greil Marcus does (*Lipstick Traces* 1989) in order to make inspired connections that produce something far more intellectually stimulating than a piece of vinyl. That is one path to enlightenment. You can document a movement, its rise and fall, and provide the evidence as Jon Savage does in *England's Dreaming*, a fine piece of work marred precisely by his own embarrassing diary extracts. Or you can interview the left-overs, the stragglers, the survivors, who tell it the way it really was.

And, if you must, then you can play around with your signifying chains and situationist slogans until something is almost resolved, some semi-narrative emerges, some sense is made. Quite by accident you find yourself hoping against hope, part of the wish fulfilment industry that says punk was not *a* revolution but *the* revolution.

If punk was a revolution then what was it for and what was it against? In the abstract I can tell you that it was about the end, about going the whole way, about the collapse of the self into chaos. Equally it was about footless tights and upsetting your boss and giving people a laugh at the bus-stop and wearing as much make-up as you could and trying to get off with boys. It was about being the same but different. A safety-pin could do voodoo on your elders.

Greil Marcus is right of course to pin it all onto a certain Mr Lydon. In him, whatever it was, was there to see. In his face and in that voice. The music merely emanated from his presence. We were possessed by his possession. I was working in a school for mentally disturbed children when the Sex Pistols appeared on *Top of the Pops*. Rotten, perfectly bandaged by Westwood, was singing 'Pretty Vacant'. 'Turn it off' said the guy in charge. The children were prone to epileptic fits and getting over-excited even though most of them were medicated up to the hilt. I was over-excited myself. The notion that a singer, a pop star, could give these kids the wrong idea when they had never had the right idea in the first place was intoxicating. Punk seemed for a moment as if it might change the world. It seemed all-powerful.

So if I really tried I could join together such moments dot-to-dot to make a picture. But why bother? There are already too many valiant attempts to plot a socio-cultural and political history of punk that are brilliant in their invention but remain little more than documents of small numbers of core movers and shakers clustered around London or Manchester. The claims made on behalf of punk are, by their very nature, doomed to exaggeration because, despite the central message of punk being about the ultimate meaninglessness of everything, meaning must still be evacuated. We cannot resist this existential corpse but prod it from time to time. We must ridiculously respect a movement that was never interested in respect and in so doing we must search and destroy in order to make it whole.

Let us instead disrespect the dead. No one disrespects the essence of punk more than the Sex Pistols themselves. They re-formed for the money. They reformed in order to get a pension plan. Doesn't that tell you everything you need to know? Striking an attitude, one can suggest that punk remains alive and well, as it is a state of mind. Sure, when we see Keith of the Prodigy doing his scary punk thing we feel a warm glow inside for that sweet little twisted fire starter and we know punk isn't dead, it's still on *Top of the Pops* (see Figure 14.1). It still seems rather naughty, it still gives us a cheap thrill.

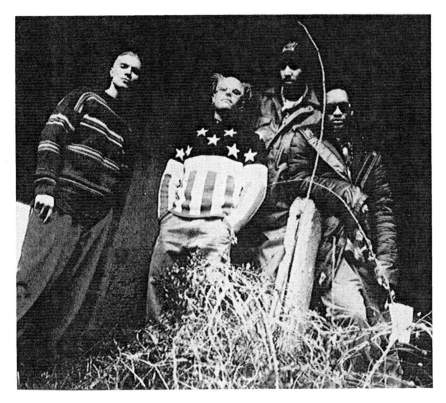

Figure 14.1 The Prodigy, 1996, with Keith Flint second left.
Source: Photograph by Phil Nicholls.

As a lifestyle choice, though, punk is dead except in some theme-park way. My daughter, when lost in the park, said she was going to ask a policeman the way 'Or a lady' she said if she couldn't find a policeman. 'But not a punk, not even a lady punk'. I felt quite proud that the crusties who inhabit my local park can still be seen as dangerous just because they have pink tufts on their heads. Maybe they really are quite dangerous. They live up trees to save them. They love nature. We always made a point of hating it even when we lived in the country. We took urban drugs and rushed around. We thought everything should be changed. Some of us still do. We wanted chaos to come and death came instead. It was difficult to keep talking about a revolution when what really happened was that a few junkies nodded out for the final time.

Sometimes I catch myself thinking 'Did it all happen for nothing?' and I hate myself for it. I have had many an argument with men who should know better telling me that punk defined their lives and so it must have defined mine. They speak of the last great subculture as though they were veterans of some war.

INDEX